ARTIST AND IDENTITY IN TWENTIETH-CENTURY AMERICA

Artist and Identity in Twentieth-Century America brings together a selection of essays by one of the leading scholars of American art. In this book, Matthew Baigell examines the work of a variety of artists, including Edward Hopper, Thomas Hart Benton, Ben Shahn, and Frank Stella, relating their art works closely to the social and cultural contexts in which they were created. Identifying important and recurring themes in this body of art, such as the persistence of Emersonian values, the search for national and regional identity, aspects of alienation, and the loss of individuality, the author also explores the personal and religious identities of artists as revealed in their works. Collectively, Baigell's essays demonstrate the importance of America as the defining element in American art.

Matthew Baigell is professor of art history at Rutgers University. A scholar of American art, he has published on a wide range of topics, and his books include *A Concise History of American Painting and Sculpture* and *Jewish American Artists and the Holocaust*.

CONTEMPORARY ARTISTS AND THEIR CRITICS

General Editor
Donald Kuspit, *State University of New York, Stony Brook*

Advisory Board
Matthew Baigell, *Rutgers University, New Brunswick*
Lynn Gamwell, *State University of New York, Binghamton*
Richard Hertz, *Art Center College of Design, Pasadena*
Udo Kulturmann, *Washington University, St. Louis*
Judith Russi Kirshner, *University of Illinois, Chicago*

This series presents a broad range of writings on contemporary art by some of the most astute critics at work today. Combining the methods of art criticism and art history, the essays, published here in anthologized form, are at once scholarly and timely, analytic and evaluative, a record and critique of art events. Books in this series are on the cutting edge of thinking about contemporary art. Deliberately pluralistic, the series represents a wide variety of approaches. Collectively, books in this series will deal with the complexity of contemporary art from a wide perspective.

For Max, Zach, Tali, and Soyer

Artist and Identity in Twentieth-Century America

MATTHEW BAIGELL
Rutgers University

PUBLISHED BY THE PRESS SYNDICATE OF THE UNIVERSITY OF CAMBRIDGE
The Pitt Building, Trumpington Street, Cambridge, United Kingdom

CAMBRIDGE UNIVERSITY PRESS
The Edinburgh Building, Cambridge CB2 2RU, UK
40 West 20th Street, New York, NY 10011-4211, USA
10 Stamford Road, Oakleigh, VIC 3166, Australia
Ruiz de Alarcón 13, 28014 Madrid, Spain
Dock House, The Waterfront, Cape Town, 8001, South Africa

http://www.cambridge.org

First published 2001

Printed in the United States of America

Typefaces Electra 11.25/13 pt. and Kabel *System* DeskTopPro$_{/UX}$ [BV]

A catalog record for this book is available from the British Library.

Library of Congress Cataloging in Publication Data
Baigell, Matthew.
Artist and identity in twentieth-century America / Matthew Baigell.
 p. cm. – (Contemporary artists and their critics)
Includes bibliographical references and index.
ISBN 0-521-77239-7
1. Art, Modern – 20th century – United States. 2. Artists and community – United
States – History – 20th century. 3. Group identity – United States – History – 20th century.
I. Title. II. Series.
N6512.B25 2000
709'.73;'0904–dc21 00-023664

ISBN 0 521 77239 7 hardback
ISBN 0 521 77601 5 paperback

Contents

Preface

Except for grammatical corrections and occasional changes in wording to account for the illustrations that are not reproduced in this book, the essays appear as originally published.

I want to acknowledge the support of Renee Baigell, John Mc-Coubrey, Jerome Housman, Donald Kuspit, and Norman Kleeblatt, who were very helpful to me at various times over the last four decades.

Introduction

These essays, written over thirty-odd years, are of a single piece even though their subjects vary considerably. I have always assumed as essential and central to my work various aspects of the American cultural and political environment broadly considered and, more particularly, the experiences of the artists themselves. I have never imposed upon myself a particular ideology or point of view or theory that I imagine would be too limiting, nor tried to reduce twentieth-century American art to a set of given variables with predictable conclusions. I feel that such a course would distance me from my own immediate experience of the artists' work as well as from the artists' formative and immediate experiences. I want to understand something about the artists' motivations as these influence the work more than I wish to place the artist within some theoretical construct. I am not opposed to such a point of view. It is that I prefer to think of each essay that I write as if it had grown from something like a conversation with the artist – an outgrowth of asking questions, receiving some answers, and drawing conclusions as the material might warrant. Furthermore, I enjoy quoting artists whenever possible because their words are as close as I can get to their thoughts. This does not mean that I am a publicity agent for any artist or that I operate in a totally value-free bubble. I come from a certain place, as we all do, and my questions

and attitudes are colored by that place. I deal with it both casually and as best as I can.

I have never found purely formal analysis an interesting tool for research (as opposed to its usefulness in the classroom as a teaching device to get students to look at works of art). The line of thought that runs from (going no further back than) the British critics Clive Bell and Roger Fry to the Americans Willard Huntington Wright and Clement Greenberg is utterly central to understanding formal developments in modernist art, but it is not very helpful in trying to understand an artist's choice of subject matter or the kinds of societal contextualization that makes a work of art meaningful in terms other than of itself. To leave out for formal concerns alone some kind of contextualization is to leave out about ninety percent of the human element in any given work, even though the remaining ten percent is obviously highly critical. It allows little or no room for thinking about and looking at art as human communication and as the product of a particular environment.

Although I certainly acknowledge their importance, I am also not a follower of the kinds of art history concerned either with identifying all the data in a particular work without any contextualization or with arranging the preliminary designs in their proper chronological sequence before the final design is completed. To cite a case in point, in one study of the nineteenth-century American painter John Vanderlyn, the author describes the figures in *The Landing of Columbus* (begun in 1837) and discusses some of the preliminary studies for the painting, but fails to ask why the work was placed in the Rotunda of the Capital in Washington during the Mexican-American War or why this painting of a Spanish-employed explorer was placed at all in the capital of an English-speaking country tracing its roots to Pilgrim and Puritan New England and to the Jamestown settlements.[1]

I much prefer to think about art as a product of environmental and experiential factors, however broadly considered. In this regard, I have been most responsive to those authors who have considered these issues in their writings. I will mention only a few of the authors whose works have been important in establishing and maintaining a basis for studying American art in this way. But a caveat: their works include discussions of aesthetic, philosophical, and sociological issues that will not be considered here. What links these authors in my mind is their concern for the effects of the environment and of particular experiences on both artists and observers as they try to understand artistic motivation and viewer response.

Archibald Alison's *Essays on the Nature and Principles of Taste* was published in England in 1790 and, soon thereafter, helped provide a language that American artists and viewers could use in considering the importance of the landscape in American cultural thought. Alison's ideas have long since been subsumed under the rubric of "association psychology." In a sentence, Alison held that matter is not beautiful in itself, but derives its beauty or importance through the mind, which learns either from experience or by association.[2] For example, let us assume that after visiting a battlefield, we reflect on what had transpired there. We realize, according to Alison, that "the beauty of the natural scenery is so often exalted by the record of the events it has witnessed and that in every country, the scenes which have the deepest effect upon the admiration of the people, are those which have become sacred by the memory of ancient virtue or ancient glory." In the early nineteenth century, American nationalists, paralleling Alison's thoughts, held that since one's strongest associations grow from one's own country, from its history and geography, then "national character often receives its peculiar cast from natural scenery . . . Thus natural scenery is intimately connected with taste, moral feeling, utility, and instruction." Literature, as well, can be considered a product of the "state of society, its leading pursuits, and characteristic institutions."[3]

Whatever the particular issues within the environment that excited the early nineteenth-century American mind and caused artists, writers, and politicians to associate the landscape with patriotic fervor, these issues clearly played a role in both the creation and the appreciation of works of art. Similar thoughts range throughout the writings of Ralph Waldo Emerson and others into the middle years of the century. In the later decades of the nineteenth century and well into the twentieth, the writings of the Frenchman Hippolyte Taine were also very important, really central, in continuing this line of thought. Taine's *Lectures on Art* was first published in this country in 1875 and republished in 1883 and again in 1896. A basic point that Taine returned to repeatedly was that "in order to comprehend a work of art, an artist or a group of artists, we must clearly comprehend the general social and intellectual condition of the times to which they belong," that art is an aid to understanding both society and one's own self, and that art develops from characteristics representative of a place, an age, and a period. [4]

We do not have to accept all of Taine's assertions to understand the importance that environment held in his theory of aesthetics, but the fact remains that well into the twentieth century his ideas about the

environment clearly affected the ways American museum curators, arts administrators, critics, and artists, including Thomas Hart Benton, Edward Hopper, and John Sloan, understood the entire artmaking process.[5] Closer to our own time, John Dewey's book *Art as Experience* is essentially a sustained argument for the idea that art "is not divorced from the context of ordinary life," an idea with which Taine would certainly have agreed.[6]

In our own time, the interest in environmental influences has shifted its focus from aesthetic and philosophical concerns to the effects of various social environments on artists. This has resulted in, for example, a vast literature on the relationship between mainstream culture and those artists along with their supporters and critics, who are concerned with feminist, gender, racial, and minority issues. In fact, it would seem today that the dominant, and to me the most interesting, historical and critical writing about American art reflects, not exclusively, but in great measure, the ideas set forth by Alison, Taine, and Dewey.

I probably came to this point of view, or rather had it thrust upon me, because of my own family associations. An uncle married a sister of the Soyer brothers, and an aunt married Louis Arenal, the Mexican artist and the brother-in-law of David Alfaro Siqueiros. (I still have photographs of myself as a child with Siqueiros and other family members.) I grew up hearing about the social view of art, the responsibilities of art and artists to society, and the ways artists reflect various economic and political tendencies in society.

In my family, disdain, not for America, but for American Scene painting, was a given. My elders considered American Scene painting provincial and quite possibly a harbinger of some form of nationalistic fascism. Naturally, I wanted to find out as much as possible about this kind of art. This must have been part of my rebellion against the authority figures in my life. I was not interested in adopting either a left point of view or, for that matter, even a modernist one that regarded the art of the period as hopelessly figurative. That is, I tried to have no preliminary point of view. Rather, I wanted to find out what motivated the artists to think and to paint as they did and what the artists had in mind when they constructed their subject matter. I wanted to get as close as possible to their present moments and to the particular ways in which they witnessed their time. Not least of all, this goal enabled me to learn more about an America that was somewhat distant, but not totally remote, from my own childhood in New York City.

Initially, I wanted to know why, since it was supposed to be so terrible, American Scene painting did not disappear and why, if Grant Wood's *American Gothic* was so bad, it remained the most famous work ever painted by an American artist. Or, why did people literally shudder at the mention of the name Thomas Hart Benton? There had been no recent studies of Wood and very few of Benton when I started my research, so I was basically on my own.

Wood turned out to be much more sophisticated than either his American Scene supporters or his detractors had led me to believe. Thus in my essay "Grant Wood Revisited," I emphasized the artist's savage critique of American society, which he began earlier than and which was certainly as critical as any by a Social Realist. Wood, however, did not couch his criticism in economic terms; instead, he attacked American society as a whole. I still believe his assault to have been more total than that of any artist on the left.

I found that another artist of this period, John Steuart Curry, had a surprisingly liberal attitude toward race issues, which I felt enhanced his reputation as an American Scenist. Although some of Curry's images can be considered condescending today, they were quite advanced for their time, and when I wrote "The Relevancy of Curry's Paintings of Black Freedom" in 1970, before the great outpouring of literature on African American artists and imagery, I thought it important to say so.

Wood, Curry, and their fellow artists were critical and affirmative by turns in assessing their country. Regardless, they wanted their art to grow from and relate to the American environment. A problem I had with these artists was that they confused their own immediate experiences in America with the experiences of Americans in general. They thought that theirs were the "true American experiences," that their particular experiences were in fact universal ones. This perspective of course left out women and left out anybody with a different ethnic background, anybody who lived either far west of the Mississippi River or east of the Ohio, and anybody tainted by too many European memories.

A similar problem occurs with the thought of Alison, Taine, and Dewey, all of whom believed that a country or region could have a monolithic, majority culture and that that culture could represent everybody who lived within it. The search for a monolithic American culture continues to this day, although it is no longer, or at least should not be, a contestable issue. Yet it is still as fascinating to ask people what they think is mainstream American as it is to ask them why they

continue the search. I considered some of these issues in "American Art and National Identity: The 1920s."

Among the American Scene artists, Thomas Hart Benton proved to be the most difficult of the middle westerners because he seems to have had the most disdain for easterners and because he was well read and, therefore, a compelling, if narrow-minded, debater. He was the only American Scenist with whom I spent much time. Immediately upon my introducing myself to him – I was still standing at the threshold of his house – Benton asked me if I was a New York Jew who had come to roast him. I responded by asking him if he was a prejudiced middle western Christian. We both recoiled slightly, caught our breaths, and subsequently managed an amiable professional friendship. But I ultimately came to believe, as I suggested in "Thomas Hart Benton and the Left," that Benton's America and mine existed on separate planets. Benton's desire to be inclusive, to paint works, as he said, that would have meaning for as many Americans as possible, was really exclusionary. Not everybody in America could claim the kind of ancestry Benton deemed essential for being really American. In this regard, as I suggested in "Walt Whitman and Early Twentieth-Century American Art," Benton was not the Whitmanesque artist I suspect he thought himself to be. Benton's America, too ethnically and religiously narrow and too ostentatiously working class, was barely an echo of Whitman's expansive and celebratory America. In place of Whitman's openness, Benton and the other American Scenists seem to have hunkered down behind the ramparts of a much more narrowly defined America. This is not to say that Benton forfeits all claims to our attention. Like Grant Wood, he could point out and critically attack political corruption and predatory capitalist business practices. And Benton's critiques, like Wood's, could be devastating.

Each period in America's history has more than one profile, however, and trying to build an understanding of modern America based on pioneer heritage and local experience alone does not tell the full story of the 1920s and 1930s. Any number of critics during those decades found America to be a country missing the basic cultural amenities of life, a country filled with alienated people brutalized by "the system," who, surprisingly, lacked any sense of their heritage. The artist whose work most nearly visualizes this point of view, Edward Hopper, became the subject of "The Silent Witness of Edward Hopper." Some of the concerns that helped define Hopper's art for me reemerged in Philip Pearlstein's work a generation later, and so "Pearl-

stein's People" might be considered an extension of the Hopper essay. In fact, one could flesh out a much larger study of artists whose images suggest isolation and alienation by including, say, Richard Diebenkorn's figurative paintings and George Segal's sculptures of everyday life, let alone the late portraits of Thomas Eakins. Through these works one could suggest some useful characterizations of the effects of urbanization on the American psyche.

Because I accept the importance of the environment in art production, it has always seemed strange to me that the American roots and backgrounds of the artists associated with mainstream modernism were rarely studied. Most of these artists grew up in this country and lived here for much of their lives, but the literature, especially the literature on the Abstract Expressionists and, to a lesser extent, on the artists associated with Alfred Stieglitz and Robert Henri earlier in the century, stressed European influences. Since Emerson and Whitman are among my favorite writers, I wanted to explore their connections to twentieth-century American art. I found that early in the century, critics used Whitman's name both as an adjective, to describe a variety of characteristics, and as a noun, to describe the rather desperate search for a painter who could be Whitman's equivalent, a painter whose work would finally express visually all that Americans presumably represented. One might read, for example, in magazine articles of the period that Artist X shows Whitmanesque verve, but Artist X is not our Whitman in paint. (Such an artist was never found.)

Robert Henri exhorted his artist friends to read Emerson, but Emerson's influence seems to have been stronger on the early modernists such as John Marin and Georgia O'Keeffe. Provocative parallels can be drawn between their statements and letters and various ideas found in Emerson's writings, suggesting that these artists should be incorporated more profoundly into the history of American culture than is usually the case. I considered these notions in "Walt Whitman and Early Twentieth-Century American Art" and in "American Landscape Painting and National Identity: The Stieglitz Circle and Emerson." But the parallels are most striking between Emerson and the Abstract Expressionists, particularly with regard to creating one's own self, encouraging the exploration of one's own individuality, and reducing history to one's own actions or biography.

I would argue here that two of the supreme Emersonian moments in American art were Jackson Pollock's famous break with his mentor Benton – a break with the past and with prior knowledge – in order to

forge his own personality and testament, and Robert Rauschenberg's erasure of a de Kooning drawing. Each artist in effect reaffirmed at least two of Emerson's great assertions of the self in search of its own authenticity: first, "I am only an experimenter. Do not set the least value on what I do, or the least discredit on what I do not, as if I pretend to settle anything as true or false. I unsettle all things. No facts are to me sacred; none are profane; I simply experiment, an endless seeker with no Past at my back," and, second, "I had better never see a book [read: painting] than be warped by its attraction clean out of my own orbit, and made a satellite instead of a system."[7] These and other parallels between the artists and Emerson are the subject of "The Emersonian Presence in Abstract Expressionism."

Continued invention, discovery, and expansion of one's horizons are images that Emerson returns to repeatedly. It is disheartening to realize, therefore, that in Robert Smithson's writings, this Emersonian sense of amplification seems to be missing. This lack might only be a problem with Smithson. Nevertheless, among the artist-writers of his generation (Robert Morris and Donald Judd, among others) Smithson is the only one, whether or not he knew it, whose writings can be connected most easily to ongoing concerns within the history of American culture in regard to personal aspirations and expectations. So I take his writings very seriously. (I think Smithson's writings on landscape are the most important by an artist following the interview statements given by George Inness in the late nineteenth century.) For example, how un-Emersonian Smithson sounds when he says:

> I posit there is no tomorrow, nothing but a gap, a yawning gap. That seems sort of tragic, but what immediately relieves it is irony, which gives you a sense of humor . . . The day of the artist is very long . . . A feeble push and pull over the grey surface. The icon is sinking into a big vat of grey paint, and there is nothing to do but watch it sink like the watchman watches the night.

And even sadder, because it inverts Emerson's buoyant trope in his essay "Circles" on ever-expanding horizons, is Smithson's comment:

> No matter how far out you go, you are always thrown back to your point of origin. You are confronted with an extending horizon; it can extend onward and onward, but then you suddenly find the horizon is closing in all around you, so that you have this kind of dilating effect. In other words, there is no escape from limits.[8]

I do not believe that Smithson's thoughts here are part of the tradition of the American jeremiad that began with the Puritans, since he offers no hope of redemption.[9] Rather, Smithson said basically that the parameters are in place and that ultimately entropy would triumph. In effect, he found in the mainstream a deep malaise. This attitude, to greater or lesser degree, is explored in the essays "American Art Around 1960 and the Loss of Self," "A Ramble Around Early Earth Works," and "Reflections on/of Richard Estes." Although I cannot deny that there has been a tremendous amount of artistic activity since 1960, I found in the subjects of these essays few expansive gestures, little to lift the spirits, a missing sense of purpose and commitment, and no reason to make art other than to make art. All of these artists appear to be Hopper's children.

Today, however, in the art of minority groups – art that reflects minority racial, cultural, gender, and religious points of view, as well as the environments those points of view inhabit – purpose and commitment seem to be everywhere. This is the kind of art that now generates the greatest interest for me. It is easiest for me to connect to the art of the Jewish-American experience – not to art merely by Jewish artists, which could be about anything, but to art that in some way reflects, or reveals, or articulates a particular aspect of Judaism or Jewish culture (I say more about this in the last essay in this volume, "Postscript: Another Kind of Canon"). In ways analogous to my studying artworks from an Americanist viewpoint or works by artists of my own generation, looking at the works of Jewish-American artists has opened up for me new areas to explore, including self exploration, and new environments to consider. For in studying such art not only is there a relatively little-known history to be constructed, there is also a counternarrative to be developed in relation to the mainstream narrative. For example, Ben Shahn's postwar works on Jewish subjects reveal him to have been a serious student of the Bible, a topic discussed in the essay "Ben Shahn's Postwar Jewish Paintings." And Newman's stripe paintings, considered in "Barnett Newman's Stripe Paintings and Kabbalah: A Jewish Take," may have owed as much to the artist's reading in Jewish mysticism as they did to anything else, just as their subject matter may have devolved as much from specifically Jewish contemporary events as from anything else.

Obviously, the study of interactions between one's own ethnic, racial, and religious backgrounds, and one's gender and gender prefer-

ences, with contemporary society can lead to new ways to view the art of the last several decades and to completely new areas for research. For example, how do globalization and industrialization affect national and regional identification and the use of regional subject matter? Are there ways to accommodate these changes or must one retreat into a mythic racial, religious, or ethnic past? How do artists navigate between ethnic memory, religious belief, and mainstream culture? These questions alone suggest an endless number of topics worth pursuing.[10]

ONE

Walt Whitman and Early
Twentieth-Century American Art

uring the first three decades of this century, Walt Whitman's name probably appeared more often in the art press than the name of any other literary figure. Art critics invoked his name when referring to the contemporary scene. And several artists mentioned his name in articles, diaries, and interviews, indicating that they had read at least some of his work. That he was an influence and a presence goes without saying, but the important question lies less in determining the extent of his influence and presence than in asking how his name was used. I think this is important for two reasons. First, and quite simply, his name was invoked for different reasons by different artists. Second, because he was so incredibly popular, particularly around 1920,[1] he was probably thought to have had more influence than he might actually have possessed, and to have been the originator, rather than simply the major representative, of various trends in American culture.

Many would have agreed with Malcolm Cowley's assessment in the early 1920s that "before Walt Whitman America hardly existed; to him we owe the pioneers, the open spaces, in general the poetry of square miles."[2] Cowley meant that Whitman taught a generation how to read, to think, and to view itself. Unquestionably, Whitman was then a lightning rod for various ongoing concerns in American intellectual

history, but Cowley's remarks must be considered an overstatement on self-evident grounds. Closer to our own time, Max Kozloff, in an article entitled "Walt Whitman and American Art," indicated Whitman's still potent, if not hegemonic, significance in his account of the persistence of Whitmanian thought in abstract expressionism. As part of his argument he cited some passages from Whitman and found their echoes in the writings of Barnett Newman, Clyfford Still, Robert Motherwell, and David Smith. The passages are taken from different sections of "A Song of Joy":

> O the joy of my soul leaning pois'd on itself, receiving identity
> through materials and loving them, observing characters and
> absorbing them,
> ...
>
> The real life of my senses and flesh transcending my senses and
> flesh,
> ...
>
> To be indeed a God![3]

Kozloff argued that there could not be "anything more summary of the Olympian strain of this aesthetic than David Smith's pronouncement: 'I feel no tradition. I feel great space. I feel my own time. I am disconnected. I belong to no mores – no party – no religion – no school of thought – no institution. I feel raw freedom and my own identity."[4]

Whitman's lines, as well as David Smith's, reflect a point of view less Olympian than Adamic and belong to a tradition in American intellectual thought that I would term radical, disjunctive, and subversive. It includes figures such as Ralph Waldo Emerson and the historian George Bancroft and, among abstract expressionists, Jackson Pollock most of all. In this tradition, by no means a purely Whitmanian one, the individual reinvents himself unhindered and uninhibited by the past, and, by extension, contributes to nation-building equally unimpeded by the past.[5] On various occasions Whitman stated as much, perhaps nowhere more concisely than with these lines from "Song of the Open Road": "From this hour I ordain myself loos'd of limits and imaginary lines, / Going where I list, my own master total and absolute."[6]

Before Whitman, Emerson wrote both about himself as an Adamic figure who names the beasts on earth and the gods in the heavens and about individuals who strive to discard inherited traditions in order to

become free and independent. "No facts," he wrote in "Circles," "are to me sacred; none are profane; I simply experiment, an endless seeker with no past at my back."[7] Whitman's desire, then, to interact directly with things, materials, and even ideas as a way to achieve self-definition was voiced by Emerson in a previous generation and by David Smith in a subsequent one. All such passages, therefore, however they may be interpreted by the Malcolm Cowleys and the Max Kozloffs, relate to something elemental in American intellectual history and cannot be traced back to a single individual.

This, of course, does not deny Whitman's importance early in the century or even toward its midpoint. On the contrary, various ideas about the self and about national identity that Emerson and Whitman held in common were probably first encountered by most Americans in Whitman, at least in the early part of the century. But I do not think it to be sound scholarship to saddle Whitman with more than his fair share of responsibility.

A question: why, early in the century, was Emerson considered a secondary figure even though most of the ideas that the early twentieth century found so seductive in Whitman can be traced directly to Emerson? After all, Emerson did have chronological primacy. Whitman himself helps us answer the question. In his essay "Emerson's Books (The Shadow of Them)," Whitman wrote that Emerson was concerned only with the self, that he functioned best as a "critic and diagnoser" rather than as a seer or prophet, and that he lacked passion and imagination. Whitman found that a "cold and bloodless intellectuality dominates him."[8] These qualities, reiterated by early twentieth-century critics such as Norman Foerster, Waldo Frank, and Van Wyck Brooks, were not the qualities wanted by a generation seeking revitalization in American art and American life.[9] They found in Whitman, rather, the personification of what they were looking for – energy, emotional abundance, physicality, democratic rather than elitist interests, and a powerful concern for national identity.

There were other reasons as well for Whitman's great popularity, perhaps not articulated at the time but in retrospect quite evident. First, since in his writings Whitman associated himself so closely with the country, celebration of self meant celebration of country. For Whitman, America "was an idea and ideal that he strove to embody" – its personality, youth, rowdiness, revolutionary ideas in politics, life, and art.[10] He also celebrated the very fact of being alive. For him, "human potential was released only through the act of relating to nature, to others and to

one's own self."[11] He embodied a spiritually and physically reborn America that gladdened the hearts of those trying to escape the inhibitions and conservative forces dominant around the turn of the century and in the years just afterward.

Second, compared to Emerson, who defined nature in terms of spirit, Whitman did the reverse: he defined spirit in terms of nature. His "celebration of the body and its power," as one historian has suggested, "anticipates Freud's later descriptions of the somatic bases of libido."[12] (Freud's *Interpretation of Dreams* was published in English in 1913.)

Third, Whitman must also have touched the same nerve as the popular French philosopher Henri Bergson, whose books were translated into English early in the century and who lectured in the United States in 1913.[13] Whitman's sense of energy, his willingness, as he wrote in his poetry, to pour himself into other people and, in return, to respond in kind to them and, perhaps most important, to trust his intuitions, links him to Bergson's concept of the *élan vital*. Since reality for Bergson resided in movement and also in intuition, along with a desire to participate in some kind of sympathetic communion with objects and people that resulted in a sense of endless creation, it is more than likely that lines such as these by Whitman, "Urge and urge and urge / Always the procreant urge of the world," must have had an impact much stronger than we can imagine today.[14]

Fourth, in a period of international warfare and social dislocation and, by 1920, of modernist pessimism, Whitman's "greatest act of pioneering," one critic subsequently argued, "was in helping the modern sensibility feel at home in the natural world."[15] For Americans, not as overwhelmed by world events as were Europeans, Whitman became an inspirational force.

And fifth, as the only American figure in any of the arts equal to European artists, Whitman was the only real American vanguard artist about whom one could speak without embarrassment. Without Whitman, the art world could boast only of the Armory Show of 1913, a mere exhibition. He became the point of reference and the point of departure. As the editors of the magazine *The Seven Arts* insisted, "The spirit of Walt Whitman stands behind THE SEVEN ARTS. What we are seeking, is what he sought."[16] I raise the questions: What did he seek? What were they seeking? Once again the questions revolve around how Whitman's name was used.

We can start with Robert Henri, who became familiar with Whit-

man's work in the 1890s.[17] Henri responded most profoundly to two aspects of Whitman's thought: the desire for self-identity and self-reliance on the one hand, and the desire for connection to and reflection of community, the American community, on the other. The former aspect can easily be traced to Emerson, with whom Henri was familiar;[18] the latter, although considered by Emerson as well as other nineteenth-century Americans, might be more associated with Whitman than with anybody else. But two points should be noted here. First, several writers addressed the question of national identity in the arts during the years Henri wrote about Whitman.[19] And second, artists like Henri might have absorbed some of their concern for community connection in a general, if not a specifically American, sense from the Frenchman Hippolyte Taine. Now it is true that the first *Leaves of Grass* was published in 1855 and Taine's work did not begin to appear in English translation until 1865, but I suspect that for the generation that came of age in the early twentieth century, Taine's influence was much more important than we have realized – both Whitman and Henri were familiar with Taine's writings – and that it permeated the art world through the 1930s. Taine believed that art is inextricably involved with the community in which it is produced and that to understand the one, study of the other is essential.[20] Henri, then, responding to the potentially antithetical interests then invigorating the American art world – the development of a sense of self and the development of a sense of national identification – found Whitman to be a profound source of inspiration, but certainly not the only one.

Henri's article "Progress in Our National Art" is the best single source for study of his reading of Whitman.[21] The first sentence of the second paragraph reveals Henri's concerns precisely: "What is necessary for art in America, as in any land, is first an appreciation of the great ideas native to the country and then the achievement of a masterly freedom in expressing them." Whitman, too, often combined these two different notions, sometimes in the same sentence, as did Henri, and perhaps most succinctly in his essay "Nationality – (And Yet)": "What most needs fostering . . . in all parts of the United States . . . is this fused and fervent identity of the individual . . . with the idea and fact of AMERICAN TOTALITY."[22]

In his essay, Henri at first stressed connection to the totality. "For successful flowering [art] demands," Henri wrote, "deep roots, stretching far down into the soil of the nation, and in its growth showing, with whatever variation, inevitably the result of these conditions. . . . But

before art is possible to a land, the men who become artists must feel within themselves the need of expressing the virile ideas of their country; they must demand of themselves the most perfect means of so doing, and then, what they paint or compose or write will belong to their own land."

But then Henri began to waffle. He continued in a still Whitmanian vein by seeking individual self-definition before public utterance could take place. He wrote, using Whitman as his example, "It seems to me that before a man tries to express anything to the world he must recognize in himself an individual, a new one, very distinct from others. Walt Whitman did this, and that is why I think his name so often comes to me. The one great cry of Whitman was for a man to find himself, to understand the fine thing he really is if liberated." Henri then singled out Winslow Homer and John Twachtman, two very different figures, as artists who found their distinctive voices. Then, retreating entirely from connections to community and becoming more Emersonian in the process, he concluded this section of the essay by saying, "Each man must take the material that he finds at hand, see that in it there are the big truths of life, the fundamentally big forces, and then express whichever is the cause of his pleasure in his art. It is not so much the actual place or the immediate environment; it is personal greatness and personal freedom which any nation demands for a final right art expression."

Henri never quite resolved the paradox of seeking self-definition and community identity simultaneously. Later in his life, he gave up his nationalist concerns in his search for, as he called them, "my people," clearly giving himself over to his interest in self-definition. He might very well have come to regard Whitman in the same way, for in *The Art Spirit*, Henri said that Whitman's work is an autobiography.[23] One might argue, as well, that Whitman never reconciled the paradox either and never did learn to merge his own identity with that of the group.[24]

Of the artists associated with Henri, only John Sloan's comments about Whitman have been recorded – and only on a single occasion. Certainly, Sloan's understanding of Whitman must have been similar to Henri's, but Sloan's recorded comments point us in a slightly different direction. Sloan seems to have particularly responded to "Whitman's love for all men, his beautiful attitude toward the physical absence of prudishness . . . all this represented a force of freedom. . . . I liked what resulted from his descriptive catalogues of life. They helped to interest me in the details of life around me."[25] From this single

response we can gather, first, that Sloan acknowledged Whitman's lib-
erating attitude toward the body and, second, that by Whitman's exam-
ple Sloan was encouraged to explore to his heart's content contempo-
rary life – that is, to indulge his proclivities as a means to artistic
liberation and self-definition.

The liberating qualities of Whitman's writings about the body and
its physical functions, often noted by literary critics,[26] entered prior to
1920 into the art criticism of at least one writer, Paul Rosenfeld. It is
impossible to say, however, if knowledge of Freud made acceptance of
Whitman's sense of physicality easier or if knowledge of Whitman made
acceptance of Freud easier. Suffice it to say that all three, Whitman,
Freud, and Rosenfeld, can be read in the context of the greater sexual
frankness characteristic of the early years of the century. Be that as it
may, Rosenfeld on one occasion praised Arthur Dove's nature paintings
for their chaste and robust animalism, and some solid feeling of soil.
Dove begins a sort of *Leaves of Grass* through pigment (fig. 1). Rosen-
feld goes on to say that "Dove brings the beginning of an [*sic*] whole
man to his art. He brings a spirit which does not separate any one
function of life from the other. It does not know noble and ignoble
organs."[27] Rosenfeld was certainly paraphrasing Whitman's lines from
the first *Leaves of Grass* of 1855:

> Welcome is every organ and attribute of me, and of any man
> hearty and clean,
> Not an inch nor a particle of an inch is vile, and none shall be less
> familiar than the rest.[28]

Rosenfeld continued by contrasting Dove's paintings with those of
Albert Pinkham Ryder, suggesting that Ryder, a victim of the Puritan
repression of physicality, revealed in his paintings not a whole person
but rather a "duality between body and soul."[29] In what today seems
a rather loopy critique of Ryder, Rosenfeld also argued that "sexual
fear in particular speaks from [Ryder's] forms. For this reason, the
lower parts of his paintings, corresponding to the lower parts of the
body, were left relatively empty in comparison with the middle and
upper parts which corresponded to the 'spiritual regions of the
body.'"[30] The implication clearly was that Dove, by comparison, in-
tegrated his body with his soul and thus was able to integrate the lower
and upper parts of his paintings. In fairness to Rosenfeld, it should be
noted that these observations were also meant as a comment on the
lack of cultural encouragement and fulfillment artists such as Ryder

encountered in American life, but his use of language, I believe, is unthinkable without Whitman and the recognition of his example by such turn-of-the-century literary historians as John Macy and Hamilton Wright Mabie.[31]

During the years Rosenfeld wrote about Ryder and Dove, just before and after 1920, both literary and art critics were searching and calling for artists who could picture the nation's identity, personality, and character, that is, to do for American art what Whitman had done for American literature. Perhaps the critics were responding to Whitman's own calls for great artists who would reflect an American identity in the arts and to Whitman's belief that through the arts, particularly through poetry, the nation could be fused into a single entity. He wrote in *Democratic Vistas* that two or three original poets or artists could provide the nation with "more compaction and more moral identity ... than all its Constitutions, legislative and judicial ties, and all its hitherto political, warlike, or materialistic experiences."[32] Art critics like Rosenfeld, borne along by the nationalistic tide, began to believe that the nation's artists might be ready to "produce a great native expression."[33] One senses urgency in the voices of the art critics, in part to find and to champion an artist the equal of Whitman and in part to associate American artists with the rising nationalism. But Rosenfeld and others thought that the great individual demanded by Whitman had not yet appeared, although Rosenfeld held out the possibility that Alfred Stieglitz might be that person.[34] An editorial in the magazine *The Arts* for November 1921 even upped the ante beyond native identity to global proportions when it asked rhetorically if its generation might "produce an artist capable of moulding the ideals of mankind, capable of winning man from the shams of modem life." The editorial then stated that in Whitman, American literature had "produced a man whose influence over human thought and feeling has spread over the earth." In conclusion the editorial asked its readers to "prepare for the time when an American painter or sculptor ... like a Phidias or a Giotto will have an influence that would dwarf that of Whitman."[35] Returning to continental limits, art critic Henry McBride thought in 1922 that the nation had already begun to produce in Charles Demuth, Charles Burchfield, and John Marin the "lusty" artists Whitman had prophesied.[36] But in 1925 the search for such an individual was still going on. Art critic Thomas Craven in that year asked for an artist who, like Whitman, "with brains, energy and original vision ... will convert the vast panorama of American life into living form."[37]

1. Arthur Dove, *Nature Symbolized No. 2* (c. 1911). Pastel on paper. 18 × 21⅜ in. Courtesy of The Art Institute of Chicago. Gift of Georgia O'Keeffe to the Alfred Stieglitz Collection, 1949.533.

But even if no artist emerged either as Whitman's equal or as the major interpreter of American culture, several were praised for Whitmanesque qualities in their works. For example, Rosenfeld found Marin's work to be Whitmanesque "for its richness of touch, sensuality, crudeness and roughness."[38] Another critic pointed out resemblances between the paintings of George Luks and Whitman's poetry. "There are," the critic said, "the same unconventionabilities, the same felicity of expression coupled with passages which are clumsily executed. There is the same downright sincerity."[39] I will grant that this last citation is a good example of early 1920s artbabble, but my point is that Whitman's name became a part of the art dialogue of the time and artists were measured in one way or another against it. Whitman, in effect, became the competition.

Surprisingly, several modernists disclosed a keen interest in Whitman, including Marsden Hartley, Stuart Davis, Joseph Stella, Maurice

Sterne, and Abraham Walkowitz.[40] Of the modernists, only Hartley, like Henri, indicated a strong response to Whitman's desire for personal liberation and for an American identity. In 1918, during a period in which he was, as he said, "an American discovering America," he argued that an American art will emerge "only when there are artists big enough and really interested enough to comprehend the American scene. Whitman was a fine indication of promise and direction. It has not occurred since excepting in the local sense of poetry. . . ."[41] Hartley also acknowledged Whitman's importance for artistic emancipation, coupling him with Cezanne as having "done more . . . for the liberation of the artist, for the freeing of painting and poetry, than any other man of modern time."[42] Echoes of both Hartley's and Henri's readings of Whitman can even be found in the endorsement of the first exhibition of the Society of Independent Artists in 1917. Henri-Pierre Roche, the French critic then living in New York City, wrote in an article in the Dada journal *The Blindman*, "May the spirit of Walt Whitman guide the Independents. Long live his memory; and long live the Independents."[43]

Joseph Stella, who had read Whitman in Italy before emigrating to America in 1896 and who, by 1913, had become fully conversant with modernist styles, found Whitman useful in yet other ways. He associated the poet more with the development of a modern art in America than with a specifically American art derived from American experiences. In fact, he equated Whitman with futurist artists. By futurists, Stella did not mean the Italian futurists but those who were intent upon destroying tradition in order to create a new language "to express the feelings and emotions of the modern artist." American artists, he believed, had not yet fully understood the importance of developing a new artistic language for a new age, but, as he said, "America which is so young and energetic and has the great futurist work first achieved by Walt Whitman," should follow the example of the Europeans by creating such a language.[44] It is no wonder, then, that in his painting of the Brooklyn Bridge (fig.2), the symbol of industrial modernity in America, Stella invoked Whitman's verse "soaring above as a whole aeroplane of Help . . . leading the sails of my Art through the blue vastity of Phantasy. . . ."[45] Precisely which passages in Whitman's work helped Stella navigate the vastity of Phantasy is a mystery to me. But it is quite likely that Stella's understanding of Whitman's significance for modern art grew from conversations with Benjamin De Casseras. At any rate, both published articles in 1913 which treated Whitman in a similarly vision-

2. Joseph Stella, *Brooklyn Bridge* (c. 1919). Oil on canvas. 84 × 76 in. Courtesy of Yale University Art Gallery, New Haven, CT. Collection of Societe Anonyme.

ary manner. De Casseras, a critic in the Stieglitz circle, believed that logic, rationality, and causation did not apply to modern life. Instead, chance, intuition, and irrationality were the governing modes of existence. Among the various figures he singled out from the ancient and modern worlds who acknowledged "the sense of the Irrational as [a] principle of existence" were Emerson, Thoreau, and Whitman. He called them "the three supreme Irrationalists of the age . . . for they reported what they *felt*, not what they *saw*." And because of their apparent dedication to the irrational, he considered them to be "fathers of the cubists and futurists."[46]

Unlike De Casseras and Stella, who considered Whitman central to

the development of the modern spirit, Stuart Davis found in Whitman a poet who explored the quotidian and the ordinary and who reveled in his wonder and love for America. Writing in his journal in 1921, around the time he was painting his "tobacco pictures," as he called them, he attacked European modernism, calling cubists good metaphysicians and Dadaists "jugglers with whom we have been acquainted in vaudeville for some years." By contrast he considered works such as *Lucky Strike* and *Sweet Caporal* to be original and without parallel (fig. 3). "In poetry," he wrote, "we have [Vachel] Lindsay, [Edgar Lee] Masters, [Carl] Sandburg, and [William Carlos] Williams, all in some direct way direct descendants of Whitman, our one big artist. I too feel the thing Whitman felt – and I too will express it in pictures. America – the wonderful place we live in. . . . I want direct simple pictures of classic beauty – expressing the immediate life of the day. I want this now, always have wanted it and always will want it."[47]

It is important to note here that Davis seems to have accepted Whitman as the master delineator of the American scene both in spirit and in content. Whitman had become, for Davis, institutionalized. Davis might even have thought that Whitman would have approved of the tobacco pictures, for they were original and, by implication, American in that they expressed, as Davis conceived them, "the immediate life of the day."

Until 1939 no painter, to my knowledge, illustrated specific passages in Whitman's poetry or prose. The only instance I know of, aside from book illustrations of his verse, are the thirteen panels Ben Shahn and Bernarda Bryson Shahn painted for the Bronx Central Annex Post Office in 1939. These were inspired by the eighteen-line poem "I Hear America Singing."[48] In the poem Whitman wrote that he heard mechanics, carpenters, masons, boatmen, shoemakers, woodcutters, and women, "each singing what belongs to him or her and to none else."[49] And in Whitmanian fashion, the Shahns presented in heroic scale various ordinary Americans going about their daily tasks. As Shahn said of these murals, "My idea was to show the people of the Bronx something about America outside New York."[50] Whitman is here used as a tour guide.

A further question needs to be asked. Did any artist come close to capturing the aura of Whitman in his work? Some might say that Thomas Hart Benton did, but I would argue the opposite. Unfortunately, I cannot find in Benton's writings any direct references to Whitman, although they must exist, since Benton was well read and could

3. Stuart Davis, *Bull Durham* (1921). Oil on canvas. 30¼ × 15¼ in. Courtesy of The Baltimore Museum of Art. Edward Joseph Gallagher III Memorial Collection. Estate of Stuart Davis/Licensed by VAGA, New York, NY.

hardly have missed Whitman.[51] In any event, there are several passages in Whitman that seem to describe Benton's attitudes toward American art and culture better than those of any other artist. For example, Whitman wrote that "the greatest writers only are pleased and at their ease among the unlearned, – are received by common men and women familiarly, do not hold out obscure, but come welcome to table, bed, leisure, by day or night."[52] It would seem that most of Benton's *An Artist in America* was written as an emendation to that thought, for Benton described in great and loving detail his contacts with common people in the South and Southwest.[53] Benton's desire to meet with such people was predicated on the beliefs that American art should not be derived from European art, that the American artist should, as Whitman said, "respond to his country's spirit," that the American artist should neither paint the elite nor paint for them, and that he should not prefer one region to another.[54] Further, Benton painted, as he often said, typical scenes and typical people engaged in typical tasks. All of these themes can be found throughout Whitman's prose and poetry, notably in the preface to *Leaves of Grass*, "Song of the Broadaxe," "Song of Myself," "By Blue Ontario's Shore," and *Democratic Vistas*. Why, then, was Benton not considered the Whitman of American painting? I believe that Benton was rejected by so many even during the 1930s because of his narrow, nationalistic reading of American art and culture. In place of Whitman's open expansiveness and quest for the ideal democratic individual in the entirety of America, Benton was instead exclusionary, hostile, and ethnocentric. In the end, Benton violated Whitman's vision by substituting ideas of the *Volk* and appealing to history and tradition instead of honoring Whitman's endless chant to an America still in formation, still open to growth, change, and new songs.

In seeking to assess Whitman's significance for American art early in the century, I have tried to take nothing for granted and have therefore remained as close to the evidence of the written word as possible rather than to assume overarching influences from Whitman. To do the latter would mean, I believe, assigning too much significance to one person without considering his influence within a context that would include the contributions of Emerson, William James, and a host of others concerned with American art and life. Granted, Whitman was the representative figure for many, the person whose example was important, even primary, but he was not in every case the originator, and we need to guard against such simplistic and one-dimensional thinking. Nor was there, as I have tried to suggest, a canonical Whit-

man. Certainly, he was the stellar example of an artist concerned with both self-definition and national identity. He was also a model for those wanting to document the contemporary scene, an aspect of the larger issue of national identity. And he was also mentioned in discussions of sexual liberation and cited as a visionary and forerunner of modern art. These various perceptions of Whitman are linked together by the implicit acknowledgment of his desire to break with the past, whether it be a past influenced by Europe or by the Puritans. In this regard, he was recognized as the country's first vanguard artist, and, as such, artists and critics could find in his work and in his example whatever they were looking for. Or as Whitman wrote in "Song of Myself":

> Stop this day and night with me and you shall possess the origin of all poems.
>
> .
>
> You shall listen to all sides and filter them from your self.
>
> .
>
> Not I, not any one else can travel that road for you,
> You must travel it for yourself.[55]

TWO

American Landscape Painting and National Identity

The Stieglitz Circle and Emerson

Since the founding of the nation in 1789, the issue of national self-identification has been raised continuously, especially in this year of the bicentennial celebration of the Constitution. Unlike earlier periods, however, when people hoped that a single American culture, an American spirit or an American consensus might one day emerge, contemporary observers indicate that this will never happen, as much by what they say as by what they do not. For example, Elizabeth Hardwick has suggested that "America is more concrete than American. In spite of the most insistent drumming, we are not a folk."[1] And Hendrik Hertzberg has observed:

> We may sing about purple mountain majesties and fruited plains, but we have no mystique of land or blood. We have no *patrie*, no *volk*. We come from all over the place, we're all different colors, and we don't all look alike. What unites us, finally, is a political compact, a constitution: the Constitution.[2]

He goes on to comment about the fragmentation of that illusive American consensus:

> The ties that bind are no longer just the ties of propinquity. The communities that count are communities of interest and belief –

communities that are at least as likely to be national as local. Ideology, profession, class, even racial and sexual identity – these are the soil our roots grow in now, as much as or more than where we live.[3]

In today's art world, interest in an American consensus or in identifying an American factor in art is minimal and insignificant, and we have forgotten how important defining an American art had been to generations of artists. But such concerns had been basic from the 1780s to the 1940s. This was especially true in the earlier part of this century when questions of national self-identification and nationalism were all but inseparable from the language and ways of thinking within the American art world.[4] Surprisingly, modernist American artists were affected as much as traditionalists and realists, including Alfred Stieglitz and the most insistently modernist artists he supported – John Marin, Georgia O'Keeffe, Arthur Dove and Marsden Hartley. Not surprisingly, their principal vehicle for exploring and revealing American qualities in their work was the traditional one of landscape painting. It was James Jackson Jarves, the important nineteenth-century critic, who once wrote, "the thoroughly American branch of painting based upon the facts and tastes of the country and people is the landscape."[5] In their choice of subject matter, Marin and the others acknowledged and perpetuated Jarves' observation well into the twentieth century, providing their art with an often overlooked American dimension. It is precisely this aspect that I would like to consider here by concentrating on their search for identities as individual as well as American artists. In both instances, I want to invoke the Emerson-Whitman tradition, not with the intention of pointing out specific, provable influences, but to suggest that the Stieglitz artists, in wanting to be both individual and American, drew upon a tradition to which Emerson and Whitman belonged.

In discussing artistic nationalism in the Stieglitz circle, it is best to state first what it was not. It was not dependent upon the kind of sloppy and superficial thinking in which facts and interpretations of images were twisted to suit the wishes and fantasies of artists as well as critics. In an astonishing number of observations, almost any way American landscape painting could be made to look good and look American was acceptable. Here are a few examples: American landscapists, whatever their European sources, could be compared favorably to their European models. By this reasoning, Childe Hassam, J. Alden Weir, Ernest Law-

son and J. Francis Murphy were better painters than Monet, Sisley and Pissaro because the Americans had assimilated and made more accept-able "tendencies that in others [were] exercised to a disproportionate degree."[6] By a similar sort of stand-on-your-head reasoning, American Impressionists were considered essentially American despite their obvi-ous European training and styles.[7]

Other aspects of American landscape painting were considered at-tractive to critics besides good taste and the imitation of European models. The American spirit, whatever its many definitions, had some-how infused itself deeply into the minds of landscape painters. In a typical account, one observer noted: "no painting is more permeated with a native spirit than the painting of [George] Inness, [Alexander] Wyant, [George] Fuller, [Winslow] Homer, Murphy and Weir. Their pictures are all but redolent with the very odour of the American countryside; they represent . . . the heart and soul of this country's in-nate spiritual and sentimental identity."[8] This kind of conservative, ruralizing thought meshed easily with anemic remnants of older Ro-mantic notions which in place of finding in the landscape moral and civic regeneration, now found "sanity first of all" and "a sedative and tonic" from modern life.[9] American landscapists were also considered more lyrical rather than epical because of the nation's continued suc-cess in contrast to Europe's many tragedies. The landscape painters, because of their interests in local scenes, also had access to "the birth-place of so much of our poetry and of our strength, of the humor and of the kindly tendencies of our nation."[10] The American note was also struck louder in landscape scenes than in other subjects, since recogniz-ably American places could be seen, or, at least, imagined. Increasingly as the twentieth century progressed, views of, say, Arizona began to look more like Arizona, New England views more like New England, rather than like views of the Seine, Holland or the Brittany coastline.[11]

Stieglitz and the artists he supported were much more tough-minded in their searches for American qualities in art (if tough-minded is the right phrase for something as vague and ultimately indefinable as finding American qualities in art). Despite varying contradictory asser-tions and claims that are inevitable over a period of three or four decades, the basic intentions of Stieglitz and the others were these: to develop an American art based on a sense of place and a desire for the artist to respond as authentically as possible to that place. That is, the artist, in defining himself through his relationship to the landscape and to whatever cultural and personal meanings the landscape might con-

vey, would define himself as an American artist. The quest was a double one: for personal identification and for an American identification. By defining oneself, one also defined oneself as an American. Authenticity and Americanism went hand in hand. Of course, this has to be qualified in all sorts of ways. Nobody in any society possesses an authentic self totally free from cultural conditioning, least of all the Stieglitz artists who were so profoundly influenced by modernism (both artistic and literary) and of their sense of themselves as Americans. But given these obvious constraints, they sought to paint, as it were, with their own voices and they believed that by so doing they would reveal their American voices.

This point of view began to gain currency in the art world at least by the century's turn. In magazines such as *The Craftsman* and in writings especially by Robert Henri, the leader of the early twentieth-century realists, great emphasis was placed on revealing the spirit of the country through its art. Emphasis, however, tended to lean toward subsuming oneself within the larger national body rather than stressing one's own unique experiences.[12] The Stieglitz artists did the reverse. Their own experiences were primary. American sources for this point of view grew ultimately from that tradition associated with Ralph Waldo Emerson and Walt Whitman. And since precise influences are hard to pin down, it is more appropriate to say that in the Stieglitz circle there were Emersonian and Whitmanesque recollections, reflections and parallels. But they were clearly there, although not as demonstrably apparent as they were among artists in the Henri circle.[13]

Probably Whitman was the more potent immediate source for the Stieglitz artists, since his name was invoked repeatedly in the literary and artistic press before and after 1920 both as a model and as the first important American artist.[14] In Whitman, too, the problem between retaining one's individuality or merging it with the larger national body was also more immediate since he was primarily a creative poet rather than an essayist like Emerson. On balance, Whitman did not merge his individuality with the larger group, and, as indicated, neither did the Stieglitz artists.[15]

This is of some importance to mention because parallel with the Emerson-Whitman tradition, and, indeed, intertwined with it, was another in which the culture was studied first as a way to understand its art and artists. This point of view stems immediately from the social-minded Frenchman Hippolyte Taine rather than from Emerson the individualist. Taine's position, briefly stated, was that "to comprehend a

work of art, an artist or a group of artists, we must clearly comprehend the general, social and intellectual condition of the times to which they belong."[16] Whitman was familiar with Taine's writings, but ultimately preferred to hear the voice of the larger body in his voice rather than to lose his own in the larger body. Or, at least, we can conclude this from the following passages in "Song of Myself" and "By Blue Ontario's Shore":

I celebrate myself, and sing myself,
And what I assume you shall assume,
For every atom belonging to me as good belongs to you.

A Nation announcing itself,
I myself make the only growth by which I can be appreciated
I reject none, accept all, then reproduce all in my own forms.[17]

Emerson, too, acknowledged the importance of environment several times in his essays. "No man," he wrote in "Art," "can quite emancipate himself from his age and country, or produce a model in which the education, the religion, the politics, usages, and arts, of his time shall have no share."[18] But more typical is this passage from "Self Reliance," in which the individual is seen as more important than the group and, as in Whitman, can become a spokesman for the group. "To believe your own thoughts, to believe that what is true for you in your private heart, is true for all men, – that is genius."[19]

The more sociological point of view associated with Taine, although present throughout early twentieth-century literature on American art, reached its climax in the American Scene movement of the 1930s when artists such as Grant Wood and Thomas Hart Benton, who often acknowledged Taine's influence, tended to subvert the authenticity of their own responses and experiences for those of the larger group, whether regional or national, and, by so doing, changed the focus "from an open search for national identity to nationalism of a narrower sort."[20] I might add here that in the Abstract Expressionist search for authenticity of expression beginning in the middle 1940s, the American factor was disavowed to such an extent that if it appeared at all it did so as a residual by-product. Since that time, it is significant that the American factor has had so little significance in American art except, as in Pop Art, in a critical way.

In considering, then, the search for self and country in the Stieglitz circle, it is easiest to conflate their concern for national identity with the Emerson-Whitman tradition. Most broadly, Stieglitz and the artists

found the act of painting more important than adhering to particular doctrines. Whatever their awareness of European thinkers (Bergson, Nietzsche) or cult figures (Madame Blavatsky), their inclination was for the real rather than the abstract, for the experiential rather than the conceptual. They seemed willing to be inconsistent and to remain open to possibilities – all Emersonian traits. Stieglitz in his various galleries – the Little Galleries of the Photo-Secession (1905–1917), the Intimate Gallery (1925–1929) and An American Place (1929–1946) – offered something equivalent to Emerson's Concord – a place in which ideals could be considered reasonably free of trade and commerce. Concord, like the galleries, could be "a place where thought and imagination could be exercised in relative freedom from immediate consequence, a center of intent both culturally, revolutionary and politically power-less."[21] Stieglitz, like Emerson, found history a hindrance, since its traditional forms arrested individual and spiritual development, and both believed that man's mind was stronger and more important than institutions. Both preferred individual adventure to group activities or mass movements. Stieglitz, no doubt, would have been sympathetic to the notion that "Emerson was advocating the mythic nature of our existence, the constant possibility for man to be in touch with his creation and in living along that channel to determine his daily real-ity."[22] (From this point of view one might read American Scene painting as a colossal loss of nerve and Abstract Expressionism as very Emerson-ian.)

At his most Emersonian, Stieglitz could say:

> I am the moment. I am the moment with all of me and anyone is free to be the moment with me. I want nothing from anyone. I have no theory about what the moment should bring . . . I am merely the moment with all of me . . . When I am no longer thinking but merely am, then I may be said to be truly living, to be truly affirm-ing life.[23]

This sort of expression, whatever its associations with Henri Berg-son's *élan vital*, reverberates with Emersonian feeling of the sort ex-pressed in the essay "Nature." "Every hour and season yields its tribute of delight; for every hour and change corresponds to and authorizes a different state of mind, from breathless noon to grimmest midnight."[24] Stieglitz's contempt for the dead hand of tradition also finds its echo in Emerson. Just as the former considered 291 (the shorthand name for his first gallery) in revolt against authority, "in fact against all authority

in everything," so Emerson said in "The American Scholar" (which was a declaration of intellectual independence), "I had better never see a book than to be warped by its attraction clean out of my own orbit, and made a satellite instead of a system. The one thing in the world, of value, is the active soul." He repeated the thought in "Self Reliance:" "What I must do, is all that concerns me, not what the people think," and in "Circles," "No facts are to me sacred; none are profane; I simply experiment, an endless seeker, with no Past at my back."[25] My point in citing all of these references is not to play the game of notecard shuffling to find parallel thoughts in Emerson and Stieglitz, but to indicate how profound were the reverberations of the one in the other, or, rather, how profoundly both, and the artists as well, responded to similar ongoing strains in American thought. And just as these parallels can be observed, other, more sharply focused ones can also be found expressing the need for an American content – not necessarily in particulars, but in general terms. In "The American Scholar" and in "Self Reliance," Emerson asked for studies of the American scene. In "The Poet," he sought a poet who might celebrate America. The quest for American definition and the regret that it was slow in coming were also strong in Stieglitz's mind. As early as 1911, years before he had decided to concentrate on encouraging the growth of an American art, he wrote, "there is certainly no art in America today; what is more, there is, as yet, no genuine love for it." Nevertheless, as he reflected much later, "In the years before the war [World War I], I was constantly thinking of America. What was '291' but a thinking of America?"[26] By the 1920s, when he had committed himself to American art, he wrote to the poet Hart Crane, "This country is uppermost in my mind – what it really signifies – what it is."[27] He began to concentrate his attention on John Marin, Georgia O'Keeffe, Arthur Dove, Charles Demuth, Paul Strand, the photographer, and himself. He also supported Marsden Hartley. Stieglitz's Intimate Gallery (1925–1929) was "dedicated primarily to an Idea and is an American Room. It is used more particularly for the intimate study of seven Americans [the above, less Hartley]." As Stieglitz said, "What I am doing here is to ask America, in the name of America, whether there is no place here for her own."[28]

Just as Emerson wrote in "The American Scholar," "We have listened too long to the courtly muses of Europe," so Stieglitz also questioned reliance on European models. In a letter to Paul Rosenfeld, who might be characterized as the resident theoretician of the Stieglitz circle, Stieglitz argued against an American art with "French flavor."

That's why I continued my fight single handed at 291. That's why I'm really fighting for Georgia [O'Keeffe]. She is American. So is Marin. So am I. Of course the world must be considered as a whole in the final analysis. That's really a platitude – so self understood. But there is America – Or isn't there an America. Are we only a marked down bargain day remnant of Europe? Haven't we any of our own courage in matters aesthetic?[29]

In a letter to art patron Duncan Phillips, Stieglitz virtually trumpeted, "I have a passion for America and I feel, and have always felt, that if I could not believe in the worker in this country, not in the imitator of what is European, but in the originator, in the American himself drifting from within, pictures for me would have no significance."[30] Over the years his efforts were gratefully acknowledged by the artists. "His battle was principally for the American artist-photographer, sculptor, painter," O'Keeffe said. "In his time the French were of much more interest than the Americans, but he thought that something of interest and importance must come out of America. And one by one, he chose a group that he thought of interest and did his best to make it possible for them to work."[31]

Of the painters Stieglitz supported, Marin, Dove and O'Keeffe are closer to each other than any are to Hartley, who ever restless, travelled to Europe both physically and spiritually far more frequently than the others. He will be considered separately. Marin was probably the most insistently and consistently American and closest to the Emerson-Whitman tradition. Even his mannered writing style, his punctuation and his use of dashes recall Whitman's essay "Specimen Days." And it was Marin more than the others who combined, as did Whitman, a love for both the rural and the urban. In fact it is not a little startling to realize that the following passage from Whitman's *Democratic Vistas*, published in 1874, is one of the best descriptions of Marin's work and captures wonderfully the excitement and vibrancy of his scenes of New England and New York City *avant la lettre*:

The splendour, picturesqueness, and oceanic amplitude and rush of these great cities, the unsurpassed situation, rivers and bay, sparkling sea-tides, costly and lofty new buildings, facades of marble and iron . . . the flags flying, the endless ships, the tumultuous streets . . . barely ever intermitted even at night; these, I say, and the like of these, completely satisfy my senses of power, fullness, motion, etc., and give me, through such senses and appetites, and through my aesthetic conscience, a continued exhaltation and absolute fulfill-

ment . . . I realize . . . that not nature alone is great in her fields of freedom and the open air, in her storms, the shows of night and day, the mountains, forests, sea – but in the artificial, the work of man too is equally great . . .[32]

Marin's concern for an American art developed most strongly in the 1920s, but he was already aware of his responsibilities as an American artist when, after living abroad from 1905 to 1909 and planning to return to Europe, he decided that an American artist should remain in America.[33] During the 1910s, he developed the idea that artistic expression must come from immersion in the locale, or nature, or the landscape – the words become interchangeable. This point of view, it is important to stress, is basic to all of the artists in the Stieglitz circle. Writing to Stieglitz in 1919 about two artists whom he met in Maine, Marin said their Maine was not like his.

Theirs [was] a sort of Pseudo Romantic, Chaldean, Persian, Grecian, Roman, Italian, French, German Combination Vision, an Abstract Concreteness, a monumental memory of things. A lighthouse, two figures of an old European romantic manufacture . . . Sheep on an island used to Express Symbollicaly their European eyed Abstractions.

He preferred to have:

at the root of the matter, however abstract, however symbolicaly expressed . . . "town of Stonington," "the boats of Maine," "the people of Maine," "the sheep of Maine isles," seething with the whole atmosphere of Maine. In all great expression you feel that, and to such an extent that one might almost say that they didn't feel it, but, well, that it just was [fig. 4].[34]

For Marin and the others, the starting point for art, then, was nature, not art or the imagination, and the descriptive language was, as might be expected, filled with references to nature. One of the recurring images in the art literature of the time was that of the soil or the earth. In the Stieglitz circle, it did not carry folksy connotations more appropriate to the American Scene movement. For example, art critic Jerome Mellquist's assessment of Dove, that "he comes all loamy from the American Soil. His work does not arise in the European experience. . . . He is fully attached to the soil of America," is not the way the image was used in the Stieglitz circle.[35] Rather, it carried, in addition to American connotations, intimations of sensuousness and even sexual

4. John Marin, *Tree and Sea* (1919). Watercolor with charcoal on white wove paper. 13⅝ × 16½ in. Courtesy of The Art Institute of Chicago. Gift of Georgia O'Keeffe to the Alfred Stieglitz Collection, 1949.559.

release, of fulfillment, of completeness of being. Georgia O'Keeffe, writing about Dove, said:

> [He] is the only American painter who is of the earth. You don't know what earth is, I guess. Where I come from the earth means everything. Life depends on it . . . Dove comes from the Finger Lakes region. He was up there painting, doing abstractions that looked like that country which could not have been done anywhere else.[36]

Paul Rosenfeld found in Dove a "love and direct sensuous feeling of the earth," and in his work suggestions of its odors and textures (fig. 1).[37] O'Keeffe and Rosenfeld used such images to imply that Dove, an American artist, was finally painting with his entire being, with his "head, breast and belly," as Rosenfeld said, not just with his head, and that an American painter was finally beginning to emulate Whitman and bring the "whole man to his art."[38] This quality, Rosenfeld thought, was a key to the development of an authentic American art – evidence of the wholeness of an artist's person, of his authentic self in his work, evidence which had been lacking in the past. The soil then, was not a country-home image as it was to become in the 1930s, but one implying a loss of personal inhibition, of the presence of artistic maturity in and self-fulfillment for American artists.

It was certainly in this context that Stieglitz once said of Marin, "[he] does not set out consciously to paint things American but he does so necessarily, because he is himself of the soil."[39] Marin's own use of the image was simultaneously more nationalistic and more descriptive of his art. "It is a legitimate hope," he once stated, "That Our Soil will produce the artist . . . When we grow potatoes in this country we use American soil and when we paint pictures I guess we use something like it."[40] Marin's potato image was his way of telegraphing his preference for art based on forms in nature. He disdained abstract art and believed that abstract artists found no delight in looking at the world. Of Mondrian, he once said, "Curious, isn't it – there's a man with an exceptionally fine head – making a series of fine uprights and horizontals as supports for things to grow – Yet nothing grows thereon."[41] Marin held, rather, that "art is produced by the wedding of man and nature," that the artist "can create from that which he has seen," that "to close one's eyes to the seeings on this Earth – to specialize in a limited seeing – that one is not for me and that limited seeing full of distortion – nothing recognizable – that you've never really seen with love," and that the artist "can transpose . . . can play with [his] material, but when [he is] finished that's got to have the roots of that thing in it and no other thing."[42]

Dove also derived inspiration from forms in nature. In 1913, he wrote to Stieglitz that his line had gone dead because he had momentarily stopped working from objects in the landscape.[43] Unlike Kandinsky who wrote in On the Spiritual in Art, with which Dove was familiar, "that art is above nature is no new discovery," Dove held that "what we

call modern should go smack to nature as a source." On another occasion, Dove wrote:

> Actuality! At that point where mind and matter meet. That is at present where I would like to paint. The spirit is always there. And it will take care of itself.[44]

Finally, in a letter to Stieglitz, written in 1929, Dove indicated his preference for the real as his point of departure when he said "to choose between here and there, I should say here."[45] But preference for the actual did not mean preference for imitation. Dove would have agreed with Marin who wrote in 1950, "Nature is so beautiful so wonderful – that to make that which is based on an imitation almost seems a Crime."[46]

O'Keeffe, too, found nature to be an essential source of her inspiration. When asked about the relation between nature and her work, she said:

> From experience of one kind or another, shapes and colors came to me very clearly. Sometimes I start in a very realistic fashion and as I go on from one painting [to] another of the same thing, it becomes simplified till it can be nothing but abstact, but for me it's my reason – for painting, I suppose.[47]

Reliance on fact was, of course, basic to Emerson, but tyranny by fact was anathema to him as it was to Marin, Dove and O'Keeffe. Of the many passages one can find in Emerson's essays, one from "History" and another from "Art" well illustrate these points. After discussing the effect of the tyranny of facts over people, Emerson wrote:

> If the man is true to his better instincts or sentiments, and refuses the dominion of facts, as one that comes of a higher race, remains fast by the soul and sees the principle, then the facts fall aptly and supple into their places; they know their master, and the meanest of them glorifies him.

> In landscape, the painter should give the suggestion of a fairer creation than we know. The details, the prose of nature he should omit, and give us only the spirit and splendor. He should know that the landscape has beauty for his eye, because it expresses a thought which to him is good, and this, *because the same power which sees through his eyes, is seen in that spectacle* [my italics]; and he will

come to value the expression of nature, and not nature itself, and so exalt in his copy, the features that please him.[48]

The italicized passage points to Emerson's mystical belief in the connection between matter and spirit and to his own desire to connect to the wholeness of nature, that in the end nature was a teacher and a guide and the elemental stuff from which he derived his knowledge. The artists, if in less exalted terms, also felt a similar humility before the entirety of nature as well as a desire to learn from it and to comprehend and relate in some way to its vastness. For example, speaking of nature in a purely visual context, but with spiritualizing overtones, Emerson wrote in "Nature," "Such is the constitution of all things, or such is the plastic power of the human eye that the primary forms, as the sky, the mountain, the tree, the animal give us a delight *in and for themselves* . . ."[49] Almost as if in extension of this observation, Dove wrote in 1927, "I should like to take wind and water and sand as a motif and work with them." Two years later, in suggesting that one "should be able to feel a certain state and express it in terms of paint," he said:

> To feel the power of the ground or sea, and to play or paint it with that in mind, letting spirit hold what you do together rather than continuous objective form, gaining tangibility and actuality as the plane leaves the ground, to fly in a medium more rare and working with the imagination that has been built up from reality rather than building back to it.[50]

Marin, too, in his way, indicated a similar thought when he wrote in 1928, "Seems to me the true artist must perforce go from time to time to the elemental big forms – Sky, Sea, Mountain, Plain – and those things pertaining thereto, to sort of re-true himself up, to recharge the battery."[51]

In their desire to possess and be possessed by nature, Emerson and the artists did differ, but only by degrees. Emerson, the nineteenth-century person, believed profoundly in the interconnectedness of the physical and spiritual worlds with man as the mediating agent. The artists, more self-conscious twentieth-century creatures, held back. They probably would have instinctively understood, but not gone as far as Emerson who wrote, in his most famous passage asserting his belief in the continuity of spirit and matter:

> There [crossing a common or walking in the woods] I feel that nothing can befall me in life, – no disgrace, no calamity (leaving

5. Georgia O'Keeffe, *The Grey Hills* (1942). Oil on canvas. 20 × 30 in. Courtesy of The Indianapolis Museum of Art. Gift of Mr. and Mrs. James W. Fesler.

me my eyes), which nature cannot repair. Standing on the bare ground, – my head bathed by the blithe air and uplifted into infinite space, – all mean egotism vanishes. I become a transparent eyeball; I am nothing; I see all; the currents of the Universal Being circulate through me, I am part or parcel of God.[52]

By contrast, O'Keeffe turned a potentially similar sublime experience into domestic commonplace when describing a sunset in New Mexico to Stieglitz:

At five I walked – I climbed way up on a pale green hill and in the evening light – the sun under clouds – the color effect was very strange – standing high on a pale green hill where I could look all round at the red, yellow, purple formations – miles all around – the color intensified by the pale grey green I was standing on. It was wonderful – you would have loved it too. . . . [fig. 5][53]

And Marin, perhaps more poignantly sensing the loss of connectedness and the alienation of modern man from nature, wrote in 1927:

As I drive a good deal I am conscious of the road, the wonderful everlasting road, a leading onward, a dipping, a rising, a leading up

over the hill to the sea beyond. To nail that, to express that, to find the means to clutch, so that there it is, that's what torments me, to show with startling conviction.[54]

But O'Keeffe's quest was no less profoundly felt than Marin's, and on at least two occasions she discussed it in phrases that were filled with Emersonian resonances. In a letter to Sherwood Anderson, she wrote:

Making your unknown known is the important thing – and keeping the unknown always beyond you – catching – crystalizing your simpler clearer vision of life – only to see it turn stale compared to what you vaguely feel ahead – that you must always keep working to grasp.[55]

Picking up the same line of thought years later, she wrote:

The unexplainable thing in nature that makes me feel the world is big beyond my understanding – to understand maybe by trying to put it into form. To find the feeling of infinity on the horizon line or just over the next hill.[56]

Although versions of O'Keeffe's quest appear in several essays by Emerson, her words seem most nearly to be a gloss on passages in "Circles." In that essay, Emerson wrote:

The eye is the first circle; the horizon which it forms is the second; and throughout nature this primary figure is repeated without end . . . Our life is an apprenticeship to the truth, that around every circle another can be drawn; that there is no end in nature, but every end is a beginning . . .[57]

In a brilliantly perceptive essay on O'Keeffe, Marsden Hartley noted some very Emersonian correspondences in her work. He understood the ways she interrelated spirit and matter. From the first, he said, "the element of mystical sensation appears . . . passionately seeking direct relation to what is unquestionably to her, the true face of nature from which source and this alone – she is to draw forth her special deliverance." He felt that she operated at the border between "finity and infinity," but that she always returned to nature. "Nature in her simplest appearance is consorted with and we find numbers of canvases and drawings that seek only to inscribe the arc of concrete sensation and experience." He continued, comparing her to Blake and to Emanuel

Swedenborg, the mystic, and found that at times she, like them, might try to reach beyond reality, but "the struggle is always toward a glorification of the visible essences and semblances of earth. . . ."[58]

Such wrestlings between the here and the not-here require tremendous strength of character and independence, and in their various declarations of artistic independence, the Stieglitz artists were resolutely, almost belligerently, Emersonian. None of the artists revealed a social vision or utopian schemes, unlike several contemporaries abroad. Instead, their aim was to fulfill themselves as artists. Their intentions were entirely personal and privatized, not public. For example, O'Keeffe wrote in 1923:

> One day seven years ago I found myself saying to myself – I can't live where I want to – I can't go where I want to – I can't do what I want to. School and things that painters have taught me keep me from painting as I want to. I decided I was a very stupid fool not at least to paint as I wanted to and say what I wanted to when I painted as that seemed to be the only thing that I could do that did not concern anyone but myself – that was nobody's business but my own. [59]

She then presumably began to paint to please herself. Dove, too, thought that artistic growth hinged on self-awareness and self-knowledge. In a poem he wrote in 1931, he said:

> It must be your own sieve through which you sift
> All those things and the residue is what is left of you.[60]

In similar fashion, Marin showed his disdain for conformity on several occasions. In letters to Stieglitz, he said:

> This living in crowds, living in herds, seems to kill fine things, fine thought. Kill the art output of the nation. Jealousies, Strivings. Competing to get ahead of one another. Instead of keeping ahead within ourselves.

> When your real artist transgresses he does it consistently so that it ceases to be a transgression and that's what your proper gentleman can never get.

> Reason and knowledge are the things we have to combat, they are always fighting sight. The thing seems to be to know how we see, not to let your knowing how the thing is to conflict.[61]

Again, passages in Emerson pop up in response to these assertions, but the ones closest in tone are from "Self Reliance" and "The American Scholar."

> And truly it demands something godlike in him who has cast off the common motives of humanity, and has ventured to trust himself for a taskmaster.

> Whoso would be a man must be a nonconformist . . . Nothing is at last sacred but the integrity of your own mind . . . What I must do, is all that concerns me, not what the people think.

> The sluggish and perverted mind of the multitude, slow to open to the incursions of Reason, having once so opened, having once received this book, stand upon it, and makes an outcry of it if it is disparaged. Colleges are built on it. Books are written on it by thinkers, not by Man Thinking; by men of talent, that is, who start wrong, who set out from accepted dogmas, not from their own sight or principles.[62]

This is strong and inspirational language. Even if Marin, Dove and O'Keeffe had not read Emerson directly (as had the artists of the Robert Henri circle – John Sloan, George Luks and the rest), they might have discussed his ideas with Marsden Hartley who had read Emerson when he was eighteen years old and, a short time later, Whitman's *Leaves of Grass*.[63] Hartley's relation to Emerson is ambiguous, however, since he read widely in European mystical literature, and his interest in American art, at least in the 1930s, assumed a sociological rather than a more purely individualist flavor.

Hartley was also most willing to view American art as something separate from himself, something more than a conversation between his own genius and nature. In his various articles and unpublished manuscripts, he sought American qualities in others and, like others, scrambled around sometimes in contradictory fashion, trying to define American traits. He found Winslow Homer to be a Yankee and aware of locale – Maine – because his work was "flinty and unyielding, resolute as is the Yankee nature itself. . . ." For Hartley, Homer "typifies a certain sturdiness in the American temper . . ."[64] John Singleton Copley's art was national in "those metallic, almost dissonant harmonies and highly incised acid rhythms and designs [which] could only have been produced by American temper and American sensibility." Hartley found "hard sticking to facts" to be the distinguishing characteristic of American artistic sensibility – no sloppiness

or slopping over, but evenness, regularity, measure and thus, with Copley, there was "a distinct racial decisiveness about him."[65] And Hartley found American traits in primitive painters to be "essentially cool, restrained and brittle and they are happily devoid of extraneous showmanship."[66]

At the same time, he praised the late nineteenth-century figure George Fuller, in whose work he found a quality resonant of Deerfield, Massachusetts, which Hartley described as possessing a "high grade tradition" and which was revealed in Fuller's work through the amplitude of his pigment.[67] Hartley ranked Fuller with Albert Pinkham Ryder as the finest American artists for their "timelessness" and because they "strike a louder note in the American scale than any other of the American artists."[68] The note reverberated, without much definition, with both private imaginative and public American qualities. On a few occasions, Hartley singled out Ryder, Fuller and also Homer Dodge Martin as particularly American because "they were conscious of nothing really outside of native associations and native deductions," and, with Edgar Allan Poe, they were the "great imaginatives of our personally racial kind."[69]

Whatever were his varying and even opposing assertions of typical American traits, one thing remained clear. Ryder was Hartley's favorite, "our most original painter . . . the first of our real painters and the greatest in vision," because of his combination of imaginative powers and his truth to experience.

> What painter's culture he acquired was essentially European, his private experience was universal, and what gave him his personal and national power, was his New England gift of penetration into the abysses of loneliness. He knew the meaning of being alone with the Alone.[70]

In contrast to Hartley's observations of Copley's Americanisms, he found Ryder "in his autographic quality [to be] certainly our finest genius, the most creative, the most racial. For our genius, at its best, is the genius of the evasive; we are born lovers of the secret element, the mystery in things."[71] Whatever the characteristics of American art by turns became, Ryder was Hartley's hero and he probably projected his own longings and artistic aspirations onto Ryder's art. To read Hartley on Ryder is to read Hartley on Hartley.

Hartley described his first encounter with Ryder around 1909 as if it were an epiphany:

> When I learned he was from New England the same feeling came
> over me in the given degree as came out of Emerson's Essays when
> they were first given to me – I felt as if I had read a page of the
> Bible. All my essential Yankee qualities were brought forth out of
> this picture [a marine] and if I needed to be stamped an American
> this was the first picture that had done this – for it had in it
> everything that I knew I had experienced about my own New
> England . . . It had in it the stupendous solemnity of a Blake mysti-
> cal picture and it had a sense of realism besides that bore such a
> force of nature as to leave me breathless. The picture had done its
> work and I was a convert to the field of imagination into which I
> was born. I had been thrown back into the body and being of my
> own country as by no other influence that had come to me.[72]

Ryder then was the model, arguably an Emersonian model, an
imaginative mystic with an immeasurable imagination whose work was
nevertheless rooted psychologically rather than descriptively in a spe-
cific American locale. Whatever else Hartley said or did, this was the
artist he wanted to become, but he probably did not quite sense this
until the 1930s. Before this time, we can catch glimpses of his search.
A few examples will suffice.

As early as 1913, Hartley rejected Kandinsky's art, about a year after
he had been introduced to it, stating, "It is without the life germ – it is
the philosoph painting – the theorist demonstration – not the artist's
will bent on creation. He gets it in his writing but not in his painting."
He found Kandinsky to be theosophic and Marc "psychic in his render-
ing of the soul life of animals," and rejected them as models, saying
that he could never be French or German, but would always remain
American. "The essence which is in me is American mysticism . . . so
expressive of my nature. . . ."[73] In Emersonian fashion, he rejected their
mysticism in order to acknowledge his own, based on his own experi-
ences, and to follow nobody's lead but his own. As he wrote in 1914:

> A picture is but a given space where things of moment which
> happen to the painter occur. The essential of a real picture is that
> the things which occur in it occur to him in his peculiarly personal
> fashion. It is essential that they occur to him directly from his
> experience.[74]

This profoundly Emersonian response has not been without echoes
in the Abstract Expressionist generation. In 1947, Herbert Ferber said:

Space and form take shape concomitantly in creating an arena where the creative personality of the artist is in anxious conjunction with his perception of the world about him.[75]

Five years later, Harold Rosenberg refomulated this idea:

At a certain moment the canvas began to appear to one American painter after another as an arena in which to act . . . What was to go on the canvas was not a picture but an event. The painter no longer approached his easel with an image in his mind; he went up to it . . . to do something to that other piece of material in front of him. The image would be the result of this encounter.[76]

All three statements seem to posit the ideal Emersonian situation – a presumably knowledgeable artist in the act of creation who is aware of but at the same time lets slip from his mind the inhibitions of his past training and experience when in the act of creation in order to free his mind for a more direct and a more honest and more authentic response to the stimulus at hand. Whether this is the ideal artistic situation is another matter, but it is certainly an Emersonian one.

In 1918, during another bout of Americanitis, Hartley discovered, when in the American Southwest, that he was "an American discovering America."[77] Responding to the then all but pervasive search for a credible American art, he anticipated the revival of an American realism after World War I. He felt that a more honest type of realism would emerge through "genuine individuals appearing with their own relationships to things, and their own methods of expression." This new realism would, therefore, be "a sturdier kind of realism, a something that shall approach the solidity of the landscape itself, and for the American painter the reality of his own America as Landscape." This meant, in a Southwestern context, more than painting Indians in Parisian modes. "There will be an art in America only when there are artists big enough and really interested enough to comprehend the American scene," in a manner, he said, similar to Whitman's example. This could happen only when "a stouter connection [is] established, a verity of emotion between subject and observer." Artists, then, had to establish contact with the land and what it signified in regard to customs and culture. "The painters will somehow have to acquaint themselves with the idea of America as landscape, as a native productive space before they can come to conclusions which will have any worth whatsoever among artists of America and the world."[78]

While Hartley was making these observations, common enough at the time, he was also praising the Maine poet, Wallace Gould, for projecting a sense of place in his poems and a "feeling for his own specific soil. He is Maine inside and out in his poetry."[79] But Hartley was unable to take his own advice. He did not remain in the country, let alone return to New England, for several years, despite the opinions and encouragement of his friends.[80]

Finally, in 1931, Hartley, one of several other artists at this time, found it necessary to return to the United States for cultural sustenance and to redefine themselves and their art as American. Spending time in Massachusetts, he found Gloucester "to be a creative shot . . . It has given me a real connection with my native soil."[81] In a poem written for an exhibition of works painted there, he alluded both to reestablishing his bonds with New England and to an Emersonian interconnectedness of elements in which a single spirit moved through all things.

> When rock, juniper, and wind
> are of one mind,
> a seagull signs the bond –
> makes what was broken, whole.[82]

Despite good intentions, he did not make what was broken (his separation from his native turf) whole. Hartley returned only intermittently to New England in the following years and did not stay in his native Maine for any length of time until 1937. It would seem that from the evidence of both his writings and paintings after this time the balance between an Emersonian mystical union with nature and a more nationalistic feeling for northern New England tipped in favor of the latter. For example, in 1933 in the Bavarian Alps, he described an experience that approximates Emerson's "transparent eyeball" passage from "Nature."

> Something whisked me away, completely enfolded me. I felt myself becoming everything – continuity, measure, surcease. I had become nothing and in that instant I saw myself perfectly – out of myself, and when I returned I heard myself saying to myself – wasn't it wonderful. Now we can begin again.[83]

By contrast, Hartley wrote in an essay in 1936, "On the Subject of Nativeness – A Tribute to Maine," a year before he returned to that state, of his need to identify with and become a part of the state. He hoped that one maintained one's nativeness "no matter how far afield

6. Marsden Hartley, *Mount Katahdin* (1942). Oil on hardboard. 30 × 40⅛ in.
Courtesy of The National Gallery of Art, Washington, DC. Gift of Mrs. Mellon
Byers.

the traveling may be . . . This quality of nativeness is coloured by heritage, birth, and environment, and it is therefore for this reason that I wish to declare myself the painter from Maine."[84]

But what was the quality of nativeness? Partly it was painting local objects "thrown up with the tides . . . marine vistas [expressing] the seas of the north."[85] Partly it was an unnameable capturing of the spirit of place. "I am completely recognized as an authentic painter of Maine born in Maine, but this recognition comes I am happy to say from the state itself and the native spirit which recognizes the authenticity of my private and local emotion."[86] This emotion was derived from, as Hartley said, "my tall timbers and my granite cliffs – because in them rests the kind of integrity I believe in and from which source I draw my private strength both spiritually and esthetically."[87] Hartley also described the quality of northern light as cold and oblique, and which made people "introspective, sullen and bitter" rather than spontaneous and expansive. Moreover, he found the north to project a "primeval savagery" and to possess "elemental dangers."[88] All of these terms describe visual qualities

Hartley infused into his late landscapes and which provided them both with a sense of locale and the imprint of Maine, whatever the subject (fig. 6). By melding a style that evoked the feel of the landscape of a locale with objects found in that locale, he clearly believed that an art would emerge representative of the life, customs and habits of that locale.

Despite his brave words, Hartley soon tired of Maine. "I am tired of this country and anyhow I have done my bit for Maine," he wrote to art dealer Hudson Walker in 1941. "I am so sick of granite and balsam and fir and whatever that I could scream almost."[89] But, presumably, Maine would remain within Hartley wherever he went. It was his authentic voice, both his own and his region's. Arthur Dove's comments on an art more representative of the entire country are pertinent here.

> When a man paints the El, a 1740 house or a miner's shack, he is likely to be called by his critics American. These things may be in America, but it's what's in the artist that counts. What do we call American outside painting? Inventiveness, restlessness, speed and change. Well then, a painter may put all these qualities in a still-life or an abstraction, and be going more native than another who sits quietly copying a skyscraper. . . .[90]

In their different ways, the Stieglitz artists attempted just that – to suggest through the local the larger American context, but not at the price of losing their own individuality. Thus, they also sought to suggest through the personal the larger American context. In this sense, they contributed to the search for an authentic American art, an important aspect of American art before 1940, but they did so in an Emersonian context and with strong Emersonian reverberations. Their modernism was tempered, then, by a respect for the real and by its extension into the spiritual and, not least, by a respect for self and for country.

THREE

The Silent Witness of
Edward Hopper

E dward Hopper belonged to that generation which matured
during World War I. Its artistic, literary and cultural leaders
found few redeeming features in the quality of American
life and, by the early 1920s, had instituted a wide-ranging attack upon
the nation's past history and present direction. Few aspects of American
life did not receive their just, or unjust, share of abuse, ranging from
gentle rebukes to Harold Stearns's wholesale condemnation, "Great art
is the expression of an age, and that age itself must be great. Ours is
not; it has nothing to express."[1] In novels, articles, essays and historical
criticism, Stearns, along with Van Wyck Brooks, Waldo Frank, Joseph
Wood Krutch, Sinclair Lewis, H. L. Mencken, Lewis Mumford, and
others, reviled the country's Puritan and Victorian heritage, its present
moral and spiritual flaccidity, its artistic impoverishment, and its sheep-
like populace browbeaten by intellectual know-nothings and crippled
emotionally by virtually everything in American life including the many
facets of the current menace, The Machine Age.

In ways appropriate to the visual media, artists, including Charles
Burchfield, Charles Demuth, Charles Sheeler and Hopper, also re-
corded their distaste for contemporary society. Their art, firmly rooted
in the pessimistic and anxiety-ridden modes of thought characteristic of
the 1920s, was largely devoid of the human warmth and flow of life

that pervaded the work of realists and modernists of the previous generation.

One main theme explored was the isolation of the individual in the world. A variety of artists created images evocative of the many hateful and hurtful contemporary descriptions of modern life, but Hopper, by virtue of his stylistic and emotional manipulation of the human form, created the most forceful pictorial realizations of these themes. He is the painter of the 1920s *par excellence*. It would be an arid exercise to look for direct cause-and-effect relationships between the artists and their literary counterparts, especially since Hopper himself once reminded us that "in every artist's development the germ of the later work is always found in the earlier. The nucleus around which the artist's intellect builds his work is himself; the central ego, personality, or whatever it may be called, and this changes little from birth to death."[2] All seem to have been caught in the drift of the times. However, Hopper clearly furnished us with profound observations upon attitudes common to the 1920s and, transcending that period, with disturbing insights into the modern human condition itself. The essential attitudes revealed in his work are contemporaneous with our own time. A painter of modern life, he tells a sad story.

According to observers of American life circa 1920, the populace, particularly urban dwellers, had a particular composite character: most individuals, while not actually barbarians, lacked a sustaining background of culture. One observer noted that they were faceless, if not entirely mindless, and that they lived no more than one-twentieth of their lives as individuals. "The other nineteen-twentieths [they] spend as members of a crowd. Personal individuality is almost completely smothered." That small degree of individuality served little purpose. As Joseph Wood Krutch said, "What man knows is everywhere at war with what he wants." This did not provoke rage, as it might today, but resignation and impotence instead. Krutch observed, with sadness, that as individuals grew increasingly less important, "Man is left more and more alone in a universe to which he is completely alien." Mythology, religion, philosophy or tradition no longer helped interpret human experience adequately. The average person, bereft of useable props to shore up his unstable world, was sinking ever faster into an emotional coma.[3]

The prospects were not good. Even life in the lively city of New York, where Hopper lived since 1900, did not necessarily mean that the lives of individuals were lively. On the contrary, Waldo Frank, in his moving account of the development of American civilization, found

that New Yorkers were "lowly, driven and drab. Their feet shuffle, their voices are shrill, their eyes do not shine." As did Walter Lippmann in the 1920s and Alvin Toffler in the 1970s, Frank attributed these characteristics to the visual and aural assaults of urban existence. "The city is too high pitched, its throb too shattering fast. Nervous and spiritual fiber tears in such strain." In other words, Frank had, in 1919, diagnosed the kind of sensory overload that describes the condition called future shock.[4]

According to contemporary observers, urban dwellers could find few outlets for their desires, the inhibitions created by past customs and present situations being too strong to overcome. Sexual outlets were, of course, stifled. But even though sexual habits had begun to change after World War I, and places like Greenwich Village gained reputations as havens of sexual freedom, few writers found Americans less sexually frustrated or repressed than in previous years. A few brave persons, such as Emma Goldman as early as 1913, might give public lectures on sex education, but for the substantial majority of Americans, "the lusts of the body have been relegated to a furtive subterranean life." Even in important novels of the early 1920s, such as F. Scott Fitzgerald's *This Side of Paradise*, sex was essentially a matter of yearning and petting rather than gratification of desires and needs.[5]

This wide-ranging psychological depression and sexual frustration were part of conditions relating to The Machine. The Machine – and the term The Machine Age – had become synonymous with the standardization of industrial techinques, working and living conditions, in fact, of existence itself. Lewis Mumford summed up attitudes toward The Machine Age and its institutions when he wrote, "We have had the alternative of humanizing the industrial city or de-humanizing the population. So far we have de-humanized the population."[6]

In the eyes of contemporary critics, then, the ordinary person, caught between the loss of old values and the necessity to develop new ones, could barely cope with his modern existence. Rather than recognize that the resulting isolation might lead to a new kind of personal freedom (a notion successfully exploited by the Abstract Expressionists), observers concentrated on the psychological and cultural deprivations suffered by the populace. They found a nation of people lacking spiritual resources, sexually frustrated and unable to develop, let alone nurture, healthy human relationships.[7]

Such spiritual, sexual and psychological blight describes Hopper's people: in fact, passages from some societal critiques evoke in the

mind's eye specific paintings of Hopper's. What makes Hopper's work so trenchant is the fact that he found an appropriate style in which to cast his social commentary.

Hopper often put only one person in a painting. If there are more, they usually do not interact with each other. As a rule they are immobile and they stare; they lack self-assurance and self-identity. When they walk or move, their actions are enigmatic and mechanical. Figures sometimes look as if they might be walking forward or backward. The woman in *Evening Wind* might be getting into or out of bed (fig. 7). Even when moving, they appear depressed and look as if something horrible has happened to them, as if in some way their humanity has been stripped away. The nudes do not seem to know what to make of their nudity. They endure and maintain a respectful emotional distance between themselves and the recognition of their experience. They are people without qualities.[8]

Hopper's figures often appear to be in a state of withdrawal, perhaps even evincing symptoms of schizophrenic retreat. Some have slipped into a near catatonic trance; their struggle has become a totally private one. Hopper does not endow them with a world of fantasy as Philip Evergood would or grant them physical exuberance as would John Sloan or Reginald Marsh. And unlike the sad-looking figures of the Soyer brothers, Hopper's people do not communicate sadness (or happiness, joy or despair). They do not share their experiences with the viewer or with each other. The most harmless relationship might overwhelm them in some way; their postures and attitudes suggest that it is better not to relate at all. In a discussion of schizophrenic behavior, R. D. Laing said that the very act of experiencing the other as a person becomes suicidal. One kind of defense is to become a stone before somebody else turns you into a stone.[9]

It is interesting, therefore, to observe that Hopper often provided his buildings with greater individuality than his people. They stand isolated, free and unbound, whereas people are invariably surrounded by interior or exterior walls. In fact, his buildings and his interior views are often more visually exciting than the people who are pushed to the peripheries of our attention. They, on the other hand, are not so much trapped by architecture as needful of it; it provides shelter and boundaries. Their relationships are fixed; nothing is left to chance encounter.

Hopper's manipulation of color also contributes to the mood of his pictures. His colors are bright, but unlike the bright colors of virtually

7. Edward Hopper. *Evening Wind* (1921). Etching. 6⅞ × 8¼ in. Courtesy of The Philadelphia Museum of Art. Purchased: Thomas Skelton Harrison Fund.

every other artist using watercolor or oil-based paints, Hopper's do not impart warmth. Buildings and people remain objects for visual contemplation; their color keeps them at a distance.

Perhaps the most important element of Hopper's art which creates the feeling of mute entrapment is his composition. At times, Hopper's figures appear to be incidental shapes in otherwise well-ordered compositions that intrude upon the underlying design and might better be removed. Usually, however, his figures are so carefully integrated into the design that it cannot function without them. Furthermore, by use of color and value changes, continuities of movement patterns across a picture plane, and similarities in the shapes of animate and inanimate forms, Hopper's figures are locked into a compositional framework which isolates them from each other in multi-group works and from interaction with the viewer in single-figure paintings. Hopper's figures do not and cannot move in any direction. They are inextricably

8. Edward Hopper, *Sunday* (1926). Oil on canvas. 29 × 34 in. Courtesy of The Phillips Collection, Washington, DC. Acquired 1926.

a part of the two-dimensional design, physically and psychologically incapable of movement.

As if to underline their helplessness, Hopper often emphasizes their three-dimensionality in comparison with inanimate forms, but does not allow them its use to move through space. And despite their more abundant bulk, he does not provide them with a textural richness that would differentiate them from other forms. All textures are even. He thus acknowledges their bodies, but does not allow them the freedom to use them. His control is quite total and quite oppressive; they are reduced to inanimate objects.

The man portrayed in *Sunday* reveals Hopper's "lock-in" technique (fig. 8). He is framed between vertical lines, one of which continues down his body through the vest. The line of the lowest wall board is continued through his arm garters and forearms. The light-dark con-

9. Edward Hopper, *Eleven A.M.* (1926). Oil on canvas. 28 × 36 in. Courtesy of The Hirshhorn Museum and Sculpture Garden, Smithsonian Institution. Gift of the Joseph H. Hirshhorn Foundation, 1966.

trasts of his nose, mouth and cigar are repeated in the wooden colon-nette decorations.

Eleven A.M. shows the same compositional control (fig. 9). The changes in value of the woman's hair are similar to those of the lamp shade, a form that competes with the human figure for our attention. The line of shadow cast by the window sash is continued along the woman's back, locking her firmly to the architecture in and of the picture. Her knees, similar in form to the chair arm, continue the horizontal movement of the floor's edge on the left and line of shadow at the right. Her arms form both a pattern of tubular shapes with the window curtains and a series of dark-light patterns with the window sill. The zig-zag shapes of her shoes respond to angular shapes across the bottom of the canvas. She cannot move without de-stroying the design of the picture. Hopper's figures are stylistically in-capable of movement because clear limits have been placed upon

them. Not only do buildings provide boundaries; so, too, do the necessities of composition.

A theme which Hopper often painted and which best reveals the distressed psychological qualities of his figures is that of a person standing or sitting near a window. Variations include dressed or undressed figures looking out of a window (males are always dressed); the viewer voyeuristically looking in a window at the subject or subjects; and the format in which the viewer observes the subject through one window as the subject peers out another. In these works, the subjects can expose themselves or they can be exposed to the viewer. Those looking out, the ones exposing themselves, seem to be yearning for human contact. Yet, they sit or stand within a room viewing the world as a thing apart from themselves, a theater to which they allow themselves entry only as spectators. They avoid human engagement. The window becomes an effective barrier set up between themselves and the world. In those paintings which allow the viewer to look into a room, to be an observer of the activities within, the window is still an untraversable barrier.

Of all the works employing this theme, *Evening Wind* strikes me as the most memorable and most poignant. The figure's movements are enigmatic, as mentioned before, but one clearly senses the frustration, repression, desperation, and longing in the woman's body, made all the more intense by the billowing but not quite enveloping drapery. It is also Hopper's least typical version of this theme in that its emotional and sexual urgencies are the least controlled. Moreover, it is Hopper's least repressed work, the one which shows the greatest degree of internal struggle within a figure.

The question naturally follows: where does Hopper himself fit in? To what extent did the creator of these disturbing images rely on insights into the modern condition or respond to dilemmas within his own personality? To what degree did Hopper mirror his own times or project his own problems? How autobiographical are his paintings?

Hopper and his wife, Jo, led a plain, nearly Spartan existence and lived in a walk-up apartment in Greenwich Village before and after the time economic necessity forced such simplicities upon them. Although the couple had friends, they did not participate to a great extent in the life of the Village. Hopper was a private person and, according to all accounts, often a silent one.[10] Reticent about his childhood, he did not speak about his mother at all and rarely mentioned his father whom he considered a failure. During the preparation of his retrospective exhibition at the Museum of Modern Art in 1933, Hopper was even reluctant

10. Edward Hopper, *Cape Cod Morning* (1950). Oil on canvas. 34¼ × 40⅛ in. Courtesy of National Museum of American Art, Smithsonian Institution. Gift of Sara Roby Foundation.

to divulge information concerning his early work. He was also secretive about his mature work. In 1943, for instance, he assured Juliana Force, then director of the Whitney Museum of American Art, that he had kept accurate records of his work done since 1923, and subsequent major exhibitions of his work were mounted, it is presumed, with his full concurrence and cooperation. Yet, after his death in 1967, and Mrs. Hopper's death in 1968, a number of works bequeathed to the Whitney Museum had never been seen by anybody, including his closest friends. These facts might indicate only that Hopper liked his privacy, a normal desire to which he was certainly entitled. But as one scrutinizes his paintings and reads his recorded remarks, alternative responses emerge.

Of his few statements concerning art, each would appear to be psychologically innocent at face value, but when put together, they suggest a personality troubled by free and easy contacts with others and

in need of the barriers he placed around his subjects. For example, he once said of his use of color, "Maybe I'm not very human. What I wanted to do was to paint sunlight on the side of the house."[11] Perhaps, then, Hopper found buildings an acceptable surrogate for people. (Charles Birchfield, during a difficult period in his life around 1918, also found buildings to be a substitute for and symbols of people.) If it is true that Hopper's own need for order pervaded his art, then it follows that few persons would appear in his travel pictures. Those who do are placed in controlled situations – in an automobile, in a railroad car. For as Hopper indicated, "There is *a certain fear and anxiety*, and a great visual interest in the things that one sees coming into a great city" (italics added).[12] That he was aware of the rigid stylistic and psychological barriers he imposed upon his subjects can be inferred from statements he made concerning two paintings. First, he found displeasing his *Intermission* (1963), a painting of a woman sitting alone in a theatre. He thought that the figure of the woman was too finished, too complete, and not suggestive enough. Compared to his other works, his own criticism is well taken. The woman is not locked into the composition as are most of his other figures. She is, in fact, liberated from objects around her in a most un-Hopperesque manner. Second, Hopper remarked that *Cape Cod Morning* "perhaps comes nearer to my thought about such things than many others. That's all I can say about it [fig. 10]."[13] He did not indicate what was his thought, but the painting is one in which the viewer observes a room while the subject stares out another window; yet, a third window allows the viewer to look beyond – a tour de force of barriers and missed psychological connections.

In view of the controls Hopper imposed upon his subjects, one may even speculate that his preferences for realistic styles was a control he exerted upon himself. Modern artists have turned their isolation into positive channels by exploiting techniques based on purely formal relationships and upon products of modern technology. Despite his sophisticated understanding of the formal problems of modern art, Hopper chose instead to paint realistically. Rather than explore formal and thematic problems in an open-ended manner, he clung to familiar points of reference and sought easily recognizable guideposts, thus securing a measure of control both over himself and the way in which his works would reveal psychological relationships.

It seems logical to assume that Hopper's own observations upon issues prevalent in the 1920s, his insights into the alienated condition of modern life and his "lock-in" compositional devices were in part

based on personal attitudes with which he constantly struggled. It is no wonder his art has remained so popular over the decades – few artists have been such compelling silent witnesses to the passing of modern life.

American Art and National Identity
The 1920s

Beginning in 1916, and continuing for the next five or six years, a major shift occurred in American art comparable to the change that took place in the mid-1940s with the emergence of Abstract Expressionism. At that earlier time artists grew increasingly aware of themselves as American artists and wanted to reveal in their art an American presence. For the next twenty-odd years the exploration and revelation of their American qualities served as a major animating force, culminating in the American Scene Movement of the 1930s. But the American Scene Movement as interpreted through the voices of chauvenistic critics such as Thomas Craven and through the various governmental art projects betrayed the original intentions of those searching for a national identity in American art. For the search that had once seemed free and open in the early twenties became institutionalized; the search for recognition and definition of the American self had turned nativist, toward a particular kind of American self. The several American selves that began to be revealed by artists such as Stuart Davis, Charles Burchfield, Charles Sheeler, Charles Demuth, Edward Hopper, and the early Thomas Hart Benton were closeted. Description replaced examination. Programmatic notions of American art replaced what just a few years before had seemed to be a sense of free inquiry and personal exploration.

In the first decade of the century, critics encouraged American artists to shake loose from the European influences that were academic, Barbizon, or Impressionist. In doing so, artists would learn to express themselves and, by extension, would reflect American values and characteristics. As Giles Edgerton (Mary Fanton Roberts) said, an artist "*must* paint best what he feels and knows and understands best" in order to express himself.[1] It is this attitude, that national identity went hand in hand with self-expression, that was lost in the 1930s.

Robert Henri, the leader of the Ash Can School, was quite articulate in this matter. Seeking both the release of and the expression of the American spirit in art, he wrote in 1910:

> As I see it, there is only one reason for the development of art in America, and that is that the people of America learn the means of expressing themselves in their own time and in their own land. In this country we have no need for art as a culture; no need of art as a refined and elegant performance; no need of art for poetry's sake, or any of these things for their own sake. What we do need is art that expresses the *spirit* of the people today. It is necessary for the people of this country . . . to understand that [art] is the expression of the temperament of our people . . .[2]

In effect, Henri was reminding Americans of their European dependency, that art did not belong in a hothouse and that art should be a vehicle for national self-discovery. He did not try to define the American spirit or say where it came from because I do not think it really mattered to him. He seemed much less a nationalist than a person who believed that self-expression was primary and that it would reveal larger national patterns because of the interaction between the artist and his environment. He was less influenced by nativist feelings than by the thoughts of figures such as Ralph Waldo Emerson, Hippolyte Taine, and Leo Tolstoy which provided him with a conceptual framework and a language with which to articulate his thoughts. Emerson and Tolstoy both wanted artists to respond to and to reflect the societies in which they lived. Taine sought explanation for art in those responses and reflections. When Henri wrote that an American art required "a real understanding of the fundamental conditions personal to a country and then the relation of the individual to these conditions," he clearly reflected Taine's dictum that to understand the mind of the artist, his taste, choice of style, character, and sentiments, then "we must seek for them in the social and intellectual conditions of the community in the midst of which he lived."[3]

Others, in the period before World War I, also wanted an American spirit and character to emerge in art, but left less to chance than Henri. They had a better idea of the qualities American art should reveal, but these, in truth, had little relation to reality. Instead, both an ideal and an idyllic vision was offered, made up of good intentions, self-delusions, and a profound misreading of this or any other country. The range of vision reached from the gentle to the genteel. One observer found a lyric quality to be important: "The more national quality, especially in painting and preeminently in the works of our landscape men, is the lyric note." The landscapists, more than any others, knew "the birth-place of so much of our poetry and of our strength, of the humor and of the kindly tendency of our nation."[4] Others found the dominating qualities in American art that revealed American ideals to be "simplicity in subject and treatment . . . , honesty of presentation, sincerity of exe-cution," and a "light, spontaneous charm . . . a refined vigor."[5] These same observers were as much pro-American as they were anti-European in their encouragement of American artists to find their own and their American voices. Patriotism coalesced with competition in their desire to see the emergence of a free and independent American art.

Not surprisingly, the Armory Show of 1913 forced American artists and critics to focus on the question of national identity in art and how it might be found. Randolph Bourne, one of the ablest cultural critics of the period, felt profoundly humiliated by the exhibition and sug-gested that it was held "with the frankly avowed purpose of showing American artists how bad they were in comparison with the modern French." The exhibition represented to him "an appalling degradation of attitude which would be quite impossible in any other country. Such groveling humility," he continued, "can only have the effect of making us feeble imitators." Believing that "our cultural humility before the civilizations of Europe . . . is the chief obstacle which prevents us from producing any true indigenous culture of our own," he felt that "the only remedy for this deplorable condition is the cultivation of a new American nationalism."[6]

Where would the source of that nationalism lie? European artists who visited the United States in 1913 for the Armory Show and in 1915 because of the outbreak of war in Europe offered one answer – the present. Instead of agonizing over the health of or the release of the American spirit or assuming that American art should evolve from the nation's real or imagined heritage, they realized that it should spring from the immediate moment. American artists should seize the present

to which one only need be alive to respond. Their iconoclasm was frightening, surely, and the inference that American artists could be American if they thought *modern* rather than *American* must have been eye-popping.

In 1913, Francis Picabia, visiting the country for the Armory Show, said in an interview, "France is almost outplayed. It is in America that I believe that the theories of The New Art will hold most tenaciously."[7] Heady stuff, but the arrival of Picabia, Marcel Duchamp, Albert Gleizes, and others in 1915 must really have provoked artists and critics to question inherited and outmoded traditions. Picabia, particularly, indicated that American art needed no past. In the famous interviews given by the Europeans in the *New York Tribune* in 1915, Picabia said, "since machinery is the soul of the modern world, and since the genius of machinery attains its highest expression in America, why is it not reasonable to believe that in America the art of the future will flower most brilliantly?"[8]

Picabia and the others must have assumed that the American spirit to be revealed by American artists would be one of daring, chance-taking, and a disdain for the past. The Europeans must also have assumed that the art of the future would be abstract and therefore universal, and would rise above local and national concerns. Some American artists, such as Man Ray and Morton Livingstone Schamberg, responded accordingly, but most could not leave America behind. For artists such as Charles Sheeler and Charles Demuth the future had to grow from the past and the past would have to be embedded in the future in complex ways. For figures such as Charles Burchfield and Edward Hopper the past was essentially an urban one only a generation or two old. In the 1920s, Benton responded to both past and present; Stuart Davis to the present alone.

By 1916 the terms of the quest for an American art had changed. The vague search for the American spirit and an American identity in art, as well as the genial encouragement of artists to find these, were transformed in two paradoxical ways. On the one hand the nation as a whole – its materialism, its past, its heritage, its prospects – was savaged for not allowing an American art to emerge. On the other, an almost mystical belief gained strength that reflected a longing for a vital self-sustaining and independent American culture. Or, to say it differently, before a new American culture could emerge, the old one had to be identified and destroyed. Things had become quite serious.

The attacks were vicious. Briefly, the American character was con-

sidered frayed, fragmented, and buried beneath generations of psycho-logical and sexual repression. People lacked a sense of organic culture and also lived in profound isolation from each other. A few examples will suffice. Van Wyck Brooks, a devout critic of American culture at the time, noted in 1917 "if we are dreaming of a 'national culture' today it is because our inherited culture has so utterly failed to meet the exigencies of our life, to seize and fertilize its roots."[9] Where Brooks found spiritual values drowning in a sea of material ones, Harold Stearns found Americans unable even to face the truths of their exis-tence. He believed that American writers and artists "have not yet learned how to get below the surface of things. Nor will they until our optimistic compulsion has been destroyed, until in the world of the spirit of the mind we find that there is one moral obligation and only one: to tell the truth as we honestly see and feel it."[10] This observation was only slightly less devastating than his depressing, more general, assessment of the times. "Great art is the expression of an age, and that age must itself be great. Ours is not, it has nothing to express."[11] Even within the circle of modernists around Alfred Stieglitz, critiques of American culture were evident. Marius de Zayas, for example, found "the real American life . . . still unexpressed . . . , America remains to be discovered."[12] Still others found that the diverse heritage of Americans and their willingness to maintain Euro-American cultures prevented the emergence of a deeply rooted national culture.[13] The yearning for such a culture was so strong that artists were accused of not being strong enough to break through "the crust of mere appearance . . . to face this America in which [they] live . . ." As a result, "American painting in the sense of a deep national expression . . . has not been born yet."[14]

The effects of World War I also added a measure of urgency to the quest for a national culture. The diversity of national feelings about the war indicated that assimilation was not as successful as had been as-sumed. People had not melted enough in the melting pot.[15] In addition, the effects of the war so challenged well-received ideals, beliefs, and illusions that the confusions thus engendered in the American psyche strongly suggested that "the most important task [confronting] patriotic Americans is that of assisting in the recovery of a common and confi-dent national consciousness."[16]

But even before America's entry into the war, a concerted effort had begun to reinvigorate the American spirit. In journals such as The Dial, The New Republic, and, most of all, The Seven Arts, one can follow both the devastating critiques of and the encouraging cheers for Amer-

ican culture, Under the criticisms there lay a peculiar kind of hope that from honest soul-searching, a genuine American culture might emerge, a unitary culture derived from the American plurality, self-aware, tough-minded, yet based on spiritual rather than material values. James Oppenheim, editor of *The Seven Arts*, nursed the hope of a renascent period in American arts, of "the coming of that national self-consciousness which is the beginning of greatness," of "an expression of our American arts which shall be fundamentally an expression of our American life." Without a "tradition to continue" and "no school of style to build up," artists were free to explore and to find as they might. Oppenheim, taking an extreme position, found no traditions, no symbols, nor even a sense of destiny in American culture. Yet he held that "it is in nationality today that the race finds that larger self to which the individual may give all and become human and high."[17] Like Nietzsche, who believed that art marked the apex of a civilization, Oppenheim wanted "to incarnate our longings and our aspirations in works that shall reveal us to ourselves. A nation finds itself when it creates a great book, a great architecture, a great music."[18]

Responding to similar motivations and promptings in American society as a whole as well as within the narrower confines of the art world, artists began to look at the American scene, increasingly aware of themselves as American artists and as artists in America. Artists whose styles had been formed before the late teens – Impressionists such as Childe Hassam, realists such as George Luks – were congratulated on their American qualities, which might range from a spiritual connection to Walt Whitman to an appreciation for a particular landscape.[19] For example, Paul Strand, the photographer, especially liked John Marin's watercolors of Maine (fig. 4). "His [Marin's] work attests frankly to a conscious recognition on his part that he is rooted in this American continent," Strand said. "This is Maine and nowhere else. It is America and nowhere else. We are made to experience something which is our own, as nothing which has grown in Europe can be our own. We are taken up bodily . . . and are shoved into the core of our own world – made to look at it."[20] Strand seems to be asserting that through examining the particular environment, one could find America – through evoking the local, the national. For Strand, Marin's landscapes were successful in their lack of generalization, and he was pleased to note that they could not be mistaken for Californian, let alone European, scenes. No doubt, Strand was reacting to the steady stream of articles asserting that the works of American Impressionists, such as Childe

Hassam, Willard Metcalf, and Edward Redfield, were thoroughly American despite their obvious French derivation.[21] Marin himself was aware of what he was doing. In a letter to Stieglitz written from Maine in 1919, he indicated that he did not care to paint with memories of older styles in mind. Instead, he wanted his work to be "seething with the whole atmosphere of Maine."[22]

Other younger artists, borne along by the desire to find a sense of national identity in their art, began to look at the American environment. Perhaps, like James Oppenheim and similarly minded critics, they sought an all-encompassing national spirit, but more likely – and more realistically – their own perceptions, guided by personal and local concerns, filtered out such grandiose visions. None, except Thomas Hart Benton, really thought of defining his work in terms of a national expression.

At least two artists reacted along lines suggested by Francis Picabia – to an America liberated from its past. Joseph Stella, like the poet Hart Crane, turned to the Brooklyn Bridge as a symbol of modern America, seeing it as "the shrine containing all the efforts of the new civilization of AMERICA" (fig. 2).[23] It is worthwhile noting here that Stella used the word "America," not the phrase "the modern age," in identifying the new civilization. And Louis Lozowick, who toured the country in 1919, completed a series of paintings by the middle 1920s that evoked the modern metropolis (fig. 11). Believing that "the dominant trend in America today, beneath all the apparent chaos and confusion, is towards order and organization which find their outward sign and symbol in the rigid geometry of the American city," Lozowick caught the rhythm of modern America through angular forms and sweeping arcs.[24] He painted an urban America, a historyless America, cut off from its past. Because his work was perhaps too impersonal and modernist, he did not become a central figure like Charles Sheeler in the 1920s. (It is also true that Lozowick was abroad for several years during the decade.)

Sheeler, like Burchfield, Demuth, Davis, Hopper, and Benton, turned a more probing eye upon the country just before and after 1920. Sheeler, reexamining the premises of his art in 1916–17, altered his style and thematic concerns, but unlike Lozowick he combined an interest in the forms of modern America with those of the past. Until 1915 Sheeler produced works such as *House and Trees* that were generically Cubist, innocent of specific national or local references. By 1917, however, his studies of barns in Bucks County, Pennsylvania, referred to barns in that area and in no other area (fig. 12). Although abstracted

11. Louis Lozowick, *Minneapolis* (1926–1927). Oil on canvas. 30⅛ × 22⅛ in. Courtesy of The Hirshhorn Museum and Sculpture Garden, Smithsonian Institution. Gift of the Joseph H. Hirshhorn Foundation, 1966.

12. Charles Sheeler, *Bucks County Barn* (1918). Gouache and conte crayon. 16⅛ × 22⅛ in. Courtesy of The Columbus Museum of Art, OH. Gift of Ferdinand Howald.

into flattened planes, they are described with great accuracy, their parts clearly seen and easily identified. It is as if he already understood the intentions of his future friend, William Carlos Williams, who would write in the introduction to his *In the American Grain* in 1925, "I have sought to rename the things seen, now lost in chaos of borrowed titles, many of them inappropriate, under which the true character lies hid."[25]

During the 1920s critics were especially pleased to recognize the Americanness of his works, one of them stating that "no artist has done more for the neglected native scene, the very spirit of early America, than has Charles Sheeler."[26] But it was more than just a matter of recall and antiquarianism. Another critic, setting off Sheeler from French artists who "paint by theory" and muddle "their paint with philosophy," said that he became most American when he expressed "in terms of extremely simplified realism the permanent and essential character of the natural object."[27] Sheeler's disdain for nonessentials was also considered very American. That is, he could get right down to fundamentals.

Sheeler was certainly aware of the American qualities critics found

in his work. He also realized in the 1930s his need to remain physically in the American environment in order to absorb and to respond to its visual forms and cultural configurations. As he recounted in his autobiographical statement written in the mid 1930s:

> I have found that quite unconsciously the things which have to do with indigenous social necessities have for the most part claimed my interest . . . For this reason, and despite the enjoyment of European visits, a prolonged residence abroad has never seemed desirable. It remains a persistent necessity that I should feel a sense of derivation from the country in which I live and work.[28]

But I think it was more than just the forms of American buildings or furniture invoked in his work or a presumed American sense of paring things to their essential components that prompted observers to comment on his American qualities. I think it existed in his rational organization of things.[29] This can be seen best in his Ford Motor Car Company paintings of about 1930 (fig. 13). These works reveal him as the true artist of corporate capitalism. In these works he painted the system of a success. Everything is properly groomed and in its place. Managerial efficiency dominates both the composition of the paintings and in the ways the buildings are portrayed. In a tradition that includes Edward Bellamy's *Looking Backward* (1888) and the time and motion studies of Frederick Taylor (*The Principles of Scientific Management*, 1911), Sheeler records the organization of modern life into carefully arranged, articulated, and idealized units. No effort or motion is wasted. The experts have tamed the anarchy of industrialized capitalism.

In comparison, Thomas Doughty in his *Gilpin's Mill on the Brandywine* (1826), to paraphrase Leo Marx's image of the machine in the garden, shows an idyllic nineteenth-century vision of the machine domesticated in the garden.[30] Two boys swim at the waterhole now shared by a mill, suggesting that rustic and industrial can easily thrive on the same turf. Sheeler, in a twentieth-century version, shows the garden, now reduced to a small pond with its rowboat, absorbed, dominated, and surrounded by the clean, well-ordered, and superbly functioning American machine. Man's order has replaced God's. Perhaps Sheeler caught in his Ford Company paintings the rational capabilities of the American mind, the true expression of the American spirit and national character. I do not know if this reflects the hoped for liberation of the American spirit or the nailing of it to the wall, but there is certainly an American element in these works.

Surprisingly, Thomas Hart Benton did try to nail capitalism to the

13. Charles Sheeler, *River Rouge Plant* (1932). Oil on canvas. 20 × 24 in. Courtesy of The Whitney Museum of American Art. Purchase.

wall in the 1920s, and even the 1930s. Like Sheeler, he too changed styles and thematic concerns around 1920. At least until he served in the navy during World War I, he had been a modernist.[31] Soon after, he turned to American themes, and in a series of mural studies, the Historical American Epic, on which he worked until 1927, he tried to develop a uniquely American style. Much later, in 1951 Benton admitted that his original purpose had been "to present a people's history" in order "to show that the people's behaviors, their action on the opening land, was the primary reality of American life." He also wanted to show that "as civilization and technology advanced," the people "became increasingly separated from the benefits" of their labors.[32] In effect he had painted a Marxist history in murals. As he recollected, he:

> Could then see no conflict between American democratic ideals and the ideals of Soviet Russia. My readings in American history

were convincing me that the people of America, the simple hard-working, hard fighting people who had . . . built up the country were, more often than not, deprived of the fruits of their labors by combinations of politicians and big businessmen. I was convinced that the American dream had been continually discounted by capitalist organizations which had grown beyond the people's control. All of this kept me in substantial agreement with those Marxist historians and political theorists who were describing America in Marxist terms.[33]

Benton's ties to the left were in fact quite strong during the early 1920s. He had even conspired with Robert Minor, a cartoonist and party functionary, "to provide secret meeting places for the persecuted members of the communist party, one of which included my own apartment in New York."[34] Benton broke with Marxism in the late 1920s but remained critical of modern American capitalism, ultimately retreating into a pre-industrial nativism.

In the early 1920s, Stuart Davis was also caught up in defining himself and his art in an American context. His generically expressionistic *Autumn Landscape* of 1919, for example, does not describe a particular American place or state of mind, but his Tobacco pictures of 1921, such as *Lucky Strike, Sweet Caporal,* and *Bull Durham,* are of especial interest because, although their European connections are obvious, their American associations have not been fully explored (fig. 3). Davis wrote in his journal in May 1921, "I feel that my Tobacco pictures are an original note without parallel so far as I can see." Now able to create, as he said, "really original American work," he attacked the Cubists as "metaphysicians," the Dadaists as "European jugglers with whom we have been acquainted in vaudeville for some years. In America are only imitators of these." He felt that copying Cezanne, Matisse, and Picasso caused Americans to ignore their own abilities "by our foolish worship of the foreign God."[35] Later, in March, 1922, he wrote about another unidentified group of works, "starting now I will begin a series of paintings that shall be rigorously, logically American, not French. America has had her scientists, her inventors, now she will have her artists."[36]

Davis wanted to paint "direct simple pictures of classic beauty expressing the immediate life of the day. . . . Pictures of this kind should be self-supporting. They have nothing in common with the trade in art galleries. They should be sold [in reproduction] in stores like newspapers and magazines."[37] He even identified himself with objects like

newspapers which existed in multiples rather than as unique objects, adding "I do not belong to the human race but am a product made by the American Can Company and the New York *Evening Journal*."[38]

By identifying himself and his art so radically with nonartistic sources and products, he allied himself with figures such as Robert Coady, the editor of *Soil*, a magazine published in 1916 and 1917, and Matthew Josephson, the editor of *Broom*, published in the early 1920s. Coady, seeking an American art based on objects found in the environment, discovered aesthetic values in industrial objects such as cranes, piers, drills, motors, and grain elevators:

> Our art is, as yet, outside of our art world. It is in the spirit of the Panama Canal, the skyscraper, the bridges and docks . . . , Walt Whitman . . . , electric signs, the factories and mills – this is American art. It is not an illustration to a theory, it is an expression of life – a complex life – American life.[39]

Matthew Josephson wanted some products examined – billboards, movies, newspapers, skyscrapers, jazz, and, perhaps, cigarette wrappings, as well. Self-conscious, like Davis, in calling for the creation of an American heritage, he wanted writers and artists to "react to purely American panoramas . . ."[40] He felt, and Davis would have agreed, that "America will never enjoy an indigenous art, if, led by its intellectuals, it adopts approved European methods of painting and writing."[41]

In the early twenties then, Davis responded to Picabia's interest in the present, or something similar to it, as well as to the radical ideas of Coady and Josephson for finding forms and subjects in nonartistic materials. Years later, in the 1940s, Davis reemphasized these aspects of his work when he wrote that artists who have flown, traveled by train and car, and used the telegraph, telephone, and radio feel differently about time and space than those who have not. And, he added a few years later, he had "enjoyed the dynamic American scene . . . and all my pictures are referential to it. They all have their originating impulse in the impact of the contemporary American environment."[42] This included gas stations, chain-store fronts, taxicabs, electric signs, movies, and, once again, presumably cigarette wrappings. Davis clearly tapped into that aspect of American culture that responded affirmatively to change, to challenge, to the frontier, and insisted on doing so in contemporary terms. He rejected the paraphernalia of the past and maintained a sense of high adventure.

Davis, like Coady and almost everybody else at the time, invoked

Walt Whitman's name in print as well as in conversation and acknowl-
edged him to be the hero of their generation. "I, too," Davis said, "feel
the thing Walt Whitman felt – and I too will express it in pictures.
America – the wonderful place we live in."[43] Malcolm Cowley, barely
exaggerating commonly held opinion, held that "before Walt Whitman
America hardly existed."[44] How Davis and others must have thrilled to
Whitman's call in *Democratic Vistas* for a poet to project "what is
universal, native, common to all, inland and seaboard, northern and
southern," and to create a "programme of culture . . . with an eye to
practical life, west, the workingman, the facts of farms and jackplanes
and engineers."[45] One senses that at the time Davis did indeed want to
create Whitman-like images that were modern, common, and Ameri-
can. But editorials and articles in magazines including *The Arts*, *The
Seven Arts*, and *The Dial* lamented the fact that an artist had yet to
appear who was Whitman's equal.[46] I suspect that Benton might have
seen himself as such an artist. Certainly of all the significant figures of
the interwar years, he, more than any other, sought an imagery that
would, as he later said, have meaning for as many Americans as possi-
ble.[47]

Charles Demuth's America was much more anemic than Davis's or
Benton's and his celebration of it much more ambivalent. After adopt-
ing a Cubist style in 1916–17, he turned to recognizable American
subject matter by 1919. Attracted and repulsed at the same time by
America, he expressed his confusions about the country in letters to
Alfred Stieglitz in 1921. While abroad that year, he admitted that "I
feel 'in' America even though its insides are empty. Maybe I can help
fill them."[48] After he returned home, and although deploring the lack
of support for art, he wrote to Stieglitz, "What work I do will be done
here; terrible as it is to work in this 'our land of the free.' . . . Together
we will add to the American Scene . . ."[49] Demuth's love-hate relation-
ship, although hidden under sophisticated irony, did not fool anybody.
One critic found his "souvenirs of Sir Christopher Wren [drawn] with
an intensity that suggests inward rage."[50] Another found his watercolors
"were not American in the sense that Lincoln and Whitman were
American," because "beautiful as they were, they were distinctly mor-
bid."[51]

Charles Burchfield's middle-period paintings, those done between
1918 and 1943, are morose rather than morbid (fig. 14). Before 1918
he painted lovely landscapes based on childhood memories and rap-
tures. By 1919, he began to feel, as he reported, the great epic of

14. Charles Burchfield, *Winter Solstice* (1920–1921). Watercolor. 21½ × 35½ in. Courtesy of The Columbus Museum of Art, OH. Gift of Ferdinand Howald.

Midwestern American life and his own being in connection to it.[52] He had read Sherwood Anderson's *Winesburg, Ohio*, almost as soon as it was published in 1919, which helped him turn his eyes outward toward his native landscape. But to what effect? One critic wrote in 1920 that "Mr. Burchfield had the great good fortune to pass his young life . . . in the loathsome town of Salem, Ohio, and his pictures grew out of his detestation of this place. . . . There is almost nothing in his work but this hatred."[53]

Edward Hopper observed, similarly, that Burchfield had captured "all the sweltering tawdry life of the American small town," but also noted without commenting upon his love-hate relationship, similar to that of John Steinbeck and other Midwestern writers, that "his is an art rooted in our land."[54] This bleak vision was then central to Burchfield's view of America. One wonders that had he ever painted, as he had intended, the equivalent of "Finlandia" by the Finnish composer Sibelius for America would he have painted the equivalent of a tone poem or a series of dirges? Burchfield's townscapes recall Van Wyck Brooks's observation that ancestral bonds are really not to be found in America. "Old American things," Brooks wrote in 1916, "are old without majesty, old without mellowness, old without pathos, just shabby and bloodless and worn out."[55]

Hopper's works from the 1920s are not really so dissimilar (fig. 8). His thematic and stylistic interests crystallized in the early part of the decade, a few years later than the other figures, after he completed a set of about twenty etchings. These interests were to last until his death, indicating that he, unlike the others, was to remain a painter of the 1920s throughout the rest of his life. Hopper was very aware of the American element in his work. In 1927 he praised members of the Ash Can School for not trading their American birthright for a European one. He responded especially to their reaction to the American land and to their "simple visual honesty and intensely emotional vision."[56] But what was Hopper's own vision? Like Burchfield's, it appears to have been a passive one. The neighborhood is changing, getting more run-down. But there is nothing to be done about it. There seems to be no way to work with these changes, but to survive in some marginal way. The buildings, the streets, the people offer no resistance to the modern industrial age passing them by. These are not mean streets, but dead streets, lacking heroism, strength or even dignity. Social cohesion has given way to fragmentation. Hopper and Burchfield painted the vanquished and, more important, the loss of community in the modern age. They reveal that the people and their spirit were emotionally stillborn. They painted a distraught community. Taking a hard inward look at the American character, they found confusion and despair in the face of modern times.

They also painted a problematic American condition. For as Alexis de Tocqueville noticed in the 1830s, American capitalism can create conditions of isolation and separation, since competitive economic individualism insures that some will win, others will lose, and that sympathy is in very short supply.[57] Loss of community is built into the American way, as it were. Yet by 1927, Hopper was considered the most successful interpreter of the American scene in that "he succeeds in getting the essence of his subject."[58] Lloyd Goodrich, then a young critic, found it "hard to think of another painter today who is getting more of the quality of America in his canvases than Edward Hopper."[59] That quality seems to be exactly what the literary and cultural critics condemned in America. Burchfield's and Hopper's work seems the exact opposite of Sheeler's.

Other artists such as George Ault through his use of urban and rural themes, and even dealers such as Stephen Bourgeois contributed to the rising interest in an American artistic identity.[60] As one scans the paintings and the writings of the time, one senses an openness to different

points of view and a quality of adventure and discovery. Exploration of the self coincided with exploration of the national self. The search for a national identity or for the American spirit did not reveal among the painters a single point of view or lead to a single set of themes, but rather to a remarkable multiplicity of concerns and responses that made the decade of the 1920s one of the richest in all of American art. One might argue that the development of the American Scene Movement in the 1930s and the support given through the various government art programs capped this develpoment. But I would argue the reverse, that American Scene painting and the government art programs led to a narrower artistic focus, a constriction of the American spirit as understood around 1920 and the cloaking of the art world under a blanket of nativism.

The nativist bias contained three interrelated aspects – the desire to exclude from consideration those lacking a proper American heritage, an emphasis on rural subject matter, and, especially in the government mural projects, the avoidance of the kind of disagreeable subjects a Hopper or a Burchfield might want to introduce. In any event, the sense of free and generous exploration suggested by figures such as Robert Henri or *The Seven Arts* group was lost.

Even as early as 1920, an article published in *The Nation* was symptomatic of the nativist response. Mary Austin, its author and a critic of some stature at the time, chided certain New York critics for confusing New York City with America, naming Waldo Frank and Louis Untermeyer, but not James Oppenheim and Paul Rosenfeld who wrote for journals such as *The Seven Arts* and *The Dial*. She said that these critics, whom she described as being Jewish, could not really be interpreters of America, could not hope to develop an American consciousness in the arts from New York, and did not understand underlying forces in American life. "Decentralization," she said, was "the only way to accomplish the release of the American genius."[61] Austin was really offering a double argument. First, in the conflicting tensions between national unity and local tradition, between nation and region, an American art would grow only from the region and from past experiences at the local level. Second, recent immigrants, or the children of recent immigrants, who congregated in large cities had little or nothing to say in these matters. In effect, national identity had no place in the immigrant's dream of America, the displaced person's dream of finding community in a new and strange land in which becoming American was itself part of the dream. Ironically, figures like Oppenheim, Frank,

and Rosenfeld did not cast themselves as outsiders who pointed to the problems of American society as, say, Kafka did in central European society. They wanted to become part of American society, to be absorbed by it, but were reminded instead of their status as outsiders.

Through the middle years of the decade the attack against recent immigrants was channeled primarily at modernist painters, but the implications were clear. Only those who possessed a certain kind of American heritage were considered American. Royal Cortissoz, the conservative critic, in observing the contemporary art scene, noted:

> There is something in this art situation analogous to what has been so long going on in our racial melting pot. The United States is invaded by aliens, thousands of whom constitute so many acute perils to the health of the body politic. Modernism is precisely of the same heterogeneous alien origin and is imperiling the republic of art in the same way . . . These movements have been promoted by types not yet fitted for their first papers in aesthetic naturalization – the makers of true Ellis Island art.[62]

In 1925, Thomas Craven, the xenophobe and anti-Semite, in discussing the famous Forum Exhibition of Modern American art which took place in 1916, indicated clearly that he did not care for artists such as Oscar Bluemner, Ben Benn, Andrew Dasburg, Abraham Walkowitz, George Of, and William Zorach posing as Americans. He added to this list Max Weber, Joseph Stella, Jules Pascin, Walt Kuhn, Maurice Stern, and Louis Bouche.[63] And Forbes Watson, in 1930, in discussing a list of artists informally elected in an all-American popularity poll, questioned whether Japanese-born Yasuo Kuniyoshi, Jules Pascin, a Jew from Bulgaria, and Lyonel Feininger, essentially a German, among others, were really Americans.[64]

The bias against foreigners taking part in forming an American art was perhaps best expressed by Benton in the early 1930s when in an article about the Ozark Mountains he wrote, "The future is and must continue to be heavily conditioned by the past and in this land, yet flavored by the pioneer spirit, the nature of our fundamental American psychology can best be understood."[65] So pervasive was this attitude that even a poet as sophisticated as William Carlos Williams in his own search for an American heritage could still believe that "the mountain woman lives untouched by modern life. In two centuries mountain people have changed so little that they are in many ways the typical Americans."[66] This point of view was clearly exclusionary of all ethnic

and religious groups which did not share a pioneer or rural heritage. By this reasoning recent immigrant groups and urban dwellers would never understand America, or lay any claim to understanding it and its heritage. (Regrettably, this attitude is still very much present in American political life.) As reported in the *New York Daily News* for August 24, 1986, presidential aspirant and television preacher Pat Robertson attacked Norman Lear, a Jew and a founder of the liberal group People for the American Way, in the following way:

> I have a fairly good idea of what the American way is because it was my ancestors who helped make this country. Regretfully, Norman Lear does not have the same sense of history that somebody of my heritage has.[67]

The American character and spirit represented by Benton's and Williams's opinions were ungenerous, narrow, and nativist. One wonders, therefore, if some of the great praise heaped on Hopper and Burchfield in the late 1920s was based on the fact that however broken down it was, they painted the old American home. What all of this suggests, and it is only symptomatic of one point of view in the 1920s, is that the buoyant release of the American spirit could not really take place because those who thought they possessed it would not share it with anybody else. They were more concerned with hoarding it than with nourishing it, and with insisting that it be conditioned by a past known only to them. The search for a usable past in this context became a burden. Or, as Van Wyck Brooks, already attacking this position as early as 1917, noted, "I think we are driven to the conclusion that our life is, on all levels, in a state of arrested development, that it has lost, if indeed it ever possessed, the principle of growth."[68]

To grow and to flourish like Davis, Sheeler, Hopper, Burchfield, and Demuth meant focusing on the evolving present rather than feeling beholden to a past that might no longer be relevant. It is of more than passing interest to note that these artists, despite their obvious concern for American subject matter, dissociated themselves from the American Scene Movement and perhaps even thought it was a betrayal of their original intentions. Edward Hopper, late in his life, said:

> The thing that makes me so mad is the American Scene business. I never tried to do that American Scene as Benton and Curry and the Midwestern painters did. I think the American Scene painters caricatured America. I always wanted to do myself . . . The American quality is in a painter – he doesn't have to strive for it.[69]

Burchfield also distanced himself from the more obvious implica-
tions of American Scene painting. He once wrote to his dealer, Frank
Rehn, that Regionalism made him sick.[70] Burchfield did not mind if an
artist lived in and worked for "one locality, but still [reached] out to the
art, past and present, of the whole world for inspiration and back-
ground."[71] Sheeler's reactions were more elliptical. "My paintings," he
said, "have nothing to do with history or the record – it's purely my
response to intrinsic realities of forms and environment . . ." and again,
"I am interested in intrinsic qualities in art not related to transitory
things. I could never indulge in social comment . . . I think of art as
being fundamentally on a different plane."[72] Stuart Davis, among the
most politically militant artists during the 1930s, believed that "regional
jingoism and racial chauvinism will not have a place in great art of the
future."[73] It would seem that they considered American Scene painting
to be fundamentally different from their art and intentions.

The various government projects during the 1930s, however helpful
and sustaining they were, need also to be considered in this light since,
in the mural programs especially, generally acceptable ranges of subject
matter were imposed on artists and a bureaucratic layer of administra-
tors grew up between artists and their subject matter.[74] The growth of
the American spirit in art became equated with a national inventory of
historical events and of topographical features rather than inciting ob-
servation, let alone personal soul-searching. Artists of the Left, associ-
ated with Social Realism, kept alive the kinds of critical readings one
finds in Hopper and Burchfield, but they did not search for national
identity in their art as much as national commentary and criticism. Like
Benton in the 1930s, they brought to their American subject matter an
agenda that dictated the kinds of scenes they chose to paint. The free
and open interaction with American culture, which characterized art
around 1920 – however difficult and implausible that might have been
– was smothered by programmatic and restrictive ways of thinking.
Artists found what they were searching for rather than finding liberation
in a break with the past or with outmoded art styles. The quest for
national identity in art became institutionalized rather than inciting,
conscious rather than intuitive, and thus became something other than
the quest that had begun earlier in the century.

FIVE

The Beginnings of "The American Wave" and the Depression

ONE

For those of us who were born in the 1930s or later, the years of the Depression are recorded, not lived, history. Whatever were its devastations, we know them only from memoirs, novels, family stories, and textbooks. Certainly we did not experience its impact on American art at first hand, nor have we been able to learn much about it at second hand. Unlike the generation of literary and political figures who lived through that decade, artists, art critics, and art historians still gloss over the Depression years. Even in Samuel Green's recent textbook, *American Art*, there are no illustrations of works by Thomas Hart Benton, Grant Wood, and John Steuart Curry, three painters who held the attention, if not always the best wishes, of the American public for a decade and more.[1]

Yet one of the most complicated problems in modern American art is the impact of the Depression, together with the Civil War one of the most profound experiences in the country's history. Not only did it involve a generation of artists, but it also created a train of ideas and habits that a later generation would in part continue as well as rebel against. In the present essay, I would like to explore only one aspect of American art that developed in the years immediately before and after the Depression – the emergence of "The American Wave." In addition

to the increasing interest in mural art, the influence of Mexican artists, and the new attitude toward the artists' role in society, it was one of the most significant features of American art to emerge in the early 1930s. All of these features, of course inextricably entwined with each other, became even further entangled when the New Deal art programs first began late in 1933.

The term "The American Wave" came into use during the 1931–32 exhibition season, describing all at once a state of mind, a type of subject, and, hopefully, a style. It was not only ". . . a movement looking forward to the production of works of art that, avoiding foreign influence, actually expressed the spirit of the land," but it was also an attitude that allowed American folk art to be viewed as proper esthetic expression and that took pride in earlier American movements such as the Hudson River School.[2] It defined a moment in the history of nationalism in American art that had been accelerating in the late 1920s and which would take on increasing spread-eagle characteristics during the next decade. It is rooted in conditions internal to the American art world of the time as well as to American cultural and political life to which it can be generally related.

To American intellectuals and artists during the 1920s, cultural nationalism was not unknown. On the right, for example, the League of American Artists could blandly state: "America is marching on to an artistic renaissance which will carry the nation to a great cultural height."[3] And, on the left, Joseph Freeman could write in 1925, in the prospectus for the magazine that became *The New Masses*, that various modes of American life which have no precedent in history or art have ". . . to find expression in imaginative, essential and permanent forms."[4] Implicit in both statements is the belief that America will find its own voice to express in its own style its own unique experiences. Whether in joy or sorrow, and reflecting the various conservative and progressive tendencies, American self-examination was, as revealed in the works of Harold Stearns, Vernon Parrington, Charles and Mary Beard, Arthur Schlesinger, Van Wyck Brooks, Sinclair Lewis, among many others, an intellectual and artistic industry.

Among American painters, however, there was not quite the same development. Academic painters, still important in the 1920s, did not concern themselves with American subject matter except in terms of the most general and inoffensive platitudes. Those artists working in a School-of-Paris idiom did not generally search for specifically American values in the American environment. Robert Henri and his circle,

including Eugene Higgins, Jerome Myers, and Glenn Coleman, all of whom exhibited throughout the 1920s, reflected a humanitarian internationalism – feelings common to all people – rather than national or regional biases.[5] And artists like Edward Hopper and Charles Burchfield, extremely important for the 1930s, did not begin to exert strong influence until the end of the decade.

But if the self-praise or self-immolation of literary figures did not appear with equal intensity among artists and art critics, a different kind of self concern began to make itself felt in American art toward the end of the decade – the desire to cast off European styles in the search for an American one. The development of this particular aspect of American art is complex to deal with because it involves not only an American vs. European confrontation, but also one between traditional and modern art as well. From a survey of the art journals of the 1920s and 1930s, it appears evident, but not easily demonstrable, that gradually (and then very quickly in 1930–32) those who preferred traditional to modern art began strongly to identify traditional with American and modern with European in their minds. What once had been more of a contest of styles (traditional vs. modern) transformed itself along nationalistic lines (American vs. European). To prefer modern art meant support for French art; interest in traditional or middle-road art indicated preference for American art.

Thomas Craven, who began writing articles opposing European art in the mid-1920s, was the most important, but by no means the only, critic to begin plumping for the development of an American style free of European influences. By 1925, he had propounded three related ideas that he, and others, would repeat with increasing frequency and xenophobic intensity in the following years. First, modern European art was already old and sterile, and its American followers were financial and artistic failures. Second, modern European art, really only a "question of technique," could not function as a medium for communicating the experiences of mankind. Third, Americans were not able to create a viable native art by copying Frenchmen, for the American soil could not "nourish a metaphysical imported style."[6]

Even though Craven's points could be well debated by a person taking an internationalist point of view, they were not without logic. He had found modernists living off the inventions of the Post-Impressionists and Cubists, now already a generation or two old. He did not hold an elitist view of art but one based on reflecting the experiences of the greatest number of people. And he believed that America, though heir

to Europe, was the product of a different set of experiences that called for an art derived from these experiences alone. However, it would seem that Craven argued as much from the logic of the nationalist position as from the anti-libertarianism of a puritan one. "The truth is that the Yankee believes the homely virtues and Anglo-American moralities indispensable to the conduct of life, and deep down in his heart he considers beauty corruptive and libidinous, something unholy and intoxicating, a little beyond his pragmatic grasp."[7]

He feared and hated bohemian existence, and he associated it with life in Paris as well as with the art that developed there. In time, his Francophobia became so intense that in his *Modern Art* it destroyed whatever value it might have had in surveying recent American art.[8] Unfortunately, Craven's anti-bohemian stance agreed with similar beliefs held by strong forces then in the art world, including the American Federation of Arts and its organ, *The American Magazine of Art*, as well as the editor of *The Art Digest* who gave space in each issue to the Art Division of the General Federation of Women's Clubs and the Artists' Professional League.

Critics like Craven and the people represented by the conservative organizations just named can be viewed against a range of confusing and at times conflicting tendencies that occurred during the 1920s and which were intensified by the Depression. In their concern for a native art, these people reflected that virulent strain of nativism that was possessed by fears of the urbanization of the country, of the dilution of the old Anglo-Saxon stock by immigration, of the submergence of old, trusted values by new, alien ones, and of any entanglements with Europe save the most necessary economic ones.[9] Small-town and nostalgic in outlook, they may also have reflected those elements in the country that were antagonized by the big-business oriented presidential administrations of the 1920s. "As one historian has pointed out, the governments of Harding, Coolidge, and Hoover spoke for the urban industrialist and had nothing of value to say to the beleaguered farmer."[10] Hankering after an earlier and simpler America where still by 1935 nine out of ten farms had no electricity, they were afraid of losing what was already slipping away.[11] When the Depression struck and the arguments of economic affluence could no longer quiet those opposed to Big Business, there mounted a revulsion to the architects of the crisis. In the public's eye, the bureaucrats in Washington, the financiers in New York, and their counterparts abroad began to merge as one and their values as well as their authority began to be seriously questioned.

One social observer, trying to explain the ruptures then appearing in American society, said the following:

> American individualism means, historically and dynamically, an instinctive preference for the concrete, personal, spontaneous processes of community life over the abstract, general, artificial processes of law, politics, and, above all finance – That is why the Middle West distrusts the East, where these abstract large-scale controls are concentrated; most of all, distrusts New York.[12]

Another related factor lying behind the appearance of "The American Wave" was the belief in the American Renaissance. The Renaissance, of which the country had been on the verge for years, included a number of strains in its makeup. On one level, it reflected a desire to compete with and to surpass the European achievement in the arts, and, therefore, to announce America's cultural coming of age. Concluding his book *The American Renaissance*, R. L. Duffus wrote:

> I think that there can be no doubt that America, having expressed herself politically, mechanically, and administratively, is on the point of attempting to express herself aesthetically. This has been thought before. . . . But now one begins to believe it true.[13]

On another level, the American Renaissance marked a belated aspect of that quality in the American character well represented in the twentieth century by Wilsonian Progressivism. With the same type of messianic zeal that saw, for example, Wilson turn World War I from a series of battles into a war to end all wars and a war to save the world for democracy, so the proponents of the American Renaissance saw art as a tool of moral, spiritual, and cultural uplift, a thing bringing beauty and goodness into each American's house. This point of view, supported by most art organizations and a basic policy of *The American Magazine of Art* and *The Art Digest* (but not the two other leading magazines, *Creative Art* and *The Arts*), is well summed up by Eugen Neuhaus who wrote *The History and Ideals of American Art*, as he said, to ". . . develop a pride in our artistic achievements and also [to] contribute to the formation of good taste."[14]

The American Renaissance was to be achieved, apparently, in good American fashion – through group effort, purchases, and exclusion. America would buy itself a Renaissance (for the culturally complete home, buy a painting) and, through tariffs, severely restrict or even prohibit the importation of European art works. All of America was

admonished to do as the Medicis and the Popes once did. As soon as Americans stopped refusing to buy American art and began supporting their painters, American art would then effectively begin to compete with the School of Paris. According to John Cotton Dana of the Newark Museum, "The formula is very simple: first we must buy it [art]; next we must study it; next we must criticize it; and finally, we must praise it where we can."[15]

At least three aspects of the American Renaissance are worth particular comment. First, a good portion of the art world honestly believed that a renaissance was going to take place.[16] Second, it was to be an artistic group effort. And third, it was to take place all over the country. Nowhere does one find statements to the effect that America will produce another Leonardo or Michelangelo. Rather, the general quality of American art was to be improved without benefit of individual genius. In fact, the proponents of the American Renaissance were opposed to unfettered individualism which they associated with European art. (It should be noted, however, that American art has often been characterized by group efforts rather than by solo flights. Early in the 20th century, for example, the two major events were not the emergence of particular men such as Picasso or Matisse but the exhibition of The Eight and the Armory Show.) Finally, adherents of the American Renaissance were not going to support, say, a School of New York to compete against an *Ecole de Paris* or the much earlier Florentine Renaissance. The American Renaissance was to be a nationwide affair. Minnesota would have to compete as well, as if France did not have its own *La Prairie de Goffeur*.

TWO

It would appear that the Depression did not introduce new modes of thinking into American art as much as it brought to the surface feelings and attitudes that were already present and that had already been expressed. But it did so with such vehemence that by 1932 or 1933, about four years after the Crash, people looked back upon the 1920s as if the decade were of another age. It is quite easy to find in the journals for those years statements similar to the one voiced by Maynard Walker who then worked for the important Ferargil Galleries. "The complexity and ultra-sophistication of the era just preceding the crash led many to seek only the bizarre and the sensational in art. . . . With the crash in 1929 everyone began to look around to see

if there were any realities left in the world. The rubbish from Europe was found to be rubbish."[17] In more general terms, Edmund Wilson wrote in 1932, "The attitudes of the decade that followed the war, before the depression set in, already seem a long way off. . . ."[18]

In the art world of 1927, among those who were not unalterably committed to traditionalism (e.g., the critic Royal Cortissoz or the National Academy of Design) or Americanism (e.g., Thomas Craven), serious questions were being raised about modernist American art. Although many critics could accept the modernist sweep of the 1927 Carnegie International in which Matisse took the first prize, they nevertheless argued among themselves the problem of how well Americans could adopt foreign, and specifically French, styles. For example, critics panned the Group of American Painters of Paris exhibition at the Brooklyn Museum that year, finding that expatriation had sterilizing effects on artists, that Anglo-Saxon restraints inhibited Americans from partaking fully of radical art groups, and that America was now sophisticated enough to support artists and native art movements.[19] Increasingly, critics became concerned with a national art style and concluded that none would ever emerge if European artists were continually imitated. Like the Mexicans, American artists were invited to turn to American primitives in order to develop a Western culture reflecting a "real American art." Or, short of that, they should explore their own heritage, background, and environment more intently.[20]

Painters were apparently responding to the same social and artistic pressures that were felt by the critics, for although many still painted, and would continue to paint, in modernist styles, the following was noted early in 1929. "The discovery that the commonplaces of the American scene can be quite as imagination stirring and therefore quite as worthwhile subject matter for art as the more traditional aspects is characteristic of the point of view of an increasing number of young painters."[21] George Biddle, later an important muralist, symbolized the thoughts of many when he wrote in 1929 that only recently had he come to feel how different the American mentality was from the French one. He found French art to be fluent, detached, critical, and aware of its artistry, while the best American art had always been inhibited, romantic, naive in its realism, and not often critical of esthetic problems. "I believe . . . that when I returned to America [in 1926] I was more conscious than I had ever been before of my own and of my American inner attitude toward life; and felt that the moment in my career had occurred when I need preoccupy myself less with self-

probings, and could allow my energy to flow into a more direct, subconscious emotional expression of life."[22]

If Biddle can be said to represent the modernist accommodation to an Americanist point of view, the director of the Minneapolis School of Art represented the traditional one. He found that ". . . much of importance to the young art of America can be done in the middle west."[23] Though acknowledging European art for its great worth, he nevertheless felt that American artists should develop along American lines and paint things with which they were familiar. "A Minneapolis boy, once he is taught something of organized beauty, can surely be more successful with a painting of the flour mills than some faded and far fetched idea of a castle on the Danube."[24]

Certainly the two most popular conservative art magazines encouraged the rising nationalism. In almost every issue of *The American Magazine of Art*, the editors included at least one article on regional painters. Indeed, the American Federation of Arts was committed to enlarging the country's esthetic vision by means of touring exhibitions, rural education, and regional exhibitions.[25] *The Art Digest*, too, always carried news of artists and exhibitions around the country to a degree much greater than current art journals. Indeed, if the general direction of American art in the 1920s was disintegrative, the growing interest in a distinctly American expression was one of the major things that pulled it back together again and which allowed traditionalists, modernists, and quasi-official bodies (the AFA) to cooperate with each other, especially when the government art programs began in 1933.

By 1930, the large national and international, as well as regional, exhibitions were beginning to feel the growing tendency of artists to use American subject matter in what hopefully was an American style (see Part III). These exhibitions, much more important in those days than in ours, acted as barometers of artistic interest and public taste. At the Chicago Galleries Association semi-annual in January and then through the Annual Exhibition of American Painting and Sculpture at the Art Institute of Chicago, the 37 Americans show at the Museum of Modern Art, the Carnegie Exhibition at Pittsburgh, ". . . there was a tendency on the part of many to exalt Main Street as against Park Avenue or Beacon Hill. . . ."[26] The death of Cubism and Fauvism was no longer predicted but ascertained and with it the demise of ultra-modernism. Meticulous realism appeared to be gaining in popularity. The Midwest was viewed as a new source of art and artists.[27] It was noted that "American art . . . has broken with tradition and is working out its own

destiny in a new and national way [which] is proved by nearly all of the exhibitions held in the U.S. so far this season."[28] And the point had to be made when the Worcester Art Museum purchased George Bellows' *The White Horse*, 1922, that the artist had never gone to Europe and was not in the least affected by European painting.[29]

A definite wave of hatred for modern French art appeared by 1930. Edwin Alden Jewell, critic for *The New York Times*, asked American artists to sing in their own voices or not sing at all. French art was reviled as being alien and quite useless as a source for our national artistic aspirations. Ultra-modernism, often considered the work of charlatans and madmen, was excoriated as rarely before. Articles, excerpted from the European press, were published stating how wonderful American art had become and how decadent modern European art was.[30]

In retrospect, all of this was as a quiet prelude to the verbal violence of the 1931–32 exhibition season. In addition to repeating or finding synonyms for what they had said earlier, critics and representatives of professional organizations ripped into American and European art dealers for dumping inferior European art on the American market. An organization known as An American Group was formed to fight the "French art racket," and even Forbes Watson, editor of the internationalist and modernist *The Arts*, wrote, in the last issue of that magazine, that the Parisian art dealers had turned modern art into "a kind of international dressmaker-painting, spattering it with the spirit of their own cynicism."[31]

No doubt, part of the attack on the internationalist art dealers was based on an honest assessment of the quality of the works they sold to Americans. But in 1931–32, American artists were beginning to feel the pinch of the economic depression. If a short while earlier it had been the culturally uplifting thing to buy an American painting, it now became one's patriotic duty. What little money there was available to buy art should be used to save American art from disappearing and American artists from starving. And anyway, to those for whom the American Renaissance was about to begin, "Now [was] the time . . . for the art world to assume that the fruition of America's unprecedented art movement [was] at hand."[32]

Of the 1931 Carnegie International, the critics could not say enough. Jewell of *The New York Times* said, "Today, with pride that has no need to wear the little tinkling bells of jingoism, we see the work of our artists taking a place that is second to none."[33] Dorothy Grafly, a responsible Philadelphia critic, found that "If the Carnegie Interna-

tional has a message for the artist this year it is an American message. No other section is so aware of the objective vigor of contemporary life. . . . The art . . . turns outward rather than inward through its rich discovery of the American Scene. . . . Painters will find a deep national significance in everything from a stove pipe to an automobile tire."[34]

So strong was the belief in the power of American art during that season that the Reinhardt Gallery in New York staged (held is not a strong enough verb) an exhibition in which European and American paintings competed to see which were better. Hopes were slightly dashed when, as one critic who summed up general opinion said, it was realized that although the Americans were much livelier, the Europeans were still technically superior.[35] The Whitney Museum staged a debate on "Nationalism in Art – Is It an Advantage?"[36] The Artists' Professional League, in search of a slogan, found "I Am For American Art" best of many possible choices.[37] Through the winter of 1931–32, *The Times* Sunday art pages were used as a public forum for discussing the nature of and need for an American art.

The frenzies of this exhibition year were not without their lighter moments. The prize winners of the Annual Exhibition of American Painting and Sculpture at the Art Institute of Chicago in 1931 were William Zorach, Morris Kantor, and Nicolai Cikovsky, all of whom were praised as good American artists who painted typical American subjects. Of Kantor it was said that although he could be associated with such mystics as Blake, El Greco, and Redon, and although he obviously learned much from the Cubists and the Surrealists, his "*Haunted House* was purely American in theme; a typical 'Colonial' interior flooded with light . . ." (fig. 15).[38] It would appear that except for bigots like Thomas Craven, any link with America would do, whether it be by birth, naturalization, or subject matter. Nationalism in American art was, as an anonymous reporter for *The Nation* so succinctly stated, "more anti-foreign than exuberantly patriotic."[39]

THREE

What was American about American art? This question occupied artists and public alike during this period, and the discussion rambled seemingly endlessly from exhibition catalogue to museum director's statement to magazine and back again. The question was often left open-ended – what was American about American art – because, like as not, any particular discussion

would find the parties grappling with at least four distinct, though related, concepts – the American spirit, the American style, the range of American subject matter, and what artists would have to do to paint "American." These were complicated by the positions taken, internationalist, nationalist, strictly regionalist, modernist, and by whether the participants were analyzing the situation objectively, arguing vindictively, or indulging in daydreams. To an observer, almost forty years later, it is not always easy to tell, so contradictory were the positions taken, even by the same people at different times, and so overwhelming was the amount written. Some participants seemed to know what they were talking about without precisely defining their terms. Holger Cahill, later the director of the Federal Art Project, could say, "There is an American spirit, of course, but it cannot be captured and held within a definition."[40] Or Jewell of *The New York Times* felt, "And somehow, man to man, quibbling aside, we do know what we mean when we speak of ourselves as Americans, and when, summoning the requisite temerity, we speak of American art."[41] And Virgil Barker, the historian and critic, reflected that he had ". . . been trying to track down this elusive trait of Americanism, using the word without any spread-eagle connotations, in the art of painting. I am convinced," he said, "that there is such a thing, and that it can be exposed convincingly in a good long book."[42]

Good long book or not, others were less temporizing and tried to define this elusive trait. A general consensus of opinion around 1930 would probably have agreed to the following. If there ever was to be an American art, it would require artists who did not explore the inner recesses of their own imaginations as much as they inquired into the experiences held in common by their fellow Americans. It would require a style that was realistic, simplified, and perhaps based on American Primitive art. It would probably arise in the Midwest where the taint of Europe was less strong than in the East. And it might err on the side of artlessness as long as it were easily understood. In the delicate balance between recording objects and creating forms, the invention of patterns would have to give way before visual accuracy.

The would-be definers of an American art never insisted upon a monolithic American style, believing instead that an American feeling would emerge, one clearly recognizable, in paintings where a proper subject was married to an appropriate style. But in an age overly concerned with combining a proper subject with an appropriate style, the absence of subtle reasoning is somewhat shocking. In the end, blind

15. Morris Kantor, *Haunted House* (1930). Oil on canvas. Courtesy of The Art Institute of Chicago. Mr. and Mrs. Frank G. Logan Purchase Prize, 1931.707.

faith and wishful thinking were elements in the desire to have an American art. Such an art would arise magically, as it were, and Americans would know it when they saw it. In retrospect, however, one might be shocked at the level of thinking about this matter, but one should not judge it too harshly. Those who were trying to define an American art were operating with handicaps that only became clearer when the two main off-shoots of the American Scene came into sharper focus toward the middle of the decade, Regionalism and Social Realism. In a country as big, diverse, and young as America, there was no way to determine a proper mode of representation for its art, and a cohesive set of traditions could not be manufactured in a few exhibition

seasons. The problem was, and, to a large degree, still is, insurmountable.

We may ask, nevertheless, what were artists painting around the year 1930. To make a quantitative survey of subjects is, of course, impossible. But one can make qualified guesses concerning the kind of subject matter as well as which artists aroused the most excitement and had the most profound impact. Although no single figure dominated the period, there were three who most prominently represented "The American Wave" – Charles Burchfield, Edward Hopper, and Thomas Hart Benton. These three also reflected in their work the principal types of subject matter that described Americanist painting of the time. Hopper and Burchfield represented that group which, however emotional or hard-boiled, observed and recorded what was seen. Benton represented those who tried to invent either a kaleidoscopic picture of contemporary America or an artistic re-creation of its past. The first two artists were committed to factual description; Benton, particularly in his murals for the New School for Social Research, the Whitney Museum of American Art, and the State of Indiana Pavilion at the Century of Progress Exposition, all painted between 1930 and 1933, wanted to recreate imaginatively the experiences of the American present and past. In the first years of "The American Wave," the Burchfield-Hopper point of view was by far the more common, and only when the federal government began to sponsor art projects late in 1933 did contemporary and historical surveys become usual.

All three were well known and well identified with the American Scene by 1931–32, and their paintings were considered affirmative gestures in the battle against the Europeanization of American art. At a time when American art had not yet come to lead the international avant-garde, they were seen as helping prevent American art from succumbing to the European avant-garde. Benton, who had painted in School-of-Paris idioms, began to explore the American environment soon after World War I, creating his "first strictly Regionalist painting," *The Lord Is My Shepherd*, in 1926, a portrait of an idealized older couple who have just finished a meal at their modest dinner table.[43] Hopper, a student of Robert Henri, developed his outlook and style as early as 1913, and Burchfield, a Midwesterner like Benton, had evolved, during the 1920s, from a grim fantasist to a grim observer of rural America.[44]

As early as 1924 Burchfield had been recognized for recording ". . . the inwardness of the midwestern small town," and, a few years later,

he was called ". . . the Sinclair Lewis of 'The American Scene.' "[45] "No American painter," one critic recorded, "has been able to capture and dramatize the world of contemporary American civilization with the same degree of emotional conviction."[46] And, in 1932, Thomas Craven, in a lop-sided judgment, found that Burchfield "to a large extent [was] responsible for the turn of the tide from the French school, with its concentration on mechanical ingenuity, to the native environment."[47]

Hopper, in 1927, was considered "the most successful interpreter of the American scene [in the] degree to which he succeeds in getting the essence of his subject," and the painter who ". . . today is getting more of the quality of America in his canvases [than any other painter.]"[48] By 1929, both Hopper and Burchfield were considered ". . . leaders of a school which has gotten under the skin of America."[49] One critic even found Hopper's *Hotel Room*, in which a woman sits in her underwear on a hotel bed, "one of the most beautiful and important paintings done by an American in this generation."[50]

Although these remarks emphasize their importance, their paintings do not reveal what one might expect. For their observations of the American Scene ranged from rural tawdriness to urban desolation. Yet, critic after critic believed that they had captured the mood of contemporary America, the physical background from which most Americans had sprung, and the longing, if you will, for that old desolate place called home. Their explorations of the contemporary environment as well as the nostalgia they evoked of real or imagined childhoods were reflected in a host of painters at this time. For one finds a great number of illustrations in magazines of the period depicting scenes that can only be described as bleak, ugly, commonplace, bare, and crude, whether they be views of decayed buildings, dirty backyards, or dusty streets.

It is difficult to determine if the painters only happened upon an ugly America or whether they sought it out, whether they painted from their observations and experiences, or whether they, perhaps unbeknown to themselves, were keeping alive the debunking spirit and sense of intellectual disillusionment of the 1920s. Their lack of optimism and retrospective disparagements mark one of the great paradoxes of the art of this period. Recognized as part of the emerging nativist school, perhaps even of the nascent American Renaissance, these artists recorded images that were more an indictment of America than a glory song. If there were inexhaustible riches to be found in this country, these artists were not looking for them.

Their hard, gritty realism, acerbic and melancholy at the same time, had more in common with that line of novelists running from Hamlin Garland and Edgar W. Howe through Sinclair Lewis than with earlier realist painters such as Robert Henri and his circle. Qualities like joy and love of life do not resonate from their works as they did from the paintings of the older artists, nor can one read into their works a sense of energy or drive. They painted a tired America, one seemingly drained of all ebullient spirits, one afraid to continue existing. Perhaps in a vein similar to that portrayed by Lewis Mumford and Stuart Chase, they were pointing out the psychological losses absorbed in the process of industrial development, the defeats rather than the victories of the Machine Age.[51] Even before the Depression struck, these artists indicated a loss of faith in the country, an attitude more easily understandable after 1929. They evoked a spirit of doubt, often stated and ever present after the Crash, concerning the future of America.

For the years around 1930, it is somewhat harder to locate an American style than to suggest what was an appropriate, or at least the most prominent, subject matter. There was no single style that could be defined in the same way that, say, Cubism or Fauvism could be described, either early in the decade or toward the middle when John Steuart Curry, Grant Wood, and Benton emerged as major figures. However, it is possible to find in the realism of the time elements from American Primitives, Colonial limners, old daguerreotypes, and perhaps the German Neue Sachlichkeit, for that movement, known in this country at least as early as 1926, manifested similar concerns for national heritage, rural life, dry techniques, and simplified forms.[52] Critics found in American art a sense of space, strident color, and hard outlines, but they do not seem to have penetrated to underlying attitudes toward form. The esthetic nature of the problem of style escaped them almost completely because they confused it with notions about the American spirit and subject matter. They did this not perhaps out of ignorance but because they saw art in relation to life rather than in relation to other art.

Nevertheless, we can formulate an approach to the nature of an American style in the early 1930s by focusing on one of the factors absolutely central to the School-of-Paris sensibility – the interrelation of figure and ground, of a specific form in a painting and the objects immediately around it. No artist managed this interaction as well as Cezanne. Few Americans had any idea of what it was all about, not necessarily because they lacked sensitivity, but because they were less

16. Paul Cezanne. *Le Jas de Bouffan* (1885). Oil on canvas. 25¼ × 32 in. Museum of Art, Rhode Island School of Design. Museum Appropriation.

interested in problems of abstract organization and more concerned with evocation and description of place.

In terms of style, the differences between Cezanne's *Le Jas de Bouffan* (fig. 16) and Burchfield's *Winter Solstice* (fig. 14) extend beyond recognizable building types to the obviously different manipulations of the figure-ground interaction. Take, for example, the light-valued and light-colored patch just to the left of the central tree trunk in the painting by Cezanne. (The patch is part of the house.) Because it visually ties together with other light-valued areas around the trunk, it functions as part of a light ground for the dark figure of the trunk. But, at the same time, the light patch is also surrounded by darker-valued sections of tree trunk, branches, and leaves. Thus, the light-value patch is also a figure set against a darker ground. It is, therefore, two things at once – both a figure and part of a ground. With other light-valued areas, it "closes" around the large tree trunk, and is, in turn, surrounded by the dark "closure" of the darker-valued sections.

Such closures appear all over the painting, some small, others large. It is important to remember the following points about them. First, as much as any form helps define a recognizable object (tree, house, barn), it is also part of an abstract design made up of similarly shaped forms and these tend to close with each other depending upon their commonalities. Second, because of their commonalities, forms on differing planes of depth will tend to close with each other. Third, a single form can be part of a large number of closures depending upon its value, color, or shape. Fourth, the result is an organic painting, one in which the parts seem to be in constant flux as they ally themselves now with one form, now with another. Fifth, our eyes are constantly making adjustments to the figure-ground relationships as these forms change their relationships to each other.

In the Burchfield painting, there is little interaction between figure and ground. The houses to the left balance the trees to the right, but they in no way interact with each other. The sky is a backdrop, not an integral part of the composition. Instead of inventing a continuing series of balances, Burchfield sets off one large mass against another. But even this kind of opposition is unstable because Burchfield did not provide his painting with a central hub, a device uncommon in American painting but basic to European art since the Italian Renaissance. Rather, Burchfield's forms seem to push out toward the painting's perimeter, a characteristic common to American art.

This comparison is not meant to condemn Burchfield's work nor American art in general. Instead, it is to point up the fact that American painters, and certainly those who flourished in the early 1930s, were less concerned with art than with life. Because of the mood he evokes, Burchfield tells us something about a Midwestern street and the lives that might be lived upon it. The painting is a point of departure for an internal dialogue by the viewer. Cezanne, because of his concern for the interrelationships of form, to the seeming exclusion of human responses, tells us something about art, instead. This is a profound difference and one not easily reconciled by simple comparisons of structure and form, for Burchfield obviously did not intend his work to become an autonomous creation divorced from his own feelings about the street and the house. Unlike Cezanne who was primarily concerned with his visual sensations, Burchfield was more interested in human sentiment.

If generalizations may be permitted from this comparison, I would say that American painters of the period tended to start with a particular

subject and tried to reach some sort of esthetic statement instead of first searching for the esthetic statement as the motivating force and letting the subject become the outer garment, as it were. They were more concerned with description and evocation of place than with abstract principles of art. Apparently responding to a greater need to chart and possess America than to "create" art, they seemed compelled, like many writers of the 1930s, to add detail onto detail as if multiplication of facts could be an end in itself.

FOUR

By 1932, "The American Wave" had become a loose-jointed but coherent artistic movement. It took as its principal subject the American scene; it tried to adopt styles that would reflect as little European influence as possible; it developed an attitude, used with arrogance by some, that exuded confidence in the future of American art even if a major aspect of its subject matter indicated otherwise. Wanting artists to be outgoing rather than withdrawn, it believed in giving art a public function rather than that of a coterie. Without it, the later government art programs would have taken a different direction.

"The American Wave" flourished during the early years of the Depression. Although many artists sought other professions or were reduced to near poverty, the economic calamity seemed to have brought out a certain pioneering spirit in the art world, one that was probably not lost on its public. Like other elements in the country offering ways to alleviate the Depression (e.g., the Townsend Plan), the art world found its method – to invent an American art, if it had to, and then support it. Rarely had so many disparate forces come together for the same purpose.

SIX

Grant Wood Revisited

For those of us who watch kiddie TV shows along with the children, Grant Wood's *American Gothic* has been an advertising fact of life for well over a year. The lips of the farm couple move, singing the praises of a brand of cornflakes made from real corn. And this is a pity! Grant Wood has been so closely associated with corn of one sort or another for so many years that we are prevented from seeing the artist who in a handful of paintings dating from the early 1930s attacked American institutions at least as bitterly as any other American artist. Paradoxically, the very paintings with which he is most popularly associated, and therefore the ones considered most corny, are the paintings containing his most acid comments.

Although Wood is considered a mid-western regionalist, he should not be regarded as a flag-waving hayseed. A Democrat from Cedar Rapids, Iowa, he had journeyed abroad four times by 1930.[1] And, when it came during the Depression, he strongly supported the New Deal. We should not, therefore, be duped by his famous remark delivered shortly after his first New York exhibition: "I realized [while in Paris] that all the really good ideas I'd ever had came to me while I was milking a cow. So I went back to Iowa."[2] He was then evidently playing with relish the role of a "mid-western" painter and could not have meant what he said. He was never even a farmer. Instead, his interest

in mid-western subject matter grew, as he said, not ". . . from a 'booster spirit' for any particular locality, but [was] founded upon the conviction that a true art expression must grow up from the soil itself . . ."[3] In the early 1930s, he did not always find sacred the soil of the mid-west nor the people it supported.

He saw quite clearly the reality of mid-western America during the first years of the Depression, and sought to capture it in sardonic fashion. One of his first, and ultimately most popular, paintings in this mode was *American Gothic*, a prizewinner when exhibited at the Chicago Art Institute in 1930 (fig. 17). The genesis of this painting goes back at least as far as the day in 1929 when Wood took a motor trip through the town of Eldon, Iowa.

> I saw a trim white cottage, with a trim white porch – a cottage built on severe Gothic lines. This gave me an idea. That idea was to find two people who by their severely straight-laced characters would fit into such a home. I looked about among the folks I knew around my home town, Cedar Rapids, Iowa, but could find none among the farmers – for the cottage was to be a farmer's home. I finally induced my own maiden sister to pose and had her comb her hair straight down her ears, with a severely plain part in the middle. The next job was to find a man to represent the husband. My quest finally narrowed down to the local dentist, who reluctantly consented to pose. I sent to a Chicago mail order house for the prim, colonial print apron my sister wears and for the trim, spotless overalls the dentist has on. I posed them side by side, with the dentist holding stiffly upright in his right hand, a three-tined pitchfork. The trim white cottage appears over their shoulders in the background.[4]

Even though Wood's sense of humor is evident in the painting, his distaste for his subjects is also quite apparent. This is made clear by Darrell Garwood, his biographer, who states that Wood found the Eldon house pretentious, a flimsy structural absurdity supporting a Gothic window.[5] Furthermore, Garwood also mentions that "Grant intended to satirize the narrow prejudices of the Bible Belt, which includes Southern Iowa."[6] This may give us a clue to a more profound meaning Wood may have had in mind when he painted the picture. In a manner analogous to those persons in our own day who because of their concern with "freedom" would fight Communist collectivism with a collectivism of their own, might Wood have been suggesting that religious fundamentalists were doing the work not of God but of his opposite – namely, the Devil? Might we look upon the man with his pitchfork not

as a religious farmer – the mythic New Jesus of the mid-west – but as the Devil himself, or as a symbol of the Devil's presence in Iowa? If so, then Wood's painting reaches beyond mere satire and his comment on the psychology of the Iowa couple is rooted considerably less in good-humored ridicule, as is usually thought, than in a savage kind of criticism.[7] This notion is not a far-fetched one when we search the possible implications of other paintings Wood created in the early 1930s.

But first, where might Wood have come upon the biting point of view, as well as hard, dry style of painting, that we see in *American Gothic?* So far as can be determined, it did not develop from a mid-west school of artists, or even from Wood's earlier works which had been, for the most part, a mish-mash of Romanticism and Barbizon-Impressionism.[8] The most influential Iowa painter of the generation that matured just before World War I was Charles Cummings, an academic artist trained by Benjamin Constant.[9] The level of quality he set has been described in the following terms: "The state had relegated pictorial art to the daughters of the women who had learned to paint on glass, years before."[10] While this is not exactly a precise scholarly assessment, it describes quite accurately Iowan art before 1930, and other reports on the subject do nothing to alter its essential truth.[11] The same can be said about the level of painting in other mid-western states as well. If there was a tradition of harsh realism during the opening decades of the century, it seems not to have been recorded in books or articles, most of which were written by the sisters of the painters, anyway.

Realistic painters in other parts of the country about whom Wood might have known, such as Robert Henri and his circle, found life everything but grim and difficult. The painters of The Eight found enchantment in the slums, delight in the human anecdote, and joy in the excitement of living. Wood's realism, therefore, would hardly have grown from Henri's. Rather, it seems to relate more easily to the harsh realism of early twentieth-century American literature, which, unlike eastern and mid-western painting was not overly muffled by gentility. As early as the 1890s, writers such as Hamlin Garland and Edgar W. Howe gave accounts of the hardships of mid-western life. Within Iowa itself, Alice French (Octave Thanet) wrote about problems of capital and labor at the turn of the century. Between 1915 and 1933, John T. Frederick published *The Midland*, a magazine devoted to pointing out the horrors of Iowa farm life. "It was Eugene O'Neill gone mad in the pigpens," as one local historian remembered it.[12] During the 1920s and

17. Grant Wood, *American Gothic* (1930). Oil on beaverboard. 29⅞ × 24⅞ in. Courtesy of The Art Institute of Chicago. Friends of American Art Collection, 1930.934. Estate of Grant Wood/Licensed by VAGA, New York, NY.

1930s, Herbert Quick and Ruth Suckow wrote novels concerned with the difficulties faced by the pioneers, as well as with the spare farm life led by many Iowans. By this time, however, writers and critics across the country, ranging from Sherwood Anderson to H. L. Mencken and the earlier Van Wyck Brooks, were already describing the barrenness of American life and discrediting its puritanism and false gentility. Indeed, a harsh descriptive realism was more a literary than an artistic phenomenon during the first third of the century.[13]

Wood's brand of realism, then, as seen in *American Gothic*, has stronger literary than artistic antecedents. To amplify further this notion, we may compare descriptions of mid-westerners that appeared in novels by mid-western authors and in critical writings about their books with the man and woman in *American Gothic*. For example, Sherwood Anderson says in his novel *Kit Brandon*, "There is something that separates people, curiously, persistently, in America."[14] In describing Edgar W. Howe's approach to subject matter, Henry Nash Smith has said the following:

> Howe's west offers neither color to the observer from without nor consolations to the people themselves. It is a world of grim, savage religion, of silent endurance, of families held together by no tenderness, of communities whose only amusement is malicious gossip. Howe's farmers seem on the whole to be prosperous enough, but some not easily analyzed bitterness has poisoned the springs of human feeling.[15]

And Max Lerner has recorded his impressions of *American Gothic*, "The record of the outer social tyranny and the inner repression may be read in the stony faces of Grant Wood's provincials."[16] Granted, juxtaposition of such statements leaves one open to the charge of doing no more than shuffling one's reference cards, yet it is nevertheless true that they could not be so shuffled with regard to any other well-known realist, Edward Hopper excepted, prior to c.1930.

The reasons why Wood's *American Gothic* seems related to, if not probably influenced by, a broad literary tradition already a generation old, stems from at least two factors. First, there was the Depression, which may have prompted Wood to examine carefully the America with which he was most familiar. His major satiric works date from the years immediately after 1929, and, as will be suggested in a moment, they may reflect that point of view expressed by Edmund Wilson in 1932 who noted that many artists and writers ". . . wondered about the survival of republican American institutions."[17] Second, Wood was opposed to the hateful nationalism engendered by organizations such as the Ku Klux Klan, strong in the mid-west in the 1920s, the Daughters of the American Revolution, and the American Legion. In fact, the painting of *Daughters of Revolution* was in part prompted by the DAR's reactions to one of his commissions.

The transformation of Wood's attitude toward subject matter was equaled by a change in his style. Where his forms had once been softly

modeled, they now became hard. Borders became more tautly defined and color was used more flatly. These modifications have been tradi- tionally explained as growing from the influence of Northern European primitive and early Renaissance paintings Wood saw in Germany in 1927–28, or, very possibly, from *Neue Sachlichkeit* paintings (perhaps more with regard to a general regionalist outlook than to particular stylistic sources) he could have seen there.[18] However, another factor may be suggested to account for these changes. Wood disliked intensely colonialism in American art. Although he was not a xenophobe, he nevertheless condemned American artists for imitating European styles rather than developing an art based on native values and experiences.[19] It may be speculated that the Depression, acting as a catalyst on Wood, brought to a crisis the problem of stylistic influences, and, as a result, he turned to American primitive paintings and perhaps old, nineteenth- century tintypes for future stylistic cues.

At the time *American Gothic* was painted, Wood knew that his Iowa contemporaries would be offended by it. To prevent, or at least forestall, protests, he did not enter it in the 1930 Iowa State Fair, but exhibited it first in Chicago instead.[20] Even so, he was subject to abuse, and one irate housewife is reported to have threatened, by telephone, to smash his head in.[21]

Because of the uproar created by *American Gothic*, Wood altered his plans to make paintings of a circuit-riding minister and a Bible Belt revival meeting.[22] He concentrated his gaze directly at his fellow Iowans instead and saw, evidently, the barrenness of life as it was then lived in that state. For in his two bitterest paintings, *Victorian Survival*, 1931, and *Daughters of Revolution*, 1932, he seems to have been saying that to live in Iowa was to be afflicted, an idea emphatically underlined by comparing these works with *Three Women of Provincetown*, c. 1921, a painting by Charles W. Hawthorne, which may have served as a model for Wood (figs. 18, 19, 20).[23]

Like *American Gothic*, *Victorian Survival* lends itself to critical in- terpretation. If we can view the farmer in the earlier painting as sug- gesting in some way the presence of the Devil in the Iowa soil, may we then look upon the Victorian survivor as representing the presence of decay in the Iowa mind? She hardly qualifies as a proud daughter of the pioneers, and, of the heritage she passed on to the present, there is "... in the black, stiff figure, [and] the grim mouth of the invert... much bitter truth about the late and seldom lamented Victorian era."[24]

The creation of *Daughters of Revolution*, 1932, stems in part, from

18. Grant Wood, *Victorian Survival* (1931). Oil on canvas. Courtesy of The Carnegie-Stout Public Library, Dubuque, IA. Estate of Grant Wood/Licensed by VAGA, New York, NY.

difficulties Wood experienced at the hands of local DAR and American Legion chapters. After he had executed in Germany the designs for a stained glass window memorializing veterans of World War I, local branches of these patriotic groups, still engaged in fighting that war, protested vigorously the completion of the window in the land of the enemy. As one English observer all too delicately recorded: "The

19. Grant Wood, *Daughters of Revolution* (1932). Oil on canvas. 20 × 40 in. Courtesy of The Cincinnati Art Museum. The Edwin and Virginia Irwin Memorial. Estate of Grant Wood/Licensed by VAGA, New York, NY.

20. Charles W. Hawthorne, *Three Women of Provincetown* (c.1921). Oil on canvas. 48½ × 60 in. Courtesy of Mead Art Museum. Gift of George D. Pratt, class of 1893.

Daughters of the American Revolution is a most estimable society, but there are moments when it seems not content to rest on its laurels; it is then that its policies are hardly those of the angels . . ."[25] Of the squabble and of his painting, Grant Wood spoke more to the point. "They could ladle it out. I thought I'd see if they could take it."[26]

Posing the women in front of Emmanuel Leutze's *Washington Crossing the Delaware* was a masterstroke on Wood's part. Despite its histrionics as well as critical disfavor, Leutze's painting touches a spot extraordinarily sensitive in the American psyche. For along with Gilbert Stuart's images of Washington there is probably no more popular painting in America. By showing the general on his way to whip the Hessians at Trenton, Leutze incarnated the bravery, spirit, daring, impetuosity, youth, and all-conquering spirit of the Revolution and, therefore, of all America. But who are the descendants of that Revolution? Tea-sipping ladies with aristocratic airs and hardening of the arteries. Everything the American Revolution stood for, these women obviously stand against. Destroyers, perhaps victims, of their heritage, they preserve what no longer exists. If we may say, then, that *American Gothic* points up a major failure of religion and that *Victorian Survival* suggests a failure of mind, may we view *Daughters of Revolution* as illustrating the perversion of Iowa's (or America's) democratic birthright?

If the line of reasoning so far taken has any validity, we may assume that Wood, consciously or unconsciously, was questioning the future of America. He seems to be suggesting, at any rate, that life in America in the early 1930s was an experience in oppression of the mind and suppression of the spirit, and that Americans were bigoted, narrow-minded, prematurely aged, and self-righteous. Perhaps he even meant to question the entire democratic experiment when he painted the *Midnight Ride of Paul Revere*, 1931 (fig. 21). Taking for his subject an event that had long since become myth – the ride that marked the start of the Revolutionary War – Wood portrayed it as if it were a tableau made of cardboard, a mock-up for a motion-picture stage-set. In fact, the scene appears almost as a newsreel. The horse and rider gallop over the long, winding road to the houses, and then on into the night. The painting's drama, however, unlike that of the previously mentioned works, is hollow and entirely theatrical. This is altogether unfortunate since *Midnight Ride of Paul Revere*, which has the least impact of this group of paintings, should have been his most profound work within the context of meanings suggested here.

All of these paintings were completed within a two-year period. On

only one other occasion, when he painted *Parson Weems' Fable* in 1939, did Wood employ obviously satiric devices (fig. 22). In this work, he attempted to show the story for what it was – a legend, a fabrication invented by elders for the benefit of children. Like Charles Willson Peale's famous portrait of himself standing in his museum, Parson Weems, smiling wryly, throws back the curtain and the show is on.

These five paintings, despite the fact that Wood is remembered by them, are not typical examples of his work. The great majority of his paintings done after 1930 either record the commonplaces of midwestern life or describe a highly stylized Iowa landscape. It is perhaps more difficult to explain why he stopped making satiric paintings than to suggest why he began them in the first place. No doubt, the initial shock of the Depression lessened through the years, and any antagonisms it may have caused in Wood's mind were soon spent. As director of the Public Works of Art Projects in Iowa early in 1934, he may have felt able to contribute positively to America's revitalization.[27] Or perhaps he came to believe that, with his increasing popularity as a regionalist, he had to paint pleasant themes. It may also be quite relevant to point out that, in the final analysis, he was an artist who, because of certain events, performed for a few moments beyond his innate capabilities.

In any case, an equally interesting and perhaps stranger point to consider is the popularity of his paintings with the public. They certainly do not flatter, and it is not for their composition, color, and exalted spirit that they have been remembered. Yet, one of them, *American Gothic*, is probably the most famous American painting of the century. The fascination this work holds over people is in itself fascinating. Why, for example, do people invariably laugh when they either stand before it or see it in reproduction? Is it a laugh offered in nervous recognition of what they know is true about themselves but try so hard to repress? Do they see their self-portraits in middle-age, or those of their neighbors? Wood seems to have painted an equivalent of their life and given them an image of what they may actually be. Certainly, there is the shock of recognition in those faces. Whatever else one may think of *American Gothic* – once seen, it is never forgotten.

Wood may have been from the provinces, but his intent was just as clear as that of any social realist of the period. As a matter of fact, there is probably no other group of paintings from the early 1930s that match his in popularity and vitriol except Ben Shahn's Sacco and Vanzetti series.[28] Associating Wood with Shahn in this manner is important not for purposes of establishing links between the two men, but to suggest

21. Grant Wood, *The Midnight Ride of Paul Revere* (1931). Oil on composition board. 30 × 40 in. Courtesy of The Metropolitan Museum of Art. Arthur Hoppock Hearn Fund. Estate of Grant Wood/Licensed by VAGA, New York, NY.

that growing up in the sticks did not necessarily preclude the development of a vision similar to one nurtured in the slums, and that the old labels of regionalism and social realism often mask profounder differences within the two groups than they reveal between them.

For example, there are artists who habitually prefer to paint American myths, while others try to capture, broadly speaking, American realities. Some change back and forth, even oscillate, in a seemingly random manner. The difference between the two approaches can easily be seen by comparing Thomas Cole's *The Architect's Dream*, 1840, with Edward Hopper's *Sunday*, 1926 (fig. 8). Where Cole had populated the still virgin hills of America with heavenly mansions, Hopper shows the banal streets that were eventually to run over them. The same contrast can be seen in poet Paul Engle's "America, turn and find yourself. Not a continent, but eternity is ahead," on the one hand, and Archibald MacLeish's "America was promises," on the other.[29] With regard to painting in the 1930s, the difference in attitude is to be seen in the

22. Grant Wood, *Parson Weems' Fable* (1939). Oil on canvas. 38⅜ × 50⅛ in. Courtesy of The Amon Carter Museum, Fort Worth, TX. Estate of Grant Wood/ Licensed by VAGA, New York, NY.

paintings of Thomas Hart Benton and the Woods here illustrated. The former record an imagined, mythic past, the latter questioned the present. Similar polarities occurring in the work of a single artist help us distinguish between, say, Ben Shahn of the utopian New Jersey murals (in which the poor immigrant arrives in the first panel and, a few panels later, finds himself amid ideal working conditions) and the Shahn of Sacco and Vanzetti. It would seem, then, that we do Grant Wood an injustice by associating him with the regionalist movement, and with Benton in particular, with so little qualification. His most popular paintings reflect an attitude of mind quite remote from that of Benton's, and though both were from the mid-west, they did not always respond to it with the same spirit. This is particularly the case during the early 1930s when, in a handful of canvases, Wood was one of our most probing critics.

The Relevancy of Curry's Paintings of Black Freedom

I t is unfortunate that current interest in the art of the 1930s borders on camp appreciation. The period remains misunderstood, except that now it is with a giggle rather than with an embarrassed shrug. Partisan polemics have long since subsided, but the era still brings out the worst in people. In the most recent book on modern American art, Barbara Rose's *American Art Since 1900: A Critical History* (1968), the only time that the word "vulgar" is used is in reference to the paintings of Thomas Hart Benton. There is no reason for this, because the arguments used against Benton can be similarly employed against other artists from different periods. The mindless reflex to the art of the 1930s and to its most popular representatives remains.

The 1930s did not exist for the amusement of a later time, and the questions and problems that the decade's art engendered are as valid as those of other periods. Its artists were not cardboard figures easily stacked in stylistic boxes, but singular individuals whose differences are as interesting as their similarities. For example, the three most famous Regionalists – Grant Wood, John Steuart Curry, and Benton – painted in dissimilar modes and approached their subjects from widely differing points of view. Had it not been for the importunate writings of Thomas Craven, who pleased as many as he exacerbated, they would not have

been tied together so cohesively. An important task for present-day historians is to see each artist as an individual.

The Regionalists have often been condemned as flag-waving hayseeds, the implication clearly being that they were as conservative politically as they were artistically. In fact, Wood was a New Deal Democrat who played an administrative role in at least one governmental art program during the Depression. Benton was, during the 1930s, an independent Socialist. Curry's political beliefs are not explicitly known, but the subject matter of an important group of his paintings, here discussed, as well as statements that he made, suggest strongly that his interests lay in a liberalism of one sort or another.

Involvement in societal questions was not the sole possession of the Social Realists, a group of left-wing artists centered primarily in New York City. The problems created or enlarged by the Depression became the property of all artists, as did the issues that an increased social concern insistently focused upon. As Curry himself said in 1937, "The artists of today have the opportunity to use the alive and vital issues as subject matter, and they are doing it."[1] One such issue was the history and struggle for the civil rights of American blacks, a theme often presented in folk songs and the theater as well as in art. Curry's interpretations of that theme were among the most forceful and monumental in a period of forceful and monumental paintings.

Even if Curry's beliefs might have been otherwise, he would probably have been drawn to this subject matter because of his fascination with themes of violence. Living in a violent country during a tense period, he often painted works concerned with destruction and potential destruction, of forces in contention, and of uncontrollable outbursts of emotion. He portrayed tornadoes, lightning storms, floods, animal fights, football teams in action, and fervent religious gatherings.

As early as 1931 he painted *Man Hunt*, a work that lies behind *The Fugitive* of a few years later. Of the latter, there are both painted and lithographic versions. In a writhing, contorted landscape, a black man hides from a lynch mob. His body is at once absorbed into the forms of the tree and at the same time suggests a crucifixion. Curry may have intended the double meaning by this type of figural representation. First, the black man, by becoming identified with nature, might allude to a happier, more natural time than the present. Many American painters, regardless of their stylistic tendencies or attitudes, saw only a dismal, tawdry, run-down country in the 1920s and 1930s. One has only to think of Grant Wood's *American Gothic* (1930), one of the most

popular paintings of the century, to realize that glory songs were few and far between. To Curry, then, the black man might have been an Americanized noble savage who had been brutally ravaged by whites, a symbol of the destruction of the myths that had once sustained the country but that in the time of the Depression offered little spiritual solace. Second, and related, Curry might have seen the black man as the crucified American who at the same time offered the possibility of rebirth, the new American rising from the death of the old. The same pose reappears in other paintings of his that deal with black freedom, and it is not always easy to tell if the outstretched hands suggest cruci-fixion or, in emulation of orant figures found in early Christian cata-combs in Rome, prayer and redemption.

By the middle of the decade an interest in the rights of blacks and the position of blacks in American society had become widespread. This is not the same thing as saying that there was an interest in blacks as subject matter, for almost every nineteenth-century painter portrayed them in one way or another. The famous genre painter William Sidney Mount often included blacks in his paintings. In the mid-1930s, how-ever, the older attitude was replaced by one of increased militancy (a militancy to be judged by the standards of the time, not by those of the 1970s). An exhibition by white artists entitled "An Art Commentary on Lynching" was even held at two New York galleries in 1935 and it included Curry's *The Fugitive* as well as works by Benton, Reginald Marsh, and the late George Bellows.[2]

In 1936 Curry was granted the opportunity to pursue on a large scale the theme of the black man in America. With other artists, he was invited to decorate two lunettes on the fifth floor of the Justice Depart-ment Building in Washington, D.C. This was sponsored by the Section of Painting and Sculpture of the Treasury Department, one of the federally operated programs assigned to obtain the best available works for government buildings as well as to insure the livelihood of painters at a time when private sales fell to near zero. The subjects assigned to him included "The Migration Westward, the Settlement of Land, and the Bringing of Justice," and "The Freeing of the Slaves and the Com-ing of the New Immigrants."[3]

In an early sketch of "The Freeing of the Slaves and the Coming of the New Immigrants," the immigrants arrive at the left. In the center, over the Union and Confederate dead, blacks achieve freedom. To the right, the Civil War armies march to further triumph and grief (fig. 23). The main thrust of this study is obviously the idea of America as the

23. John Steuart Curry, rejected study for *New Immigrants and Freeing the Slaves* (1936). Courtesy of the National Archives and Records Service.

land of liberty and justice for all, or America the land of the free. Liberated Europeans appear together with liberated blacks. The mighty ships and tall buildings of modern America, which the newly freed men will help navigate and build, rise to the rear.

This study was rejected on the grounds of artistic incompatibility between themes of immigration and emancipation. Curry revised his basic scheme by eliminating the immigrants and concentrated instead on the freeing of the slaves. In place of the immigrants at the left, he substituted a mule-drawn cart, still a strong symbol for blacks, to which the funeral of Martin Luther King, Jr., in 1968 gave sad witness. Although the sketch was endorsed by the Commission of Fine Arts, it also was not accepted. No doubt it was refused on the grounds that it might stir racial controversy, a flagrant acknowledgment on the part of the authorities that America was not yet the land of freemen.

Murals concerned with immigration were popular during the 1930s. Leading Social Realists such as Ben Shahn and Philip Evergood created major statements in this category, the former in the community center of Roosevelt, New Jersey, in 1937, and the latter at the Queensborough branch of the New York Public Library in 1938, portraying the European dream across the ages of an America as the new Garden of Eden, where downtrodden people are transformed by enlightened democratic procedures to productive and happy members of society. The federal government apparently thought otherwise in the case of Curry's studies.

Like Shahn and Evergood, Curry, too, was responding to modern social demands. In a speech delivered in 1937, he said, "The social, political and economic disturbances of the times have brought forth

those artists who, taking their themes from the issues, have produced telling and effective works for the cause of social and political justice."[4] In the language of the 1930s, however, one might say, that Curry's sketches were not the sort a Social Realist might create, despite their obvious social message. The religious exaltation of the blacks was a stereotype and indicated their inability to cope with modern procedures of administration and organization necessary for equality. Black freedom was granted in the 1860s, and in the 1930s it still had not been achieved. The sketches, then, perpetuated myths that blocked true progress. The despairing condition of the blacks in the 1930s might have been a more appropriate subject, so that the effects of their continued bondage might better be understood. In short, Curry fell into the trap of most Regionalists – he was retrospective when he should have pointed aggressively to social change.

Yet in our own day it is not too patronizing to say that Curry's recognition of the issues, despite his treatment of them, is important. It suggests that Regionalists could identify major issues of the day and try to cope with them in ways that might have helped to alter the climate of opinion in their favor (a factor usually denied by Social Realists at that time). That these sketches would probably have been continually rejected until the late 1960s, and even then perhaps pigeonholed indefinitely in some committee, indicates Curry's willingness to confront the sensitive issues involved at a time when they were just beginning to be broached on any kind of intelligent artistic level. One has only to recall Marc Connelly's popular and successful and altogether stereotyped blacks in *Green Pastures* to realize that Curry's approach was, for the 1930s, quite liberal and on the right track. In fact, it is quite possible to find in the works of men like Shahn and Evergood pie-in-the-sky lapses that are intellectually primitive. This is not meant as a criticism, any more than my earlier remarks were meant to criticize Curry. Rather, they are meant to point out truths shared by many artists who thought that they were in different camps at the time.

The design of Curry's that was finally accepted, "The Majesty of the Law," is a travesty of his original ideas through no fault of his own. All the cliches are there: the columned court house, the uniformed National Guard, the FBI man, all on the side of justice; on the other side are the skeleton-faced lyncher, panting dog, stickwielding mob, and torch bearers. The ultimate irony is that many people today would have trouble identifying the defenders and the destroyers of justice.

Curry was able to explore once again the theme of black freedom

24. John Steuart Curry, *The Tragic Prelude* (1937–1942). Oil and tempera on canvas. Courtesy of Kathleen Curry.

on a large scale when he received the commission to create a set of murals in the Kansas State Capitol in Topeka. In the panel called *The Tragic Prelude*, Curry placed a defiant John Brown in the place formerly held by the religiously exalted black man (fig. 24). Fortunately for the artist, the substitution was a logical one. Brown was a native New Englander but, evidently, a most important figure in Kansan history to Curry, and certainly a fit subject for a panel in the State Capitol.

Because the central figure is different from earlier ones, the meaning of the work is slightly altered from the meanings of the rejected Justice Department sketches. Facing each other across the giant form of John Brown are proslavery and free-soil forces. At their feet lie the symbolic dead of the Civil War. To the rear, through sunlight and tornado, the settlers trek ever westward. Dominating all, however, is the thundering figure of John Brown, who with Bible and rifle is a man possessed. Unlike the accepting blacks in the earlier sketches, John Brown demands. He is a leader, a doer, a man to change an unhealthy situation.

Once again, in the language of the 1930s, we may say that this time John Brown could easily have been a hero to Social Realists and Regionalists alike. It is quite possible, therefore, to look upon this mural as a summation and combination of various trends of that decade. It

25. John Steuart Curry, *The Freeing of the Slaves* (1942). Oil and tempera on canvas. 144 × 168 (center), 132 in. (sides). Courtesy of the University of Wisconsin-Madison Archives.

was finished at the very end of the 1930s, a fitting time for a *summa* to be created. It is certainly a mural of Regionalist interest, based as it is on local history, but the subject and treatment are as socially committed as anything one was likely to see at the time. Not at all retrospective, but a desperate reminder of the task that still needed to be done, it effectively combined the best of Regionalist and Social Realist attitudes and may stand as the representative mural of the decade. In a period when thousands of murals were created, this is no small consideration.

Curry explored the theme once again in 1942. Earlier, in 1936, he had been appointed artist-in-residence at the Agriculture College of the University of Wisconsin. When a new library was erected for that institution's law school in 1942, Curry painted *The Freeing of the Slaves* for its reading room. (fig. 25). The mural, a restatement of the second sketch for the Justice Department, marked his last version of this subject on a large scale. From their slave quarters on the left, blacks emerge to follow the Union Army. In the center, a joyous figure receives the blessings of liberty. At the rear, a new day dawns over the blacks and the marching troops. In a strange way, the hill on which the blacks stand and the fervor of the gestures call to mind images that Martin Luther King, Jr., articulated in the sermon he delivered the night before he was murdered. The blacks were at the top of the mountain, and they saw a new day coming.

Of this mural, Curry wrote, "I feel that in this painting I have made a work that is historically true, and I also feel it is prophetic of that which is to come."[5] In view of the increasing militancy of segregationists and those on the side of human rights and dignity, Curry's paintings of the 1930s have an urgency that the intervening decades have not blunted.

Thomas Hart Benton and the Left

D uring the 1930s, probably the most polemical and politically combative decade in the history of American art, Thomas Hart Benton became one of most belligerent artists around. He attacked virtually everybody in sight – traditionalists, modernists and leftist artists. His arguments and assertions still flavor and give character to the art of that decade.

Benton, best known as an American Scene artist, preferred to paint rural views in which he considered the activities of rural folk to be typical American activities, whether these be square dancing or laboring in the fields. In these works, the implicit message reveals that rural America is essentially more American than urban America. Benton, however, is less well known for his positive interest in the modern, technologically progressive America of the 1920s. This aspect of his career peaked in his mural cycle entitled *America Today*, completed in 1930 and now in the Equitable Assurance building in New York City. The key panel, *Instruments of Power*, includes a train, an airplane, a dirigible, an internal combustion engine, a dam and, in the metal tower, an image of modern communications (fig. 26). After completing, this set of panels, and as the Great Depression deepened in the 1930s, Benton essentially rejected this modern and urban America for a rural and old-fashioned one.

Even less well known than the Benton of *Instruments of Power* is the Benton who stood politically left of center, a position he held his entire adult life, but with certain precise qualifications. Benton absorbed in part his political views from his father, a member of the House of Representatives from 1894 to 1904. A Democrat, but, according to Benton, really a Populist, his father opposed eastern bankers, railroad magnates and industrial capitalists. As Benton indicated, his father opposed the "nefarious influences of the Eastern society." Not surprising, then, Benton fell in with the political left when he settled in New York City in 1912. He particularly became attracted to Dr. John Weischel, the founder of the People's Art Guild which Benton joined in 1914. The Guild sought to bring art to the working classes through lectures, art instruction, and exhibitions in settlement houses and community centers. Through Weischel, Benton began to read figures such as Karl Marx and to meet left-wing artists and writers such as Robert Minor, the cartoonist and Communist party functionary, Max Eastman, who broke with Communism in the 1920s, and Mike Gold, editor of *The New Masses* during the 1930s.[1]

During the early 1920s, Benton might even have been a card-carrying Communist – at least he indicated as much in an interview in 1935. "Don't get the idea that I have any hatred for Communists," he stated. "I used to be one of them myself ten years ago, and I am still a collectivist." He also admitted that he allowed the party to hold secret meetings in his apartment in the 1920s. Understandably, therefore, Benton planned his *American Historical Epic*, a mural project for which he began to make studies around 1920, as a Marxist history of the United States. (This was the first and probably only such attempt in the country with the exception of Diego Rivera's panels painted in 1934 for the New Workers' School.) Benton intended to show how politicians and businessmen deprived the common people of the fruits of their labor. As Benton later said:

> When I first started painting my American Histories, I could see no conflict between American democratic ideals and the ideals of Soviet Russia. My readings in American history were convincing me that the "people" of America – the simple, hard working, hard fighting people who had poured over the frontiers and built up the country – were, more often than not, deprived of the fruits of their labors by combinations of politicians and big businessmen. I was convinced that the American dream had been continually discounted by capitalist organizations which had grown beyond the

26. Thomas Hart Benton, *Instruments of Power*, from *America Today*, 1930. Distemper and egg tempera on gessoed linen with oil glaze. 29 × 160 in. Courtesy of the Collection of The Equitable Life Assurance Society of the United States.

people's control. All this kept me in substantial agreement with those Marxist historians and political theorists who were describing America in Marxist terms.[2]

Frankly, this point of view cannot be found in any of the ten completed panels of the *American Historical Epic*. Instead, Benton portrayed typical (rather than specific) scenes of discovery, settlement and expansion. A strong note of criticism of America, the kind a Marxist might make, does emerge, however, in the *Bootleggers* of 1927, a mural-size panel perhaps intended for the *American Historical Epic* (fig. 27). In it a wealthy businessman pays a bootlegger, planes make pickups and deliveries, and a policeman relaxes against a building while gunmen attack a truck probably filled with bootleg whiskey. For its date, this work might be literally the largest painting ever made in the country critical of the ways in which both the wealthy and the police contributed to the corruption of American society.

Benton dated his break with Marxism to this period in his life – the late 1920s. But he still maintained an independent radical stance. In brief, he found that Marx's theories and the dogmatism with which they were observed in this country did not explain American realities, nor did they allow him to exercise independent judgment. Yet, he completed his most politically leftist work between the late 1920s and the

27. Thomas Hart Benton, *Bootleggers* (1927). Oil on linen mounted on masonite. 65 × 72 in. Courtesy of Reynolda House, Museum of American Art, Winston-Salem, NC. T. H. Benton and R. P. Benton Testamentary Trusts/Licensed by VAGA, New York, NY.

mid-1930s, the period which also coincided with the bitterest moments of his feud with left-wing artists.

Even in the *America Today* panels, completed in 1930, Benton could not deny the appearance of his political feelings. For example, he contrasts a chain gang scene from the *Deep South* panel with an integrated work force in the presumably northern city in the *City Building* panel. In the panel entitled *Coal*, Benton commented on the hard lot of the miners by emphasizing their stooped postures (fig. 28). And in *Changing West*, the black smoke in the distance represented the wasteful burning of gas for a carbon mill. As Benton later wrote in one of his two autobiographies, burning gas was a "great wasteful, extravagant burning of resources for monetary profit," which reflected

28. Thomas Hart Benton, *Coal*, from *America Today*, 1930. Distemper and egg tempera on gessoed linen with oil. 92 × 117 in. Courtesy of the Collection of The Equitable Life Assurance Society of the United States.

"the mighty anarchic carelessness of our country." He continued in his wonderfully moving way:

> Our land has been gutted, the people of our land have been squeezed, tricked, and wheedled into mortgaging their lives and hopes. The great potentialities for good lying in our mineral and power resources have been sacrificed to the calculations of financial skullduggery, where even those holding the whip hand seem to derive no permanent benefit. Our forests have been mercilessly stripped for short-range profit. Out of all this our great cities have risen, full of life. Meccas for all the cunning and merciless schemers of the land, packed to the top with sordid and vicious self-seeking.[3]

The panel, *Outreaching Hands*, which Benton added to *America Today* soon after completing the other panels in 1930, more closely approximates this point of view. It includes loaves of bread suggesting a

breadline, cups of coffee given to grasping hands and also the hands of wealthy men grabbing at prison bars as well as clutching dollar bills. Benton, no doubt, meant this panel to be a commentary on the ineq-uities of the capitalist system and the disjunctions brought about by the widening of the Great Depression, then over a year old.[4]

In the very early 1930s, as Benton's Americanism as well as his disenchantment with the international Left grew, he remained still close enough to at least one left-wing writer, Leo Huberman, to illus-trate his book, *We the People*, published in 1932. The book, written from a strong leftist perspective, reads as if intended for high schoolers. Although the word "communism" never appears in the text, Huber-man's sympathies appear evident in the ways he questioned the viability of capitalism and indicated several problems and faults in American society. Benton's drawings, for their date, stand among the strongest myth-debunking illustrations ever to appear in a text written about the history of the country. One of them, entitled *Slave Ship*, describes the subjugation of black people and the violence done to them. White attitudes toward Indians were shown to be equally callous by the way pioneers and settlers drove them from their land. In other illustrations, workers enter factory precincts already tired, worn, and beaten down before beginning their work shift. Benton shows others on strike. Nei-ther in text nor in illustration could *We the People* be called a praise-America book.[5]

In the early 1930s, Benton also made at least three strike scenes, his sympathies clearly lying with the strikers, not the owners of the mines or factories. And even though Benton's relationship with New York City's leftist art world had grown unpleasant by 1933, he surprisingly participated in an exhibition, "The Social Viewpoint in Art," sponsored by the Communist-dominated John Reed Club early that year. Two years later in 1935, he contributed an oil painting to an exhibition sponsored in part by the NAACP entitled "An Art Commentary on Lynching."[6]

In other works of the period, Benton revealed his political feelings with equal vehemence. In his *Preparing the Bill* of 1934, a political boss plies a politician with drink and presumably is telling him how to vote. (Interestingly, the by-this-time unfriendly leftist press particularly liked this work, praising Benton for getting "below the surface to more significant meanings," indicating that perhaps the leftists based their hostility to Benton more on his attitudes than on his images.) Another work completed in 1934, *Ploughing It Under*, shows a farmer ploughing

under a crop. Benton indicates by its title those agricultural policies that, in order to maintain food prices, demanded destruction of produce in the fields while people starved in the streets.[7]

Even in Benton's mural commissions, his political orientation appeared clearly evident. One panel from his *The Arts of Life in America*, completed in 1932 for the Whitney Museum of American Art and now in the New Britain Museum of American Art, shows a woman driving a sporty roadster into a strike scene and toward a striker who has been shot by guards. Certainly, Benton meant to contrast the idle rich with that of the unemployed idle poor in this panel.

In 1933, Benton produced another set of murals, this one for the State of Indiana pavilion at the Century of Progress Exposition in Chicago. These panels record the history of the state from the time of the mound builders to the 1930s. At least three images remain as shocking now as they must have been then, considering they were intended for a world's fair in the midwest in the early 1930s. First, a fur trader forces an Indian to take liquor in exchange for pelts, an image Benton was to use again in his murals for the Missouri State Capitol in 1936. Thus, an independent capitalist entrepreneur is really getting something for nothing and also destroying a person as well as his culture along the way. Second, a meeting of the Ku Klux Klan, politically powerful in Indiana in the 1920s, also is portrayed. And third, Benton included a figure supposed to be Eugene Debs, the Socialist, encouraging a group of strikers in Terre Haute while guards patrol nearby buildings (fig. 29). Although the contemporary art press reported Debs to be saying "workers of the world unite, you have not to lose but your chains," a paraphrase from *The Communist Manifesto*, the poster before Debs reads instead "workers why vote a rich man's ticket." In either instance, the message appears quite clear, as do Benton's political convictions.[8]

Finally, Benton's mural cycle for the Missouri State Capitol in Jefferson City, completed in 1936, adds up to a savage indictment of old and modern America, a shocking group of panels for a midwestern state house in the middle 1930s. A quick reading suggests why. In the first large panel, a fur trader once again offers whiskey to an Indian in exchange for pelts (fig. 30). To the right, a slave auction takes place directly in front of a church building, suggesting that Benton condemned any group, religious or otherwise, that condoned such activity. In the lower panel to the left, slaves are being whipped at a lead mine, and in the panel to the right, a figure, tarred and feathered, represents

29. Thomas Hart Benton, detail, *The Cultural and Industrial History of Indiana: Panel 9 – Coal, Gas, Oil, Brick* (1933). Egg tempera on canvas. 144 × 108 in. Courtesy of Indiana University.

the Mormons who were forced to leave the state because of religious bigotry.[9]

In the next two panels, Benton illustrated aspects of life in Missouri. The sections most relevant to consider are the electioneering speech and the courtroom scene (figs. 31 and 32). The election scene, recording an image of Missouri's early history, indicates that democratic procedures could work properly. In the courtroom scene, dateable to the late nineteenth century because of the architecture behind it, the judge sleeps at the bench, indicating that civic responsibility has lessened and

30. Thomas Hart Benton, *Pioneer Days and Early Settlers* (1935–1936). Tempera on gessoed linen on plywood. 300 × 170 in. Permission granted by the Missouri Division of Tourism.

corruption has increased in the country. (In his autobiography, *An Artist in America*, published soon after completing these murals, Benton poured out his wrath against those who in the post Civil War period had economically and politically ravaged the country.)[10]

In the last panel, Benton roundly attacks modern Missouri and, by extension, the United States (fig. 33). The workers to the left side of this panel, isolated and alone, labor in front of machines and take liquor willingly. (Apparently, these figures, lacking control of their own destiny and means of production, represent the types of figures Benton might have included in his "Marxist" *American Historical Epic* of the 1920s had he created panels of contemporary life.) To the right side of the modern Missouri panel, Tom Pendergast, the corrupt political boss of Kansas City, conducts business in a nightclub. In the distance, bums warm themselves over an oil-drum fire in front of a shuttered museum, suggesting that the wealthy and the cultured have turned their backs on the poor. And in the small panel in the lower right, scavengers find unburned pieces of coal along the railroad tracks to heat their homes. All together, these panels do contain some praiseworthy elements from Missouri's history, but part of Benton's narrative is merciless in its attack

31. Thomas Hart Benton, *Politics, Farming, and Law in Missouri* (left panel) (1935–1936). Tempera on gessoed linen on plywood. 330 × 170 in. Permission granted by the Missouri Division of Tourism.

32. Thomas Hart Benton, *Politics, Farming and Law in Missouri* (right panel) (1935–1936). Tempera on gessoed linen on plywood. 330 × 170 in. Permission granted by the Missouri Division of Tourism.

33. Thomas Hart Benton, *St. Louis and Kansas City* (1935–1936). Tempera on gessoed linen on plywood. 300 × 170 in. Permission granted by the Missouri Division of Tourism.

on the political and economic systems of the state and, by extension, the country. In effect, he savages predatory capitalism, big business, big labor, political corruption, self-righteous religion and individual bigotry.

After completing panels in the Missouri State Capitol, Benton abandoned overt political commentary in his art. Since several works from the early 1930s can be interpreted in a left-leaning manner, then why did so much animosity develop between the artist and the leftist art world? It is easiest to answer this question by working from the general to the particular. Benton developed a specific socio-esthetic position at least by the middle 1920s. Simply stated, he believed that art grew from the artist's interaction with his environment. American art based on any sort of dogma, on theories of art, on mindless tradition or on international styles could not be successful art. As a result, he came to reject academic art based on tradition, modernist art based on international esthetics and left-wing art based on political theories not rooted in American experience. Therefore, he came to distrust any kind of contemporary American art not derived from the intimate experience of living in America. For Benton, such experiences became both increasingly rural ones and heavily conditioned by the past. During the 1930s,

he concentrated his animosity on left-wing art and artists. These were the largest and evidently most important targets then in sight, more important than academic and modernist artists or styles. Left-wing artists were also the only ones who really responded to his challenges and jeers. But after the 1930s, although his antagonism to the left still remained, Benton began once again to snipe at modern art with the kind of energy he had once reserved for the left.[11]

More specifically, Benton's animosity toward the left revolved around three closely related issues – immigration, Communism and Judaism. For Benton these issues and the artists involved probably became one and the same. The first clear articulation of his point of view dates from 1933 in a speech he gave before the American Federation of Arts, although he had undoubtedly discussed his feelings with friends and with those who would soon become his enemies. On the immigrant issue, he said:

> It is knowledge and love of life which supply the real content of art. And it is life experience which is emotionally shared with others, which is part of the experience of a group which gives to the symbols of art their chief social function. And as a "mirror of life" is so only to those who know the life it mirrors. It follows that no American art can come from those who do not live an American life, who do not have an American psychology and who cannot find in America justification for their life.[12]

Where did this American life exist and who lived it? Benton answered these questions the next year, when he wrote in a 1934 magazine article about the Ozarks: "The future is and must continue to be heavily conditioned by the past and in this land [the Ozarks] yet flavored by the pioneer spirit, the nature of our fundamental American psychology can best be understood."[13]

In effect, Benton said that recent immigrants and the children of these immigrants were not as truly American as those with a pioneering heritage. And since many New York-based artists came from an immigrant background and, therefore, had different American experiences from his, Benton denied them, as new Americans, the legitimacy of their art and heritage. He excluded them, in effect, from participation in America's heritage as he defined it. This kind of thinking, potentially paralleling Hitler's exclusionary art policies already being reported in the art press with regard to non-ethnic German artists, certainly caused Benton to be viewed with increasing suspicion as a xenophobe.[14]

Concerning the Communist issue, Benton's thoughts ranged from the artistic to the economic and the political. Turn once again to the speech he gave in 1933 before the American Federation of Arts for an early formulation of his position. Benton, as an independent radical, found that Communism had contributed to the social function of art and toward artistic ideals that had significance in human affairs. In fact, he said that Communism had provided art with the "greatest step [it] has made since the lords and dukes of the High Renaissance took it away from the service of religion and made it an accessory to vanity." But, he added, "its philosophy has for art a grave defect." This was its "internationalism, in the very center of its ideology, which sees meaning and value as absolute and universally valid." For Benton, Communism set up "a theoretical environment as false to real life as the 'purist' internationalism of which it is so contemptuous." Communism's great failure, then, became its irrelevance to American actualities and experiences.[15]

On another occasion, in a talk before the Communist-controlled John Reed Club in 1934, he told his audience: "Unless you are able to subordinate your doctrines and realize that the actualities of direct experience are of more value for art than the promised land, you will not make artists. The ability to submerge yourself in the actual culture, to emotionally share the play of American life, with or without your baggage of verbal convictions, is your only hope of producing anything but stock figures or bare symbols." At this same talk, Benton also stated that he would not support Diego Rivera, whose mural for Rockefeller Center had been destroyed in 1933 because it contained a portrait of Lenin. Although he admired Rivera, Benton preferred, as he said, to devote his energies to developing an American art. Benton's position on Rivera's mural, probably one of the most damaging to his reputation, suggested that Benton might have been capable of accepting artistic control and even destruction of works that defied national interests. Certainly he took a provocative position, even if not entirely articulated, in light of the artistic situation then developing in Nazi Germany.[16]

Not willing to leave well enough alone, Benton continued his argument with the left in other ways. In an essay published in 1935, he argued that despite Communist theory to the contrary, industrial development had not increased the numbers of the proletariat. Instead, a middle class of skilled workers and small-business owners had emerged, confounding the theoreticians. He went on to assert that, in the event of a class war in America, this new middle class would fight "on the

side of those who promise to hold for them or regain for them their right to own." That is, he argued, this class remained essentially conservative rather than radical and it desired possessions and upward mobility rather than equality. Benton also registered his disappointment with the progressive, democratic elements within Communism which he felt might have removed "the incubus of monetary profit from human institutions." These became tied instead "to the conviction, that class war and class dictatorship is an inevitable condition of progress." He then blamed Communist stubbornness for allowing fascism to arise in Europe because Communism allowed no compromise on the issue of class. With the recent example of the Nazi takeover in Germany, Benton's observations undoubtedly were correct ones, although he apparently had assigned more power to Communists than they actually possessed, at least in Germany. Finally, tweaking the collective noses of the American left, he said that since a proletariat had not arisen in this country, the Communists had to create one through education. Therefore, revolutionary art became essentially a manufactured art.[17]

Much later, perhaps in the 1970s, Benton wrote about a talk he had given at the Art Students League in 1934. (This may have been the talk he gave to the John Reed Club in 1934.) He lost his temper after much baiting and made reference "among other things to artistic and intellectual ghettos of New York." Differences reached their flash point in 1935 in a series of interchanges between Benton and Stuart Davis who represented the left-wing artists. Benton either naively or ingenuously thought that an interchange between himself and the left might end in a rapprochement. "What separated us," he thought, "was not our basic attitudes toward the depression-ridden people of America or even the morality of the capitalist system, but only a theory about what should be done to improve the situation . . . I thought an explanation of our definitions of realism might show that I was socially more realistic than they, at least in regard to American society." Instead, the interchange ended in invective and in an unbridgeable gap between Benton's belief in the centrality of American experiences for American art and the left's concern for an art based on enlightened social policies. Although in this interchange, Benton professed his belief "in the collective control of essential productive means and resources," he accused American leftist painters of being provincials in their adherence to imported ideologies. Furthermore, he found the Soviet dictatorship to be an exploitative one, a position not yet popular in 1935.[18]

Benton noted, decades later, his amazement of the amount of hate

both he and his comments engendered, and he remembered that leftist artists tried to picket an exhibition of his work in New York City in 1935. This might have been provoked by, among other contributing factors, a statement of his recorded in the art press. In effect, he remarked that Communist art was "the death of art because it denies experience . . . Communistic art sets up symbols, such as the working man and the capitalist, and attempts to produce art by combination of these symbols." Quoted similarly on other occasions, his position never developed further. Any dogmatic position, his own excepted, was the death of art. He believed that art grew from one's experiences, and not from something imposed by theory.[19]

In a series of articles written for the magazine *Common Sense*, in 1937, Benton summarized his political philosophy. (His murals of 1936 in the Missouri State Capitol are visually analogous.) Once again he reiterated his own brand of collectivist thought at the expense of both imported Marxist thought and what he now categorized as Stalinist fascism. Nevertheless, he still praised the Communist desire to give "the ownership, the control and the benefits of the productive mechanisms of society to those who would produce rather than those [who] would scheme. It [Communism] gives power and freedom to those who labor and create, and puts the mark of the criminal on the cunning manipulator and exploiter. This is the ideal. Who can object to it and still maintain even a rudimentary sense of human justice?" But increasingly, he found present-day Communism to be fascistic and therefore unable to fulfill this ideal.[20]

What did he want in its place? A return to the nineteenth century in effect. Although not possible, it was his ideal. He admired Jeffersonian "individualistic agrarianism and . . . [its] notions of free and independent economic units operating with little or no governmental control." Profoundly opposed to Big Business as well as to Big Labor, he thought some sort of federal restraints were essential to allow the individual to regain control of his life and livelihood, and to prevent unbridled and unprincipled free enterprise from overwhelming him. Conflicted in his mind because of the paradox of wanting governmental control to insure individual enterprise, he admitted: "Down in my heart I do not like this [federal control]." But in order for the small-time entrepreneur to survive, he found it essential. "The idea of free and independent states, groups and individuals freely cooperating is the idea that appeals most to me." To that end, he wanted to "extend the power of the electorate, including the laboring electorate, over all fields of

ownership which affect the lives of the mass of plain people who work." Acknowledging that "capitalism, as we know it is doomed," he asked, "can we attain a collectively controlled democratic economy by democratic means?" He replied that he hoped so, a vague answer at best, especially since Benton wanted to dismantle as many political apparatuses as possible in his ideal government. Under Benton's scheme, neither the Communist party nor any other mass organization would play a leadership role.[21]

Through all of his published and unpublished writings, Benton seemed unable to distinguish between the different shades of leftist opinion among leftist artists. He implied that all of them were Communists or Communist dupes. They all looked alike to him, and by refusing to recognize their individuality and separateness, he lumped together hard-core Communists with independent radicals like himself, humanitarian socialists and those who merely painted from their different American experiences.

But if Benton, a latter-day Jeffersonian with his head wrapped in nineteenth-century clouds, could not distinguish one leftist position from another, he might have been considered little more than an amiable anachronism or a crank. His insistent argumentativeness militated against such a consideration. So did his relationship with Jewish artists. Although in his published writings Benton never indicated directly, or even indirectly, his hostility to Jewish artists, or to Jews in general, unpublished passages among his papers suggest an anti-Semitic inclination. These passages appear to be drafts for material either subsequently published or which remained unpublished. Presumably, they reflect Benton's unedited feelings. Just as Benton evidently lumped all shades of leftist thought together as Communistic, so these passages also reveal Benton's willingness to conflate left-wing artists with Jewish artists. He seemed to find little or no distinction between the two. What he saw, at worst, was the enemy, anonymous, stereotyped and beneath individuation, or at best, strangers who looked and thought alike.

In truth, Benton could not let go of the Jewish issue, since probably all of the relevant passages in his papers date from the 1950s and after. The pattern that emerges suggests that the Jews somehow seduced Benton into accepting Marxism and that they turned on him when he rejected Marxism, a fact he could not easily accept. For example, in an unpublished essay entitled "Thirties," written perhaps as late as the 1970s, Benton explained that he had become acquainted with Marx between 1914 and 1915 through Dr. John Weischel, head of the Peo-

ple's Art Guild, noting that the majority of those involved in the Guild were Jews. These Jews, Benton explained, had not been provided with the myths of a Golden America in the ghetto, so they adopted revolutionary doctrines. He found them to be conditioned by their backgrounds for "radical changes in our social order." He believed that his own Populism and his previous acceptance of nineteenth-century Frenchman Hippolyte Taine's position, that to understand art one must understand the environment of the artist, allied him with Weischel's circle. In 1919, when Benton began to search for social meaning in his art, he believed that most Jewish radicals supported him.[22]

Benton clearly felt betrayed when he lost this support after his break with Communism. In part, he blamed what he called false charges of anti-Semitism. In a preliminary draft for the chapter added to the second edition of An Artist in America, published in 1951, Benton insisted the left had labeled him a fascist. "Because there were many young Jews, as was inevitable in New York, attached to the city's Marxist groups, it was easy to give my growing anti-Marxism an anti-semitic cast. The commies had already learned the technique of the smear." But so did Benton, in his way, learn to smear by grouping together radical with Jewish artists and, once again, not distinguishing between them. As he wrote of the 1930s perhaps in the 1960s, "the radical Jewish artists of New York looked upon this bloody Russian [Stalin] as not only the saviour of the world but as their very special saviour from the 'prejudices of capitalist society.'" This is not to say there were no Jewish Communist artists or artistic ideologues, but in his writings, Benton does not appear to indicate the existence of any other kind, Jewish or non-Jewish.[23]

On the same piece of paper where this passage appears, Benton also reminisced about becoming friendly with "a little Jewish fellow named Hymie." This was Benton's lawyer at the time – Hyman Cohen. Benton went on to say that in the 1930s, "when the fellow travelers of the John Reed Club had convinced so many young Jewish artists that my Americanism was disguised anti-Semitism, Hymie defended me once to the point of being called a 'traitor to his people.'" After World War II, Benton recalled, when "the young Jewish radicals had grown up to reality, a number among them had the grace to tell me they had misunderstood my Americanism."

Evidently not conceding an inch, Benton had not fully understood the exclusionary nature of his Americanism in the 1930s and his inability to distinguish between hard-core Communists and other leftists, as

well as between Jews and Communists. His attitude seems to be summarized in an extraordinary passage among his notes that amounts to a blood libel and a two-pronged attack on Marx as a German and as a Jew (despite Marx's own anti-Semitic feelings). Benton wrote, "Marx was no compromiser." A German and thus an authoritarian, he also remained a Jew "addicted to ancient Jewish apocalyptic dreams. Marx was the saviour of the people in semitic or Asiatic style but he was to save them German style by authority – authority of the proletariat. Marx was 'the leader,' the Messiah of his saviour cult. Absolute dictatorship by himself and his group was regarded as essential." Playing very fast and loose with stereotypes, if Benton had ever articulated these thoughts during the 1930s, it is no wonder the left, both Jewish and non-Jewish, responded to him with open hostility.[24]

One might ask, if Benton's Americanism did not contain anti-Semitic aspects, as Benton insisted, then why in 1932 did he include in *Political Business and Intellectual Ballyhoo*, a panel in the Whitney Museum murals, a nasty caricature of a Jew holding a copy of *The New Masses* and intoning "the hour is at hand"? Nor did Benton's reputation for open-mindedness gain luster when his close friend, critic Thomas Craven, assessed Alfred Stieglitz in his book, *Modern Art*, as a "Hoboken Jew" without knowledge of, or interest in, the historical American background.[25]

What prompted Benton to argue so much with people he seems not to have liked? Why did he spend his energies on writing, lecturing and presumably talking rather than on his art? In comparison with his contemporaries, he was among the most overtly nationalistic. In addition, he was among those most concerned with imposing his notions of the national character and forcing an American content onto his art. It is not enough to say that his Populist background influenced his political beliefs, since he could have maintained them and remained relatively silent at the same time. Nor did the widespread desire among artists in the 1920s and 1930s to search out American meanings in art entirely explain Benton's behavior. Instead, in psychobiological terms, it might be suggested that his father played a crucial role in his opinions and activities as a mature artist. Happily, dozens of letters from Benton's youth and early manhood survive which provide valuable insights about his relationship with his father. In addition, various passages from his papers, although written later in his life, add to the knowledge of his personality and help explain why he often appeared to be so defensive,

to be so easily insulted and so quick to respond, and to hide his insecurities behind a mask of aggressiveness.[26]

Benton's father was forty-one years old and his mother twenty-three when they married. Benton, the oldest of four children, was born about a year later in 1889. Toward the end of his life, perhaps in the 1970s, he wrote rather intimately and even embarrassingly about his parents' unhappy and unloving relationship. Benton also indicated that his father constantly found fault with him in private, but appeared genial and forgiving in public. As a youth accompanying his father on his various electioneering campaigns, Benton came "to disregard his carping treatment of me at home and to excuse it because of the fun I had with him in his public world." Nevertheless, Benton wrote that "in the summer of 1910 [when 21 years old] I had my last intimate association with my father."[27]

In a political family in which the young Benton was intended for the law, becoming an artist must have cost a high psychological price. Benton's letters from military academy (1906–1907), from Chicago where he studied at the Art Institute (1907–1908) and from Paris where he then lived (1908–1911) indicate as much. They were written primarily to his father. His mother, who eventually died in an insane asylum, figures in them in a secondary way. The letters, often defensive, usually began with an apology for not answering sooner or for not mailing one already written – which suggests he could not face his father. Several included Benton's belief in his God-given talent and grandiose expectations for the future. Some revealed Benton's difficulties in relating to fellow students; he portrayed them as being jealous of him, of his progress and of his talent. A few mention moments of self-doubt and prefigure his public accounts of his vulnerabilities as a modernist, especially in situations he could not control or dominate. On his return home to Missouri in 1912, he subsequently stated how angrily his father reacted to his Parisian efforts.[28]

His letters from Virginia, where he was stationed in the navy during World War I, are especially revealing. He referred to his fellow seamen as "boneheads," which might have been a slang term for those with short haircuts, but Benton's context reveals invariably a condescending tone. He considered himself quite superior to them. He also indicated how much he missed New York City, where he had settled in 1912. Yet, in 1937, when he had become a professional American Scenist, he described in his autobiography how sympathetic he had felt with the

people he met when in the navy and how delighted he was to have left New York, clearly a contradictory rewrite of his earlier feelings.[29]

The personality that emerges from these letters and from subsequent statements about these years portray a vulnerable young man who nevertheless believed in his extraordinary gifts, and who remained a rebellious but attentive son. Quite possibly he pulled away from modernism around 1918 and turned to American themes because of insecurities with his modernist peers and internalized family pressures.

Yet, in his break with Marxism around 1927, Benton adduced his changing opinions to his readings of such figures as John Dewey and especially to his travels around the country. By 1927, however, he had not traveled that much – a trip to Missouri in 1924 and one to the Ozarks in 1926. The trip to Missouri, however, was crucial and probably the most important one of his mature years. It occurred because of his father's impending death. Apparently, it affected Benton more profoundly than any other event in his life. The death of a parent obviously is disturbing and sad for a child of any age, but the child usually recovers in a reasonable amount of time, especially one like Benton, who did not seem to be close to his father and did not visit him often. Yet, Benton left his wife in New York City in order to go to Springfield, Missouri, in 1924, to take care of his hospitalized and dying father. He nursed him virtually alone. His mother, by this time somewhat estranged from his father, remained in Neosho, Missouri, Benton's birthplace. In his letters to her, he never mentioned his two sisters, but did say that his brother, who lived in Springfield, visited once or twice a day. Benton evidently remained at the hospital throughout the day, every day, alone with his father and his father's friends. He has written movingly about these last days.

> I cannot honestly say what happened to me while I watched my father die and listened to the voices of his friends, but I know that when, after his death, I went back East I was moved by a great desire to know more of the America which I had glimpsed in the suggestive words of his old cronies. I was moved by a desire to pick up again the threads of my childhood.

He asked, "where do my living contacts end as they go back into history?" He answered, "what happened in Oklahoma in my lifetime happened in Missouri in my father's and in Kentucky and Tennessee in my grandfather's."[30]

The mature Benton began to emerge after his father's death, and

here we might speculate upon its effect on Benton's life. Perhaps at his father's death, Benton could not admit to the now clearly permanent separation between them. In the conflict between his father's earlier rejection and Benton's desire for retroactive acceptance, Benton began to identify very closely with his father. Sigmund Freud wrote in his essay "Mourning and Melancholy" (1915), that the result of a break in an attachment through death or separation is the establishment of "an identification of the ego" with the abandoned object. Thus, "an object-loss was transformed into an ego-loss and the conflict between the ego and the loved person into a cleavage between the critical activity of the ego and the ego altered by identification."[31]

This means that at his father's death Benton might have begun to identify himself so closely with his father that he began to judge himself as if he were his father. As Benton's letters reveal, he viewed his father as a judge and a censor in regard to his career as an artist. Yet, Benton also acknowledged his father as a parent and through Benton's love and/or guilt, sacrificed his time and energies to care for his father when the latter lay dying. Possibly, Benton began to punish himself for his choice of career, which his father opposed, after his father's death.

Anna Freud's observations in *The Ego and Mechanisms of Defense* allow us to understand further Benton's identification with his father. Following her suggestions, it can be said that Benton's response to his father's disapproval of his career was to identify himself with his father as a way of coping with his father's rejection. But instead of blaming himself, Benton began to blame and criticize others for his presumed faults. And who could Benton blame and criticize for leading him astray? He could blame modernism and Communism (or modern art and leftist art). And he began to do so only after his father's death, probably knowing that his father disliked both modernism and any political movement that originated abroad. Thus, Benton rejected those movements in art to which he had been sympathetic because he knew his father would reject them. In this way, he could deflect criticism away from his own choice of profession as an artist. Conversely, perhaps Benton believed his father might have approved of him as an American Scenist. According to this line of reasoning, Benton became an American Scenist, in part, to gain approval of his now internalized father.[32]

Sigmund Freud provides yet another possible insight into Benton's relationship with his father – that concerning the negative Oedipus complex. According to Freud, there are positive and negative aspects of the Oedipus complex. In the positive, there occurs "an ambivalent

attitude toward [the] father and an affectionate object-relation towards [the] mother, but at the same time [in the negative aspect, a boy] also behaves like a girl and displays an affectionate feminine attitude to his father and a corresponding hostility and jealousy towards [the] mother." According to this model, Benton would have distanced himself physically and spiritually from his father because he might have been overly attracted to him. With his father's impending death, Benton could then safely reenter his father's physical space and spiritual cosmos. But this theory does not take into account that Benton, or a youth with a similarly difficult parental relationship, might have distanced himself from his father not because he feared his own desire for physical affection, but because he had not received the recognition he had sought as an artist.[33]

A third possible explanation of Benton's actions in the late 1920s includes this line of reasoning: Benton might always have been opposed to both modernism and left-wing art, but could not occupy those attitudes until his father died. His need to be an individual was too strong to permit him to admit how similar were his own preferences to those of his father. After his father's death, it no longer mattered, and Benton could become the nineteenth-century Jeffersonian he had always wanted to be. This theory might help explain Benton's discomfort with modernism and modernists as well as his dislike for Marxists with whom he had nothing in common.

Whatever the case, it would seem that Benton's father played a major role in the artist's behavior after 1924. His father had been a United States Congressman at the turn of the century and, although a Democrat, he held Populist beliefs, according to Benton. In short, Populists believed in the democratic and egalitarian promise of America, that individuals and the individual economic unit could not survive in the face of growing corporate capitalism. A significant aspect of this philosophy was the agrarian opposition to eastern financial control of the country, especially through the expanding network of railroads. More basic from Benton's point of view was the pragmatic response of Populists to specific problems based on immediate and local needs rather than on economic theories developed independently from local experiences. No all-embracing Populist theories developed to account for specific and particular problems. Furthermore, in the best of all Populist worlds, government might regulate the major sectors of finance, industry and transportation, but, as one major figure of the day

said, "the problem today is how to make the State subservient to the individual, rather than to become his master." This position Benton argued in his articles in *Common Sense*. On the darker side, some Populists advocated limiting immigration or even halting it entirely.[34]

Benton wrote, but only after his father's death, of inheriting his father's political outlook. But more than that, in an essay written in 1928 and in his autobiography published in 1937, Benton used, even exploited, his father to explain his own interests in politics and how his father influenced his art. His father appears to have been the chief determinant and influence upon Benton's character and outlook. Benton's earliest and richest memories are of his father and his father's political activities. Clearly, Benton wrote with extraordinary pride of his father. All of this seems strange in a son, so rebellious, so alienated from his father, so reluctant to communicate with him and who admitted to having no intimate associations with him after 1910, unless one assumes that a strong identification emerged only after his father's death in 1924.[35]

Perhaps Benton chastised himself for having been a modernist and for flirting with Communism for a variety of reasons that are ultimately traceable to his father's Populist leanings. Modernism was an elite art associated with easterners and foreigners. Marxism, also a foreign import, was, as Benton often observed, theory-bound and too collectively oriented for the more pragmatic and individualistic outlook of Americans. For Benton, individualism and pragmatism became two chief factors in defining the American character. More broadly, Benton's inability to find explanations for events and activities in all-embracing systems had its basis not only in Populism but in American empiricist biases. When, for example, James A. Henretta wrote about his fellow American historians in the following way, he also described Benton's intellectual outlook:

> Thus, when American-born historians raise the "facts" to a position of ultimate authority, they assume a distinct epistemological position – an empiricist approach based on three interrelated propositions: that human reason has limited power to understand the world; that models or frameworks can comprehend only the immediate data to which they apply; and that there are no fundamental patterns or structures of human life. These premises lead directly to the conclusion that each historical case has to be treated on its own, as a unique constellation of specific conditions or

events. The most general result that can be obtained is an "hypoth-esis," but this must be "tested" with respect to each new case. The "facts" remain supreme.[36]

Furthermore, by enveloping himself in the cloak of Americanism, Benton no longer had to deal with modernists or left-wing artists as peers. From his Americanist platform, he could criticize everybody else unlike himself and to whom he felt superior because of his greater understanding of the American character. He no longer had to be like other modernists or left-wingers and suffer the doubts and insecurities of such associations. At the same time, he could assuage his guilt toward his father and keep his father alive within himself. Perhaps identifica-tion with his father might have caused Benton to feel he was perpetually running for national artistic office or that he stood as artistic represen-tative of the people and had some special insight into the national character. These feelings might have prompted his strong interest in political subject matter, unique among artists not associated with spe-cific international left-wing movements. These feelings would have prompted his interest in writing and lecturing, especially in the 1930s, about the necessity for American artists to have American experiences as the basis for their art.

Perhaps his publicized tours of Appalachia, the Ozarks, and the Southwest were akin to political trips through those regions, looking at the lives of the inhabitants, but never really becoming a part of them. How much did Benton really know about and identify with those lives? Since childhood, he had read widely in European literature from Ho-mer to twentieth-century authors and was familiar with the symphonic and operatic repertory. He also had read extensively in political philos-ophy. He could become interested in the "boneheads," such as those he had met in the navy, as their champion and as their superior, but certainly never as their peer. Again, by identifying with his father, he could be separate from the people, be a person with a special aura, but also be one of them. In an artistic, if not a political, sense, he could be their leader. In this way, his insecurities also could be deflected, since the common people really offered no special challenges to him.

Benton could not ignore his antagonism to the left, then. It became his major political adversary especially during the 1930s and engaged him in a continuous election campaign to win the mind of America. If he won this battle, he might redeem himself in the eyes of his father. Or, if his identification with his father had become so intertwined, he

might be able to win his release from that identification. In either instance, Benton might well have been seeking his father's approval. Whether he ever believed he gained it, despite his relentless attacks on the left, remains an unanswerable question. In any event, after the fragmentation of left-wing art in the 1940s, modernism became his chief adversary. Apparently, he still needed to take an antagonistic position in the art world, to argue publicly his beliefs. A lot seemed to depend upon victory over the opposition.

NINE

The Emersonian Presence in Abstract Expressionism

I n all of the literature on abstract expressionism, very little has been written about what I would call the Emersonian presence. It is a presence rather than a source or an influence. And it is not limited to Emerson, since it can be found in such figures as Walt Whitman and William James, among others. But it is easier to say "an Emersonian presence" because precise influences are difficult, probably impossible, to establish. What I am concerned with is an attitude of mind that recurs in American intellectual history and that resonates through much 20th-century American art, ranging from early modernists such as John Marin through artists associated with process art. I do not mean to deny other well-documented European and American sources, influences, and presences in abstract expressionism and other American movements, but only to call attention at this time to the Emersonian presence.

With abstract expressionism, the Emersonian presence can be felt most profoundly in the late 1940s when figures such as Pollock, Still, and Newman were developing their signature styles. But the symbolic moment announcing the start of an Emersonian infusion can be said to date from 1944 with the interview that Pollock gave in the magazine *Arts and Architecture*. In it, Pollock stated that his "work with [Thomas Hart] Benton was important as something against which to react very

strongly, later on, in this it was better to have worked with him, than with a less resistant personality who would have provided a much less strong opposition."[1]

This passage is usually interpreted as Pollock's rejection of American scene painting of the 1930s for the more internationally flavored art of the 1940s, as well as a rejection of realistic art for abstraction. Certainly, the passage suggests as much. But Pollock's words convey other meanings extending beyond the immediate artistic scene and beyond the interactions of two extraordinarily strong personalities. There was something mythic in their encounter. They represented forces in some sort of larger conflict between the past and the present, between control and regimentation on the one hand and freedom and independent growth on the other. Pollock both acknowledged the master and disavowed him in a gesture that indicated his awareness of his own sense of hard-earned independence. Pollock had made, in effect, a supreme Emersonian statement.

Before explaining why Pollock's statement is so Emersonian, I want to say that I find Emerson's presence embedded in what I would consider to be the most vital art of this century – that art concerned not with necessarily building on the past nor even revolting from the past, but with the search for authentic experience. The Emerson I have in mind is not the one who has been associated with mid-19th-century luminist paintings. Art historians such as Barbara Novak, for example, have invoked Emerson to explain such visual qualities in these works as a sense of repose and the seeming interpenetration of spirit and matter. She has also, as one of her colleagues has suggested, persuasively linked "to Emersonian transcendentalism the luminist's distillation of light as a concretion of divine presence – more in the pictures of calm, glassy clarity rather than ones of vibrating exotic color."[2] But the Emerson I have in mind is a profoundly different one, concerned less wtih the appearances of images than with the processes of thought. This Emerson is a radical and a subversive, one who insists on acknowledging his own presence in virtually everything he said and did, one who witnessed the world as being in constant flux and change, and one who was anxious to escape the weight of the past in order to concentrate on his own intellectual and spiritual growth.[3] The Emerson to whom I refer was one who could write "criticism must consider literature ephemeral and easily entertain the supposition of its entire disappearance," and the one who could "treat the entire extant product of the human intellect as only one age, revisable, corrigible, reversable."[4] This is the

Emerson I mean, the one who could write, in his wonderfully provocative way, "No facts are to me sacred; none are profane; I simply experiment, an endless seeker with no Past at my back" ("Circles," p. 412).[5] Emerson made other similar assertions that in their 19th-century context concern the dead weight of European culture from which an American culture had to emerge, a new culture that, based on experiences in and on a new land, had yet to learn what it was, to develop its own habits and mores, and to write its own history. A 20th-century Emersonian deconstruction of Pollock's comments about Benton would suggest, then, that Pollock's reactions were as much to disown American scene painting as to discover the possibilities of art unencumbered by tradition, theory, or program, to be able to imagine independently of the past. It was a scant two to three years after Pollock gave the interview in 1944 that he made his first drip paintings.

Among the supreme Emersonian statements in all of American art, the drip paintings are also among the most personal paintings ever made. Each one reveals Pollock's gestures, feelings, and moods in both thoughtful and spontaneous interaction. Each one seems to echo Emerson's praise of the individual person who in the course of his activities and thoughts is working out his own destiny. "Trust thyself," Emerson said, "whoso would be a man must be a nonconformist. . . . Nothing is at last sacred but the integrity of your own mind. . . . What I must do is all that concerns me" ("Self-Reliance," pp. 260, 261, 263).

The drip paintings also suggest that Pollock wanted nothing to intervene between himself and his unconscious, to be, as it were, in the hands of his unconscious, released from the quotidian, from the moment, from consciousness. "When I am in my painting, I am not aware of what I'm doing," Pollock said.[6] This strikes me as a 20th-century equivalent to Emerson's famous lines, "Standing on the bare ground, – my head bathed by the blithe air, and uplifted into infinite space, – all mean egotism vanishes. I become a transparent eyeball; I am nothing; I see all; the currents of the Universal Being circulate through me . . ." (*Nature*, p. 10). Both Emerson and Pollock wanted to be in touch with powers beyond conscious knowledge, but which nevertheless originated within the individual person. Emerson, no doubt, would have agreed with Pollock when the latter said, "you've got to deny, ignore, destroy a hell of a lot to get at the truth."[7] One wonders whether Pollock, in the rhythmic ecstasy of spattering paint, and Emerson, in the ecstasy of being bathed by the blithe air, felt they were getting at the truth. In either instance, we can assume each was involved in discovering the

nature of his deepest self – Emerson, in his 19th-century way, by searching for the God within, and Pollock, by exploring his unconscious.

In the drip paintings, Pollock becomes Emerson's Genuine Man, one who "acts his thought."[8] Or, as Emerson stated elsewhere, "the man is only half himself, the other half is his Expression."[9] The drip paintings also seem to be works that Emerson described a hundred or so years before Pollock painted them. They seem to be visual equivalents to Emerson's thoughts, particularly when he wrote, "In nature every moment is new, the past is always swallowed and forgotten; the coming only is sacred. Nothing is secure but life, transition, the energizing spirit" ("Circles," p. 413). The drip paintings, which revealed Pollock's apparent freedom of gesture and the way they allowed Pollock to imagine in a free-form, nondirective way, also provide visual illustration of Emerson's belief that "nature is not fixed but fluid. Spirit alters, moulds, makes it" (*Nature*, p. 48). That is, Pollock's spirit moulds nature, or, in this instance, the paintings, as his spirit gains power and knowledge in the very act of confronting itself. The strength of these paintings lies in their acknowledgment that they are dependent on little more than Pollock's own will, on his human will. For Pollock, then, action was important because it underlined his active presence. Or, as Emerson might have explained these works, "power ceases in the instant of repose; it resides in the moment of transition from a past to a new state. . . . This is one fact the world hates, that the soul *becomes*. . . ." ("Self-Reliance," p. 271). The paintings are the record of Pollock's soul in the process of becoming – not in manipulating patterns, not in confronting art of the past, not in the making of "pretty" art, nor even in engaging in social or political dialogue – but in discovering its own qualities, its own powers, its own true voice.

Clyfford Still and Barnett Newman, no less than Pollock, also revealed Emersonian presences in their work. In fact, Still's writings often seem to be a gloss on Emerson's. Like Emerson, Still did not necessarily view the past with equanimity. He did not view it as a repository in which to find the best and wisest expressions of culture or as something to study for its potentially beneficial influence on the present and the future. For Still, as for Emerson, the past inhibited the individual from examining and understanding his own spirit. Emerson found that the heavy hand of the past prompted people to respond less to the act of creation than to the record of that act, that, for example, the act of making poetry, one's own poetry, was subverted by the preference for

the poem that somebody else wrote. Emerson felt that even books could become tyrants if we did not recognize our own value as equal to Shakespeare's. Emerson thought that in each of us there were creative manners, actions, and words "indicative of no custom or authority, but springing spontaneous from the mind's own sense of good and fair. . . . Genius is always sufficiently the enemy of genius by over-influence" ("The American Scholar," p. 58). In effect, somebody else's genius could stifle the development of one's own. So he stated, "I had better never see a book than to be warped by its attraction clean out of my own orbit, and made a satellite instead of a system. The one thing in the world, of value, is the active soul" ("The American Scholar," pp. 58, 57).

Emerson's constant belief in and desire to encourage the authenticity of one's own experiences is echoed in Still's statement of artistic independence written in 1944: "One simply tries to remove the load of educational negations which inhibit a student's mind, so that he may comprehend or come in contact with the forces he has within him. . . . To those who discover it, is born no competition, but a beautiful wonder and affinity with creation."[10] What makes this statement so Emersonian is not simply the fact that Still wanted to destroy the past – other artists in other countries have said as much – but that he wanted to destroy the past in order to gain contact with forces within himself and with the idea of creation. There is no social program here, but rather, a concern for individual expression engaged not in competition with anything or anybody else, but with its own powers and strengths. Or as Emerson said, "A man should learn to detect and watch that gleam of light which flashes across his mind from within, more than the lustre of the firmament of bards and sages" ("Self-Reliance," p. 259).

Still displayed an Emersonian subversiveness a few years later in 1952, when, after decrying the artist's assigned role to perpetuate societal values, he then denied the artist's responsibility to history, tradition, and authority. "We are now committed," he said, "to an unqualified act, not illustrating outworn myths or contemporary alibies. One must accept total responsibility for what he executes. And the measure of his greatness will be in the depth of his insight and his courage in realizing his own visions."[11] In Still's personal vision, "each painting is an episode in a personal history, an entry in a journal. . . . No painting stops with itself, is complete in itself. It is a continuation of previous paintings and is renewed in successive ones."[12] Still's paintings, as entries in his private journal, echo Emerson's straightforward pronouncement, "his own Culture, – the unfolding of his nature is the chief end of man."[13]

But beyond that, Emerson held that the same principle of life animated each individual as it animated nature. Both the life of an individual and the life of nature were in constant flux, presumably as the individual came to recognize his own spiritual powers and to understand his own spiritual connectedness to nature. As the individual grew, so the universe grew within him. I would think, therefore, that Still's intention to witness each painting as a development from the previous one is akin to Emerson's comments on the method of nature. In effect, nature has no beginning nor could it ever stop functioning. Rather, as Emerson said, "The permanence [of nature] is a perpetual inchoation. Every natural fact is an emanation, and from that which it emanates is an emanation also, and from every emanation is a new emanation. If anything could stand still, it would be crushed and dissipated in the torrent it resisted . . ." ("The Method of Nature," p. 119). Perhaps a similar process was at work through Still's journey from painting to painting.

Emerson held that knowledge was gained in the experience of creation and that experience itself created its own appropriate forms. As he said cryptically, "it is not metres, but a metre-making argument, that makes a poem, – a thought so passionate and alive, that, like the spirit of a plant or an animal, it has an architecture of its own, and adorns nature with a new thing" ("The Poet," p. 450). His meaning is that the argument, or the thought, is primary and the form in which it appears is secondary. The thought is prior to the form. The form will grow out of the thought. This would certainly describe Pollock's drip paintings as well as Still's autobiographical paintings. It also gets to the heart of a position that Newman articulated on a few occasions.

In 1947, Newman wrote that American painters like himself started

> with the chaos of pure fantasy and feeling, with nothing that has any known physical, visual or mathematical counterpart and then bring out of this chaos of emotion images which give these intangibles reality. . . . The Americans evoke their world of emotion and fantasy by a kind of personal writing without the props of any known shape. . . . With the European abstract painters we are led into their spiritual world through already known images. . . . To put it philosophically, the European is concerned with the transcendence of objects while the American is concerned with the reality of the transcendental experience.[14]

In other words, American artists, by exploring the reality of the transcendental experience, will then develop a form to reveal it, to put it in and contain it. The feeling, the thought, or the argument comes

first. The art comes later. As Newman wrote earlier, "the painter of the new movement . . . is . . . not concerned with geometric forms per se but in creating forms which by their abstract nature carry some abstract intellectual content."[15] It is interesting to note here that Arthur Dove, the early American modernist, once penned the aphorism, "not form but formation," a concept close to both Emerson's and Newman's constructions.[16]

On another occasion, Newman, following Emerson, described, in effect, "not metres, but a metre-making argument," when he stated that Kwakuitl artists created abstract shapes that were to be "a vehicle for an abstract thought complex," rather than a "formal 'abstraction' of a visual fact."[17] That is, Native American artists tried to develop a form that would encompass their thought. Whether in fact this was the Native Americans' mode of operation, Newman chose to describe it in Emersonian terms.

Newman was, perhaps, most Emersonian when he wrote in 1948 that American artists, free from European culture, are "reasserting man's natural desire for the exalted, for a concern with our relationship to the absolute emotions. . . . We are freeing ourselves of the impediments of memory, association, nostalgia, legend, myth. . . . Instead of making *cathedrals* out of Christ, man or 'life,' we are making it out of ourselves, out of our own feelings."[18] Newman is saying more than one thing here. First, he seems to be asserting man's need for a new start, to reclaim man from history, as if he wanted to become a new Adam. Newman had earlier considered the relationship between the artist and Adam:

> The writer's creative impulses told him that man's origin was that of an artist. . . . The fall of man was understood . . . not as a fall from Utopia, but rather that Adam, by eating from the Tree of Knowledge, sought the creative life to be, like God, 'a creator of worlds' . . . What is the *raison d'etre*, what is the explanation of the seemingly insane desire of man to be a painter and poet if it is not an act of defiance against man's fall and assertion that he return to the Adam of the Garden of Eden? For the artists are the first men.[19]

Newman's words recall Emerson's own desire to look upon the earth as if he were the first person. "What shall be the substance of my shrift," Emerson asked. "Adam in the garden, I am to new name all the beasts in the field and all the gods in the sky. I am to invite men drenched in Time to recover themselves and come out of time, and taste their native immortal air . . ."[20]

By invoking the Adamic figure, Newman, like Emerson, was search-ing for lost origins that he hoped to find either in the self or in the Garden of Eden, the symbol for lost innocence. Both Newman and Emerson, in wanting to start over again, sought to escape the cultural heritage of European thought and art. Each wanted to invent a lan-guage, verbal or visual, that was not derived from prior language or theory. Newman, like Emerson, sought to discover new ways to think, to act, to paint, to forget traditions in order "to reinforce a potentiality for response in the self . . ."[21] If anything, Newman's assertion of the self was more desperate than Emerson's since Emerson was concerned with finding the God within while Newman's assertion of self was grounded exclusively in the self. What made Newman's assertions so scary was that beyond the artist, there was nothing – no God, only the abyss. Such a chilling prospect might have prompted Robert Motherwell to write in 1951 that abstract art grew "from the primary sense of gulf, an abyss, a void between one's lonely self and the world. Abstract art is an effort to close that void that modern men feel."[22] The point here is that Newman, and perhaps Motherwell, were following to a logical conclu-sion a precept asserted by Emerson.

Newman's interest, mentioned before, in reasserting man's natural desire for the exalted, "to express his relation to the Absolute,"[23] was caught up in his concern for the location of the sublime, whether it be in objects of art and nature or whether it be within the individual. From the tenor of his remarks, "we are making it [cathedrals] out of our-selves," he seems to be arguing for the location of the sublime within each individual – that is, he posited the notion of an internal sublime. This, too, is pure Emerson. It also marks an instance of what Harold Bloom would call the American Sublime. As Bloom points out, "the distinguishing mark of the specifically American Sublime [is] that it begins anew not with restoration or rebirth . . . , but that it is truly past such displacement. . . . Not merely rebirth, but the even more hyper-bolic trope of self-begetting . . . , The American Sublime is not a re-seeing but rather is a re-aiming."[24] Bloom finds the source of the American Sublime in Emerson's "refusal of history" and in such para-digmatic lines as these from Emerson's essay "Fate": "The revelation of thought takes man out of servitude into freedom. We rightly say of ourselves, we were born again, and many times. We have successive experiences so important that the new forgets the old. . . . We are as lawgivers; we speak for Nature; we prophesy and divine" ("Fate," pp. 954–55). Whatever the price, Newman, like others before him such as Whitman, celebrated, to use Bloom's language, "an ecstatic union of

soul and self . . . , the American Sublime of influx, of Emersonian self-recognition and consequent self-reliance."[25]

Certainly, Newman wanted no past at his back. He seemed to agree with Emerson in believing that the individual was central and that the world existed only in relation to him. History was not complex, nor composed of impersonal forces, nor did it beat down inexorably on man. Rather, history grew from the individual and was to be explained as human experience. Since Newman was widely read – he had visited Emerson's home in 1936 – he might have been familiar with Emerson's belief that "all history becomes subjective; in other words, there is properly no history; only biography" ("History," p. 240).[26] So, Newman painted history from his own being. This is not to say that the individual should remain unaware of the past, but that he should not be overawed by it. "The student," Emerson said, "is to read history actively and not passively; to esteem his own life the text, and books the commentary" ("History," p. 239). Of this passage, Harold Bloom commented, "so much indeed for history." He then continued, saying that the text was not impenetrable for the reason that there really was no text. "There is only your own life. . . ."[27] In effect, then, Emerson and Newman after him were saying that each of us is his or her own text. We are our own history and therefore of our own making. We are the discoverers of our own voice. By acting, we discover our own voice. And so Pollock, Still, and Newman acted.

In this context, it is not at all surprising to realize how very Emersonian is Harold Rosenberg's famous definition of action painting. "At a certain moment," he wrote in 1952,

> the canvas began to appear to one American painter after another as an arena in which to act. . . . What was to go on the canvas was not a picture but an event. The painter no longer approached his easel with an image in his mind; he went up to it . . . to do something to that other piece of material in front of him. The image would be the result of this encounter. . . . What matters always is the revelation in the act.[28]

Rosenberg posits the ideal Emersonian situation of a presumably knowledgeable artist in the act of self-definition who is aware of, but at the same time forgets, the inhibitions of past training and experience for a more direct and more honest and more authentic response to the stimulus at hand. The artist is creating out of himself. His own life is his central theme.[29]

But Rosenberg's observations, startling as they were in 1952, had already been articulated in 1914 by Marsden Hartley. In that year, Hartley exhibited paintings composed of abstracted elements based on the uniforms of German officers. Of them, he wrote, "A picture is but a given space where things of the moment which happen to the painter occur. The essential of a real picture is that the things which occur in it occur to him in his peculiarly personal fashion. It is essential that they occur to him directly from his experience."[30] There are compelling historical reasons for Hartley to have described his paintings in this way. He probably wanted to deflect attention away from their obvious German content because Americans were then growing hostile to German actions in World War I. But it is interesting to note that his formulation was an Emersonian one.

To suggest that the abstract expressionists were not the only artists in whose works one can find Emersonian presences, it is worthwhile at this point to consider briefly two of Hartley's contemporaries, John Marin and Georgia O'Keeffe. (As a matter of fact, perhaps the most Emersonian gesture by any American artist was the erasure by Rauschenberg of a drawing of de Kooning, thus quite literally eliminating the past at Rauschenberg's back.) The principal difference between the earlier and later generations is that abstract expressionists internalized Emersonian precepts in their abstractions, whereas the early modernists, still acknowledging the centrality of landscape painting in American art, used the landscape to reveal Emersonian presences in their work.

If it were just a matter of demonstrating their interest in the landscape, then it would not be necessary to invoke Emerson's name in considering the early modernists. American artists painted the landscape before Emerson began to write and he was not the cause of the continuing interest in landscape painting throughout the 19th century. But it is useful to consider Emerson with regard to the early modernists, since, like Emerson, they seem to have quested after self-knowledge, and they relied on the landscape, on nature, to help them in their quest. The landscape became, in effect, part of their autobiography as well as a vehicle to connect to a force larger than themselves. For Emerson, living in a more religious age, the larger force was God. For Marin and O'Keeffe, the force was something unknowable, an indeterminate power that we might simply call nature, perhaps a symbol of their sense of alienation from themselves and from the larger American community.

When, for example, Marin wrote in 1928, "seems to me the true

artist must perforce go from time to time to the big elemental forms –
Sky, Sea, Mountain, Plain – and those things pertaining thereto, to sort
of re-true himself up, to recharge his battery," he was echoing in his
folksy way Emerson's realization that the aboriginal self is "not diverse
from things, from space, from light, from time, from man, but one with
them and proceeds obviously from the same source whence their life
and being also proceed."[31] Just as Emerson was aware of the need to get
in touch with something basic in nature, that his rhythms should be in
touch with nature's – or, as he said, "I am part of the solar system. Let
the brain alone, and it will keep time with that, as the shell with the
sea-tide" – so Marin felt the need to "re-true himself up" with the
elemental big forms.[32]

Marin also felt the need to confront nature directly without anything
at his back. "Reason and knowledge," he said, "are the things we have
to combat, they are always fighting sight. The thing seems to be to
know how to see, not to let our knowing how the thing is, to conflict."[33]
That is, Marin, like Emerson's Adam in the Garden, wanted to see
nature as if for the first time, to glory in his own perceptions unencum-
bered by prior memory. His exultations in the presence of nature, his
desire to establish some kind of spiritual relation with nature, also move
along the same axis as Emerson's "I think [nature] must always combine
with man. Life is ecstatical, and we radiate joy, honour and gloom on
the days and landscapes we converse with."[34]

Georgia O'Keeffe's desire to find some larger meaning through the
landscape seems at times more desperate than Marin's. In the land-
scapes of New Mexico, she must have sensed more profoundly both the
loss of connectedness to nature and her strong need to reconnect in
ways almost physical as well as spiritual. She once said, "it was the
shape of the hills there that fascinated me. The reddish sand hills with
the dark mesas behind them. It seemed that no matter how far you
walked you could never get into those dark hills, although I walked
great distances."[35] I do not think she wanted to dominate those hills, to
overwhelm the physical landscape, as much as to find a way to enable
her spirit to merge with the spirit of those hills. Where Emerson's
transcendental yearnings concerned the merging of his soul with God,
I am assuming that she, in a more secular manner but no less pro-
foundly, wanted to merge her soul with the spirit of the landscape.

O'Keeffe also revealed her particular quest for insight, growth, and
self-renewal through nature when she wrote "the unexplainable thing
in nature that makes me feel the world is big beyond my understanding

– to understand maybe by trying to put it into form. To find the feeling of infinity on the horizon line or just over the next hill."[36] If I read this passage correctly, she is saying that she knows there are no boundaries to understanding, that understanding is a permanent process, that even the feeling of infinity is beyond comprehension. Like Marin and the abstract expressionists, she did not seem willing to give up the search. She wanted to keep moving into the unknown, a voyager, essentially alone with no props and, with Emerson, no past, to find the feeling of infinity on the horizon line. It is certainly appropriate to place her thought in juxtaposition with Emerson's formulation that,

> the eye is the first circle; the horizon which it forms is the second, and throughout nature this primary figure is repeated without end. . . . Our life is an apprenticeship to the truth. . . . The one thing that we seek with insatiable desire is to forget ourselves, to be surprised out of our propriety . . . to do something without knowing how or why; in short, to draw a new circle. ("Circles," pp. 403, 414)

In other words, Emerson wanted to push back infinity. O'Keeffe just wanted to have some sense of where it was. But, through their use of words or visual images, both shared a common desire for self-awareness and self-knowledge, a desire also shared by the abstract expressionists. Emerson, in his essay "Spiritual Laws," wrote that man,

> by doing his own work he unfolds himself. . . . Somewhere . . . every man should let out all the length of all the reins; should find or make a frank and hearty expression of what force and meaning is in him. . . . Until he can manage to communicate himself to others in his full stature and proportion, he does not yet find his vocation. ("Spiritual Laws," pp. 310–11)

In the late 1940s, no less than at other times during the present century, American artists attempted nothing less.

American Art Around 1960 and the Loss of Self

E verybody knows that an incredible amount of activity took place in the New York art world in the years just before and just after 1960. New movements included Assemblage, Happenings, Minimal Art, Pop Art, and Op Art. Nevertheless, I would like to suggest that in the works and statements of some artists, there appears to be what I would like to call a loss of self or a negation of self, an absence of a centered self, a personal sense of dislocation. There is no single term to cover what I have in mind, but I feel its presence is indisputable.

These artists, or the selves they presented, would seem to be the opposite of Ralph Waldo Emerson's poet who "stands among particular men for the complete man . . . ," and who "perceives that thought is multiform; that within the form of every creature is a force impelling it to ascend into a higher form," or of Emerson's ideal individual who "is its [the world's] head and heart, and finds something of himself in every great and small thing, in every mountain stratum, in every new law of color, fact of astronomy, or atmospheric influence which observation or analysis lay open."[1] That is, the artists I want to consider – Robert Rauschenberg, Frank Stella, Robert Smithson, Robert Morris, and Andy Warhol – do not at all project the kind of self-assurance and unlimited confidence of Emerson's poet and singular individual both of whom

seem ready to colonize the universe and to encompass within their own beings all that is not themselves. (I am not saying that they should, but that I am using Emersonian notions as points of contrast.)

In Emersonian terms, Abstract Expressionists such as Jackson Pollock and Barnett Newman did try to reach beyond themselves. In fact, Newman's famous statement, published in 1948, "instead of making *cathedrals* out of Christ, man, or 'life,' we are now making [them] out of ourselves, out of our own feelings," is probably the most impassioned Emersonian statement ever delivered by an American artist. His statement also suggests that in a post-war, hostile world, he would make his own values. As Wylie Sypher suggested in his important book, *Loss of Self in Modern Literature and Art*, paraphrasing remarks Bertrand Russell made as early as 1918 in the aftermath of World War I, "We must go on from this despair to a tragic confidence in ideals we must erect unaided."[2]

But by the middle 1950s, Newman's imperial self, his centered, yet searching self concerned with values, morals, ideals, and purpose had become lost to the younger artists.

Take Rauschenberg, for example. In his Combines of the middle 1950s, he did not want to provide illustrations of his will, but to document what he had observed (fig. 34). He said, in regard to finding objects to include in his work, "I felt as though I were collaborating with the neighborhood."[3]

The usual explanations for Rauschenberg's art at that time revolve around his presumed reactions to the autobiographical excesses of the Abstract Expressionists and to the general loss of a societal value structure after World War II. The art of the early 1960s has also been explained in similar terms. Speaking about Minimalism, Maurice Berger has suggested that there was a "desire for pure experience independent of memory or logic [which] recalls the New Left's demand for liberation from society's oppressive conventions and standards." And Robert Morris more precisely pointed out that perhaps due to a lessened concern for absolutes, an acknowledgment of the exhaustion of modernist forms, an awareness of emotional weariness, of global threats, of life in a nuclear society, of environmental distress, and of industrial pollution, "that sense of doom has gathered on the horizon of our perceptions and grows larger everyday." In any case, the future can hardly be said to exist and "a numbness in the face of gigantic failure of imagination has set in."[4]

But Rauschenberg's friendship with the composer John Cage is

certainly equally important to consider. Cage, a student of eastern philosophies, began to study with Gita Sarabhai and Daisetz T. Suzuki at Columbia University in 1945. He met and worked with Rauschenberg at Black Mountain College during the summer of 1952, and a few years later Rauschenberg created sets for the Merce Cunningham Dance Company of which Cage was musical director. In 1956, Cage taught occasional classes at the New School for Social Research in New York City which were attended by several younger artists, and by the early 1960s his ideas were well known to the dancers, musicians, and artists (Robert Morris among them) who were part of the Judson Dance Theater.[5] Because of Cage's activities as well as the publication of books on Zen by Suzuki and the more popular Alan Watts, one can speak of a Zen presence in New York City at the time.[6]

In any event, Rauschenberg's comments apropos his Combines recall one of Cage's observations written before 1961. In regard to the use of random noise in a composition, Cage wrote, "One may give up the desire to control sound, clear his mind of music, and set about discovering means to let sounds be themselves rather than vehicles for man-made theories or expressions of human sentiments."[7] This is a very Zen statement. As Suzuki and Watts often reiterated, Zen was not about sinking into an abyss or losing one's personality, but rather of subsuming one's individuality by connecting "with Being and Life which animates all things." The idea was not to fall into the "blankness of unconscious," but to gain, through intuition, immediate knowledge (certainly, an open-ended proposition).[8] Like Emerson, Suzuki was opposed to "blind acceptance of an outside authority and a weak submission to authority," but unlike Emerson, who called for concerted efforts at understanding more and more about nature, Suzuki explained that in Zen there might then be "perfect freedom to the self-unfolding of the Mind within one's self."[9]

Cage's interest in "non-intention," then, is a Zen concept, and Rauschenberg's willingness to interact with his neighborhood when making Combines also reflects Zen thought. With this in mind, one understands Cage's observation that Rauschenberg's work allowed him to walk without disgust through Times Square. "Our intention," he said, "is to affirm this life, not to bring order out of chaos or to suggest improvements in creation, but simply to wake up to the very life we're living, which is excellent once one gets one's mind and one's desires out of its way and lets it act of its own accord" (1961).[10] And with this also in mind, it is Rauschenberg's Zen self that allows for collaboration

34. Robert Rauschenberg, *Gloria* (1956). Oil and collage. 66½ × 63¼ in. Courtesy of the Cleveland Museum of Art. Gift of the Cleveland Society for Contemporary Art. Robert Rauschenberg/Licensed by VAGA, New York, NY.

with various materials. The artist is, as he said, "part of the density of an uncensored continuum that neither begins nor ends with any decision of action of his."[11] Implicit and explicit here is the loss of a domineering self, a frank willingness to allow the self to be a co-author of its creations, and a paradoxically conscious willing of the self into a lack of conscious identity and dominance.

Ad Reinhardt, a popular artist of the time and well known to the younger figures (Stella owned a painting by Reinhardt), was also a student of Eastern mysticism, but clearly understood it differently from Rauschenberg. He had attended Suzuki's seminars at Columbia University in the early 1950s, and later that decade and into the next wrote what were in effect explanations and manifestos concerning his "black

paintings" as these reflected his beliefs. It is my belief, however, that he misunderstood Zen and perhaps misinformed his younger friends. Zen ways of thinking and modes of action betray normal Western concepts of human agency, rationality, and direct action. It is not easy, perhaps ultimately impossible, for a Western person raised in a culture whose precepts are so antithetical to Zen philosophy to adapt to a Zen way of life. And so Reinhardt provided instruction and was quite directive rather than to allow his readers to find their own way. In his most famous essay, for example, "Twelve Rules for a New Academy" (1957), he insisted that a painting have no texture, no forms, no design, no colors, no space, no time, and no subject, among other features. And in one of his journal entries, he wrote that an artist "has always nothing to say, and he must say this over and over again." The very word "must," of course, defies Zen tenets, and whatever Reinhardt passed on to the younger artists was less a sense of Zen emptiness than of personal emptiness.[12] This might help explain, for instance, Robert Morris' quasi-Zen statement when reminiscing about his work of the early 1960s.

> At 30, I had my alienation, my Skilsaw and my plywood. I was out to rip out the metaphors, especially those that had to do with "pep," as well as every other whiff of transcendence. When I sliced into the plywood with my Skilsaw, I could hear . . . a stark and refreshing "no" reverberate off the four walls; no transcendence and spiritual values, heroic scale, anguished decisions, historicizing narrative, valuable artifact, intelligent structure, interesting visual experience.[13]

Regardless, the sense of emptying out, of taking oneself out of the work in question, whether Zen inspired or not, whether understood in a Zen context or not, whether societally induced or not, seems to have been present around 1960. Zen might even have been nothing more than a symptom of larger social issues. Whatever the case, at the very end of the 1950s, barely a decade after Barnett Newman wrote about building cathedrals to ourselves, Frank Stella began to exhibit his notched canvases, according to which the shapes of the canvases and the widths of the stretchers (the framing edges) determined the internal patterns of the paintings (fig. 35). Of these works, Stella said that the act of painting was, like handwriting.

> And I found out that I just didn't have anything to say in those terms. I didn't want to make variations; I didn't want to record a path. . . . I always get into arguments with people who want to retain the old values in painting – the humanistic values that they always

35. Frank Stella, *Pagosa Springs* (1960). Copper metallic enamel and pencil on canvas. 99⅜ × 99¼ in. Courtesy of The Hirshhorn Museum and Sculpture Garden, Smithsonian Institution. Gift of Joseph H. Hirshhorn, 1972.

find on their canvases. . . . My painting is based on the fact that only what can be seen there *is* there. . . . What you see is what you see.[14]

Stella and Newman seem hardly to be talking about the same thing, namely, the act of painting. Let me insert here a passage from Emerson's essay, "Circles," because it helps explain something about Stella and also to distinguish Stella from Rauschenberg. Emerson wrote,

The eye is the first circle; the horizon which it forms is the second, and throughout nature this primary figure is repeated without end. . . . Every action admits to being outdone. Our life is an apprenticeship to the truth that around every circle another can be drawn; that there is no end in nature, but every end is a beginning, that

there is always another dawn risen on mid-noon, and under every
deep a lower deep opens.[15]

That is, there is a self, a centered, aggressive self in constant motion,
in constant process of aspiring toward some higher level of understand-
ing, of comprehension, believing that every boundary can be broken.
Rauschenberg's self is no longer an imperial self, but it does keep
moving, opening itself to, as the artist said, "an uncensored continuum."
By contrast, Stella, in the notched paintings, works from the depicted
shapes, from the boundaries, inward. Limits have been set and estab-
lished. It is as if he has hunkered down behind the perimeters or
barricades of the framing edges. There are no confrontations with the
infinite, no heroics because, it would seem, the sense of self is enfee-
bled. It lacks strength to push out beyond the horizon of the edges.
 Even if one wanted to argue that each band represented a horizon,
I would counter that each band is the same size and therefore possesses
the same value. It does not matter which way the eye moves or if it
moves at all. Movement, in the Emersonian sense, is of no consequence
except for the sake of movement. This implies that the viewer is re-
duced to a nullity in that he or she need not take responsibility for
reading a work in any particular order. The work is prescribed by the
external power of the framing edge rather than by one's own experi-
ences or, for that matter, the artist's. The self does not dictate, but is
dictated to.
 The question of the edge and the interaction between the edge and
the center was also taken up by Robert Smithson in his writings of the
mid-1960s and in his Site–Non-Sites. Perimeters for Smithson were
fraught with peril. For example, he ended one of his essays, "A Museum
of Language in the Vicinity of Art" (1968), with an analysis of the dot
in Buckminster Fuller's World Energy Map. Smithson reported that
each dot was supposed to represent one percent of the world's harnessed
energy in terms of human equivalents. What that might mean remains
moot, but Smithson did say something important about the dot. It
"evades our capacity to find its center. Where is the central point, exit,
dominant interest, fixed position, absolute structure, or decided goal?
The mind is always being hurled towards the outer edge into intractable
trajectories that lead to vertigo."[16] Rather than exult in whatever the self
might discover on the outer edge, as in Emerson's horizons, here it
leads to vertigo. The edge, then, is not necessarily a good place to be.
There is uneasiness at the thought of the unknown.

This idea becomes clearer when Smithson explained the relation-ship between the center and the edge in the Site–Non-Sites. In a Site–Non-Site, the non-site is the central focal point wherever it might be – in a designated area in New Jersey or California. "The site is the unfocused fringe where your mind loses its boundaries and a sense of the oceanic pervades, as it were. I like the idea of quiet catastrophes taking place. The interesting thing about the site is that, unlike the nonsite, it throws you out to the fringes." Speaking specifically about a Non-Site on Mono Lake in a desolate part of California, he stated, "There's nothing to grasp onto except the cinders and there's no way of focusing on a particular place. One might even say that the place has been absconded or been lost. This is a map that will take you some-where, but when you get there you won't really know where you are." And then he repeats, "in a sense, the non-site is the centre of the system, and the site itself is the fringe or the edge."[17]

On other occasions, Smithson expressed concern for the interaction between the center and the edge probably as a way to articulate his own ambivalent position in any particular environment. What was at the fringe or beyond was problematic. For as he once noted, "No matter how far out you go, you are always thrown back on your point of origin. You are confronted with an extending horizon; it can extend onward and onward, but then you suddenly find the horizon is closing in all around you. . . . In other words, there is no escape from limits."[18] The unknown, then, marks the negative limits of knowledge. To say the least, this is not Emerson's very puncturable horizon, but rather an admission of the impossibility of pushing back the boundaries of the future. It suggests to me a kind of living death of the self.

On another occasion, writing in his most famous essay, "Entropy and the New Monuments" (1966), Smithson mentioned the works of certain artists – Dan Flavin, Don Judd, Sol LeWitt – by using the phrase "beyond the barriers, there are only more barriers." Smithson said that their works are for perception only – a sort of what you see is what you see – which he believed to be a "deprivation of action and reaction." Of Dan Flavin's pieces, Smithson said that prolonged viewing is impossible because ultimately there is nothing to see, and Judd's works "hid nothing but the wall they hang on."[19] These descriptions follow a discussion of the null and void of entropy, which Smithson sees as our future condition. He mentions a book by Wylie Sypher, which must be *Loss of Self*, published in 1962, in which Sypher defines entropy as the "tendency for an ordered universe to go over into a state

of disorder. . . . the behavior of things tends to become increasingly random; and in any system tending toward the random there is a loss of direction. Entropy is drift, then, toward an unstructured state of equilibrium that is total. Entropy is evolution in reverse."[20] Evidently, the artist cannot fight it. It overwhelms. For as Smithson said, "Everyone who invents a system and then swears by it, that system will eventually turn on the person and wipe him out."[21] The self, apparently, cannot hope to triumph, but rather remains passive in the face of things coming loose.

Gary Shapiro's analysis of the film of the making of "The Spiral Jetty" (1970) comes to a similar conclusion. He describes a shot of Smithson running on the jetty, but photographed in such a way as if to seem running in place. Shapiro also observes that "we do not see [Smithson] – or any other human being – involved in shaping, moving, or applying materials," and that in the film "language and action never coincide in a single figure. . . . When [Smithson] is shown running counterclockwise to the center of the spiral, we can imagine that he is trapped in the maze or labyrinth." Finally, questioning the lack of human agency, Shapiro notices that the "the loss of the center induces vertigo, like the historical vertigo consequent upon the proliferation of multiple temporalities and the disappearance of expected narrative."[22] Putting together Smithson's comments about vertigo at the edges and Shapiro's concern for vertigo at the center, the individual self does not have much room for maneuver.

The labyrinth to which Shapiro metaphorically referred was in fact built by Robert Morris in 1974. In the context of the present discussion, Morris' "Labyrinth" is an object one enters, gains minimal information in order to get out of it, and does not reach any further level of understanding. There might also be a certain amount of aimless wandering around as at a Site–Non-Site, even the abandonment of knowing where one is. The voyage into the unknown, which, by comparison, was a voyage of personal revelation for Abstract Expressionists, is here a physical journey. No insights are gained along the way. No growth. It is a doing activity, a reduction of process to its most basic physical level.[23]

Obviously, the idea of process in recent art and of Process Art itself has received much positive attention, but Wylie Sypher offered a critique as early as 1962 when he wrote in *Loss of Self* that concern for process is really a statement about ignoring what lies outside of the self, of denying cognizance of anything else. Cultivating the self in this way means cultivating a self without culture, and since "culture means

criticism, and criticism is only the capacity for dissatisfaction and self scrutiny," then those lacking this capacity lack authenticity. Such a person, and, by extension, such an artist involved virtually exclusively with process "remains a creature limited by his self-satisfaction."[24]

Morris perhaps tried to put a favorable spin on this issue when he stated that "the only authenticity is one which has refused every identity conferred by an institution, a discourse, an image or a style, as well as every delight and oppression offered by that gulag called the autobiographical."[25] But how favorable is it, really? To invoke Emerson again, his notion of freeing oneself, or to quote a line from his essay "Circles," "no facts are to me sacred; none are profane; I simply experiment, an endless seeker, with no past at my back," becomes a means to find one's authenticity, not to reduce it to physical movement or to submerge it and drown it as Morris would have it.[26]

To make my point clearer here, I want to compare Morris' statement with two passages by Georgia O'Keeffe that are pure Emerson. On one occasion, she wrote, "The unexplainable thing in nature that makes me feel the world is big beyond my understanding – to understand maybe by trying to put it into form. To find the feeling of infinity on the horizon line or just over the next hill." And in a letter she wrote to Sherwood Anderson, probably in 1923: "Making your unknown known is the important thing – and keeping the unknown always beyond you – catching and crystallizing your simplest clearer vision of life – only to see it turn stale compared to what you vaguely feel ahead – that you must always keep working to grasp."[27]

This is not to say that Morris should be more like O'Keeffe (or vice-versa), but rather to point out the extent to which the self had been emptied out by the 1960s. So it is not surprising to find this observation made by dancer Yvonne Rainer, one of Morris' colleagues at the Judson Dance Theater: "The artifice of performance has been reevaluated in that action, or what one does, is more interesting and important than the exhibition of character and attitude, and that action can best be focused on through submerging of the personality; so ideally one is not even oneself, one is a neutral doer."[28]

Morris, like Stella, also worked within perimeters in the early 1960s. One piece, called "Passageways" (1961), contained ever-narrowing walls which grew more confining until the individual who entered it could only back out. The horizon here had completely shut down. During these same years, Morris also created his "Portal" series, works which were usually in the shape of door frames. These, too, especially those

like boxes opened on only one side, were quite confining. A work in this series, "Untitled – Pine Portal with Mirrors" (1961), contains mirrors on its inner sides. Passing through this portal, as Kimberly Paice pointed out, "involves a decentering of the body vis-a-vis the frame – as though to pass through the doorway is to leave a dispersed and doubled image of oneself as a kind of deposit or trace."[29]

The word "trace" probably refers to Jacques Derrida's use of the word. In brief, Derrida suggests that any object or "substance" includes so many allusions that it cannot refer only to itself, "that no element can function as a sign without referring to another element which itself is not simply present . . . There are only, everywhere, differences and traces of differences."[30] In the context of the mirrored portal, I would go even further than Paice by saying that to pass through the doorway is to leave a trace which is then erased immediately after passing through. There is no residue except the work itself. The self here would seem not to have a center strong enough to contain itself within the peripheries of the portal, but rather is leached out by the mirrors. In Smithson's trope of the Site–Non-Site, the self at the center is the non-site and the edges absorb all of its energies. The portals, then, which can be confining, might also be agents of dispersion and loss.

Morris is, however, very present in his "I-Box" of 1962. But in what ways? When the "I-Box" is closed, we see the letter "I." When it is opened, we see a photograph of the naked Morris with a slightly erect penis. Maurice Berger suggests that the work "recalls Beckett's drained vision of the world, where 'I' is often little more than a vacant word, a coffin that enshrouds its subject in claustrophobic isolation."[31] I would add that there is no sense of an inner being, but instead a self that thinks of itself as a letter in the alphabet and knows itself only through public display. *That* is a decentered self. The "I" is the self literally revealed, totally, but only externally. What we see here is the desire for pure experience unmediated by meaning or logic, a self that probably responds only to the ways others perceive it. It is a self involved with the most minimal kind of self-identification. It seems to lack the energy to react except in a physical way and unable to assert itself other than by its actual presence. Morris' body becomes his unique signature, a substitute for a unique style or a unique self. In the "I-Box," Morris implies that self-definition comes not from interactions with reality, but from language and physical immediacy. His naked body is incapable of making history, of moving to another level of being, since there is no sense of potentiality, only presence without a future.

The superficial self that Andy Warhol projected reveals surprising parallels to the selves expressed by Stella, Smithson, and Morris. In an odd way, Warhol's self had some of the same character that described Rauschenberg's at the time, although I would not push the comparison too far. Nevertheless, as Rauschenberg felt as if he were interacting with the neighborhood when making a Combine, so Warhol was "never embarrassed about asking someone, literally, 'What should I paint?' "[32] But while Rauschenberg seems to have been responding to a Zen idea, Warhol seem rather to have been exhibiting a characteristic typical of the "other-directed" person described by David Reisman in his *The Lonely Crowd*, a popular book in the 1950s and 1960s. According to Reisman,

> What is common to all other-directed people is that their contemporaries are the sources of direction for the individual – either those known to him or those with whom he is indirectly acquainted through friends and through the mass media . . . The other-directed person is, in a sense, at home everywhere and nowhere, capable of a rapid if sometimes superficial intimacy with and response to everyone.[33]

Reisman was probably describing the post-modern mentality before the term was invented, for, as sociologist Kenneth J. Gergen has suggested, in that mentality, "the self vanishes fully into a stage of relatedness. One ceases to believe in a self independent of the relations in which he or she is embedded . . . ," and, paradoxically, "Life is rendered more fully expressive and enriched by suspending the demands for personal coherence, self-recognition, or determinant placement, and simply being-within the ongoing process of relating."[34]

And although nothing in the literature even hints at Warhol's involvement with Zen, his statement, "I'm sure I'm going to look in the mirror and see nothing. People are always calling me a mirror and if a mirror looks into a mirror, what is there to see?" somewhat parallels the concept of *wu-wei* which is about the nongrasping of things in order to let them go their own way in one's mind. As one ancient master is reported to have said, "The perfect man employs his mind as a mirror. If it grasps nothing, it refuses nothing. It receives, but does not keep."[35] But looking for connections is less valid than realizing the condition of the self in American art during the 1960s.

It is more to the point, however, to think of Warhol in terms of Baudrillard's simulacrum, as if he, Warhol, were acting as a sign for the

real instead of the real itself. In this regard, we might view Warhol, as Baudrillard describes the contemporary person, as one who has "not even his own body to protect him anymore." For such a person,

> The end of interiority and intimacy, the overexposure and transparence of the world . . . traverses him without obstacle. He can no longer produce the limits of his own being, can no longer play nor stage himself, can no longer produce himself as mirror. He is now only a pure screen, a switching center for all the networks of influence.[36]

Warhol almost forces us to think about him in this way when we consider some of the remarks he made over the years. "I'd love to be able to know everything about a person from watching them on television." "Good performers, I think, are all-inclusive recorders because they can mimic emotions as well as speech and looks and atmosphere." "I have no memory. Everyday is a new day because I don't remember the day before. Every minute is like the first of my life. I try to remember, but I can't." "If you want to know about Andy Warhol, just look at the surface. There's nothing behind it." "Before I was shot, I always thought that I was more half there than all there. I always suspected that I was watching TV instead of living life."[37] These are not the statements of a person concerned with projecting a powerful sense of self.

In their differing ways, then, these artists assaulted the concept of the primacy of the self during the 1960s, questioned its centrality both in life and in art, and left it very vulnerable as an agent of order, control, and authority. Only Warhol seems to have remained in the thrall of this sensibility for the remainder of his career. Stella moved on to make works in which the designing mind of the artist is clearly evident. The others, in one way or another, became involved variously in projects based on environmental, cultural, and political factors. In other words, these artists once again valorized intentionality, the assertion of self, and a concern for values aesthetic or otherwise. Perhaps they responded, in part, to pressures brought to bear on the mainstream avant-garde by formerly marginalized groups such as feminist artists or African-American artists who had an agenda and a purpose, and whose work was certainly charged with human agency. By 1970, the desire to break through to the next horizon was present once again – not necessarily in Emersonian terms, for Emerson's was a nineteenth-century project, but one appropriate to our own time.

ELEVEN

Pearlstein's People

> ... our most perceptive minds have distinguished them-
> selves from our popular spokesmen by concentrating upon
> the dark other half of the situation. . . .
>
> Harry Levin, *The Power of Blackness:*
> *Hawthorne, Poe, Melville*[1]

P hilip Pearlstein is certainly among the most perceptive art-
ists in our own time to have probed the dark other half of
the situation. Within a surprisingly narrow range of the-
matic material – the draped and undraped human body posed in indoor
settings – he has created some of the most disturbing and truthful
images of modern life, a self-portrait of a generation (fig. 36). But his
paintings of anonymous nudes and his portraits of married couples can
also claim a distinguished heritage in the history of American art and
might even have played a role in alerting us to that heritage. For
Pearlstein's paintings form an important chapter in the still unwritten
history of American paintings of the isolated, the depressed, and the
alienated.

Although their shared characteristics still need precise definition,
such works can be traced back at least as far as the immediate pre-
Revolutionary War period. Perhaps the earliest examples are John Sin-

gleton Copley's somber portraits of New York women painted in the early 1770s in whose faces, unlike those of the sturdy and more familiar New Englanders, one may find presentiments of the disturbing events which were to occur later in the decade. In succeeding years, however, portraitists found in their sitters pleasant and more amiable moods. Occasionally a face might glare at the viewer, but the posture or bearing of a sitter rarely suggested that he or she was troubled by personal agonies.

It was not until the end of the nineteenth century that the recording of such moods grew common, during an era considered a watershed in the history of American culture when doubt and despair first scarred the American character.[2] Perhaps George Fuller's hallucinated youngsters of the 1880s, who sit or stand in outdoor settings, are interpreted too personally to be considered part of a general tendency, but, during the next decade, several artists completed portraits characterized by qualities of sadness and even pain.

The great majority of these paintings were of women. Artists such as Thomas Dewing and Edmund Tarbell as well as several other Tonalists and Impressionists painted middle-class women sitting in interiors disengaged from any activity. Often they stare blankly into space and, unlike their French sisters, seem alone and self-absorbed even when friends and family are present. Getting dressed up appears to be the purposeless principal activity. The succession of seemingly delightful sunny afternoons, a burden and a bore for most of them, was to be passed as mindlessly as possible. That the women were aware of their ornamental role in society and desolated by their inability to overcome it was best conveyed by Thomas Eakins' compelling studies of his female friends and acquaintances.

During the period between the two world wars, several artists explored a similar range of themes, their focus shifting from the caged middle-class ladies of the turn-of-the-century to less genteel and often self-supporting, but equally helpless, women and also men. In the hands of these artists, the Edenic sheen glossing American culture, which the Tonalists and Impressionists still honored, was dissolved entirely. Edward Hopper, the most sensitive observer among the painters of the interwar generation, recorded the psychological isolation of lower-middle-class urbanites throughout his career.[3] His melancholy observations of sexually aroused, but unfulfilled, women are among the most important forerunners of Pearlstein's figures even though the latter are more passive and appear to have lost their erotic charge. Artists such as

36. Philip Pearlstein, *Two Female Models with Drawing Table* (1973). Oil on canvas. 72 × 60 in. Courtesy of The Philadelphia Museum of Art. Purchased through a grant from the National Endowment for the Arts and contributions from private donors.

the Soyer brothers and even Grant Wood portrayed people victimized by their environments, the former showing the personal devastation caused by the Depression and the latter the bitterness between people that Sherwood Anderson, a fellow Middle Westerner, found endemic in American life.[4]

During the 1950s, Richard Diebenkorn also showed the loneliness and isolation of individuals in a group of paintings which avoided

specific environmental and social factors. These are important works because Diebenkorn, in concentrating on an interior, existential sense of loneliness, suggested that isolation and withdrawal were now part of the modern human condition rather than the result of specific forces in society. Works such as these provide the immediate ancestry for Pearlstein's figures.

(The tradition to which Pearlstein belongs shades off into one closer to a sinister Dostoevskian vision of anxiety and torment, and would include the works of artists such as George Tooker and Gregory Gillespie. Their paintings describe the pathology of alienation, of an escape into another kind of spiritual world removed from the one inhabited by Pearlstein's still "normal" people. A third tradition lies at the opposite extreme and reflects more positive values than the other two. This tradition includes John Sloan and Alex Katz whose middle-class subjects are physically healthy and psychologically uncomplicated.)

Because of the freer sexual mores of the last 20 years as well as the willingness of married couples to reveal the nature of their relationship more readily, Pearlstein's paintings reflect the customs of their times as, say, Dewing's and Hopper's of theirs. As with the other artists, the extent to which Pearlstein has projected himself into his portrait of his period is, of course, unknown. One never knows how much is private obsession or terse commentary, autobiography or inspired observation. This ambiguity is not lessened by the minimally appointed interiors in which he places his sitters. We see the figures and little else. Unlike protagonists in a novel about whom we may often speak without worrying about the novelist (Don Quixote lives independently of Cervantes), Pearlstein's figures are, at the same time, extensions of the artist's personality, independent beings, and creatures of the viewer's fantasies.

For example, I have always found Pearlstein's paintings of nudes to be wildly ambivalent. He forces the viewer to focus on genitals by placing them centrally on the canvas (even in paintings of dressed figures). This emphasis on genitalia makes the paintings as sexually charged as paintings can be, yet the images are never erotic. The negation of eroticism depends on the combination of at least three factors. First, usually nothing is happening. Individual figures seem remote. Figures in paintings containing two women or heterosexual couples, even when touching, do not relate to each other. There is an absence of feeling, not just between the figures, but between the viewer and models and the artist and models. Second, Pearlstein presents odd and not necessarily the most seductive views of his figures. Third, they

are often unattractive and painted in unappealing ways. Flesh hangs
and sags, more so in women than in men. Colors are harsh. As a result,
the sexual aspect is less that of either pleasant memory or expectant
participation than of incipient hostility at worst or indifference at best.
Or, what is probably the case, the viewer is reduced to a spectator's role
since the figures maintain their physical and psychological distance
from the viewer (and from each other). Perhaps the viewer cannot or
does not want to enter into the world of the figures. This is voyeurism,
then. Pearlstein's figures do not acknowledge anybody's presence nor
are they posed for sensual delectation as are figures by artists as varied
as Titian and Ingres. The viewer is an intruder. He or she is allowed to
look, but at the same time is repelled. It is as though the expected
rapport between viewer and figures becomes too difficult to handle
easily. Either Pearlstein is revealing something about himself or he is
commenting on a society which desperately needs its sex manuals, or
both.

On the other hand, one may argue that Pearlstein, in denying
eroticism even though he focuses on erotic parts of the body, might be
contributing to human liberation. Nudity need not always be associated
with sexual activity. The artist, after all, is not obligated to paint sexual
fantasies for the public. As he once said, "I'm concerned with the
human figure as a found object."[5] In the paintings of heterosexual nude
couples, where the possibility of pleasant sexual encounter, or encoun-
ter of any sort, appears remote, this might be interpreted as a very
enlightened position. Heretofore, American men have been offered two
primary models for physical contact: aggressive mock violence between
men (locker-room, jock stuff) and raw sexual contact.[6] Pearlstein seems
to suggest an alternative: emotional closeness brought about by physical
proximity. But a casual glance at his couples suggests that their implied
sexual impotence is derived from their emotional impotence. The im-
plied fear of sexual encounter obviously indicates resistance to emo-
tional communication, or vice versa, and without one there is little
likelihood of the other. His figures not only lack the will to use their
bodies, they cannot establish contact with each other on any level,
sexual or otherwise. Nor, in the end, can we. We remain voyeurs of
scenes in which nothing will happen and we do not always know if the
sense of ungivingness is ours, theirs, or Pearlstein's.

Should we have sympathy for the plight of the figures, or for our-
selves? Are we given the means to establish sympathy? No, nor are we
meant to. Pearlstein's penchant for cutting off parts of a figure's head

lessens the figure's value as a human being. It is as though an individual's thought and feeling processes have been excised, along with an interest in their intrinsic worth. In several paintings, figures sit or recline with their eyes closed, further inhibiting communication. Their bodies do not telegraph, in today's language, positive interpersonal messages, since most are so relaxed as to be somnambulistic. In fact, Pearlstein's nudes, in both single-figured and multi-figured works, seem to lack motivation of any sort. Trapped in their bodies, they live a life of enforced solitude. They do not lack feelings as much as Pearlstein resists letting them reveal any. Or, as he has indicated, when painting, he plays recorded music to "keep studio conditions constant and to drown out thought."[7]

In the portraits of married couples, there is a greater measure of interaction between artist and sitters and between the sitters themselves (since everybody probably knows each other too well for complete emotional stasis). These figures reveal more emotion, usually one of generalized anxiety which, because of their bodily positions and facial expressions, extends to barely controlled feelings of hostility. Their eyes rarely focus on the same object(s). In a very few of these paintings, one of the partners seems to want to leave the room. The women, as often as not, wear brightly patterned garments which hide their bodies, implying further emotional and sexual estrangement from their mates. Pearlstein's couples seem unable to extricate themselves from their private hell, or, as if acting roles in Sartre's play *No Exit*, they chose to stay in it, or perhaps they have been deliberately placed in it.

Since Pearlstein's nude figures lack motivation and his married couples avoid confrontation, then it would seem that the artist is describing modern alienation. His figures, in avoiding the appearance of a dialogue with each other, evade responsibility for their own lives and signal their refusal to face an oppressive reality. Georg Lukacs, the Marxist literary historian, might say that they have accepted the modern human condition as the human condition to which there is no alternative.[8] Pearlstein has provided them with a reality which is self-referential. The modern condition of alienation is accepted as the given. According to this line of reasoning, Pearlstein, through his figures, has not adopted a critical posture toward society, but has succumbed to its intolerable pressures. He paints the isolates of society who keep the remnants of their personalities intact by refusing to interact with others. Pearlstein keeps his own distance from his figures and he also keeps the viewer at a distance as well. In this regard, he is

somewhat akin to the Social Realists of the 1930s who were criticized by Communist critics for painting only those beaten down and vanquished by capitalist society instead of those who were supposed to be building the civilization of the future.

No doubt, it is easier for novelists and playwrights to show modern alienation as a single phase of contemporary life rather than as its primary aspect. For a painter to adopt a stance of critical realism, he might end up painting propaganda pieces. His medium of expression inhibits the creation of works critical rather than symptomatic of his time. As creatures reflecting alienated conditions, Pearlstein's figures would make remarkable subjects instead for an existential psychiatrist. This type of therapist, less interested in changing society, focuses attention on ways society affects individuals and on the techniques such individuals might develop to cope with their immediate situation. One such psychiatrist, Viktor Frankl, has coined the phrase "existential vacuum" to describe symptoms similar to those Pearlstein's figures reveal.[9] Those so afflicted, according to Frankl, complain of a "loss of interest and lack of initiative." Meaning has evaporated from their lives. He calls this the loss of will to give meaning to life. Part of a patient's therapy is to develop a commitment to something or somebody beyond himself, to learn to transcend the moment and thus rekindle the will to provide meaning to life. Pearlstein's figures lack that special will. Emotionally paralyzed, they cannot make gestures signifying communication or commitment or self-definition. Their lives remain static. They live in a perpetual ahistorical fragment of time.

Pearlstein's style perfectly complements the content of his work. Although he turned to the figure around 1960, his mature work dates from 1963 when forms grew more precise and a more controlled technique replaced his earlier painterly brushwork. Figures which once seemed capable of movement were locked into rigid compositional schema. Bodies once softened by ragged shadows and streaked highlights became surfaces for displaying calculated lighting effects. Flesh grew less human, less suggestive of slight movements caused by breathing or subtle shifts of position, and more a field for technical displays of tonal variations. Like Edward Hopper's and Richard Diebenkorn's figures, Pearlstein's lost the potentiality for independent action as their body parts and the different tonal areas playing across them increasingly became subsumed by organizational units that reached across bodies, chairs, and couches as well as rugs and shadows on floors and walls. Even though figures dominated background elements, seemingly

denying the modern tradition of figure-ground interaction, Pearlstein nevertheless assertively included non-figural areas in his system of organization. This habit of organizing forms in relation to the total area of the canvas also helped negate the possibility of movement. As in a painting by Franz Kline (Pearlstein's figures corresponding to Kline's black slabs), figures bisect the canvas to create active patterns between themselves and the edges to a much greater extent than in paintings by other figure painters. And despite their apparent three-dimensional bulk, Pearlstein's figures seem immobilized, incapable of making the simplest gestures, creatures over whom the artist has exercised total control.

Their physical paralysis is exaggerated by their scale in relation to the size of the canvas. They crowd the picture plane and impose upon the physical space of the viewer. Yet, they are not part of the viewer's space because they cannot move into it. On the contrary, they are involved in, or doomed to, a private drama which we observe, are witness to, but are excluded from. Their world is separate from ours even as they make their presence known in it. Easy access to their world, easy communication, sexual or psychological, with Pearlstein's figures, big as they are, is effectively curtailed, just as figures within his paintings are unable to acknowledge each other.

Pearlstein turned to the figure about the same time that artists such as Roy Lichtenstein and Andy Warhol began to use pre-existing signs of popular culture to portray that culture. Their images, derived from the popular media, allowed them the luxury of hiding their true reactions behind pre-digested forms, just as Pearlstein filled his works with a similar psychological distancing. Both Pearlstein and the Pop artists effected a position of detachment from the implications of their content. But Pearlstein showed the effects of modern culture on the inhabitants of that culture. Where Pop artists emphasized the one-dimensionality of modern emotional responses without becoming involved with those responses (as in Lichtenstein's comic strip paintings), Pearlstein developed an art of greater authenticity and, despite his evident desire to remain uninvolved, greater engagement with the effects of modern life on the human mind. Where Pop artists accepted the effects of mass society and turned them into self-deprecating jokes, Pearlstein showed the results of those effects. And compared to the epigones of the Pop artists, the PhotoRealists, Pearlstein did not disengage the life of the mind from that of the eyes; his figures are invested with meaning beyond mere presence.

Pearlstein would disagree with all of this. Since 1962, when he first exhibited his paintings of realistic figures, he has always insisted that the meaning of his work is relatively simple. Calling himself a post-abstract realist, he has maintained that his figures are not meant to carry social content or comment. Rather, the meaning resides in the conjunction of forms and colors, of body positions and abstract shapes. In an early statement, he said that "the most meaningful experience in painting the figure" is in the relationship of the picture plane to the poses of the models,[10] an understandable attitude in an era when the picture plane was considered an article of art theology rather than a mere point in space. In 1977, he made a similar statement, presumably with equal fervor: "My aim is to be a mechanic of art. How a picture is put together is all that I'm interested in. Content is not interesting. What is interesting to me is how the page is divided."[11]

Despite Pearlstein's explanations, critics and observers have invested his works with a content ranging far beyond formal analysis. His constant denial of content may be a necessary factor in his creative process. Probably his stand against interpretation reflects his ideal of painting as well as a strategy to deflect unwelcome questions. In his most recent work, painted roughly 15 years after his first exhibited figural studies, Pearlstein seems finally to have made paintings which approximate and reflect his long-standing position. Simply put, his new works resist interpretation of the sort observers have been making for years. Even though his subject matter has not changed, there is less to say now about content than about form, a condition that shifts the grounds of discussion closer to Pearlstein's statements. Models are now obviously posed instead of sitting or reclining in more natural positions. Entire heads are cut off so that bodies are increasingly read as a sequence of shapes. Skin tones have grown silky and less sickly-looking. Shadows have become more obvious and compete with figures for attention. Pieces of furniture, always present, are now used less as props than as forms of intense interest in their own right. As a result, the viewer now knows that a scene is a staged tableau rather than an existential mirror, an exercise in composition, organization, and finish rather than a guarded inquiry into the modern psyche.

Pearlstein's recent work, perhaps marking a new and major development in his career, might also be part of a general trend among realist artists whose content has been similar to his. Among all of his contemporaries, Pearlstein might best be associated with George Segal. Both artists developed realistic styles about the same time and, through

the 1960s, both explored similar themes. For reasons still not clear, both moved the focus of their art away from these earlier concerns, Segal a few years earlier than Pearlstein. At the start of the 1970s, Segal added a new facet to his art when he began to make reliefs created within a more narrowly defined, studio-bound artistic context. Similar changes also characterize the work of Leon Golub, another artist who used his art until recently to probe aspects of the human condition. His flawed giants and assassins of the 1950s, 1960s, and early 1970s described unfulfilled human potential for greatness as well as man's capacity for destruction. But within the last few years, he has substituted portraiture, albeit portraits of political figures, for the high moral content of his earlier pieces. He, too, has cooled the premises of his art.

One may argue that these three, along with others, continued at least one major aspect of Abstract Expressionist painting in that they were intensely concerned with the horrors of the modern human condition as well as with facets of contemporary American life. They did in realistic terms what the previous generation accomplished in abstract forms. Pearlstein seems to have painted less from a sense of rage or from a need for personal assertion than as one who understood too well the effects of society on the individual, an observer as well as a victim. But one may further argue that Pearlstein's recent paintings have lost that earlier creative tension borne by his observation and victimization, that he is now more willing to escape into art rather than to use his art to confront the present. If so, then we should be thankful that his paintings and his statements about art remained so far apart for so long.

Robert Morris's Latest Works
Slouching Toward Armageddon

R obert Morris's works shown at the Sonnabend and Leo
Castelli Galleries in January 1985 are among the handsom-
est and well-crafted produced by any artist in the last several
years (fig. 37). They are fully formed statements rather than examples
of works in progress or a set of ideas still in the process of development.
Certainly they represent a major effort on Morris's part, and one senses
in them the artist's desire to create a series of masterworks that sums up
his recent thoughts on the subject of human annihilation. Undoubt-
edly, they will be discussed from several points of view and fitted into
different readings of Morris's art, of the art of the present moment, and
of that of the past several years. The point is – they are important works.

I am referring particularly to those pieces in which Morris com-
bined images from the Firestorm Series with those of the Hypnertoma-
chia Series, the former composed of solid, densely drawn but indistinct
forms in pastel centered in and framed by the hydrocal reliefs of the
latter. They are large, as much as six and more feet in height and
length. Of course, any number of works by other artists exist in multi-
ples of six feet, but the amount of visual incident in Morris's works –
which have not been given an overall name or specific titles – provides
them with a massiveness not measurable in feet and inches.

The pastels, averaging about three to five feet square, are set within

thin metal frames. Just beneath the bases of several frames and largely hidden from view Morris has added sentences stamped on thin metal strips that refer to the firebombings of German cities. The pastels seem cut right into the centers of the hydrocal reliefs which act as large frames. Cast skulls, hands, and genitalia cover the surfaces of the frames. These do not provide, however, a consistent rectangular support for the pastels but contain notches, openings and even separate units that might recede or project from the plane of the pastels. For the most part, the frames are several inches wide. In one work, the reliefs are constructed to form rectangular legs that are joined by an apron of cut felt pieces. In most works, as in this one, the swirling forms of the pastels are continued onto the reliefs, suggesting a baroque continuity of movement from painting to sculpture and back again. Colors that emerge in the pastels also splash over onto the generally dark reliefs and warm their surfaces with dull reds and purples. Especially with the larger pieces, it is easy to read the combination of the central pastels and the surrounding frames as components of altar pieces; the subject of worship, however, is destruction rather than resurrection.

As in Morris's recent exhibitions, the added texts orient the viewer toward the meaning of the works. In this exhibition, he included eight statements concerned with the firebombings.

On the night of July 27,1945, the R.A.F. bombed Hamburg with incendiaries. Temperatures reached 1000 degrees centigrade. High winds were produced, 8 sq. miles were incinerated and 40,000 killed. The first deliberate manmade firestorm.

What would burn was ignited. For a week the city glowed and ashes filled the sky. A place, a population, a certain way of life had come to an end.

The center was a handful of energy never understood. Moments within an emptiness stretching to the stars where the heart beats for nothing.

Firestorm winds of hurricane force collapsed walls and sucked away the oxygen. Its heat melted metal roofs and blew showers of molten sparks which burnt holes in the corneas of their eyes.

Concussion waves (which leave no marks on the body), incineration, fragmentation devices, asphyxiation, flying glass, and melting roofs that create a rain of molten lead and copper on those below.

37. Robert Morris, *Untitled* (1983–1984). Painted hydrocal, watercolor, pastel. 88 × 72 × 3½ in. Courtesy of the Sonnabend Gallery, New York City.

None will be ready when it touches down. Yet we have seen it gathering all these years. You said there was nothing that could be done.

In the snow at 60 below zero, while the city burned, General Holder wrote, "We have reached the end of our human and material resources." The massive counterattack came without warning.

In Dresden it was said afterward that temperatures in the Alstadt reached 3000 degrees. They spoke of [many thousand] dead. Wild animals from the destroyed zoo were seen walking among those leaving the ruined city.

The central panels in each of the works suggest but do not describe the firebombings. Areas of intense red obviously refer to burning objects, and the great swooping arabesques to tornado-like firestorms.

Sparks of fractured colors play through the broad circular forms and whole sections of brightly colored marks are momentarily halted as they bounce through the heat of the infernos.

Although Morris is portraying chaos, he does so in an altogether controlled way, without any sloppiness. There is no Abstract Expressionist raggedness nor layers of Turneresque translucence, but a controlled expressionism that communicates the implied content of the works without provoking strong empathetic responses. The surfaces are – well – just too beautiful and deflect one's raw emotional reactions to firestorms, and the paths of movement are too certain to suggest the frenzy of incendiary holocausts. Morris is clearly not presenting topical views but is commenting on the idea of firestorms. In this regard he created, in effect, examples of the Kantian sublime. For Kant, the sublime was "to be found in a formless object, so far as in it or by occasion of it *boundlessness* is represented, yet its totality is also present to thought."[1] That is, the sublime cannot actually be visualized, but is available instead to the imagination. No object in nature is of itself sublime, since an "object is fit for the presentation of a sublimity which can be found [only] in the mind, for no sensible form can contain the sublime properly so called."[2] As Samuel Monk in his book *The Sublime* has suggested concerning Kant's interpretation of the sublime, "in experiencing the sublime, the imagination seeks to represent what it is powerless to represent, since the object is limitless, and thus cannot be represented. This effort and this inevitable failure of the imagination are the source of the emotions that accompany the sublime. Which achieves its effect by the opposition between the object and our faculties of knowledge."[3]

For Morris, the firebombings represent an experience beyond visualization, but which he imagined in forms boundless and limitless. This is a different order of sublime from that associated with Edmund Burke, for whom specific objects, forms, or events were essential to stimulate feelings of the sublime,[4] or even the later English writer on landscape William Gilpin, who suggested that "many images owe their sublimity to their *indistinctness*; and frequently what we call sublime is the effect of that heat and fermentation, which ensues in the imagination from its ineffectual efforts to conceive some dark, obtuse idea beyond its grasp. Bring the same within the compass of its comprehension, and it may continue great, but it will cease to be *sublime* . . ."[5] Clearly, Morris preferred his pastel images to remain indeterminate rather than to be

brought up to the level of indistinctness. His are not, as has already been suggested, Turneresque concoctions.[6]

In this regard, Morris seems to have understood, knowingly or not, Barnett Newman's criticism of the failure of European artists to achieve the sublime. In a symposium on the subject published in *Tiger's Eye* in 1948, Newman wrote, "the failure of European art to achieve the sublime is due to this blind desire to exist inside the reality of sensation (the objective world, whether distorted or pure) and to build an art within the framework of pure plasticity (the Greek ideal of beauty, whether that plasticity be a romantic active surface or a classic stable one)."[7] But unlike Newman who located the desire to achieve the sublime within his own being – "we are reasserting man's natural desire for the exalted, for a concern with our relationship to the absolute emotions" – Morris created his works in response to past and potential holocausts. His controlled surfaces were not created in answer to the ecstasies of sublime feelings triggered by natural sights and events or one's inner sense of transcendence, but in grim contemplation of total annihilation. He did not depict explosions of Mt. Vesuvius or expulsions from Eden, but images that peer into the abyss of our civilization.

It is also quite obvious that these new pieces reflect points of view different from those Morris held in the 1960s and 1970s. But consistency is no virtue, and any person, let alone an artist, who maintains the same attitudes over a 20-year period is probably dead from the neck up. This is certainly not Morris's problem; he continually demonstrates a genuine inventive spirit as well as an openness to new ideas. For these new pieces, the question that needs to be asked is not how they differ from his earlier works, but what are the continuities within his art that would help define its personality. Nothing short of a full review of Morris's career would allow us to position these works in his oeuvre, but a few observations can be made.

Most basic, it now seems quite clear that a didactic element has always asserted itself in his art, whether it concerned the nature of Minimalism during the 1960s or the prospect of annihilation in the 1980s. That is, Morris yoked his art to an idea or a set of ideas of which the particular works were illustrations. When he wrote in 1971, for instance, that "it seems a truism at this point that the static, portable, indoor art object can do no more than carry a decorative load that becomes increasingly uninteresting,"[8] I do not think he meant to condemn all indoor portable pieces, but those that were merely decorative.

His own work, whether indoor or outdoor pieces, contain few such elements. This is not to say that he is uninterested in quality of finish or design, but that it is difficult to isolate elements in his work that have purely decorative functions. Morris is, at heart, a moralist.

In a career as varied as his, it is difficult to pick out a consistent mode of compositional organization, but one of the recurring motifs in this aspect of his work is the particular way he relates forms to surrounding fields. Especially in the scatterpieces of the late 1960s, he diffused focal points to the extent that figure and field were not so much interchangeable as in a painting by, say, Cezanne, as they were continuous. As Morris once indicated, accumulations are closer to our true readings of visual fields.[9] Even though he originally argued this point in regard to art as energy, as process, and as flux, the point remains that he was quite willing to ignore traditional compositional elements such as dominant and subordinate relationships or centers of focus. In the new works, the colors that swarm over the pastel surfaces also lack hierarchies of interest and, to keep the pastel sections from becoming dominant forms of focus within the relief-covered frames, Morris allows the movements and colors generated in the centers to spill over the frames to their edges. Although these works are not as rigorously wholistic as, say, Barnett Newman's mature paintings or Jasper Johns's early pieces, they clearly continue a mode of visual investigation traceable throughout Morris's career.

Morris has also inserted himself actively into his work, and not only in performance pieces on a stage with dancers or over an open field on horseback. As early as his *I-Box* of 1962, in which a nude photograph of himself appears behind an opening in the shape of the letter "I" and later in 1974 in his poster of himself in a German helmet and chains, his presence has been apparent. And now, in one of the new pieces, the forms and colors of an attached childhood drawing of a human aircraft coupled with a death's head serve as the basis of its design. Whatever the larger meanings that might accrue to the connection of a youthful drawing with a mature work, combining images of Walpurgis Night with Gotterdammerung, Morris does not see himself as a passive, anonymous spectator to the gestation of art movements or the passing of civilizations.

Another theme that recurs in Morris's work is that revolving around destruction, disappearance, and entropy. This can be seen in his scatterings and felt pieces as well as in his monumental pilings of lumber and concrete, and, particularly, in relation to the new pieces, in several

works made since 1979. A major difference between the earlier and more recent pieces is, of course, the concentration on human destruction.[10] The earliest instance of this new concern emerged in the drawings of tombs for victims of hurricanes, mining disasters, drownings, and air crashes in 1979. These lead to the Cenotaph Series, eight drawings with typed explanations, which, in turn, served as the basis for the *Preludes (for A.B.)* of 1980. This set included onyx stones topped with a death's head on each piece and covered with silk-screened statements describing those commemorated: the victims of industrial poisoning, economic imperialism, materialistic decadence, floods, and air crashes. Some of the texts presented scenarios describing how the event of death might take place. There is a curious conflation in them of present and future time.

Following the *Preludes (for A.B.)*, Morris exhibited in 1980 a piece called *Orion*, a silvered human skeleton hanging from the ceiling entwined with tangled aluminum wires. In the next year, he designed the startling environmental piece *Jornada del Muerto* (from "The Natural History of Los Alamos"), which reviewed the development of the atomic bomb and the destruction of Hiroshima. Its major features included black-painted skeletons astride missiles, a mural of a mushroom cloud, photographs of the creation of the first atomic bomb and of the burn victims in Japan, copies of Leonardo da Vinci's drawings of the Deluge, and "two large flags of thick felt with three-dimensional stars and stripes hanging leadenly against a wall."[11]

In the same year (1981) Morris created *Restless Sleepers/Atomic Shroud*, silk-screened linen and pillowcases in the form of a bed with the top sheet turned back. The texts on the pillowcases include the following: "it would be difficult to achieve erasure with a single thermonuclear device, given the present state of technology," and "more practical and more certain would be the utilization of several dirty, fairly high megaton yield devices."[12]

Altogether, these works might be considered a high form of agitprop, in their ways not too dissimilar from, say, Ben Shahn's *Lucky Dragon* of 1960 in which he portrayed a victim of American nuclear tests in the Pacific, a sailor whose ship was dosed by fallout. The text in that painting reads: "I am a fisherman Aikichi Kuboyama by name. On the first of March 1954 our fishing boat the Lucky Dragon wandered under an atomic cloud eighty miles from Bikini. I and my friends were burned. We did not know what happened to us. On September twenty third of that year I died of atomic burn."

With the development of the Psychomachia (also Psychomania), Firestorm, and Hypnertomachia Series in 1982, Morris substituted abstract statements about destruction for the agit-prop of the immediately preceding pieces. The Psychomachia drawings included stenciled images of men spun about the surfaces of each sheet. The Firestorm drawings evoked images of atomic blasts. Although Morris acknowledged the influence of Leonardo's drawings of the Deluge, his more shattered, explosive, and centrifugal forms also evoke some of Jackson Pollock's drawings of the mid-1940s (the drawings strongly influenced by Kandinsky).

The Hypnertomachia Series, whitened reliefs made of hydrocal, included body fragments, organs, and genitalia. Of the three sets, texts were added to the Firestorm pieces. At least one recorded Morris's own thoughts. "Working with blackened hands in a dark overheated room and thinking about an approaching firestorm that is consuming the city, an attempt is made to recall the motion in one of Leonardo's last Deluge drawings."[13] The others, however, describe events in Hiroshima. "Around 11 a.m. the in-rushing air developed into a whirlwind and a firestorm began sweeping toward the hypocenter incinerating everything in its path. The sky became dark with clouds of ashes which fell later in the day as a lethal black rain," and "There is no record of those who gathered that morning at the Miyuki Bridge. Some died on the pavement from their burns before they could cross. No one had any comprehension of what had happened. Many who managed to cross that day came to wish they had never survived." By late 1983, color had been added to the black firestorms and white hydrocal reliefs, and elements of both series had been combined into integrated units. The most recent works are further examples of the combination of firestorms and hydrocal reliefs.

But there is more to say about them than just pointing out their provenance in Morris's work. An essay by Morris published in 1981 is quite suggestive of his state of mind then and perhaps now.[14] In it he suggested that American art could be divided roughly between four attitudes or positions, the aggressive, expansionist, abstract (Pollock); the cynical, ironic concerned with systems (Duchamp); the realistic, reflecting alienation (Hopper); and the decorative, accumulative, repetitive (Cornell). He found the last to be the most mindless and least challenging, but the one, unfortunately, to be dominant in American art. He associated its popularity with the exhaustion of modernist forms and the condition of modern life.

An emotional weariness with what underlies them [the exhaustion of modernist forms] has occurred. I would suggest that the shift has occurred with the growing awareness of the more global threats to the existence of life itself. Whether this takes the form of instant nuclear detonation or a more leisurely extinction from a combination of exhaustion of resources and the pervasive, industrially based trashing of the planet, that sense of doom has gathered on the horizon of our perceptions and grows larger everyday. Concomitantly, credible political ideologies for the ideal future no longer exist and the general values underlying rationalist doctrines for an improved future through science and technology are crumbling fast ... In any case the future no longer exists and a numbness in the face of a gigantic failure of imagination has set in. The Decorative is the apt mode for such a sensibility, being a response on the edge of numbness.[15]

This is strong language, rarely matched by an American artist. One thinks of Thomas Cole's prediction in 1835 of the breaking up of the United States and of his five paintings titled *The Course of Empire*, a dispirited warning to a rapacious and greedy public betraying the ideals of the Founding Fathers.[16] But Morris, of course, has raised the ante to world destruction rather than the failure of a particular country or political system, and has given us not a warning but a vision of the holocaust.

If any ray of hope exists in these works, it is suggested in psychobiological rather than politicoeconomic terms. In his essay, Morris wrote that "if the impulse for the energetically abstract could be identified with Eros, the decorative would fall on the side of Thanatos."[17] Perhaps these words provide a clue to reading the new pieces, in that they contain a series of dialogues between life and death instincts. On one level, the firestorms represent Eros and the hydrocal reliefs, with their repetitive body parts, Thanatos. On another, the sentences attached to the firestorms (listed earlier) represent the presence of the death instinct in life. In the reliefs, the reverse is the case, the sexual members suggesting the presence of life in death. (The idea of sex as a loss of body fluids, as a momentary loss of control, and as a preliminary to sleep also suggests the immanence of death.) So, as Eros and Thanatos are totally intertwined with each other in Freudian theory, so their visualizations are intertwined in Morris's new work. As there is death in life and life in death, so there are Morris's handsome pieces that dwell on horrific themes, acts of creation dealing with threats of destruction.

Similar thoughts and images course through works by contemporary

poets. As with artists, approaches range from the purely descriptive to the abstract, from "see-it-now" accounts to the evocatively imaginative. The perceptions of at least one poet, James Merrill, parallel Morris's, particularly in the former's complex book-length poem *Mirabell: Books of Number,* in which apocalyptic visions are intimated. One passage seems especially close to Morris's latest works as well as to the earlier monocolored firestorms and hydrocal reliefs.[18]

> THIS ATOM GLIMPSED IS A NEARLY FATAL
> CONSUMMATION
> ONE FLOATS IN CLEAR WARM WATER THE SUN OF IT
> PULSES
> GLOWS
> Through eyelids, a veined Rose
> A MUSIC OF THE 4 COLORS TO FLOAT LAPT BY COOL
> GREEN
> Sun yellow, aquamarine,
> Cradle of pure repose
> & OF INTENSE FISSIONABLE ENERGIES BLACK &
> WHITE
> WHICH EITHER JOIN & CREATE OR SEPARATE &
> DESTROY
> Day and night, day and night
> O IT IS SPERM EGG & CELL THE EARTH & PARADISE O
> A burning in our eyes –
> What you must feel, recalling that lost joy!
> (But They feel nothing, They have told us so.)

This is the right moment to end this essay, but I would like to raise one issue. It concerns the way blame is assigned for past and possibly future holocausts. In the *Jornada del Muerto,* Morris clearly blames the United States for instituting atomic warfare and in the new pieces he holds the Royal Air Force responsible for the firebombings of German cities. In a telephone conversation, Morris acknowledged the terrible war record of the Axis countries, but added that the Allies had crossed a moral line, too. From the tenor of our conversation, I assumed that he was not among those – the unilateral disarmers being the extreme – who see only evil in Western military actions, but rather one who did not want to see the West engaged in moral transgressions whatever the provocation.

THIRTEEN

A Ramble Around Early Earth Works

I will bet that I am not the only sympathetic person who still has trouble with early Earth Works. In trying to understand their significance as well as to locate them in American art, I find evaluation very difficult. On the whole, the most interesting and affecting examples, with few exceptions, are not the early pieces, but those connected to reclamation projects. But even many of these are neither too different nor too distinct from the efforts of landscape architects, a fact made abundantly clear by turning the pages of the magazine *Landscape Architecture*. I do not mean to argue that art must be socially useful. Art needs no excuse to exist, but at some moment questions of context, quality, purpose, and meaning arise, that is, questions of value, and these are not easily put off by the kinds of explanations which appear throughout the literature on Earth Art. To understand something about the particular Earth Work is one thing; to assign value is another. And in this regard early Earth Works still remain problematic.

A basic issue concerns the artists' relations to the land, at least before the beginning of the reclamation projects in the middle 1970s. Initially, some comments recalled less an interest in the land than the kind of hostility to the Big City and all that it represented held by Regionalists of the 1930s: centralization, urbanization, commodification of objects

through the gallery system, loss of contact with nature. In 1969, Robert Smithson asserted, "the tools of art have too long been confined to 'the studio.' The city gives the illusion that the earth does not exist. [Michael] Heizer calls his earth projects 'the alternative to the absolute city system.'"[1] Heizer himself wrote in the same year, "both art and museums are victims of the city which demands compliance with its laws and limits."[2] Critic Edward Fry, combining words reminiscent of Lewis Mumford's diatribes in the 1920s against the city with a modern nostalgia for a past that never existed, felt:

> the new Romanticism of Natural Art is almost purely secular and phenomenal. It aspires not to romantic transcendence but to a historically conditioned nostalgia for the Edenic, the primeval, and the prehistoric, rendered acutely desirable by the excessive urban monopoly of contemporary cultural life and by the degradation of American cities themselves.[3]

Finally, another critic, Nicholas Capasso, suggested that Earth artists, reeling from the psychological onslaughts of the Big City, might be suffering from future shock or something bordering on an inability to cope with modern civilization.[4]

But these notions of escaping the city by returning to the soil are at best debatable, and seem to be more the responses of critics than of artists, since artists have insisted that they were less interested in relating directly to nature itself than in using it for at least two chief purposes. It could be another tool or material with which to work, or, depending upon the setting and siting of a piece in nature, artists might try to invoke other cultures or sequences of time. In either instance, nature was to be used in deliberate ways that were fully urbanized as well as loaded with the apparatuses of the then contemporary styles of Minimalism and Process Art. Recording transcendent experiences or emphasizing the restorative charms of nature were not primary. Bucolics were applied bucolics.

Artists such as Carl Andre, Dennis Oppenheim, Heizer, and Smithson also emphasized the separation between art and nature. Andre quite succinctly indicated his position when asked if Earth Art suggested a kind of romantic primitivism. He said that artists had a limited stock of ideas which go in and out of fashion and this notion was more relevant to Earth Art than "a big return to Mother Earth."[5] Smithson found that "photography [made] nature obsolete. My thinking in terms of the site and the non-site," he said, "makes me feel there's no need to refer to

nature anymore."[6] Oppenheim turned to Earth Art because he wanted to go beyond indoor pieces. His "use of a terrestrial area came through a very formal concern with sculpture."[7] Of his *Directed Seeding-Cancelled Crop*, which was the letter "X" plowed into a grain field in Holland in 1969, Oppenheim said, "planting and cultivating my own material is like mining one's own pigment . . . I can direct the later stages of development at will."[8] He also wanted, as he said, to get below ground level, since he did not like protruding objects. At that time, 1970, he thought about sites through studying maps and collecting data, rather than in response to his physical presence at a site.[9] Heizer, in discussing his *Complex One/City*, a large monument in Nevada erected from 1972 to 1976, stated, "it's about art, not about landscape."[10] This statement seems to reflect his general attitude at the time, since in 1969 he created the pattern for *Dissipate*, a sequence of depressions in the Nevada earth, by first dropping match sticks on a surface.[11] Other outdoor works of this period seemed to satisfy his feeling for and interest in space rather than for any kinship he might have felt for nature.[12] With Heizer, a note of nationalism was also present in the early years. It was not just bringing to the landscape highly abstract notions of art nurtured by the history of avant-garde taste, not to say knowledge of business procedures in dealing with construction workers and their earth-moving equipment, but a desire to be both modern and American at the same time. Like Stuart Davis, earlier in the century, who acknowledged the influence of the telephone, the telegraph, the radio, the car, and the airplane on his sense of form and pictorial space, Heizer said,

> we live in an age of the 747 aircraft, the moon rocket – objects that are constructed by man that range from the most minuscule complex electronic dial to airplanes that have wings weighing 45 tons on them. So you must make a certain type of art.[13]

This new art, which he identified as American art, should match the scale of America's architectural and technical accomplishments, he believed.[14] Instead of escaping the Big City, Heizer really wanted to compete with its products as an artist and he evidently wanted to do so in an arena physically large enough to handle his responses to a 747.

In fact, several Earth artists, perhaps unwittingly, created Earth Works that had the paradoxical effect of suggesting the presence of urban civilization in general, but offering a temporal escape from our particular one. Figures such as Robert Morris, Nancy Holt, Walter de

Maria, and Smithson invoked references to megalithic constructions and religious edifices of earlier civilizations such as those at Stonehenge, Chichen Itza, and the Nile Valley and sited their works according to highly sophisticated knowledge of solstices and equinoxes. Heizer even approached the size of Pre-Columbian forms in his *Complex One/ City*. However, the various man-made mountains designed by these artists and their uses of astronomical calculations had ultimately less to do with relating to nature than with giving it order. As Paul Shephard suggests in his important book, *Man in the Landscape*, ancient cities were based on agricultural surpluses, or dominance over the land. Structures in early cities, which were invariably associated with a priestly class, symbolized insulation from climate and from nature. Such structures, man-made mountains, actually implied a break in the harmony with the environment, a mastery over it, rather than a reciprocal interaction with it.[15] Employing such forms and using such calculations, then as now, were urban ways of trying to control nature because systems predominate. As for Earth artists, their invocation of past civilizations really put us more in touch with our minimal book knowledge of past civilizations than with nature, past or present.

This is not necessarily bad, just urban. But one can object to the ways in which prehistoric and non-Western monuments have been invoked. Usually, objects from other cultures have provided artists with two significant sets of possibilities, one of style, the other of content. For example, Japanese prints and African sculpture have had tremendous impact on Western artists with regard to plastic possibilities and the uses of color. Nothing of the sort has emerged from yoking the names of Stonehenge and Chichen Itza to Earth pieces. Certainly no new types of visualization of forms have occurred. Furthermore, invoking the names of prehistoric constructions as a way to "recapture the force of primitive monuments,"[16] strikes me as bogus. Those earlier monuments were integral to their cultures, reflective of profoundly held beliefs and associated with a strong priestly class. To mention them in association with works that are entirely personal and with attitudes of the artists that are essentially ephemeral is to provide the modern works with a heritage and profundity they neither possess nor deserve. Comparison, say, between the density of meaning of Chichen Itza with that of Heizer's *Complex One/City* is simply improper, and indicates a kind of appropriation of an important artifact from another culture, let alone a gross and playful colonialism, that demands further scrutiny.

Nor is the viewer given any clues, really, about responding to these

works or relating them to ongoing experiences, theirs or the artists', other than in a knowingly name-dropping way. In contrast to the glib ways the names of these monuments have been used, one has only to think of how profoundly, say, Marsden Hartley and Barnett Newman considered and were influenced by the cultures of Southwestern and Northwestern American Indians, respectively. Consequently, only with great generosity can I agree with one critic's observations that Heizer's *Complex City/One*, Robert Morris's *Observatory* (1971, The Netherlands) and Smithson's *Broken Circle-Spiral Hill* (1971, The Netherlands) "support comparison with ancient and tribal monuments that seek accommodation with, signify worship of, or aspire to protection from natural deities," and that these works "partake of the dramatic formal vocabulary, the iconic appearance, and the mysteriousness of earlier prototypes."[17]

The desire to align works with the equinox and the solstices by figures such as Robert Morris and Nancy Holt also seems superficial. True, Morris's *Observatory* (1971, The Netherlands) and Holt's *Sun Tunnels* (1976, Utah) reflect planetary motion, but in a way utterly vague to the casual observer, and, I suspect, as well to the artists involved, who are probably not very interested in nor conversant with the spiritual and religious (or scientific) elaborations of astronomical calculations in any society, let alone their own. By comparison, such works do not even begin to approach the participative and ritualistic intensities of Jackson Pollock's paintings of the 1940s, nor the profound desire to study and comprehend, in any kind of scientific way, the geological changes in and geological history of the earth's surface visible in Frederic Church's landscapes of the 1850s and 1860s, nor the profound responses to nature's cycles witnessed in Thomas Cole's landscapes in the second quarter of the nineteenth century. Pollock, Church, and Cole display in their work an inner necessity quite lacking in the Earth pieces.

In *Sun Tunnels*, which is aligned on the solstices, Holt has revealed one plausible explanation for creating works with narrow, confining openings on the landscape. It is that of the typical urban desire for control over nature. I am not criticizing this desire, but I merely want to point it out – in the same way I once suggested that the delight Hudson River School artists experienced in coming upon a house in the wilderness had as much to do with affirming the domestication of the wilderness as with being able to spend a night indoors.[18]

Despite the fact that Holt enjoyed being in the desert in Utah

"linked through thousands of years of human time with the people who had lived in the caves around there for so long," she also "wanted to bring the vast space of the desert back to human scale . . . The panoramic view of the landscape [was] too overwhelming to take without visual reference points," she said. "Through the tunnels, parts of the landscape are framed and come into focus."[19] Thus framed, the landscape is made visually manageable. Despite arranging the tunnels on the solstices, Holt clearly did not want to ritualize that alignment nor suggest a merging of her soul with the Infinite, but to reduce the size of the Infinite to the scale of the individual. Who's boss, anyway? And like Holt, Charles Ross, another Earth artist, also prefers to center the universe around himself. For a work being completed in New Mexico, he wants to "bring the motion of the stars to personal measure, so we can feel the unity of the movement of the universe in relation to ourselves."[20] Unlike Henri Bergson and early twentieth-century American landscape painters such as Max Weber, Arthur Dove, Marsden Hartley, and Georgia O'Keeffe who wanted to project themselves into the flux and flow of universal time and universal rhythms, Ross wants to maintain control, to reduce the movement of the universe to something manageable, to relate it to us. His is less an adventure into the unknown than an attempt to stabilize the unmanageable, to become the sun around which all else rotates. Now any number of artists have imposed their wills on the landscape by using Claudian compositional frameworks, and artists such as Alfred Bierstadt have reduced the scale and splendor of the American West to the psychological size of a living room wall, but what makes artists like Holt and Ross different is that they want to impose control on the entire cosmos for what seems to be primarily personal reasons rather than to try to understand it for religious, cultural, nationalistic, or philosophical ones.

A case in point is Holt's *Rock Rings* of 1977–78 in Washington, in which she further refined her sense of control over the landscape by cutting holes in the rings sighted on various compass points. By looking through the holes she felt that one might get to know one's self better. "The viewer explores himself in relation to an expanded environmental field," she said. The openings "seem to have a voyeuristic function with the landscape. They function to frame or isolate distant views and make them available to the viewer for observation."[21] I am not certain how one explores oneself in such a landscape, but, as in a Renaissance painting with single-point perspective, the landscape view is controlled and the interaction between viewer and landscape is minimal. Again,

this is not bad, but it does imply dominance over the landscape, not sympathy with it. Nor does this really invoke prehistoric sites which were aligned with planetary movements for reasons other than personal development.

One wonders, at least in the early Earth Works, how artists really felt about the land. Heizer, for one, said, "in the desert, I can find that kind of unraped, peaceful, religious space artists have always tried to put into their work. I don't want any indication I've been here at all. My holes have no history, they should be indeterminate in time . . ."[22] This must have been said before he began *Double Negative* which, in its massive assault on the land, reflects, perhaps like the Pumping Iron fad, a machismo response to the frustrations of the war in Vietnam. Of these earlier cuts and holes in the landscape, Peter Hutchinson, at least, understood that "there is a sort of immortality to these Western landscapes that he has violated . . . It is as though an alien presence has been there."[23]

More symptomatic of the ways nature was manipulated for reasons that had little to do with the landscape was the response of one critic to *Double Negative*. By invoking Saussure to explain the two cuts in the mesa floor, Rainer Crone provided a totally intellectualized and urbanized interpretation of Heizer's piece. Crone argued that signs function through their relative positions rather than through their intrinsic values. Thus we know about dark because we are familiar with light. In regard to *Double Negative*, "we experience the mesa, a part of the landscape of nature, as a positive entity through its opposition to the two trenches which represent the negative element."[24] This is basically an environmental argument without considering the environment, because if you really want to experience the mesa as a positive entity, you merely have to look over its edge into the great valley to see the negative element.

Such human-made intrusions on nature which require such desperate justifications speak of sensibilities utterly alienated from nature as well as from the self. In an overwhelming amount of criticism of Earth Art, there is an insistence on experiential qualities – of the self in its temporal relations to the spaces, forms, and colors of the site. But experience and self-awareness to what purpose? Most often, it would seem, to a mere cataloguing of the site and to describing one's passage through it rather than to any kind of evaluation. It would seem that one must visit a site in order to become self-aware and that seems to be recompense enough.

But occasionally something more profound might occur. One critic described Walter de Maria's *Lightning Field* (1977, New Mexico) in what must have been an unintended parody of one of Ralph Waldo Emerson's most famous passages. In *Nature*, Emerson related a transcendental experience, a merging with the Infinite, in the following way:

> Crossing a bare common, in snow puddles at twilight, under a cloudy sky, without having in my thoughts any occurrence of special good fortune, I have enjoyed a perfect exhilaration . . . standing on the bare ground, – my head bathed by the blithe air, and uplifted into infinite space, – all mean egotism vanishes. I become a transparent eyeball; I am nothing; I see all; the currents of the Universal Being circulate through me.[25]

The modern critic, recounting her experience out there in the desert, wrote:

> Standing beneath the poles, with their reflecting surfaces mirroring the light and the colors of the ground, the sky, and ourselves, we see them as connectors between earth and sky. As human beings we have the same vertical orientation as the poles. We too are bridges between earth and sky – how often do we perceive ourselves in this manner?[26]

Not very often, it would appear. Nor, given the self-conscious language of this passage, is there any compelling reason why we should or could. But what is interesting about these observations is the fact that nature appears almost as a stranger, as something to be considered in highly intellectual terms or to remind us that there is an "out there" out there. Nature seems so exotic that we observe it and we know we are supposed to be stirred by it, but we really cannot relate to it except by observing that we do not relate to it.

Another critic, observing the panorama from the tumuli forms of animals designed by Heizer at Ottowa, Illinois, in 1984–85, suggested that "the viewer is not encouraged to surrender consciousness to the overpowering forces of nature but to use that consciousness in a way compatible with nature [whatever that means]." Then reverting to cataloguing the site, the critic said that "standing on the mounds one has a direct physical awareness of the densely compacted earth that forms the mass of the works [this sounds like an introduction to people from Mars about what to expect on our planet], as well as of the silky grasses whose roots hold the contours in place [that is what roots do]."[27]

This sort of analysis also suggests unresolved problems in Process Art which shares fundamental traits with Earth Art. In Process Art, the artist might want to call the doing experience an art experience, but the viewer, not necessarily involved in the process of the doing, is left with trying to make something out of the remains of the artist's experience. Robert Morris articulated the artist's position clearly in 1970 when he wrote:

> There are "forms" to be found within the activity of making as much as within the end products. These are forms of behavior aimed at testing the limits and possibilities involved in that particular interaction between one's interactions and the materials of the environment . . . [Process Art] has been involved in uncovering a more direct experience of basic perceptual meanings [direction, weight, balance, motion] . . . through the experience of interaction between the perceiving body and the world which fully admits that the terms of this interaction are temporal as well as spatial, that existence is process, that the art itself is a form of behavior.[28]

This statement certainly describes what the artist does and how s/he looks upon the making of the object, event, etc. But it really does not inform the viewer how to witness the art work except in the most general, experiential way. The viewer is left with two choices – recreating the artist's activities by verbal description or trying, as in an Earth Work, to experience it by walking through it and concentrating on what s/he sees. Unless there is some esthetic or ritualistic dimension to enlarge the experience beyond mere observation, then the experience does not transcend the ordinary or the narcissistic, since it is involved only with the self. If, for the viewer, becoming more aware of one's surroundings when viewing an Earth Work can be called an artistic experience, then any kind of awareness becomes an artistic experience or, at least, a Happening. Hence, I suppose, the excuse for dragging in prehistoric monuments in attempts to raise the experience above the ordinary.

Just the same, there are times when artists like Holt, certainly Smithson, Alan Sonfist, and others can move beyond narcissism and urbanism. At such moments, the landscape is used with great sympathy and understanding rather than as another kind of material, albeit larger in size and scale than those used in an artist's studio. And I do not mean land reclamation projects however intelligently planned and useful these might be.

I would argue, for example, that Holt's *Hydra's Head* (1974, New York) is her early masterpiece rather than the more acclaimed *Sun Tunnels* because it cannot be compared invidiously with works by earlier artists, American or otherwise, and because it has interesting transcendental and luminist resonances. It is also a work that escapes the artist's control and becomes anonymous in the landscape. Its six circular concrete pipes, placed vertically in the ground, are filled with water which reflect the sky. Struck by the implications of these images, Holt wrote "the sky has suddenly fallen and is circled at my feet. Clouds drift through the earth . . . Nature's mirrors absorb."[29] These thoughts, evoking a sense of organic continuity between earth and sky in which the viewer both participates and observes, recall similar passages by Thoreau in *Walden* and in *A Week on the Concord and Merrimack Rivers*. In *Walden*, Thoreau, describing a lake between storms, noted that in the stillness of both air and water "the clear portion of the air above it [the water] being shallow and darkened by clouds, the water, full of light and reflections, becomes a lower heaven itself so much the more important." And in *A Week*, writing about a river on a still day, he said, "we were uncertain whether the water floated the land, or the land held the water in its bosom . . . For every oak and birch, too . . . we knew that there was a graceful, ethereal and ideal tree making down from the roots and sometimes Nature in high tides brings her mirror to its foot and makes it visible. The stillness was so intense and almost conscious, as it were a natural Sabbath."[30]

As Thoreau was willing to trust his response to nature unmediated by his need to control, so was Holt in this instance. In a different context, Holt, in another passage describing *Hydra's Head*, provided a late-twentieth-century interpretation to an image Emerson had considered over a century before, an image that reaches beyond Earth Art to social commentary on our epoch. She wrote, "evaporation and rain interact in an emptying and replenishing cycle. Each drop of rain causes circular ripples to multiply circles within circles within circles."[31] The image is one of repetition, of containment, of limitation, even of exhaustion. By contrast, the more optimistic Emerson wrote in his essay "Circles":

> The eye is the first circle; the horizon which it forms is the second; and throughout nature this primary figure is repeated without end . . . Our life is an apprenticeship to the truth, that around every circle another can be drawn; that there is no end in nature, but every end is a beginning; that there is always another dawn risen on mid-noon, and under every deep a lower deep opens.[32]

Constantly at war with limitations, Emerson, according to one recent critic, understood that, "liberation from one enclosing cultural discourse is to be achieved only by drawing another 'circle' around it, all the while knowing that eventually it, too, will become an inhibition."[33] Such blind faith in the ability to break through "circles" vanished from the American art world by 1920, and even when contemporary artists use the actual landscape itself, none of its old associations contained in notions such as purity or new beginnings can surmount our awareness of limitations and of the accountability that lies beyond frontiers.

Among Earth artists, Robert Smithson is the most interesting to consider in this regard as well as in relation to Emerson and to earlier artists such as Thomas Cole. For unlike Emerson, but like Cole, Smithson was one of the great pessimists in the history of American art and, because of his interest in entropic situations, a genuinely modern critic of American culture. In fact, his various comments on the American landscape are perhaps the most cogent among artists since those of George Inness in the late nineteenth century. Smithson found the potentialities for equilibrium and decay much more evident and demonstrable than those for growth and development. Almost as if in response to Emerson's notions in "Circles," Smithson said that "no matter how far out you go, you are always thrown back upon point of origin. You are confronted with an extending horizon; it can extend onward and onward, but then you suddenly find the horizon is closing in all around you ... In other words, there is no escape from limits."[34] In place of ever-expanding circles, Smithson's key image is that of a spiral or, better, a vortex that encompasses and encloses. As he suggested, "the desert is less 'nature' than a concept, a place that swallows up boundaries."[35]

Although Smithson felt that he was part of nature, he thought that "nature isn't morally responsible. Nature has no morality."[36] In an indifferent nature, the transforming qualities of one's spiritual resources counted for little. Consequently, Smithson was resolutely materialistic. In place of spiritual dilation, there was material entropy. In a revealing statement, he said that "rust becomes the fundamental property of steel."[37] Unlike the poetry that Emerson could find in railroad trains and their impact on modern life, Smithson found a deadpan reality in his preference for sites "that had been in some way disrupted or pulverized," sites "that [had] been disrupted by industry, reckless urbanization, or nature's own devastation."[38]

At such sites, in such entropic situations, Smithson understood that time should be considered as something random rather than linear.

The end product is the result of an equilibrium of forces rather than the result of a trajectory through time in the sense of a rise and a fall or a reaching for perfection than a dismemberment. In entropy, there is not a sense of progression through time as much as happenstance movement in time. Smithson worked with this modern notion of time, and it distinguishes him from probably all previous American artists who used the landscape in one way or another. The differences are most clear when comparing his point of view to that of Thomas Cole, whose concerns with the growth and destruction of empires as well as the life and death of individuals are linear in concept. Smithson's, by contrast, are diffuse and multiple. And they should be, since he was concerned with the materiality of objects whose destruction could be witnessed. He does share with Cole, however, the knowledge that nature cannot be controlled and that human activity and human endeavors are subsumed by time. Where Cole found solace through his belief in a timeless and eternal God, Smithson, with his more fluid sense of time and greater understanding of science and history, wanted to "explore the pre- and post-historical mind," and to "go into places where remote futures meet remote pasts."[39]

This would appear to be a desperate quest, one which might show a way beyond entropy. But since Smithson was so interested in geology, he was probably in search of an understanding of entropy in all its man-made and natural occurrences, of how it occurs in time, of how the earth and what lies upon it, man-made or otherwise, had ended up in whatever condition it was in. "The strata of the Earth is a jumbled museum. Embedded in the sediment is a text that contains limits and boundaries which evade the rational order, and social structures which confine art. In order to read the rocks we must become conscious of geologic time, and of the layers of prehistoric material that is embedded in the Earth's crust."[40] Self-enlightenment did not seem to be his goal, nor control of nature, but rather a desire to understand its force and then to create works, to create an artistic reality, that paralleled the ways those forces might operate.

In effect, Smithson appears to have been working toward a modern reading of nature. He discounted those who still adhered to the idea of the pastoral, those who had "an elegant notion of industrialism in the woods."[41] And, by applying his tough-minded notion of entropy to the modern landscape, he cut through the whoozy romanticism of artists ranging, in the twentieth century alone, from Max Weber to Mark Rothko to Alan Sonfist who preferred to avoid the problems of modern

civilization and industrialization, let alone attempt to understand how nature might really operate, by escaping into or bringing to us a construct of nature that was pure and uncontaminated and unreal.

For Max Weber, under the general influence of Bergsonian ideas early in the century, art was a mechanism to gain access to the life inherent in objects and to the flux of time. "Even inanimate objects," he said, "crave a hearing, and desire to participate in the great motion of time and its indentations . . . The flower is not satisfied to be merely a flower in light and space and temperature. It wants to be a flower in us, in our soul. Things live in us and through us."[42] Unlike Smithson, who wanted to understand nature's processes more directly, Weber imagined a sense of life in everything and projected a desire to become one with everything. "Works of art are man's revelations of nature's contents," he said. "To infer from the visible to the invisible, to penetrate the opaque, to soar high into space, and to dive deep into the seas, to walk through fissures to the center of the earth, to imagine one's self being a fish or a bird, is to penetrate more into the spheres of the unknown."[43]

Even if Smithson's language is occasionally similar to Weber's, meaning is obviously different. Smithson wants to observe: Weber, like Emerson, wants to merge. Similar differences also exist between Smithson and Arthur Dove, a contemporary of Weber. Both Smithson and Dove wanted to work with nature's basic substances. Smithson indicated that he liked "to work with water, land, air and fire (solar light) as a whole interconnected phenomenon."[44] Dove wanted "to take wind and water and sand as a motif and work with them . . ."[45] But where Dove tried to suggest the oneness of nature, the interconnectedness of the physical and the spiritual (he was a Theosophist) as well as "instincts from all of life,"[46] Smithson seemed to be more concerned with the effect one thing had on the other. He was more interested in the physical processes of nature than its imagined spiritual ones.

Smithson would probably not have responded to Mark Rothko's desire, after 1947, to reveal in his paintings "the principles and passions of organisms," for Rothko's quest, like Weber's and Dove's, was of a spiritual, if more private, sort.[47] Rothko wanted to escape into a timeless stream of organicity. Smithson, more materialistic and therefore more aware of physical limitations, based his intuitive concerns on the hard, unyielding surfaces of objects.

Among Earth artists, Sonfist most nearly approximates the Weber-Dove-Rothko line of thought, but gives it a late-twentieth-century inter-

pretation. Sonfist has, like Weber, realized that his "work deals with the idea that the world is always in a state of flux. My art," he says, "deals with the rhythm of the universe. A plant grows in cycles – man moves in cycles – my work tries to bring about awareness of these move- ments."[48] But religion is gone and transcending the ordinary by merging with the Infinite is gone, as well. In their places, Sonfist has assumed responsibility to remind people that nature still exists and that we should be aware of it. Unlike nineteenth-century landscapists who were quite articulate in explaining the ways in which nature affected viewers, Sonfist is vague. He knows it is out there and it is important in some way, but does not guide us to it. He merely presents it. When he says, "my art presents nature. I isolate certain aspects of nature to gain emphasis, to make clear its power to affect us, to give the viewer an awareness that can be translated into unravelling of the cosmos," he is speaking in generalities.[49] These will not work any longer, since we no longer have paths – religious, transcendental, scientific – to get from the general to the specific in nature. A case in point is his *Earth Monument*, 1971, in which earth from the site was presented to show through "the variations of color and texture of the rock . . . events in the history of that land during millions of years."[50] How are we to react today to layers of earth? Who has the proper geological information? What will it change or re-enforce in our ways of thinking? Like using ancient monuments such as Chichen Itza to give meaning to modern Earth Works, presentations such as Sonfist's *Earth Monument* are ulti- mately disorienting. We do not know how to make the connections meaningful except in the most non-directive, generalized ways. We can applaud the effort to make us more aware of nature, but, in the end, to what effect, with what kind of focus? Perhaps in the doing activity, Sonfist found some sort of fulfillment, but this does not translate easily to the viewer except in ways that are verbal and conceptual rather than organic and spiritual. We go over in our minds what and why Sonfist did what he did, rather than respond to the effect the work is supposed to have. It seems to me that this is the reverse of what Sonfist had in mind.

I find, then, that most early Earth artists created works too personal for an art that is really in the public domain. In some of these works the landscape was used only as another tool or a thing with which to work, rather than as a something that carries a built-in content hard to ignore. I do not really see an escape from the Big City or the gallery system or anything much beyond a similar manipulation of materials.

Some works, although well intentioned, were much too general in that data is presented, but without suggesting ways to interpret intentions. This might be perfectly acceptable if there was something to look at other than the documentation, that is, some sort of visual organization that added up to more than the documentation, or if there was some compelling focus of content that was more than bare-bones archaeological or astronomical. So many pieces also look like rehearsals for something yet to come. On the other hand, the works that seem most successful are those in which the artist elicited from nature qualities peculiar to the landscape itself or in which statements were made, even in the absence of interesting visual presentations, that reached beyond the merely personal. Smithson's ideas are most central because they are theoretical in addition to being descriptive of his activities. His hard-nosed vision of the landscape is a welcome addition to the ongoing dialogue that American artists have conducted with the landscape for over 200 years, and it established a new base position from which to view the landscape. His writings, as well as many of his works, would seem to provide the strongest arguments for the viability of early Earth Works. They hold their own in whatever comparisons one might want to make with earlier writings or works. But, with a few other exceptions, I am still having trouble.

FOURTEEN

Reflections on/of Richard Estes

Nothing is certain in this Postmodern age.
Buck Browning, Colorado River Raftsman, July 5, 1991

This was the last thing I expected to hear after shooting another rapid at the bottom of the Grand Canyon. Unaccountably, or perhaps because I had not looked in a mirror during the previous week and because the raft had just floated over a glass-smooth stretch of water before entering a particularly turbulent part, I thought immediately of those paintings by Richard Estes which show a sheet of window glass parallel to the picture plane, those paintings in which you can see through the glass – often into a luncheonette interior – as well as what is reflected on the glass behind you (fig. 38). I thought about why these works had not been accepted into the discourse on contemporary art even though, despite traditional use of paint on canvas, they reveal various postmodern qualities. Although I was travelling light, I had, evidently, brought all my baggage with me.

Let's call them the window paintings. Estes painted about thirty of them from 1967 until the mid 1970s.[1] They are, to my mind, his strongest and most important work and warrant serious and sustained consideration. Of all his works, these are the most interesting to speculate about and the paintings which raise the most unanswerable questions.

38. Richard Estes, *Double Self-Portrait* (1976). Oil on canvas. 24 × 36 in. Courtesy of The Museum of Modern Art. Mr. and Mrs. Stuart M. Speiser Fund. Photograph copyright The Museum of Modern Art, New York. Richard Estes/Licensed by VAGA, New York, NY/Marlborough Gallery, New York, NY.

They are usually frontal, or, at least, the glass window is frontal and extends most of the width of the canvas. Often a bit of the street before the window is shown. As you look through the window you can make out interior forms and objects such as countertops and stools (or whatever the interior is used for) and walls sometimes covered with shiny, reflective mirror-like materials. As you look *at* the window, you see reflections of the street behind you – streets both parallel and perpendicular to the window and therefore to the picture plane, signs and writing which appear mirror-imaged in reverse, and bare traces of people walking, their shadows falling on the window or on objects within the interior. Because the perspective behind the viewer is the reverse of that within the interior, the further you peer or seem to peer into the interior, the more distant you see what is behind you. That is, at the same time that you see most deeply into the interior, you also see what is most distant behind you. Without turning your head, you can see what is both in front of you and what is over your shoulder. This means that projected space merges with reflected space. What you are looking at and what is behind you are both superimposed and juxtaposed.

What you do not see is an image of yourself standing in front of and staring at the window, nor, with the exception of *Double Self-Portrait*, can you find an image of Estes standing in your place or next to you. (In *Double Self-Portrait* he appears twice – once full-length in the window reflection standing passively next to a camera on a tripod and once, bust-length, reflected in a mirror-like surface within the interior.) In the transference of the image from his photographs to the painting, he and/or we have been painted out.

Estes has not been helpful in explaining these works. Like other photorealists, his comments about his art have been consistently dead-pan. He chooses to paint city scenes, he said, because he lives in a city (New York City). "You look around and paint what you see." Concerning reflections, he found them to be "rather rich and exciting – and stimulating to do." They opened, he thought, possibilities. His elaboration of this point indicates that his concerns were purely formal ones: "the eye tends to focus either on the reflection or on the interior, but both can be painted with equal emphasis." He largely omitted figures from these works because the viewer might begin "relating to the figures and it's an emotional relationship. The painting becomes too literal whereas without the figure it's more purely a visual experience."[2]

Just how much a visual experience he intended the paintings to be and by extension the city itself can be suggested by comparing Estes' thoughts with those of Edward Hopper. Their interest in light was similar. Hopper once said, "maybe I'm not very human. What I wanted to do was to paint sunlight on the side of a house."[3] Estes said "I've always considered light to be the real subject of painting."[4] But they part company in what light was to illuminate and in their responses to it. Hopper, describing as much his work as Charles Burchfield's, asked of the latter's studies of buildings, "is it not the province of work such as Burchfield's to render to us the sensations that form, color, and design refuse to reveal when used exclusively as an aim in themselves, and which works fail to encompass?"[5] By contrast, Estes denies to his work emotional content by insisting "I don't think my paintings have much emotion. They are rather straight forward."[6] And Estes, rather than allowing his buildings and street scenes to suggest meaning beyond even the use of language to describe any mood they might suggest, preferred to keep the visual separate from the emotional. "Even though you might have these ugly structures, nasty, smelly cars and dirty streets, when you look at it all as a picture you don't think of that: you look at it as visual organization. In a way this is the real abstraction – to abstract

the visual from the reality and just look at that without the emotion within the subject."[7] Estes wanted as few mediating agents as possible, even language, to stand between the viewer and the works. "I just feel that this is the way I want the paintings to look. . . . I don't think about those things because they're just words. Language is a very limited and flimsy thing."[8]

Estes clearly rejected narrativity, despite his multiplication of and apparently intense regard for details. Even his insistence on maintaining a clear focus on all objects revolves around his desire to deny narrative meaning. He has reasoned that if some objects were fuzzy and out-of-focus, the viewer would be directed to look at what was in focus. This would make "very specific what you are supposed to look at, and I try to avoid saying that. I want you to look at all. Everything is in focus."[9] He emphasized his denial of any sort of hierarchy of forms, or, to say it differently, he emphasized his desire for an impartial all-overness of effect and of object definition when he said "I don't think I've ever done a painting looking at it as a whole. Most of my paintings are worked out as details, and I can only hope that the whole thing comes together. But I can't deal with it all at once."[10]

What this seems to mean is that Estes is really not concerned with any sort of story line and that on a formal level he wants at the same time fragmentation and wholeness, multiplicity and unity, and that he cannot be held accountable for a painting's ultimate order. "I can only hope that the whole thing comes together." His disinclination to accept final responsibility is not unlike his ambiguous statements concerning his own intentions. On the one hand, he once indicated that his goal was "only to set down on canvas or paper what was before me."[11] On the other hand, he has indicated that when working from photographs, he selects, adds, subtracts, and imitates, since he wants the painting to be more like the place than the photographs of it. He wants more than what the photographs can offer.[12] And what could Estes possibly mean, in view of the sometimes unresolvable complexities of forms and space in the window paintings, when he says "in art you have to introduce structure, so we can see in an ordered way because that is what we get satisfaction from"?[13]

Other questions that can be raised without knowing where the answers lie include: is he really that disassociated from the narrative content of his work? is vision the only narrative? is his insistence on formal qualities a way to assert himself as a painter despite his photographic sources? has he painted himself and his camera out of the

picture for the same reason? does he use the paint medium as a way of reasserting himself as an artist in the creative process? why does he insist on using an old-fashioned medium, painting, to imitate the look of a modern medium, photography? On a different level, we might ask are these the quintessential contemporary urban paintings of the urban person literally absorbed and swallowed up by the overwhelming proliferation of objects and sights of the city? has the urban person literally disappeared – a disembodied substance – into the forms of the city, no longer able to do much of anything but focus intently and obsessively on a tightly controlled range of forms and not even be able fully to comprehend these spatially?

No doubt, there are other questions to be raised. But rather than ask more questions, or try to suggest answers to them, which would only raise more questions, I would rather consider the works in regard to postmodernist notions in order to establish a broad context for dealing with them as well as to suggest the seriousness with which they should be considered.

For a working definition of the term "postmodernism" I will rely here on distinctions between modernism and postmodernism made by Brian McHale in his book *Postmodernist Fiction*.[14] McHale suggests, broadly speaking, that modernism is concerned with epistemological questions while postmodernism is concerned with ontological ones. That is, modernists will ask questions such as "how can I interpret this world of which I am a part? what am I in it? what is there to be known? who knows it? how do they know it and with what degree of certainty? how is knowledge transmitted from one knower to another and with what degree of reliability?" Postmodernists, by contrast, foreground questions such as "which world is this? what is to be done in it? which of my selves is to do it? what actually is a world? what kinds of worlds are there, how are they constituted and how do they differ? what happens when different kinds of worlds are placed in confrontation and when boundaries between worlds are violated?"

Although one might question the validity of using for visual material the criteria and questions developed for written material, McHale keeps his discussions quite loose, readily admits that a particular work might have both modern and postmodern qualities, that an author's work over a period of time can change from one to the other, and that the entire issue of modern and postmodern is not necessarily one of chronology, but of intention and emphasis. He provides, therefore, a guide and a set

of questions rather than strict categories which can easily enough be used for considering visual material.

Parenthetically, by considering the differences between modernism and postmodernism to be as much a matter of intention as of chronology, one can argue that the seeds of postmodernism can be found in collage Cubism, Dada, and Surrealism, and that Abstract Expressionism, despite its debt to Surrealism, is the last of the great modern movements because of the artists' concerns with self-definition and self-understanding. The first important American postmodernists are, therefore, Johns, Rauschenberg, and Kaprow.

Staying with McHale for the moment, he considers one aspect of the postmodern novel as describing a world completely destabilized. Here he refers to works by Alain Robbe-Grillet and Carlos Fuentes, among others, in which "there is no identifiable center of consciousness through which we may attempt to recuperate the text's paradoxical changes of level and other inconsistencies."[15] Now I do not want to make mechanical analogies between McHale's analyses of literary works and Estes' window paintings, but there is something here to consider. Estes did say, as indicated earlier, that "my paintings are worked out as details. . . . I can't deal with it all at once."[16] Within the restricted range of visual data with which Estes works, this is borne out by the fact that he denies, or severely limits, a visual center of focus, let alone a narrative one. We cannot always organize the window paintings in our mind's eye in a spatially coherent way, or reconstruct them in an orderly manner, since Estes seems to be methodical in his ordering of spatial disorder. He presents the work but insists on a non-resolution of the spatial and narrative possibilities as well as an unwillingness to be responsible for the appearance of the whole in a logically organized manner. We become more aware of the artist as a force setting loose spatial and narrative ambiguities in the window paintings than as an organizing presence.

And just as Estes superimposed what is seen in the interiors through the window with what is seen on the window, so McHale describes several novels with similar co-existing realities. The easiest example to use here is from a part of a story, "The Invention of Photography in Toledo," from the book *Da Vinci's Bicycle* (1979), by Guy Davenport, in which "exploiting the homonymy between Toledo, Spain, and Toledo, Ohio, Davenport superimposed the two cities, their topographies, histories, and cultures." One passage will suggest how he did this.

" 'Originally a part of Michigan until Andrew Jackson gave his nod to Ohio's claim, the fierce violet of its stormy skies inspired El Greco to paint his famous view of the city.' "[17] Estes' juxtapositions and superimpositions are not as spatially nor probably as psychologically discontinuous as Davenport's, but in his own way and using the utterly banal imagery of interiors one normally walks by with hardly a glance, Estes makes the windows into liminal borders between the here and the there, between the reality of what is actually seen through the window and the fiction of what is behind, between appearance and reflection, between the ultimately measurable spaces of the interior and the unmeasurable spaces of what is behind. It is reasonable to extend this trope to consider that what is seen through the window (the interior) symbolizes civilization, since it is measurable, and what is behind the viewer is wilderness or the unknown. Or one could argue that what is both through and behind the window is a reconceptualization of America in urban terms, both knowable and unknowable, both visually cacophonous and strangely aurally silent, one which forces you to concentrate on insignificant particulars, but denies your physical and spiritual presence from the scene both because of the impersonality of the painted surfaces as well as by your literal absence from the street. You become a disembodied eye without even the filter of a mind which takes in every visual datum that appears before you. Or we might say that that which is through the window is epistemological because ultimately knowable and that which is behind is ontological, or perhaps it can be said that there is at least an oscillation and an ambiguity between epistemological and ontological views and between levels of reality. Perhaps, despite Estes' assertions to the contrary, he even intended an ambiguous content to the window paintings. Perhaps not. In any event, the mingling of seen and reflected objects disengages our eyes and minds from the normal syntax of seeing and thus provokes this kind of continuous speculation.

To which paintings can Estes' window paintings be compared? I think less to Velazquez's *Las Meninas* and Manet's *Un Bar aux Folies-Bergere* than to Monet's "Waterlilies" in the Musee de l'Orangerie.[18] Both Monet and Estes painted transparent surfaces and what was reflected on them. But Monet's ambiguities of space have more to do with a person in search of something than a person manipulating self-consciously his own intentions and our responses. Monet painted and sketched in front of nature and tried to convey the experience of what he saw and felt. "I want to succeed in expressing what I feel," he wrote

in 1908, and four years later he said "I only know that I do what I can to convey what I experience before nature."[19] Paul Claudel, the literary figure, perhaps best described the effect of Monet's paintings when he wrote that Monet, after studying light his entire life, "finally addressed himself to that most docile, that most penetrable of elements, water, which is at once transparency, iridescence, and mirror. Thanks to water, he became *the indirect painter of what we cannot see.*"[20] Since Monet recorded changes in weather so quickly and fleetingly in the "Water-lilies" paintings, he invites the viewer to meditate simultaneously upon the past, the present, and the future, as well as upon the nature of reality. The paintings, by showing the murky depths beneath the water, what is floating on the water, and what is reflected on its surfaces, alludes to the commingling of matter and spirit, of physical reality and transcendental meditation. The paintings can become a palimpsest to be read as intimately as the viewer desires. As much as the paintings might record weather conditions, they also provide a personal space for reverie.

Estes' window paintings, by comparison, are incomplete records of the larger unit of the building, the block, the neighborhood. They also include not inferences, but quotations of things seen in reflection. Self-referential puzzles of pictorial space which inhibit any sense of experience but that of establishing some sort of visual equilibrium, they alienate the viewer in that they isolate scenes from any narrative context. The fact that Estes derives his images so closely from the surface appearance of photographs indicates, to me, at least, his desire to isolate and deny lived experience. Rather, he heroizes the photograph by copying its surface effects. His paintings, then, are simulations rather than representations of lived reality. He offers the feel and shape of what he sees, the memory of actual experiences, but not the record of actual experiences. Sensations of the actual have atrophied. For Estes, the present moment is already an item of nostalgia, a nostalgia of sight. It is as if one knows it is snowing outside by hearing about it on a TV weather report even if one has just come indoors.

Although critic Bob Rogers was referring to photographs, his comments apply to the window paintings when he said that photographs deny "the collective journey narrative." He goes on to say that "separated from this historical context [the collective journey narrative], the image cannot make sense, and the result is a feeling of disjointed, surreal, fragmented time, the insignificant made timeless. . . . The lens's dispassionate monumentalization of trivia and its equally dispassionate

trivialization of everything else derives, in great measure, from taking the image out of its social/cultural context and looking at it as an isolated curio or work of art."[21] Estes' second-hand images only compound Rogers' observations. This is not to say that they are bad or wrong. On the contrary, they speak immediately to the postmodern condition of fragmentation and of considering things in multiple contexts as few other works do. It would also seem, by extension, that the window paintings reflect the urban experience writ large – the daily assault of multiple and insistent images, the concern to blot out all but what is directly in your path of movement, the often compulsive desire not to relate your immediate experience to the larger experience of the street. As much as Monet's paintings are autobiographical and allow for autobiographical musings, Estes' paintings are not and do not. He has, in effect, painted himself out of his canvases. The paintings remain; he is gone.

By eliminating his touch and even his biography from the window paintings, he has allowed himself, following Foucault's suggestions concerning the absence of the author, to disappear into their impersonal surfaces and to be subsumed by the camera, as if the camera made the choices of subject matter and organization for him.[22] Estes becomes less the creator of the window paintings than a mediator who has mastered the codes of photography. Although there is no narrative in the traditional sense in these paintings, the viewer becomes aware of the way Estes "narrates" the paintings based on the codes of photography – the inclusiveness of detail of the photographic negative and the slick surface finish of the print. Of course Estes made all the choices, but he presents the window paintings as if he were the camera's silent partner by his effacement before the photographic image.

By denying his own physical presence in the paintings, Estes sabotages our understanding of the point from which space, and therefore graspable reality, is measured. His position, and ours, evaporates as we try to locate ourselves. He denies the assertion of a logical space by paradoxically manipulating space into something unmeasurable and ultimately unknowable. Such close examination of space, then, is ultimately a subversive ploy to deny the artist's place in his own work. In *Double Self-Portrait*, in which he appears reflected in the window standing next to his camera and tripod and again reflected in a mirror-like wall in the interior, Estes painted less a double portrait of himself than a sign of his presence.

Ultimately, it is impossible to determine if Estes, in his hand-made

paintings, is trying to humanize the modern urban experience by leaving a trace of his presence however minimal or if he acknowledges that since reality is constructed so arbitrarily then why not let the camera dictate reality's appearance. His paintings are not precisely examples of Jean Baudrillard's notion of simulation or of the hyper-real which is based on electronic sources, nor is Estes the complete modern person envisioned by Baudrillard "now only a pure screen, a switching center for all the networks of influence," but the paintings do bump up against Baudrillard insofar as Estes, by using photographs as his models, has substituted "signs of the real for the real itself" and that for Estes reality itself lies in the signifier (the camera) rather than in the signified (the window).[23] What all of this means is that the reality of the painted surface for Estes is produced in accordance with the codes of photography – basically what the camera sees and what the photograph looks like.

By insisting on imitating the surface appearance of a photograph, Estes limits or eliminates any sense of affect from the window paintings, a condition Frederic Jameson feels is central to postmodernism. (A cityscape by Munch is the obvious opposite.) Jameson suggests that the lack of affect does not necessarily result in neutral or passive responses. "The silence of affect in postmodernism is doubled with a new qualification in surface and accompanied by a whole new ground tone in which the pathos of high modernism has been inverted into a strange new exhilaration, the high, the intensity, some euphoric finale of Nietzsche's Dionysian impulse. . . . The alienated city of the great moderns, with its oppressive streets and constricting menace, has been unaccountably transformed into the gleaming luxury surfaces of Richard Estes' Manhattan."[24]

Jameson further suggests that paintings like those of Estes depend on the new "industrial dynamic of the computer, of nuclear energy, and of the media." All of this new machinery is involved with reproduction and process, not with manufacturing. These new systems, Jameson holds, have begun to colonize our unconscious.[25] With Estes, the camera, apparently, has colonized his unconscious. Beyond that, Jameson has suggested another way to think about Estes' paintings and to account for their "gleaming luxury surfaces." Jameson holds that the schizophrenic condition is also central to postmodernism. What he means by this is a breakdown in the relationships of signifiers – in this instance for Jameson the experience of time and of the memory of language. As a result, the schizophrenic "is condemned to live in a

perpetual present . . . Schizophrenic experience is an experience of iso-
lated, disconnected, discontinuous signifiers which fail to link up into
a coherent sequence. The schizophrenic will clearly have a far more
intense experience of any given present of the world than we do, since
our present is always a part of some larger set of projects which force us
selectively to focus our perceptions."[26] Two caveats here: Jameson is
speaking metaphorically, not clinically, and Estes is, of course, not
schizophrenic. But Jameson's comments do help locate the window
paintings in this particular critical perspective, especially when it is
remembered that Estes wants all the forms in a painting to be in focus
at the same time. The ideal viewer for Estes would not selectively focus
his or her perceptions or sensations.[27]

Another aspect of the schizophrenic experience is that of ignoring
other people so that the individual is not swallowed by the experience
of another. A person can maintain his or her own psychological integrity
by simply not interacting with anybody else. The subjects Hopper
painted in the privacy of their living rooms and bedrooms often exhibit
this tendency.[28] Estes, it would seem, shows what these people might
see and how they might feel when out on the street – concentrating on
small units of space in front of them with terrifyingly large and indeter-
minate spaces behind – in their soundproof capsules. Other people
appear rarely and never confront the viewers of the windows. Usually
people materialize as ghostlike traces on reflected surfaces, their silhou-
ettes hardly visible and barely brought to recognizable form. There is
certainly no Baudelairian heroism of modern life here. It would even
seem that both Estes and the viewer are absent *flaneurs* both apart from
and hidden from the crowd. Unlike Baudelaire's *flaneur*, "an 'I' with an
insatiable appetite for the 'non I,'" Estes is concerned only with his
own vision.[29] It is his only performative function in observing and
partaking of city life. What he sees is the city as phantasm. The more
carefully he looks, the more elusive everything becomes.

FIFTEEN

Ben Shahn's Postwar Jewish
Paintings

Unlike several of his contemporary Abstract Expressionists
who were Jewish, Ben Shahn embraced Judaism in his
art with a passion and a fire that is just this side of
shocking. Despite his secular leftist and civil rights bona fides, he
created, with Barnett Newman, the most important body of religious
Jewish art through the 1950s and 1960s of any American artist. Shahn's
works are important, perhaps unique for their time, because in place of
traditional Jewish genre scenes he created nonliteral and nonnarrative
works inspired by biblical and other ancient texts. These works are not
illustrations of the lives of, say, Moses or Job, but independent inven-
tions based on sacred writings, what we might call free, parallel inven-
tions.

Some of these works are very strong, but very coded, statements
made in support of the still young, new country, Israel. And others,
because he made such extensive use of biblical material and because of
the particular passages that inspired his works, suggest that Shahn had
some sort of spiritual awakening, or reawakening, perhaps even a spiri-
tual crisis. He might even have become a closet believer. Whereas in
the 1930s we might have said he had substituted Marx for God as a way
to explain and to understand the workings of the world, by the 1950s

213

we would have said he had substituted God for Marx as a way to accept that the world was ultimately inexplicable to humans.

Whatever the Holocaust's impact on Shahn and whatever his own personal needs, his sense of his Jewishness was clearly abetted by his readings in the so-called Soncino Bible, a multivolume edition of the Pentateuch, the Prophets, and the Writings, which he received as a gift in the late 1940s, as well as his readings in kabbalistic literature, especially those works concerned with the mystic Abraham Abulafia (1240–c. 1290s), who favored an ecstatic approach to gaining knowledge of the Divine. It is also important to mention here that some elements in Shahn's postwar Jewish art are based on the kinds of knowledge that any individual who had had Orthodox religious training and had lived an Orthodox life would automatically possess.[1]

Shahn's *Sound in the Mulberry Trees* was his first work to show his new direction (fig. 39). In it, a young girl looks at a sign in a shop window printed in Hebrew and a young boy sits on a staircase blowing bubble gum. As much as this work is still a genre scene, it is also a celebration of the newly created Jewish homeland in Israel. The Hebrew words are from 2 Samuel 5:24: "And let it be, when thou hearest the sound of a gong in the tops of the mulberry trees, that thou shall bestir thyself; for then shall the Lord go out before thee, to smite the host of Philistines."[2] This passage is from a chapter describing the victory over the Philistines by Jewish forces led by David. Subsequent chapters describe the establishment of Jerusalem as the capital of ancient Israel. Since hardly any of Shahn's viewers or political compatriots knew Hebrew, let alone the text of 2 Samuel in any language, this was a very guarded acknowledgment by the artist of the birth of the newly resurrected country, but an acknowledgment that would grow stronger in succeeding years.

I want to make a point here that I reiterate in the last essay in this book, "Postscript: Another Kind of Canon." By combining an event described in the Bible with a modern one, Shahn, in a very traditional Jewish way, has conflated contemporary with biblical time. His joining of the past with the present in this way can be seen as an act asserting both the continuity of Jewish collective memory and the "eternal contemporaneity" of the biblical past with Jewish affairs. But it is also an example of the Jewish habit of conflating current successes and catastrophes with ancient ones, of, say, comparing a particular pogrom to the destruction of Solomon's Temple in 587 B.C.E. "The greater the catastrophe," one historian has pointed out, "the more the Jews have recalled

39. Ben Shahn, *Sound in the Mulberry Trees* (1948). Tempera on paper. 48 × 36 in. Courtesy of the Smith College Museum of Art, Northampton, MA. Estate of Ben Shahn/Licensed by VAGA, New York, NY.

ancient prototypes. . . . The perceived desecration had a unifying effect when the covenantal promise was invoked in group dialogue with God, just as the attempt to put cataclysm in a continuum implied shared, communal memory."[3] So Shahn, who had had a rigorous Orthodox upbringing, probably associated the positive bibilcal archetype of Da-

vid's victory with Israeli independence as a way of suggesting the contin-
uum of communal memory.

Years later, Shahn explained the timeless connection to the ancient
past in a way that any observant Jew or anybody who had received
Orthodox religious instruction would immediately understand because
such a person reads through the entire Torah (Pentateuch) once each
year and studies the weekly portion, year after year:

> At that time [as a youth in Lithuania], I went to school for nine
> hours a day, And all nine hours were devoted to learning the true
> history of things, which was the Bible. . . . Time was to me, then, in
> some curious way, Timeless. All the events of the Bible were, rela-
> tively, part of the present. Abraham, Isaac, and Jacob were "our"
> parents – certainly my mother's and my father's, my grandmother's
> and my grandfather's, but mine as well. I had no sense of imminent
> time and time's passing.[4]

Shahn's conflation of the biblical past and his own present, then, was
part of a time-honored tradition, and perhaps his recollections were as
much a trip down the memory lane of his youth as they were part of
his renewed interest in Jewish practices.[5]

With all of this in mind, I want to look at three paintings with
related titles completed between 1948 and 1955. These are *Allegory*,
Second Allegory, and *Third Allegory* (figs. 40, 41, 42). *Allegory* is based
on a fire in Chicago that killed four of seven children in a single family.
Of the children, whose poses are derived from those of Holocaust
victims, in a photograph, Shahn said that they represented "the sense of
all the helpless and innocent" and that they "resemble my own brothers
and sisters" – none of whom was killed in a fire, unless we understand
this to mean his fellow Jews burned in the ovens of the murder camps.[6]

To continue *Allegory*'s Holocaust associations, the enigmatic lion
might refer to similar creatures that appear on a variety of Jewish
ceremonial objects, especially on the decorative shields that are placed
over Torah scrolls and on the curtains covering the ark in which the
scrolls are placed when not in use. If we assume that the lions symboli-
cally protect the Torah which in turn symbolizes the Jewish people,
then we can imagine Shahn suggesting that the oversized lion is, like a
parent, watching over its now dead children. I make this speculation
because the names of the subsequent two paintings, *Second Allegory*
and *Third Allegory*, clearly imply some kind of a link to *Allegory*. Like
Barnett Newman, who began his series "Stations of the Cross" without

40. Ben Shahn, *Allegory* (1948). Tempera on panel. 36⅛ × 48⅛ in. Courtesy of The Modern Art Museum of Fort Worth. Gift of Mr. W. P. Bomar, Jr., in Memory of Mrs. Jewel Bomar and Mr. Andrew Chilton Phillips. Estate of Ben Shahn/ Licensed by VAGA, New York, NY.

that particular subject in mind, Shahn, I think, had something similar occur with these three paintings.

The image in *Second Allegory* is, I believe, entirely biblical in origin, but it also has Holocaust reverberations. Shahn might have begun to read into the earlier *Allegory* some passages from Exodus (32:10–12) in which God tells Moses that he wants to destroy the Jewish people for worshipping the Golden Calf, and Shahn may have put this together, in good Talmudic fashion, with the startling passage in Deuteronomy 9:20 in which God becomes so angry with Aaron that he wants to destroy him. But Moses intervenes, saving Aaron's life. This is, I feel, the subject of *Second Allegory* – the hand of God about to smite Aaron. It symbolizes God's wrath against the Jewish people. Its title, *Second Allegory*, then, refers to Moses' second ascent of Mt. Sinai with the second set of tablets, having broken the first set in a moment of rage (Exodus 32:19; 34:1, and 34:10).[7]

41. Ben Shahn, *Second Allegory* (1953). Tempera on masonite. 53⅜ × 31⅜ in. Courtesy of The Krannart Art Museum and Kinkead Pavilion, The University of Illinois, Champaign. Estate of Ben Shahn/Licensed by VAGA, New York, NY.

42. Ben Shahn, *Third Allegory* (1955). Tempera on paper. 39 × 24 in. Courtesy of the Vatican Museums, Vatican City. Estate of Ben Shahn/Licensed by VAGA, New York, NY.

According to this reading, *Allegory* is about death, and *Second Allegory*, given that the Jewish people survive despite the Holocaust and that the modern state of Israel is born, is about witnessing one's own agony and being able to survive despite overpowering forces. Aaron, the personification of all that had befallen the Jewish people, became here a symbol of Jewish suffering. He failed, and so all Jews must be punished. Shahn would have known this to be an old-fashioned Orthodox response to tragedy. In Orthodox Judaism, tragedy, including the Holocaust, is believed to be caused by the sins and the failures of the Jewish people who have in some way broken the Covenant.

But after punishment comes redemption. *Third Allegory* is, by contrast, about triumph and redemption, both in biblical time after the Covenant had been reinscribed on the second set of tablets and in modern times, after the foundation of the state of Israel. Here, the lionlike figure stands erect, wearing a blanket of blue and black with white stripes on which the tablets rest. A figure with purplish skin wears a prayer shawl and blows a shofar (a ram's horn), calling people to attention and proclaiming the presence of the Lord. In the distance, golden towers are surmounted by crosses. The colors of the blanket might be a play on the color schemes of prayer shawls, usually black and white before the establishment of Israel and blue and white afterward. More certainly, the predominant colors in the painting – blue, crimson, purple, and gold – are the colors intended for the ark and its accoutrements, as mentioned several times in Exodus. The golden towers might be meant to invoke Solomon's Temple in Jerusalem, even though only the temple's interior was surfaced with gold (1 Kings 6:21–35). The crosses atop the golden towers might be an allusion to the phrase "and all the nations shall assemble there" (Jeremiah 3:17), meaning Jerusalem. No doubt, this would reflect Shahn's hope that all religions could live in harmony in Israel – and elsewhere.

I am arguing, therefore, that these three paintings are about the near death, survival, and redemption of the Jewish people in the new state of Israel. As a group, these works can be read for their biblical imagery, and as a commentary on contemporary events, for their conflation of biblical with recent history. And as a group, they are as pure an example of this Jewish habit of combining the present with the biblical past as we are likely to find in the entire history of modern art.

Shahn celebrated the creation of Israel and his concern for its survival by invoking biblical precedent in other works as well. I also think that in them he alluded to hidden, personal concerns that reflect

43. Ben Shahn, *Ram's Horn and Menorah* (1958). Tempera and gold leaf on board. 16½ × 28 in. Courtesy of The Sid Deutsch Gallery, New York City. Estate of Ben Shahn/Licensed by VAGA, New York, NY.

a certain amount of turmoil in his mind about his own sense of Jewishness and about his family relationships. We see this, for example, in two virtually identical works, *Ram's Horn and Menorah* (fig. 43) and *The Call of the Shofar*, both from the late 1950s. Each painting includes a Hanukkah menorah on the left; a man's head covered by a prayer shawl as he blows a shofar; and five differently colored heads under the shofar, each presumably representing a different human race. This work is usually interpreted as an expression of Shahn's belief in racial equality. A more religious interpretation would also include the phrase "before God," because in the painting a hand emerges from flames, indicating the presence of the Lord and suggesting his creative power and his ability to intervene in human affairs. The shofar is thus an instrument to awaken people to God's presence.[8] Students of the Talmud, the commentary on the Torah codified in the mid-third century C.E., would also catch an arcane reference that Shahn might have remembered from his childhood religious training. It concerns the shofar, which is depicted as an instrument with a straight stem rather than with the much more common curved stem. Of course, Shahn might have designed the instrument that way for compositional purposes, but it is stated in the Mishna, a part of the Talmud, that the shofar used to commemorate the new year must be one that is straight and must be

blown by a single priest, whereas on a fast day two priests might blow curved shofars. Since the context of the painting is celebratory rather than solemn, the use of a straight shofar is certainly appropriate.[9]

Shahn included in this painting lines from the Prophet Malachi (2: 10), a prophet not read as commonly as, say, Isaiah or Jeremiah. "Have we not one father? Hath not one God created us? Why do we deal treacherously every man against his brother, to profane the covenant of our ancestors." Everybody assumes that in including this quote Shahn, an advocate of civil rights and a person on the political left, was referring to racial equality. But the commentaries in the Soncino Bible suggest neither racial equality nor godly presence, although these notions might certainly have been part of Shahn's design. Malachi lived in Jerusalem after 516 B.C.E. when the Second Temple would already have been rebuilt, and he wrote his prophecy around 460 B.C.E. The country was then under Persian rule, and the people were abandoning Jewish practices at an alarming rate. The commentaries clearly state that the lines Shahn cited were part of Malachi's rebuke of the Jewish people both for their intermarriage with non-Jews and for the high rate of divorce of Jewish men from their Jewish wives. (Shahn was married at the time to Bernarda Bryson, a non-Jew.) The appeal "Have we not one Father?" is not about racial equality; rather, as one commentary states, "since God is Israel's father and they are His children, it follows that brotherly love should be shown one another and family loyalty upheld." The phrase "to profane the covenant of our ancestors," refers directly to intermarriage, which is, according to the commentary, "a menace [to] the distinctive faith which was the basis of God's covenant with Israel, as well as to the national existence."[10]

In fact, the entire text of Malachi is a rebuke to the Jews for their shortcomings. To merit God's love, Jews must reform their ways or else be destroyed by fire and turned to ashes (Malachi 3:19), a passage that would reverberate with any Jew after the Holocaust. The last line of Malachi, however, holds out the promise of redemption at the end. For God will send Elijah before the terrible day of destruction "to reconcile parents with children and children with their parents, so that, when I come, I do not strike the whole land with utter destruction" (Malachi 3:24). It is well known that Shahn did not get along with his mother, neglected his children from his first marriage, and was married to a non-Jew. Thus it is interesting to speculate about the effect Malachi had on him, since he was guilty of all the charges the prophet brought

against Jews. If nothing else, the quote from Malachi was a brilliant choice. On one level, the passage reaffirmed for the general public Shahn's civil rights credentials. On another level, it was about strengthening Israel, only ten years old in 1958. And on yet another level, it was about his own life.

Such multiple messages permutate through other Shahn works. Shahn's lithograph, *Thou Shall Not Stand Idly By* (1965), shows a white hand reaching down for a black hand that is reaching up. The words, from Leviticus 19:16, are printed in Hebrew and in English on the lithograph. The meaning is obvious and is emphasized in the commentary on that passage in the Soncino Bible. But in a variation of this image, with two white hands instead of one white hand and one black hand, Shahn quoted Psalm 133: "Behold, how good and how pleasant it is for brethren to dwell together in unity." Once again, a civil rights message is suggested, but the commentary presents an altogether different interpretation of this passage. Evidently, the psalm was written around 425 B.C.E. in support of the Prophet Nehemiah's concerns for the security of Israel and for Jerusalem and his plan to increase the city's Jewish population. This passage, then, is less about racial or religious concord than it is about Jewish people living together in a restored and strong nation. The commentary states, "what is advocated is not concord but co-habitation. The members of the restored nation should not be scattered but live together as a compact body."[11] I would argue not that Shahn was then thinking about emigrating to Israel, as did many Jewish people in the 1950s and 1960s, but that he had found in the Bible another reference to the creation of a strong and unified Jewish state, couched in the language of the civil rights movement.

Other works by Shahn seem to be both more personal and more about his own relationship with the Divine. For example, in 1954 Shahn painted an imaginary portrait of Maimonides (1135–1208), the philosopher who is a basic figure in Jewish religious education. In the work, a stern-looking, bearded figure holds open a book on which is written: "Teach thy tongue to say I do not know and thou shall progress," certainly a humbling message for any arrogant viewer who might think he or she has access to the truth. For Shahn this portrait is an unusually unsympathetic one; its didactic message severely undercuts his earlier political beliefs as well as those of his generation who believed that a better world could be built through socialism. Seen in this

light, the portrait of Maimonides is less celebratory than it is chastising, a reminder that not everything in and of this world can be comprehended.

I would not suggest this reading for the Mainonides portrait were it not for other works by Shahn that seem to make the same point, particularly those works based on passages from Job. In *When the Morning Stars . . .* God yells at Job for his arrogance (fig. 44):

> Where were you when I laid the earth's foundations? Speak if you have understanding. Do you know who fixed its dimensions, or who measured it with line? Onto what were its bases sunk? Who set its cornerstone when the morningstars sang together, and all the divine beings shouted for joy? (Job 38:4–7)

According to the Soncino commentaries, this section of Job is about why Job suffers. He represents humanity and wants to know God's plan, but God wants him to remain ignorant. Job is humbled. He realizes that he cannot understand God's mysteries, and, therefore, he recognizes his own puniness. In effect, Shahn has painted God's reply to Job's presumption. Job becomes a passive spectator to that which he cannot understand, let alone control.

In the serigraph *Pleiades* (1960), Shahn included a different text from Job (38:31–38) in the lower half of the work. In the upper half, Shahn included an outline of the constellation and a contained ovoid shape made up of small, irregular, colored rectangles. In the passage from Job, God asks Job if he knows the laws of heaven, if he can make wind and rain, if he can order the celestial sphere. In this series of challenges, Job is once again humbled. Four years later, in *Where Wast Thou?* (fig. 45), Shahn printed the text he had used in *When the Morning Stars . . .* and imagery similar to that of *Pleiades*. These three works represent an implicit acknowledgment of human feebleness in the face of the Divine scheme or, to say it in less religious terms, in the face of an indeterminate and inexplicable cosmic power. These works also convey the notion of initial humiliation, then repentance, and finally redemption. Some questions here: why does Shahn invoke aspects of Job's story? Is this Shahn's story? the story of the Jewish people? Is this a commentary on the Holocaust? Is this Shahn's version of the old Jewish tale of God's punishment for Jewish arrogance? Is Shahn once again collapsing contemporary history into biblical history? I cannot answer these questions, but I raise them because most Jewish people today no longer think like those of Shahn's generation, who might have

responded this way reflexively, instinctively, without being conscious of their own modes of thought. Without this awareness on our parts, much of the allusiveness of Shahn's imagery is, I believe, lost.

Shahn conflated past and present in another group of works. He invoked Jewish communal memory by printing the memorial prayer offered in every synagogue on Yom Kippur (Day of Atonement) for the martyrs who were murdered in Roman-occupied Judea for violating Emperor Hadrian's decree prohibiting them from instructing their students in the banned Jewish religion. "These I remember, and my soul melts with sorrow, for the strangers have devoured us like unburned cakes, for in the days of the tyrant there was no reprieve for the martyrs murdered by the government." Their martyrdom is usually interpreted as both a challenge to the emperor's claim to divine authority and a commemoration of "their resolve to serve the Lord to the fullest."[12] But since Shahn omitted from his text the actual number killed in ancient Judea, ten, his intent was rather to commemorate those murdered in the Holocaust.[13] This certainly lay behind Shahn's serigraph, *Warsaw 1943* (1963) in which the same text is included under an image of a man who hides his face in his arms, obviously a reference to the failed uprising in the Warsaw ghetto.

Shahn probably had similar intentions for a series of works that include the head of a woman and the text from a passage in Jeremiah – which in Jewish publications is verse 8, line 23, and in Christian publications is verse 9, line 1: "Oh that my head were waters and mine eyes a fountain of tears, that I might weep day and night for the slain of the daughter of my people." As with his other texts, this one was also carefully chosen. Shahn undoubtedly read in the Soncino Bible that Jeremiah's ministry in Jerusalem lasted from 625 B.C.E. until the overthrow of the Judean state, the dispersion of the Jewish people, and the destruction of Jerusalem in 586 B.C.E. by the Babylonians. Within that roughly forty-year period, Jeremiah witnessed the reversion to idolatry (which had occurred before 625 B.C.E.), Assyrian rule, and serious losses in battle.[14] Shahn's graphic works on this theme, then, refer both to the biblical Jews now cast out into the Diaspora and to the destruction of the European Jewish community in the Holocaust, another instance of collapsing contemporary time into biblical time.

Shahn may also have found in the ancient texts a way to comment more directly on his own life. He wrote that he was infatuated with the language of Ecclesiastes, probably since childhood, and, later in life, he used a passage from Ecclesiastes, verse 11, line 9, to comment on the

44. Ben Shahn, *When the Morning Stars* . . . (1959). Tempera and gold leaf on paper mounted on panel. 54 × 48 in. Courtesy of Alex and Beatrice Silverman. Photo: John Parnell. Estate of Ben Shahn/Licensed by VAGA, New York, NY.

passing of time.[15] He appended the text to an image of a man whose head is shown frontally with a profile attached on either side and on whose chest appears a similarly composed three-headed beast, intended to suggest the ages of man (fig. 46).

> Oh, youth, enjoy yourself while you are young! Let your heart lead you to Enjoyment in the days of your youth. Follow the desires of your heart and the Glance of your eyes – but know well that God will call you to account for All such things.

45. Ben Shahn, *Where Wast Thou?* (1964). Gouache and gold leaf on paper. 51¾ × 42 in. Courtesy of The Amon Carter Museum, Fort Worth, TX. Estate of Ben Shahn/Licensed by VAGA, New York, NY.

The entire narrative of Ecclesiastes is enigmatic in that it speaks of the futility of life, but nevertheless of enjoying life while one can. In the end, "God will call every creature to account for everything unknown be it good or bad" (12:14). One commentary Shahn undoubtedly saw in the Soncino Bible held that since God will judge everybody, regardless of his or her actions, the teachings of the Torah studied in one's youth should remain a constant guide; that one should remember

שמח בחור בילדותך ויטיבך לבך בימי בחורותיך והלך בדרכי
לבך ובמראי עיניך ידע כי על-כל-אלה יביאך האלהים במשפט

46. Ben Shahn, *Ecclesiastes* (1966). Serigraph. 26½ × 20½ in. Courtesy of the
New Jersey State Museum Collection. Gift of Edward T. Cone in memory of
Ben Shahn FA1968.31.7 Estate of Ben Shahn/Licensed by VAGA, New York, NY.

"the learning which you derived from your teacher"; and that one
should follow tradition and established custom.[16]

Did Shahn take this to heart? It is true that he did try to lead a
morally correct life at least in respect to honoring the rights of all
peoples. To be sure, one need not be Jewish to do that. But does this

imply in Shahn a desire to return to roots or perhaps a newly found sense of religiosity? Late in his life, Shahn made a series of works based on the famous passage by Hillel: "If I am not for myself, who is for me? And when I am only for myself, what am I? And if not now, when?" This is one of the classic, existential passages that question Jewish self-identity, combining an inquiry into one's sense of self-worth with an obligation of service to humanity, both of which must guide one's actions constantly. (This is probably the ur-source of Jewish guilt jokes.) Whatever Shahn's sense of self-worth (it was high) and his sense of moral obligation, he couched it in terms familiar to any practicing Jewish person down through the ages. It is also interesting to note that Shahn's favorite psalm was Psalm 150.[17] Entirely a hymn of praise to God, its last line, "Let every thing that hath breath praise the Lord. Hallelujah," could not be more explicit.

Shahn's regard for Jewish subject matter extended to the letters of the Hebrew alphabet. In the 1950s, he developed a serious interest in the mystical properties of the letters through his readings in or about Jewish mystical texts, notably the Kabbalah. His interest was unprecedented in the history of American art and of Jewish-American art, and is a part of the history of religion in modern American art that is yet to be written. In 1954, Shahn published *The Alphabet of Creation: An Ancient Legend from the Zohar* and, in 1963, *Love and Joy About Letters*.[18] The earlier book is entirely a meditation on the mystical qualities of letters, and the latter book is partly so. For *The Alphabet of Creation*, Shahn copied his text from and created appropriate illustrations for a passage in one of the central works of kabbalistic literature, the *Zohar*, written in the last third of the thirteenth century. In *Love and Joy About Letters*, he quoted, without revealing his source, two long passages from Gershom Scholem's seminal *Major Trends in Jewish Mysticism*, probably the first modern book on mystical Jewish writings and the Kabbalah to reach a wide audience.[19]

In *The Alphabet of Creation*, Shahn repeated, with few changes, the following passage from the *Zohar*: "Twenty-six generations before creation, the twenty-two letters of the alphabet descended from the crown of God whereon they were engraved with a pen of flaming fire. They gathered around God and one after another spoke and entreated, each one, that the world be created through him." After listening to each letter, God decided to create the world through the letter "Bet" (the first letter of the Torah) and decreed that "Aleph" should be the first

letter of the alphabet. Shahn's illustrations include each letter of the Hebrew alphabet as well as a variety of other images he would use repeatedly in succeeding years.[20]

Concerning *Love and Joy About Letters*, Shahn must have been deeply affected by Scholem's treatment in *Major Trends in Jewish Mysticism* of Abraham Abulafia. Abulafia's method was to meditate on the letters of the Hebrew alphabet and on "the mystical contemplation of letters and their configurations as the constituents of God's name," for in God's name could be found "the hidden meaning and totality of existence; the Name through which everything else acquires its meaning and which yet to the human mind has no concrete particular meaning of its own." For Abulafia, "the world of letters . . . is the true world of bliss. Every letter represents a whole world to the mystic who abandons himself to its contemplation. Every language, not only Hebrew, is transformed into a transcendental medium of the one and only language of God."[21]

I quote these passages from Scholem because Shahn identified with Abulafia at some deep level of his being. Shahn began *Love and Joy About Letters* with a lengthy quote from Scholem who in turn quoted Abulafia, and Shahn ended his book with another lengthy quote from Scholem-Abulafia in which Abulafia describes the preparations for meditation and the hoped-for ecstasy.[22] Between the opening and closing citations, Shahn quoted Abulafia further and identified himself with Abulafia's love of letters:

> There is the glory of the Hebrew that I had sensed so deeply as I had first learned to make letters. Now I did not hesitate to register my own feelings; The prohibitions of art must melt before one's own authority, one's sure knowledge of what he feels and what is right for him. I made many paintings using Hebrew letters or the more ancient Aramaic in gold or red or black, realizing with Rabbi Abulafia their mystery and their magic.[23]

So magical that, in 1957, Shahn developed a seal, akin to Whistler's signature butterfly, made from a jumble of Hebrew letters, that he used as a stamp above his name. Perhaps this was his way, following Abulafia, of meditating on the Name of God and of entering the Divine Stream that Abulafia wrote about. I do not know Shahn's motivation or if he believed any of this, but it is astonishing that he would write so openly of his spiritual association with Abulafia, that he would write about the Hebrew alphabet in such mystical terms, and that he would use a seal

that even remotely suggested Divine exultation. For it is one thing to love letters, to love making letters, to love looking at letters, and quite another thing to suggest, as Shahn did in his two books, that the letters have mystical properties. All of this had to be a very private kind of identification with his heritage.

Looking over the body of works considered here, I believe Shahn wanted seriously to be Jewish without having to become part of an organized Jewish community. (In my own recent correspondence with over sixty contemporary Jewish artists, many have said that they feel intensely Jewish, read about and honor various Jewish customs, but reject the thought of going into a synagogue or joining a Jewish organization.) Perhaps Shahn even came to believe in the existence of God. The dilemmas he might have faced were these: how do you honor your sense of Jewishness without participating in obvious Jewish communal activities such as lighting Sabbath candles? Can you separate religious obligations from ethnic activities? Can you be a Jew in private? What kind of Jew can you be in private? Can you support Israel and remain in America? What about a non-Jewish spouse? These dilemmas were not Shahn's alone, but belong to the histories of generations of Jewish Americans. Clearly, Shahn was groping for answers as articulated through his paintings and prints. As a result, for over a twenty-year period, he found in the Bible and other ancient texts subject matter for some of the most profoundly Jewish works ever created by an American artist.

SIXTEEN

Barnett Newman's Stripe Paintings and Kabbalah

A Jewish Take

arnett Newman's famous stripe paintings are based on the esoteric teachings of mystical Judaism known as Kabbalah (fig. 47). We know this from Thomas Hess' account of Newman's career, published in 1971. Since then, this startling piece of information has barely been mentioned and, equally startling, never been explored further.[1] I want to ask here one question: just how Jewish was Newman's use of Jewish sources? My conclusions will suggest that neither the artist nor his biographer used Kabbalah from a normative Jewish point of view, or, to say it differently, neither used Jewish sources in a way acceptable to traditional Jewish thought.

I use the term *normative Judaism* to imply acceptance of Jewish interpretations of one's relationship with God. Equally important in my analysis are esoteric kabbalistic interpretations of the creation of the universe. Most professing Jews, however, rarely study and know little of the mystical Jewish writings collected under the rubric of Kabbalah, and if they did, they might not accept very much of it. But, at the same time, normative Judaism and kabbalistic writings share certain assumptions about one's relationship with God.

Thomas Hess, no doubt with Newman's full cooperation, based his analysis of the vertical stripe on Gershom Scholem's *Major Trends in Jewish Mysticism*, particularly Scholem's discussions of Rabbi Isaac Lu-

47. Barnett Newman, *Onement II* (1948). Oil on canvas. 60 × 36 in. Courtesy of
The Wadsworth Atheneum, Hartford. Gift of Tony Smith.

ria, a sixteenth-century mystic from Safad, a community now part of modern-day Israel. According to Scholem (and Hess), Rabbi Luria explained how the world was created from nothing by postulating the concept of *Tsimtsum*. To create a primordial space for the universe, God contracted into himself. *Tsimtsum* is the contraction, the withdrawal, the shrinkage of God. Next, God sent out a ray of light in which he revealed himself as God the Creator. This act set the "cosmic process in motion." Subsequently, "the first being which emanated from this light was *Adam Kadmon*, the man. . . . He is the first and highest form in which the divinity begins to manifest itself after the *Tsimtsum*."[2]

Newman's stripe paintings accord with Scholem's explanation of creation up to this point. The single stripe may be understood as representing the first ray of light and the first man. But Scholem goes on to say that from Adam's eyes, mouth, ears, and nose, the lights of the divinity burst forth in an undifferentiated mass. This image calls to mind the random and diffused focal points of Mark Tobey's white-writing paintings. Clearly, Newman preferred to visualize the moment immediately before light multiplied, that is, the space into which depth had not yet been introduced. In a virtually perfect match of style and content, Newman suggested a pictorial surface in which all forms seem to be on the same plane.

To achieve this surface, Newman manipulated depth cues based on the size and color intensity of the forms. Normally, we read both large shapes and intense colors as projecting toward us, and small shapes and weak colors as receding into the distance. But in his stripe paintings, Newman deemphasized the color intensity of the larger rectangular shapes and, by contrast, emphasized the color intensity of the stripes so that the size cues of the large shapes are balanced by the intense color cues of the stripes. The stripes, then, seem to lie on the same plane as the larger rectangular fields, which, despite their size, are held in check because of their more subdued color. Thus, both color intensity cues and size cues for suggesting depth cancel out each other. By making the stripes and the rectangular fields appear to be on the same plane, Newman captured on the pictorial surface the very moment of creation that Rabbi Luria described – the moment of the first ray of the light of creation, before matter, and therefore space, became differentiated. This was a brilliant formal solution on Newman's part to a spatial conundrum – how to make forms without suggesting depth. But it had nothing to do with Jewish influences on Newman's thinking.

Hess described Newman's *Onement I*, the first stripe painting, as,

a complex symbol, in the purest sense, of Genesis itself. It is an act of division, a gesture of separation, as God separated light from darkness with a line drawn in the void. The artist, Newman pointed out, must start like God, with chaos, the void . . . Newman's first move is an act of division, straight down, creating an image. The image . . . reenacts God's primal gesture . . . He [Newman] has taken his image of Genesis, of the creative act, of the artist as God.

In normative Judaism, however, Jews do not try to act like God, except in the sense of leading holy lives, nor do they merge with him. There is instead a clear distinction between humans and God. Hess understood this key distinction between Jewish and Christian mysticism when he acknowledged that, in Jewish mysticism, there is no union with God.[3] What kind of Jewish artist would violate a basic tenet of Judaism by confusing his own creative powers with those of the deity? A Jew might answer, one possessed by a *dybbuk* (a demon) or, far more likely, one who read and thought about Jewish writings very selectively. The latter possibility gains credibility if we examine Newman's thinking as it evolved in the years just before he began to make the first stripe paintings in 1948.

To see Newman assuming a God-like role in the creation of art, we need go back no further than 1945. By that time, Newman had already begun to speak of himself and of his fellow artists, including Adolph Gottlieb, Hans Hofmann, Jackson Pollock, Mark Rothko, and Rufino Tamayo, as creating a new American religious art,

> a modern mythology concerned with numinous ideas and feelings. . . . The present movement in American art transcends nature. It is concerned with metaphorical implications, with divine mysteries. These new painters have brought the artist back to his original primitive role as the maker of gods.[4]

This is a very immodest statement. Newman is asserting that the artist possesses transcendent power. But Newman also implies a distinction between humans and divine beings, between humans and forces or energies in the universe.

By early 1947, Newman began to identify the artist with those forces, specifically with a vaguely identified sense of nature. In his review of an exhibition of Theodoros Stamos' paintings, Newman appeared to be drifting toward a secular pantheism. Stamos, according to Newman, "redefines the pastoral experience as one of participation with the inner life of the natural phenomenon." Of such communion with nature,

"one might say that instead of going to the rock, he comes out of it."[5] Here, Newman seems to be saying that the artist is either on equal terms with nature's creative forces or at least an intimate part of them.

But by the end of 1947 or the beginning of the next year, Newman began to foreground the artist to the exclusion of all else. Writing about an exhibition of Herbert Ferber's sculpture, Newman said:

> By insisting on the heroic gesture, and on the gesture only, the artist made the heroic style the property of each one of us, transforming, in the process, this style from an art that is public to one that impersonal. For each man is, or should be, his own hero.[6]

By becoming his own hero, Newman asserted, each man emphasizes his own centrality in the universe and, by implication, his need for self-realization. In this statement, communion with whatever is out there is replaced by a defiant need for self-aggrandizement and self-assertion. The artist now, according to Newman, creates, or re-creates, himself.

In 1948, Newman's evolving thought achieved its definitive formulation when he wrote "The Sublime Is Now":

> We are asserting man's natural desire for the exalted, for a concern with our relationship to the absolute emotions. . . . We are creating images whose reality is self-evident and which are devoid of props and crutches that evoke associations with outmoded images, both sublime and beautiful. We are freeing ourselves of the impediments of memory, association, nostalgia, legend, myth, or what have you. . . . Instead of making cathedrals out of Christ, man, or "life," we are making [them] out of ourselves, out of our feelings.

The key phrase here – "making cathedrals . . . out of ourselves" – is an extraordinary assertion of self-willed strength that has no precedent in the history of American art. Earlier artists clearly distinguished their creative acts from the divine, their paintings from God's handiwork in nature. Thomas Cole, for example, a deeply religious artist associated with the Hudson River school, wrote, "Art is in fact man's lowly imitation of the creative power of the Almighty."[7]

Newman's idea of the artist as creator can be positioned with the individualism, self-worship, and self-creation associated with Ralph Waldo Emerson and Walt Whitman. Newman had great respect for Emerson, whose home he visited in 1936. He may well have been familiar with Emerson's essay "Circles," which claims, "No facts are to

me sacred; none are profane; I simply experiment, an endless seeker with no Past at my back." Newman may also have known these lines from Whitman's *Leaves of Grass*: "There will soon be no more priests. Their work is done. . . . A new order shall arise and they shall be the priests of man, and every man shall be his own priest."[8]

But the ideas of Emerson and Whitman do not explain why Newman began to make stripe paintings in 1948. I think, rather, that three important books published in 1946 and 1947 – Jean-Paul Sartre's *Existentialism*, Martin Buber's *Tales of the Hasidism: The Early Masters*, and Scholem's *Major Trends in Jewish Mysticism* – help us better understand Newman's developing sense of self-exaltation.[9]

In the aftermath of World War II, conventional morality and public values were being called into question. By the late 1940s, Sartre and his philosophy were widely discussed in the periodical literature. As a high school student at the time, I remember clearly the interest that Sartre generated, and I assume that Newman, too, was familiar with *Existentialism*'s exhortations to independent action and personal responsibility, modified by an accountability to society. Quite possibly, Newman was moved by passages such as this: "Man is nothing else than his plan; he exists only to the extent that he fulfills himself, he is nothing else than the ensemble of his acts; nothing else than his life."[10]

It would seem a short step from these words to "making cathedrals . . . out of ourselves," but to get from Sartre's secularism to the Jewish elements in Newman's stripe paintings, we must pass through the books of Martin Buber and Gershom Scholem.

As with Sartre's book, I cannot confirm that Newman read Buber's account of the early history of the pious and ultra-religious Hasidim, whose mysticism has strong kabbalistic roots, but by recalling the response to Buber by Newman's contemporary and acquaintance, the critic Harold Rosenberg, we might find some explanation for Newman's desire to make cathedrals out of the self. Reviewing *Tales of the Hasidism* for *Commentary*, Rosenberg found – quite mistakenly I believe – confirmation for the seeking of self-fulfillment. For Rosenberg, Hasidism turned out to be a quite modern religious movement that "was primarily a training of individuals in the direction of an infinitely extended subtilized discovery and recreation of the self." According to Rosenberg, one of the principal tenets of Hasidism was to claim one's own identity. As an example, he cited a passage from Buber about a certain Rabbi Zusya. When near death, Rabbi Zusya said, "In the world to come they will not ask me 'why were you not Moses?' They will ask

'why were you not Zusya?'" For Rosenberg, the "Hasid reached toward his highest possibility . . . through the world itself, through his way of appropriating concrete things and relations into his subjective experiences."[11]

The modern secular reader, following Rosenberg, might imagine that making cathedrals out of the self has roots in Hasidism. But it does not. My own studies (and family knowledge) suggest that Rosenberg misunderstood the movement and totally misread Buber's account of Hasidism, missing entirely Buber's insistence both in finding personal fulfillment within religious channels and in discovering the right paths to God. In addition, Rosenberg ignored the fulfillment that members of the various Hasidic groups find in community religious worship, their service to God, and, as an ideal, their efforts to be God-like in their behavior. Self-fulfillment comes through service to God, not to the self.

Rosenberg also singled out the one anecdote in Buber's entire book – the deathbed statement by Rabbi Zusya – that, removed from context, lent itself to a secular, existential interpretation. A more typical anecdote from *Tales of the Hasidism* concerns Rabbi Dov Baer, an early major figure of the movement. Rabbi Dov Baer is reported to have said:

> I shall teach you the best way to say Torah [the first five books of the Bible]. You must cease to be aware of yourselves. You must be nothing but an ear which hears what the universe of the word is constantly saying within you. The moment you start hearing what you yourself are saying, you must stop.

Rosenberg also gave scant regard to Buber's exhortations in his introduction concerning one's relationship to God, which Buber claimed was above and beyond all individual experience.[12] In effect, Rosenberg interpreted Buber's concern for personal fulfillment at the expense of religion.

Almost twenty years later, Rosenberg explored the same issues in an article for *Commentary* entitled "Is There a Jewish Art?" He held that the most serious theme in Jewish life was the problem of identity, but he noted that this problem was as much a modern dilemma as it was a Jewish one. Rosenberg believed that Jewish American artists asserted "their individual relation to art in an independent and personal way." They and other American artists who retained their ethnic identities

were creating, Rosenberg proposed, "a genuine American art by creating as individuals." This enterprise amounted to an "aesthetics of self." Rosenberg then came full circle in his argument by saying that this type of independent creativity amounted to "a profound Jewish expression."[13] For Rosenberg, the Jew was a modern everyman searching for identity in the modern world, an identity based on the self as the source of its own creation through, as Newman would have it, making cathedrals out of the self.

As a Jew, Rosenberg undoubtedly had some knowledge of Jewish culture. But in sorting out his identity he recognized himself also as an acculturated, though not fully assimilated, American and as a citizen of the world. To reinvent himself as a citizen of the larger American and world communities, he had to exalt his independent self at the expense of his parochial Jewish cultural and religious identity. Rosenberg and Newman belonged to the generation of my parents, a generation that knew it was Jewish but at the same time wanted, desperately sometimes, to transcend its origins and gain access to those larger communities. I should also add that Buber was immensely popular among Jews of that generation because he wrote within a Jewish milieu but demanded minimal responses and responsibilities from his largely secular Jewish readers. Traditional Jews, on the other hand, do not respond favorably to Buber.[14]

Just as Rosenberg misread Buber in 1947, Newman misread Scholem the following year. For Newman, the misreading was in assuming a God-like pose of creativity, a pose foreign to normative Judaism. In addition, in his stripe paintings Newman disregarded one of the most important parts of Rabbi Luria's cosmogony – the concept of *Tikkun*, which completes the process of creation, of *Tsimtsum*, by restoring the harmony that existed before the creation of the universe. According to Rabbi Luria, in the creation just after the great contraction, some divine sparks were lost. Mankind was responsible for their restitution. That is, every Jew shared responsibility to

> prepare the way for the final restoration of all the scattered and exiled lights and sparks. The Jew who is in close contact with the divine life through the Torah, the fulfillment of the commandments, and through prayer, has it in his power to accelerate or to hinder this process . . . The individual's prayers, as well as those of the community, but particularly the latter, are under certain conditions the vehicle of the soul's mystical ascent to God.[15]

This responsibility of the Jew was not a part of Newman's vision. Newman, a secular person, happened upon a concept of creation in a book by Gershom Scholem that allowed him to visualize the moment of creation. The artist's connection to Kabbalah was nothing more and nothing less.

Newman was consistent in his misreading of Rabbi Isaac Luria. In 1963, while explaining the kind of ritual that might take place in a synagogue he had designed, Newman echoed Rosenberg's misreading of Buber by asserting that personal fulfillment equaled religious exaltation. But Newman's description of the latter bears little resemblance to the true nature of kabbalistic ecstasy:

> [In the synagogue] each man sits, private and secluded in the dugouts [along the side walls] waiting to be called, not to ascend a stage, but to go up on the mound, where, under the tension of that "TzimTzum" [sic] that created light and the world, he can experience a total sense of his own personality before the Torah and His name.

This is the existentialist in Newman talking. But then, wanting to connect to that sense of exalted spiritual ascendance one can find in Kabbalah, Newman said: "My purpose is to create a place, not an environment, to deny contemplation of the objects of ritual for the sake of that ultimate courtesy where each person, man or woman, can experience the vision and feel exaltation of 'His trailing robes filling the Temple.'"[16]

In Judaism, one cannot experience that vision by exalting oneself. Only through God can one begin to approach the fulfillment of the self. Newman's thoughts and ultimate sources here seem to lie not in normative Judaism or even in Buber's religious existentialism but in nineteenth-century Romanticism, in Emerson and Whitman, and in Samuel Tayler Coleridge and William Wordsworth, who portray the artist as a God-like creator.

In addition to the discussions of Rabbi Luria, Hess found a possible source for Newman's stripe paintings in Scholem's discussion of the hymn "Zoharariel, Adonoi, God of Israel," derived from the *Greater Hekaloth* (sixth century C.E.), a compilation of texts that includes apocalyptic writings. Hess cites these two lines as the likely genesis of Newman's stripe:

> With a gleam of His ray he encompasses the sky
> And His splendor radiates from the heights.[17]

But the hymn, "Zoharariel" describes God on his throne surrounded by attendants, not God in the act of creation. And as all of the hymns in the *Greater Hekaloth* celebrate God, not man, they are an unlikely source for Newman's stripes.

Hess found justification of his claim for Kabbalah as the source of Newman's stripes in another book by Scholem – *On the Kabbalah and Its Symbolism*, published in 1965, long after the first stripes were painted in 1948. The passage that Hess found relevant comes from Scholem's discussion of the *Book of Yetsirah*, or *Book of Creation* (third through sixth centuries C.E.), concerning Abraham's presumed ability to imitate God's powers to create human forms. But Scholem's discussion is about the creation of a *golem*, the humanoid figure made from clay that has a long history in Jewish esoteric literature and folklore.[18] The *golem*, always a flawed creature, can hardly stand as a model for Rabbi Luria's version of the creation of the world and of the Adamic figure. And Newman would hardly have wanted to exert God-like powers to make cathedrals out of the self that would be imperfect.

Yet this book by Scholem includes a passage that might help explain Newman's frame of mind in 1948, if not the image of the stripe. Considering medieval interpretations of the legend of the *golem*, Scholem wrote:

> The members of the strong esoteric movements that sprang up among Jews in the age of the crusades were eager to perpetuate, if only in rites of initiation which gave the adept a mystical experience of the creative power inherent in pious men, the achievement attributed to Abraham . . . and other pious men of old in apocryphal legends.[19]

I take this passage to mean that in times of stress – and here stress includes the pogroms of the Crusaders – people imagine mythical or mystical powers that can overcome the oppressor. In the late 1940s, as Newman began his stripe paintings, Jews throughout the world were deeply affected by the Holocaust and the creation of the state of Israel. No Jew could have remained unmoved or neutral to either event. Even today, as Donald Kuspit has suggested, "every Jew has a Holocaust within him; in his innermost heart he has gone up in smoke or been starved to death, after being castrated by society."[20]

Newman's stripes, then, might be understood as an act of resistance as well as a celebration of renewal and rebirth, an affirmation of life during a time of Jewish trauma and national revival. Nourished by his

cultural rather than his religious identification as a Jew, Newman cre-
ated the stripes as one person's single and solitary gesture, a raw asser-
tion of the self against a society and a god that did not merit his full
respect. His desire to make "cathedrals . . . out of ourselves" is a re-
proach as well as a universalizing gesture that reaches beyond his Jewish
identity to all humanity. It is an affirmation of individual strength and
spirit in a world he wanted metaphorically to re-create.

Postscript

Another Kind of Canon

S omebody could write a first-rate history of American art as one long essay about identity politics. Unlike inhabitants of various European countries who seem to know what it means to be French or English or German or Serb, Americans have been concerned with who they are, with self-definition, since the earliest days of the republic. A historian using all the critical tools in the postmodernist arsenal could explore how the newly minted Americans tried to distinguish themselves from the British; how, after the many waves of immigrants from European and Asian countries, Americans tried to define themselves culturally and politically; how Euro-Americans had to "invent" Native Americans and African Americans in order to distinguish themselves from the Others; how these Others had to "reinvent" themselves in order to find out who they were on their own terms. One could explore the many aggressive and defensive positions that contributed to the ongoing discussions of what was American about American art. One could assemble an enormous pile of statements defining or circling around the issue of the American-ness of American art. In this history, the various movements and styles do not become ends in themselves, but means by which American artists and their critics try to figure out who they are and how they relate to the land, to its people, and to its governing ideas and ideologies. In this

history, environment – cultural, political, racial, ethnic, geographical – would be everything, style merely a tool.

This kind of history would end around 1970, to be replaced by a more specialized kind in which the identity of heretofore marginalized groups – women and members of all the various ethnic, religious, and sexual groups who were not included in the mainstream narrative of American art – became the main players. (The African-American counternarrative really begins with the Harlem Renaissance of the 1920s and 1930s, followed at some distance by Jewish artists who explored Jewish themes.) If I were to write such a history, I would argue that within the last thirty years, all of the counternarratives are really continuations of the master American narrative and, not-so-parenthetically, that what is American about American art is the insistent and persistent need for self-definition either as an American or as a member of one or more subgroups – as in, I am female, gay, black, born in the Middle West, and have an Irish grandparent. Do I march in the St. Patrick's Day parade? Who am I?

Nor would I arrange the contemporary chapters by chronology or by style and medium (e.g., conceptual art followed by installations art followed by performance art) since I believe it is more important to understand the agendas of the artists and their interconnections than to valorize the means they use to fulfill their agendas. That is, works with purposeful African-American or Asian-American elements might make use of irony, found objects, performance techniques, whatever. What is important is the similarity of the agendas, which are to achieve some kind of self-definition. I would not marginalize those artists whose work lacks ethnic, religious, or gendered content, but I would indicate that their art is not concerned in the same ways with identity politics. Or to say it differently, I would not foreground postmodernism as an end in itself, but would give central place to the ways artists use postmodernist (and modernist or traditional) techniques for their particular agenda. This is not to say that quality has no place in this history (e.g., Diebenkorn's surfaces) or that morality is irrelevant (American Nazis are also concerned with self-definition, but I do not accept their position under any circumstances): I am talking about a certain kind of history in which environment is a key, if not the key, factor.

Among the artists considered in the essays in this book, it would seem that the American Scenists were the last generation to think about American art in national terms. Thomas Hart Benton was the most restrictive, excluding recent immigrants and their children from partic-

ipating in the formation of an American art based on American experiences – unless they gave up their culture by assimilating as quickly as possible. In contemporary terms, he was not a cultural pluralist; he much preferred a monolithic national identity to ethnic diversity. In effect, he wanted time to stand still, since national identity is by definition timeless and ahistorical, a pure incarnation of a set of characteristics, immutable and unchanging. I would bet that he also rejected the concept of the melting pot, since that was predicated on the notion that a new type of American would emerge from the mixture of immigrant groups. (The melting pot concept, of course, applied only to white, European immigrants, not to people of color.)

Grant Wood was more moderate than Benton, but no less nationalistic. Wood believed that as each region of the country matured and developed its own personality, the regions would begin to compete with each other and that from this competition "a rich American culture will grow."[1]

Other artists of their generation were less specific, although no less concerned with defining American-ness. Charles Burchfield, who found the American Scene movement to be an artificial construction, nevertheless felt that an American art would emerge sooner or later. And Edward Hopper considered American qualities – these did exist for him – to be based on "the artists' visual reaction to his land, directed and shaped by the more fundamental heritage of race." From the context, race here means the white American, rather than the human, race. (Hopper was no Jungian.) He went on to say, in 1927, that artists were emerging who were "no longer content to be citizens of the world of art but believe[d] that now or in the near future American art should be weaned from its French mother."[2] Hopper's choice of words is interesting in the way he positions Americanist artists against those who were not, those who would find their identity and style and subject matter in an American context and those who would not. Many artists, down through the generations, believed that one's American-ness would emerge by virtue of one's living in the American environment. Even Jackson Pollock thought that "an American is an American and his painting would naturally be qualified by the fact, whether he wills it or not."[3] Closer to our own time, one critic linked Jean-Michel Basquiat with Warhol and Rauschenberg especially, because "they made paintings that are unrepentantly about American culture."[4]

These various passages are all premised on the notion that whether the attitude is essentialist or environmentalist, the American element

will make itself felt. The Abstract Expressionists are probably the last significant group about which one could even imagine raising such issues. In their art and in their statements, one can find many references to authenticity of the self, to autonomy of the self, as well as to a sense of a self that defines each artist's personal history. (I am, therefore I am.) These artists mark a last gasp of the American myth of rugged individualism – or of the reckless but charming American guy on the far side of middle-class respectability: Jesse James and Jackson Pollock played by James Dean. Today, most critics would examine these artists less for their American qualities, however defined, than for their attitudes toward or reflections of particular groups, which would also say something about the particular artist's sense of self-identity – Benton's homophobia, Hopper's repeated image of a nude woman before an open window.

A quick check through books and articles on contemporary ethnic and religious groups would also reveal an interest in anything but American qualities. Asian-American artists, when identified as such, attempt to express "invisible and inchoate forces that have affected their identities and identifications." Chicano artists hope to reclaim "recovered Mexican history, artistic expressions, and community activities that would ultimately lead to a reaffirmation of an identity as a people rooted in this continent." Lucy Lippard, looking back from the 1990s at the history of feminist art, found that "the themes of body, gender, and sexuality that have driven and defined women's art since the late sixties incorporate (so to speak) all the other major feminist issues, including identity, autobiography, and the most compelling economic and political concerns." Many Jewish-American artists and writers as well have begun to realize that "the great shift of multiculturalism has forced [them] to radically rethink their place in society, a place marked by the complicated definitions of American Jewish identity." They have begun to "recast their Jewish past in the matrix of postwar America, including both positive and negative aspects of growing up as a white Other in what was formerly seen as the munificent melting pot." And Richard Powell, making a point that I think is more central to understanding contemporary American art than perhaps he realized, said that "the ideological aligning of artworks with black history and culture . . . has converted post modernism into a far more lineage-conscious and, therefore, intriguing approach" to understanding the current scene.[5]

I imagine that all of the authors just cited and the artists they wrote about would agree that the various techniques, styles, and media asso-

ciated with postmodernism are means rather than ends in themselves, that these means are to be used to visualize conscious and purposeful agendas. Part of these agendas is to assert the value of the artists' culture, history, even their way of life, rather than to permit continued insult, degradation, and invisibility. The many and various religious, ethnic, and racial organizations that have been established are important because, as the social observer Michael Walzer has said, "culture requires social space, institutional settings, for its enactments and reproductions. Multiculturalism without multiple institutional networks is a fake."[6] At the same time, it should be pointed out that a multiculturalism of resentment, one that emphasizes difference rather than inclusion, is not necessarily a good thing.

Be that as it may, I also imagine that these writers and artists would reject the inclusion of their art in David Harvey's definition of postmodernism as "the total acceptance of . . . ephemerality, fragmentation, discontinuity, and the chaotic," of that kind of postmodernism that "swims, even wallows, in the fragmentary and the chaotic currents of change, as if that is all there is."[7] This kind of definition implies a world out of control, one too overwhelming for a self in search of moorings or authenticity. It describes, say, Richard Estes's paintings, of which the artist avoids responsibility for their organization. Or it describes David Salle, who questions the importance of firsthand experience and, by extension, the search for self-defining experiences.

Harvey also provides a one-sentence guide to distinguish between, say, Salle's use of art historical images and that of minority art groups. "Postmodernism abandons all sense of historical continuity and memory, while simultaneously developing an incredible ability to plunder history and absorb whatever it finds there as some aspect of the present."[8] That is, archival memory not anchored in time or community denies history and continuity. Facts are transmitted, but not knowledge. In Estes's and Salle's works, among those of many others, there is an avoidance of any structure of value. I would not insist that there should be such structure, but would say that the intentions of these artists are quite different from those of minority-group artists. Jean Baudrillard's trope that we are all now just so many switching stations is simply not relevant – it is even insulting – to all those artists trying to figure out who they are, what their values are, and, probably most important, what has value for them.[9] That is, they are not afraid to make value judgments, and they refuse passivity in the face of all the many assaults –

visual, psychological, economic – on their psyches. For them, instability is not fun and certainly has no virtue. And a self-referential art is entirely beside the point.

Because I am currently most familiar with Jewish-American art, I have found the most cogent expression of what I mean to say in the words of Natan Nuchi, an Israeli-born artist now living in New York City:

> It was quite a sobering experience, standing in the bookstore, browsing through art magazines, looking at works by contemporary American artists, and then moving on to the Judaica section to look at pictures from the Holocaust. The artists' preoccupation with the "non-authentic" and all-knowing irony forever hovering over the works, the Jasper Johnsian chess games and iconographic crossword puzzles, the quotations and recyclings of images from the history of art and their fusion with popular and pornographic images, as well as all this cultural rumination, as sophisticated as it was, seemed to me like some mental fatigue. But as far as the photographs that came to us from the Holocaust are concerned, I believe they are among the very few images in our culture which cannot be treated with irony.[10]

True, Nuchi is concerned here with a very specific event in Jewish and world history, but that in and of itself indicates his intention to speak in and assume responsibility for his own, authorial voice and to respond positively to images, however derived, based on experience, not theory. His words also suggest that concern for one's race, religion, cultural experiences, or history provides an alternative to the worst excesses of postmodernism.

Nuchi's words are also part of a history of Jewish-American art that has yet to be written, and which could be entirely subsumed in a larger study of identity politics in American art that is also yet to be written. In fact, there are three parts to a history of Jewish-American art, one that fiercely acknowledges the artists' sense of Jewishness, a second that tries to escape the artists' Jewishness while surreptitiously acknowledging it, and the last in which artists mock their Jewishness by seeing themselves through the eyes of the Christian Other.

The first group, diverse within its own loose parameters, is predicated on the notion that "a community that develops within the culture and space of another nation [America] ... needs to be aware of its special historic experience, which contains its sense of worthwhileness."[11] The other two groups, which I will consider in a moment, are

basically devoid of a center in Jewish culture or of a sense of worth-whileness and were or are involved in assimilationist politics (also a kind of identity politics).

Various kinds of subject matter inform the art of the first group, regardless of the generation to which the artist belongs. For example, and to limit myself to only two artists, both Max Weber early in the twentieth century and Eleanor Antin at the end of the century have invoked the culture of the eastern European ghetto. Especially in the 1930s, Weber, reflecting old-fashioned patriarchal concerns, painted that culture from his memories of yeshiva students and old men study-ing the holy texts. Antin, haunted by the stories her mother told her about the now-destroyed culture, created the film *The Man Without a World* (1991), which was concerned with how one maintains one's dignity in the ghetto despite poverty and ethnic hatred, and the instal-lation *Vilna Nights* (1993), which re-created a bombed and destroyed ghetto courtyard in which the viewer sees, projected on three video screens on the rear wall, an old tailor, a woman burning a letter, and two abandoned and terrified children imagining a Hanukkah feast. In both instances, as with works by countless other artists, Jewish identifi-cation is predicated on memorializing eastern European Jewish culture largely through remembered or imagined genre scenes.

Not so parenthetically, these works are surprisingly akin to those of American Scene painters of the 1930s whose project was to create typical images of present and past life in rural and small-town America. In both instances, the real subject matter is the preservation and im-mortalization of community values and activities with which the in-tended audience can identify. Of course there are differences – and Max Weber is probably turning in his grave to be associated with Thomas Hart Benton in this or any other way – but the fact remains that both Weber and Benton used their art to articulate a politics of identity.

In his book *Anti-Semite and Jew*, Jean-Paul Sartre argued that for Jews there is a "deep-seated need to attach oneself to tradition and, in default of a national past, to give oneself roots in a past of rites and customs."[12] But these words also describe American Scenists such as Benton even though he did have a national past as well as customs such as Memorial Day parades and Independence Day picnics. I think, rather, that all of these artists found and still find a need to structure, maintain, and even invent permanent rites and customs because of the constant sense of change and flux characteristic of this century, espe-

cially for immigrants who left cohesive, traditional, and small communities for life in the cities of America. (For African Americans, the celebration of Kwanza might fulfill a similar need.) Invented traditions, as Eric Hobsbawm has pointed out, symbolize social cohesion and membership in real or artificial communities. They legitimate institutions and inculcate particular sets of beliefs and value systems. There is probably less concern here with preserving the actual history of the various groups (oppression, loss) than with selecting from the histories that which promotes a sense of continuity, strength, and valor. This would probably be borne out by sifting through the visual as well as through the literary and archival records.[13]

For Jewish artists like Weber and Antin, displays of ethnic behavior can be associated with activities such as lighting the Sabbath candles or following certain dietary laws. But ethnic behavior persists through ethnic memory even when traditional activities are ignored because ethnic memory might include a heavy dose of religious beliefs learned and internalized during childhood. This process gives rise among Jewish artists to another type of subject matter concerned most broadly with improving world conditions. Messianic beliefs, common in traditional Judaism, when made secular prompted many artists during the 1930s to think that in embracing left-wing causes they could find through their art ways to ameliorate societal evils. Marx became, in effect, their secular prophet, who, no less than, say, Isaiah, foresaw a world free of the cares and problems of the moment.

With hindsight, we know that the artists' efforts were doomed, but there is no doubt that their Jewish heritage, even as many denied it at the time, played a major role in their political and artistic stances. There are contemporary Jewish artists who, no less than those of the 1930s, also want to use their art to improve world conditions. In a different and more open cultural and religious climate, they are more religiously inclined than their elders and are much more open in acknowledging their Jewishness as the source of their inspiration. The spirit that motivates these artists shades off to include those who base their art more directly on sacred texts. And here I would argue that for the first time in America there is a religious Jewish art based not on real or imagined genre scenes or on political beliefs, but on personal faith and on inspiration found in the Hebrew Bible and other ancient texts. Virtually all of this art began to appear in the 1970s, when Jews felt increasingly comfortable and secure in America and probably only after other minority art narratives began to emerge.[14]

Since there are so many possible alignments within and between artists, Jewish artists should be considered not only within a Jewish context but also in connection with other artists seeking to establish their own identities as well as to identify with one or more groups. For example, Beth Ames Swartz in 1980 performed a series of ten rituals in Israel celebrating sacred sites associated with women who were mentioned in the Bible. Her project – Jewish, mystical, and feminist – resonates with the piece by Mary Beth Edelson in which she photographed herself as an earth goddess, her *Up From the Earth* of 1979, and with the installation by Alison Saar, *Fertile Ground* of 1993, concerned with African-derived female figures placed in cemeteries. All of these works denote women's strength, independence, mythological presence, and centrality in real or imagined rituals related to the earth.[15] Hobsbawm's observations concerning invented traditions certainly apply to these works, and equally important, their narrative commonalities, the ways they reflect purposeful agendas with particular values, strike me as being the most significant thing about them, their vitality in greater evidence for me than so much theory-driven and self-referential postmodern art.

Other past and contemporary Jewish artists have not been as forthright as Swartz in proclaiming their Jewish identity, but their art and thought would comprise important chapters for both artistic and social reasons in a history of Jewish-American art. For example, nobody has worked through the Jewish problematics of Abstract Expressionists such as Rothko, Newman, Gottlieb, Lipton, and Ferber, with the exception of Ziva Amishai-Maisels's very important but scattered observations in her monumental book on Holocaust art.[16] Although many of their works and statements have an implied Holocaust (read: Jewish) content, these artists never really "outed" themselves as Jews, particularly as Jews in the 1940s, scared out of their wits by events taking place in Europe. (Newman is an exception. See my essay on his stripe painting.)

Lipton, Gottlieb, and Rothko particularly emphasized the innately brutal character of humans without exactly indicating what they were referring to. Lipton found "the sense of the dark inside, the evil of things, the hidden areas of struggle [becoming] for me a part of the cyclic story of living things." Around 1945, when anybody who read newspapers knew that millions of Jews had been murdered, he became interested in pre-Columbian death rituals, images of Moloch, and "other historical deadly devouring imagery. They became important to me in terms of the hidden destructive forces below the surface of man."

Of the image of Moloch, he allowed that "I probably felt [he] related to the war." And then, in a universalist gesture, Lipton acknowledged that "the ferocity in all [my own] works relates to the biological reality of man; they are all horrendous but not in any final negative sense, rather they are tragic statements on the condition of man." Of his "Exodus" pieces of 1947, he later mentioned that they "were part of a tragic mood of history and reality that has always concerned me . . . It is possible that Israeli history and emergence entered. *I really don't know* [italics added]. The underlying mood is tragedy."[17] Of course he knew. But I am certain that at the time Lipton was so embarrassed to admit openly his Jewish feelings that he felt he had partially to repress any religious connections. This is an old story that I well remember from my own childhood and teenage years.

From a Jewish point of view, it is also possible to account for Rothko's, Newman's, and Gottlieb's interest in the "tragic and timeless" and in the ways non-Western artists handled terror. I am referring to the famous letter Gottlieb and Rothko sent to *The New York Times* in 1943, in which they asserted "that the subject is crucial and only that subject-matter is valid which is tragic and timeless. That is why we profess spiritual kinship with primitive and archaic art," and to Newman's analysis of the Kwakiutl painter for whom "a shape was a living thing, a vehicle for an abstract thought-complex, a carrier of the awesome feelings he felt before the terror of the unknowable."[18]

Because it is traditional for Jews to re-read and study consecutive portions of the Bible annually, and because, as in the Passover seder, Jews are asked annually to regard themselves as if they had just left Egypt, there is an old habit of collapsing present time into past time in an ahistorical way, especially to connect terrible contemporary events with, say, the destruction of the Temple in Jerusalem. As the historian Yosef Hayim Yerushalmi has suggested, "there is a pronounced tendency to subsume even major new events to familiar archetypes, for even the most terrible events are somehow less terrifying when viewed within old patterns rather than in their bewildering specificity." There is an unwillingness, then, "to tolerate history in immanent terms."[19] This might help explain why Rothko, a secular Jew who nevertheless had extensive religious training, found his archetypes in Greek rather than biblical tragedies, and why Newman, who was familiar with Kabbalah, sought out the sociology of non-Western groups as his way of dealing with the rising numbers of murdered Jews during the early 1940s. Or, to say it less elegantly, like generations of Jews, there were

artists scrambling for ways to face the present without having to face the present, and found ways that were safe and not too identifiably Jewish. Ironically, the Germans Friedrich Nietzsche and Karl Jung were particularly helpful in this regard.

There is no point belaboring further the totalizing effect the Holocaust had on these Jewish artists, as it did on Jews everywhere. Rothko evidently told Peter Selz that "this kind of disfiguration [the Holocaust] and this kind of thing you cannot touch, but it is, you know, part of what you feel and part of what you express about the tragedy of it all." In addition, Rothko's daughter, Kate, has said that although the Holocaust was never discussed, it was "always in the background."[20] What this adds up to is that these artists were too close to their heritage and to the events of the time to run away, but distant enough and closeted enough not to have to face the situation directly.

One of Rothko's biographers tells an interesting story in this regard. A friend told Rothko about an incident in a classroom lecture given by Meyer Schapiro. Schapiro was discussing Soutine and Jewish culture, then interrupted himself to consider the differences between Jewish and Italian gestures, explaining that the physical closeness of Jews in the ghettos and the Jewish habit of conversing with a pointed finger in part explained Soutine's overly tactile surfaces. Suddenly, Schapiro's voice faltered, he turned his back to the class, and his shoulders began to shake. He then recovered enough to say that that culture had been wiped out and then resumed his lecture. (I witnessed this event as a young graduate student at Columbia University in 1954–1955.) According to Rothko's friend, the artist's response was one of anger. He accused Schapiro of being overly sentimental. But James Breslin, Rothko's biographer, explained that the artist's anger was directed less at Schapiro's sentimentalism than at the fact that Schapiro should not have revealed his emotions before strangers, many of whom were Gentiles.[21]

Similarly, the publicity generated by an ultra-Orthodox demonstration in New York City in February 1999 in support of their brethren in Israel embarrassed many ultra-Orthodox persons because this was a "family matter" and should not have been played out so publicly before a Gentile audience. Revealing oneself as too Jewish was and still is a problem for many.

But not so for many of the artists included in the Jewish Museum's exhibition, "Too Jewish?: Challenging Traditional Identities," held in 1996. Particular works featured noses, ornamented skull caps, prayer shawls with attached gymnastic hand grips, and Pop Art sendups of

Jewish food. Sander Gilman, in an essay in the exhibition catalogue, ended his remarks on Jewish difference by stating, "Whether they are images of Jewish difference associated with Jews on the basis of sexual orientation, color, or politics, these images must be dealt with not through repression but through confrontation."[22] Fair enough. But the big question about this exhibition was: Are the images and the attitudes of the artists ones of confrontation or of seeing themselves through the stereotyping eyes of the majority culture? (This issue is a live one in the African American community, especially concerning the painting and collecting of Sambo and Sambo-like figures.[23])

Many of the works shown at the Jewish Museum struck me as exercises in assimilationist politics, the overarching statement of the artists being that since we can laugh at ourselves, our foibles, and physiognomies, we are no longer a separate, mysterious people, but part of the mainstream – please let us in. Unlike other contemporary Jewish artists concerned with notions of repairing the world or of exploring aspects of their religion, these artists appear to be celebrating and parading their lack of knowledge of and respect for Jewish culture, history, and religion. (Artists in the 1930s at least believed in Marxist principles.) They strike a posture of social ignorance as well in that they do not seem to mind that their images reflect ways the majority culture still perceives them. Their means of Jewish identity, then, is through stereotypes. They remain the other in a WASP culture, accepting notions about themselves from non-Jews. Their interrogation of images is not so much a confrontation in Gilman's terms as it is a commodification of their differences and a willingness to allow coded messages of difference to remain, even though the codes are not of their own invention. These artists perform upon themselves a kind of visual, if not to say psychological, terrorism.[24]

Nevertheless, these artists too have their counterparts within other minority group art circles. They, too, have agendas and are certainly important in the contemporary concern for identity politics. And like American artists throughout the century, they show in their different ways the unique, the stereotypical, the community-oriented, the pleasant, and the awkward, that is, the influence of the environment in its endless ramifications and permutations. The distance between their work and that of Thomas Hart Benton is probably less than the distance between Benton's work and David Salle's, to pick two names out of many for comparison. The importance of their work at this moment is in getting it out of the rut of the aesthetic and back into life.

This, it seems to me, could be the organizing motif for a study of American, particularly of contemporary American, art. Perhaps because of the impact of globalization as well as of homogenization at the national level, people have a great need to find psychological anchors and community roots to insure themselves some kind of personal identity. Identifying American today implies, among other things, identifying with homogeneity and with many of the institutionalized forms of behavior that members of minority groups have been deconstructing since the 1960s. It is the evolution of their battle, as reflected in American art, that strikes me as provoking the most vital art of our time, their battle for the most democratic forms of cultural and artistic pluralism.

Notes

INTRODUCTION

1. Kenneth C. Lindsay, *The Works of John Vanderlyn* (Binghamton: State University of New York University Art Gallery, 1970), pp. 74, 142–147. Some of these issues are raised in my "Territory, Race, Religion: Images of Manifest Destiny," *Smithsonian Studies in American Art* 4 (Summer/Fall 1990): 13–14.

2. Archibald Alison, *Essays on the Nature and Principles of Taste* (New York: Carvill, 1830; first American edition, 1812), p. 405. See also Robert Streeter, "Association Psychology and Literary Nationalism in the *North American Review*, 1815–1825," *American Literature* 17 (1945): 243–254; "Archibald Alison and William Cullen Bryant," *American Literature* 12 (March 1940): 60; and Ralph N. Miller, "Thomas Cole and Alison's *Essays on Taste*," *New York History* 37 (July 1956): 281–299.

3. The first citation is from remarks made by the scientist Benjamin Silliman in 1819 in Edward Nygren, *Views and Visions: American Landscape Before 1830* (Washington, D.C.: The Corcoran Gallery of Art, 1986), p. 206; the second by literary figure Edward Everett in 1824 in Russell Blaine Nye, *Society and Culture in America: 1830–1860* (New York: Harper and Row, 1974), p. 241. Similar comments can be found in Lillian B. Miller, *Patrons and Patriotism: The Encouragement of the Fine Arts in the United States* (Chicago: University of Chicago Press, 1966), pp. 19–20.

4. Hippolyte Taine, *Lectures on Art*, trans. by John Durand (New York: Henry Holt, 1875), pp. 30, 83, 157–161. See also Taine's *History of English Literature*, trans. by H. Van Laun (New York: Holt and Williams, 1872).

5. Some of these issues are considered in my *The American Scene: American Painting of the 1930s* (New York: Praeger, 1974), p. 41.
6. John Dewey, *Art as Experience* (New York: Perigee Books, 1980), p. 125. First published in 1934.
7. The first citation is from "Circles"; the second from "The American Scholar," Joel Porte, ed., *Ralph Waldo Emerson: Essays and Lectures* (New York: Library of America, 1983), pp. 412, 57.
8. The first citation is from "The Iconography of Desolation," Eugenie Tsai, ed., *Robert Smithson Unearthed: Drawings, Collages, Writings* (New York: Columbia University Press, 1991), p. 35; the second is from Lucy R. Lippard's "Breaking Circles: The Politics of Prehistory," Robert Hobbs, ed., *Robert Smithson: Sculpture* (Ithaca: Cornell University Press, 1981), p. 32.
9. See Sacvan Bercovitch, *The American Jeremiad* (Madison: University of Wisconsin Press, 1978).
10. I have studied some of these issues. See, for example, "From Hester Street to Fifty-Seventh Street: Jewish American Artists in New York," in Norman L. Kleeblatt and Susan Chevlowe, eds., *Painting a Place in America: Jewish Artists in New York, 1900–1945* (New York: The Jewish Museum, 1991), pp. 28–88; *Jewish American Artists and the Holocaust* (New Brunswick: Rutgers University Press, 1997); "Kabbalah and Jewish American Art," *Tikkun* 14 (July/August 1999): 59–61; "The Persistence of Holocaust Imagery in American Art," in Bernard Schwartz and Ted DeCoste, eds., *The Holocaust: Art/Politics/Law/Education* (Edmonton: University of Alberta Press, 2000); "Jewish American Artists and the Holocaust: The Responses of Two Generations," in Omer Bartov and Phyllis Mack, eds., *In God's Name: Genocide and Religion in the Twentieth Century* (New York: Berghahn Books, 2000); "Jewish American Artists: Identity and Messianism," in Baigell and Milly Heyd, eds., *Complex Identities: Jewish Identity and Modern Art* (New Brunswick: Rutgers University Press, 2000); and the essays on Shahn and Newman in this book.

ONE. WALT WHITMAN AND EARLY TWENTIETH-CENTURY AMERICAN ART

1. Charles C. Alexander, *Here the Country Lies: Nationalism and the Arts in Twentieth-Century America* (Indianapolis: University of Indiana Press, 1980), p. 4.
2. Malcolm Cowley, "Pascin's America," *Broom* 4 (January 1923): 36.
3. *Walt Whitman: Complete Poetry and Collected Prose* (New York: Library of America, 1982), pp. 327, 328, and 330.
4. Max Kozloff, "Walt Whitman and American Art," in Edwin Haviland Miller, ed., *The Artistic Legacy of Walt Whitman* (New York: New York University Press, 1970), p. 38.
5. This reading of Emerson is based on Richard Poirier, *The Renewal of Literature: Emersonian Reflections* (New York: Random House, 1987). For Bancroft, see R. W. B. Lewis, *The American Adam* (Chicago: University of Chicago Press, 1955), pp. 161–165.
6. *Whitman: Complete Poetry and Collected Prose*, p. 299.

7. *Ralph Waldo Emerson: Essays and Lectures* (New York: Library of America, 1983), p. 412. For Emerson's influence on this aspect of Whitman's thought, see especially Jerome Loving, *Emerson, Whitman, and the American Muse* (Chapel Hill: University of North Carolina Press, 1982), pp. 62–67.

8. *Whitman: Complete Poetry and Collected Prose*, p. 1053.

9. Norman Foerster, "Whitman and the Cult of Confusion," *North American Review* 213 (June 1921): 800–801; Waldo Frank, *Our America* (New York: Boni and Liveright, 1919), p. 71: and Van Wyck Brooks, "America's Coming of Age" (1915), in *Three Essays on America* (New York: Dutton, 1934), pp. 79–80.

10. Robert F. Sayre, "Autobiography and the Making of America," in James Olney, ed., *Autobiography: Essays Theoretical and Critical* (Princeton: Princeton University Press, 1980), p. 160.

11. Jeffrey Steele, *The Representation of the Self in the American Renaissance* (Chapel Hill: University of North Carolina Press, 1987), p. 71.

12. Steele, *Representation of the Self*, p. 68.

13. *An Introduction to Metaphysics* was published in English in 1903, *Time and Free Will* in 1910, and *Creative Evolution* in 1913.

14. From "Song of Myself," in *Whitman: Complete Poetry and Collected Prose*, p. 190.

15. F. O. Matthiessen, *American Renaissance: Art and Expression in the Age of Emerson and Whitman* (New York: Oxford University Press, 1941), p. 622. See also Steele, *Representation of the Self*, p. 70.

16. Editorial, *The Seven Arts* (May 1917): vii.

17. Joseph J. Kwiat, "Robert Henri and the Emerson-Whitman Tradition," *PMLA* 71 (September 1956): 618.

18. Kwiat, "Henri."

19. See my "American Art and National Identity: The 1920s" reprinted in this book.

20. *Lectures on Art by Hippolyte Taine*, transl. and intro. John Durand (New York: Henry Holt, 1883), p. 30.

21. Robert Henri, "Progress in Our National Art Must Spring From the Development of Individuality of Idea and Freedom of Expression: A Suggestion for a New Art School," *The Craftsman* 15 (January 1909): 387–401.

22. *Whitman: Complete Poetry and Collected Prose*, p. 1050.

23. Henri, *The Art Spirit* (Philadelphia: Lippincott, 1923), p. 80.

24. Roger Asselineau, *The Transcendentalist Constant in American Literature* (New York: New York University Press, 1980), p. 94.

25. Kwiat, "Henri," 620n. Sloan also mentioned that on 16 May 1909 and on 31 May 1910 he had read "Song of Myself" and "Crossing Brooklyn Ferry," respectively. See Bruce St. John, ed., *John Sloan's New York Scene* (New York: Harper and Row, 1965), pp. 314, 428.

26. Hamilton Wright Mabie, *Backgrounds of Literature* [1904] (Freeport, N.Y.:Books for Libraries Press, 1970), pp. 199–200; and John Macy, *The Spirit of American Literature* [1913] (New York: Johnson Reprint), pp. 223–225.

27. Paul Rosenfeld, *Port of New York* (New York: Harcourt, Brace, 1924), p. 169.

28. *Whitman: Complete Poetry and Collected Prose*, p. 29.

29. Rosenfeld, *Port of New* York, p. 173.

30. Rosenfeld, *Port of New York*, pp. 14–15.

31. See n. 26.

32. *Whitman: Complete Poetry and Collected Prose*, p. 935. See also Preface, *Leaves of Grass* (1855), p. 7; and "By Blue Ontario's Shore," p. 474.

33. Rosenfeld, "American Painting," *The Dial* 71 (December 1921): 669.

34. Rosenfeld "American Painting," 656. For Stieglitz, see "Stieglitz," *The Dial* 70 (April 1921): 406; and *Port of New York*, pp. 237–238.

35. Editorial, *The Arts* 2 (November 1921): 65.

36. Daniel Catton Rich, ed., *The Flow of Art: Essays and Criticism of Henry McBride* (New York: Atheneum, 1975), p. 165.

37. Thomas Craven, "Men of Art American Style," *American Mercury* 6 (December 1925): 432.

38. Paul Rosenfeld, "The Water Colors of John Marin," *Vanity Fair* 18 (April 1922): 92.

39. *The Arts* 1 (February-March 1921): 34.

40. For Sterne, see Kent Blaser, "Wait Whitman and American Art," *Walt Whitman Review* 24 (March (1978): 116. I want to thank Roberta Tarbell for bringing this reference to my attention. For Walkowitz, see "Interview with Abraham Walkowitz," *Journal of the Archives of American Art* 9 (January 1969): 15. For Hartley, Davis, and Stella, see below.

41. Marsden Hartley, "America as Landscape," *El Palacio* (December 1918): 341.

42. Marsden Hartley, *Adventures in the Arts* [1921] (New York: Hacker Art Books, 1972), p. 35.

43. H[enri]-P[ierre] Roche, "The Blind Man," *The Blindman* 1 (April 10, 1917): 6. See also Dickran Tashjian, *Skyscraper Primitive* (Middletown, Conn.: Wesleyan University Press, 1975), p. 54.

44. Joseph Stella, "The New Art," *The Trend* 5 (June 1913): 395.

45. Cited in Irma Jaffe, *Joseph Stella* (Cambridge: Harvard University Press, 1970), p. 81, from Stella, "Brooklyn Bridge, A Page in My Life," *Transition* 16–17 (Spring-Summer 1929): 86–88.

46. Benjamin De Casseras, "The Renaissance of the Irrational," *Camera Work*, Special Issue (June 1913): 22, 23.

47. Stuart Davis, "Journal 1920–1922," entry under May 1921, collection of Wyatt H. Davis, microfilm courtesy of Robert Hunter.

48. Bernarda Bryson Shahn, *Ben Shahn* (New York: Abrams, 1972), p. 288.

49. *Whitman: Complete Poetry and Collected Prose*, p. 174.

50. *Bulletin of the Museum of Modern Art* 14 (Summer 1947): 23.

51. I cannot find references in Benton's published writings nor in the Benton material in the Archives of American Art, Smithsonian Institution.

52. Walt Whitman, "An American Primer," *Atlantic Monthly* 93 (April 1904): 465.

53. Thomas Hart Benton, *An Artist in America*, 4th ed. rev. (Columbia: University of Missouri Press, 1983).

54. See especially "Democratic Vistas," in *Whitman: Complete Poetry and Collected Prose*, p. 935.
55. *Whitman: Complete Poetry and Collected Prose*, pp. 189, 190, 241.

TWO. AMERICAN LANDSCAPE PAINTING AND NATIONAL IDENTITY: THE STEIGLITZ CIRCLE AND EMERSON

1. Elizabeth Hardwick, "The Fictions of America," *The New York Review of Books* 34 (June 25, 1987), p. 12.
2. Hendrik Hertzberg, "Let's Get Representative," *The New York Republic* 196 (June 29, 1987): 15.
3. Hertzberg, "Let's Get Representative," 16.
4. See my "American Art and National Identity: The 1920s," in this book.
5. James Jackson Jarves, *The Art Idea* [1864] (New York: Hurd and Houghton, 1877), p. 231.
6. Charles L. Buchanan, "American Painting Versus Modernism," *The Bookman* 46 (December 1917): 421.
7. See William Gerdts, *American Impressionism* (New York: Abbeville, 1984), pp. 199, 299; and Thomas Folk, *Edward Redfield* (New Brunswick: Rutgers University Art Gallery, 1981), p. 3.
8. Buchanan, "American Painting," 422.
9. Bliss Carman, *The Kinship of Nature* (Boston: Page, 1904), pp. 143–144. Cited in Charles Eldredge, "Nature Symbolized: American Painting from Ryder to Hartley," in *The Spiritual in Art: Abstract Painting, 1890–1985* (Los Angeles: Los Angeles County Museum of Art, 1986), p. 115.
10. Giles Edgerton [Mary Fanton Roberts], "American Painters of Outdoors: Their Rank and Their Success," *The Craftsman* 16 (June 1909): 282.
11. "The National Note in Our Art: A Distinctive American Quality Dominant at the Pennsylvania Academy," *The Craftsman* 9 (March 1906): 765.
12. Edgerton, "The Younger American Painters: Are They Creating a National Art?" *The Craftsman* 13 (February 1908): 521; and Robert Henri, "The New York Exhibition of Independent Artists," *The Craftsman* 18 (May 1910): 161–162.
13. See Joseph J. Kwiat, "Robert Henri and the Emerson-Whitman Tradition," *PMLA* 71 (September 1956): 617–636.
14. His name appears in issues of *Seven Arts, The New Republic, The Arts, The Dial, The Craftsman,* and *Broom,* among others.
15. Roger Asselineau, *The Transcendentalist Constant in American Literature* (New York: New York University Press, 1980), pp. 90–94.
16. Hippolyte Taine, *Lectures on Art*, trans. by John Durand (New York: Henry Holt, 1883), p. 30.
17. James E. Miller, Jr., ed., *Walt Whitman: Complete Poetry and Selected Prose* (Boston: Houghton Mifflin, 1959), pp. 25, 241.
18. Alfred R. Ferguson and Jean Ferguson Carr, eds., *The Essays of Ralph Waldo Emerson* (Cambridge: Harvard University Press, 1979), p. 210.
19. Ferguson and Carr, eds., *Essays* p. 27.

20. This formulation was provided the author by Elizabeth Broun, The National Museum of American Art, in a letter, May 11, 1987.

21. Lazer Ziff, *Literary Democracy: The Declaration of Cultural Independence in America* (New York: Viking, 1981), p. 15.

22. Ziff, *Literary Democracy*, p. 21.

23. Waldo Frank et al., eds., *America and Alfred Stieglitz: A Collective Portrait* (New York: Doubleday, Doran, 1934), p. 135.

24. Stephen E. Whicher, ed., *Selections from Ralph Waldo Emerson* (Boston: Houghton Mifflin, 1957), p. 24.

25. Alfred Stieglitz interview in the *New York Evening Sun*, cited in Dorothy Norman, *Alfred Stieglitz: An American Seer* [1960] (New York: Random House, 1973), p. 115; Wicher, ed., *Selections*, pp. 67–68; and Ferguson and Carr, eds., *Essays*, pp. 31, 188.

26. Letter from Stieglitz to Sadakichi Hartmann, December 22, 1911, in Norman, *Alfred Stieglitz*, p. 115; and passage from "Ten Stories," *Twice a Year* 5–6 (1940–41): 135–163, cited in Bram Dijkstra, *Hieroglyphics of a New Speech* (Princeton: Princeton University Press, 1969), p. 94.

27. Herbert J. Seligmann, ed., *Alfred Stieglitz Talking* (New Haven: Yale University Press, 1966), p. 212.

28. Seligmann, ed., *Stieglitz Talking*, Statement of April 21, 1926, p. 77.

29. Whicher, ed., *Selections*, p. 79; Letter from Stieglitz to Paul Rosenfeld, September 5, 1923, in Seligmann, ed., *Stieglitz Talking*, p. 212.

30. Letter from Stieglitz to Duncan Phillips, in Sasha M. Newman, *Arthur Dove and Duncan Phillips: Artist and Patron* (New York: Braziller, 1981), p. 31.

31. Georgia O'Keeffe, *A Portrait of Alfred Stieglitz* (New York: Viking, 1978), n.p.

32. Miller, Jr., ed., *Complete Poetry*, p. 462.

33. Seligmann ed., *Stieglitz Talking*, p. 131.

34. Dorothy Norman, ed., *The Selected Writings of John Marin* (New York: Pellegrini and Cudahy, 1949), p. 51.

35. Jerome Mellquist, *The Emergence of American Art* (New York: Charles Scribner's Sons, 1942), p. 362.

36. Cited in Barbara Haskell, *Arthur Dove* (Boston: New York Graphic Society, 1974), pp. 77, 118.

37. Paul Rosenfeld, *Port of New York: Essays on Fourteen American Moderns* (New York: Harcourt, Brace, 1924), p. 168.

38. Rosenfeld, *Port of New York*, p. 169.

39. Seligmann, ed., *Stieglitz Talking*, p. 28.

40. From *The Palisadian* (November 15, 1936), and from the *New York Herald Tribune* (November 18, 1936), both cited in Cleve Gray, ed., *John Marin by John Marin* (New York: Holt, Rinehart and Winston, 1970), p. 128.

41. *John Marin Memorial Exhibition* (New York: The Whitney Museum of American Art, 1956), n.p.

42. Statements in *Marin Memorial Exhibition*, n.p.; Norman, ed., *Writings of Marin*, p. 126; Gray, ed., *Marin by Marin*, p. 44; and *Marin Memorial Exhibition*, n.p.

43. Cited in Haskell, *Dove*, p. 7.
44. The first two quotes are from Sherrye Cohn, *Arthur Dove: Nature as Symbol* (Ann Arbor: UMI Research Press, 1985), p. 106. The third is from Haskell, *Dove*, p. 136.
45. Haskell, *Dove*, p. 35.
46. Gray, ed., *Marin by Marin*, p. 136.
47. Cited in John Baur, *Nature in Abstraction* (New York: Macmillan, 1958), p. 6.
48. Ferguson and Carr, eds., *Essays*, pp. 19, 209.
49. Whicher, ed., *Selections*, p. 26.
50. Haskell, *Dove*, p. 135.
51. "John Marin by Himself," *Creative Arts* 3 (October 1928): xxxix.
52. Whicher, ed., *Selections*, p. 24.
53. Letter to Stieglitz, n.d., in Katherine Hoffman, *An Enduring Spirit: The Art of Georgia O'Keeffe* (Metuchen, N.J.: Scarecrow Press, 1984), pp. 32–33.
54. Letter to Stieglitz, August 21, 1927, in Herbert J. Seligmann, ed., *Letters of John Marin* (Westport, Conn.: Greenwood Press, 1970), n.p. First published in 1931.
55. Hoffman, *An Enduring Spirit*, p. 13.
56. *Georgia O'Keeffe* (New York: Viking, 1976), opposite plate 100.
57. Ferguson and Carr, eds., *Essays*, p. 179.
58. "Georgia O'Keeffe: A Second Outline in Portraiture," [1936], in Gail R. Scott, ed., *On Art By Marsden Hartley* (New York: Horizon, 1982), pp. 104, 105.
59. "The Modern Honors First Woman: O'Keeffe," *The Art Digest* 20 (June 1946): 6. See also *Georgia O'Keeffe*, opposite plates 12 and 13.
60. Haskell, *Dove*, p. 44.
61. Seligmann, ed., *Letters of John Marin*, n.p. The first letter dates from 1928, the last two from 1919.
62. Ferguson and Carr, eds., *Essays*, p. 43; and Whicher, ed., *Selections*, p. 67.
63. Hartley, *Adventures in the Arts* [1921] (New York: Hacker, 1972), p. 7.
64. Hartley, *Adventures*, pp. 43, 47.
65. "Copley's Americanism" [ca. 1930], in Scott, ed., *On Art*, pp. 172, 175.
66. "American Primitives" [n.d.], in Scott, ed., *On Art*, p. 191.
67. "George Fuller" [1937], in Scott, *On Art*, p. 245.
68. Scott, ed., *On Art*, p. 248.
69. "American Values in Painting," in Hartley, *Adventures*, p. 55; and "On the Persistence of Imagination: The Painting of Milton Avery," in Scott, ed., *On Art*, p. 205. See also Hartley, *Adventures*, p. 70.
70. "Albert Pinkham Ryder" [1936], in Scott, ed., *On Art*, p. 266.
71. Hartley, *Adventures*, p. 40.
72. From notes written ca. 1909, in *Feininger/Hartley* [1944] (New York: Museum of Modern Art, 1966), p. 61.
73. Letters to Stieglitz, May and February 1913, in Eldredge, "Nature Symbolized," in *The Spiritual in Art*, p. 115.
74. From Exhibition Statement at Little Galleries of the Photo-Secession, 1914.

75. Statement by Herbert Ferber in *The Tiger's Eye* 2 (December 1947): 44.
76. Harold Rosenberg, "The American Action Painters," *The Tradition of the New* (New York: Grove Press, 1961), p. 25. The article first appeared in 1952.
77. Hartley, "America as Landscape," *El Palacio* (December 1918): 340.
78. Hartley, "America as Landscape," pp. 341, 342.
79. Hartley, "The Poet of Maine," *The Little Review* 6 (July 1919): 53.
80. Letter from Marin to Stieglitz, in Seligmann, ed., *Letters of Marin*, n.p.; and Rosenfeld, *Port of New York*, p. 99.
81. Letter to Rebecca Strand, November 22, 1931, in *Marsden Hartley: Soliloquy in Dogtown* (Cape Ann, Mass.: Cape Ann Historical Association, 1985), p. 13.
82. Henry W. Wells, *Selected Poems of Marsden Hartley* (New York: Viking, 1980), p. 3. See also Haskell, *Marsden Hartley* (New York: The Whitney Museum of American Art, 1980), pp, 83, 84.
83. From "Cleophus and His Own" [n.d.], in Scott, ed., *On Art*, p. 51.
84. Scott, ed., *On Art*, pp. 114, 115.
85. Scott, ed., *On Art*.
86. From "Is There an American Art?" [ca. 1938], in Scott, *On Art*, p. 199.
87. Scott, *On Art*.
88. "Impressions of Provence From an American Point of View," Scott, ed., *On Art*, pp. 143, 144.
89. Letter to Hudson Walker, October 1941, in Haskell, *Hartley*, p. 123.
90. Cohn, *Dove*, p. 9.

THREE. THE SILENT WITNESS OF EDWARD HOPPER

1. Harold Stearns, *America and the Young Intellectual* (New York, 1921), p. 22.
2. Letter from Hopper to Nathaniel Pousette Dart, editor, *The Art of Today* (Feb. 1935): 11.
3. Stearns, *America*, p. 59; Joseph Wood Krutch, "The Modern Temper," *The Atlantic Monthly* (Feb. 1927), cited in Loren Baritz, ed., *The Culture of the Twenties* (Indianapolis, 1970), pp. 363, 360.
4. Waldo Frank, *Our America* (New York, 1919), pp. 171, 172. See also Walter Lippmann, *A Preface to Morals* (New York, 1929); and Alvin Toffler, *Future Shock* (New York, 1970).
5. Stearns, *America*, pp. 65–66; and Leslie Fiedler, *Love and Death in the American Novel* (New York, new rev. ed., 1967), p. 315.
6. Lewis Mumford, "The City," in Stearns, ed., *Civilization in the United States* (New York, 1922), p. 13.
7. Parts of the following discussion grew from conversations with Margot and Athan Karras, psychologists, and Charlotte Weiss, a psychiatrist, neighbors and friends for many years. I accept full responsibility for the contents of my remarks, however.
8. See Wylie Sypher's discussion of Robert Musil's *The Man Without Qualities* in his *Loss of Self* (New York, 1964), pp. 9–10.
9. R. D. Laing, *The Divided Self* (Baltimore, 1965), pp. 47 ff. See also Arthur

Burton, "Schizophrenia and Existence," in Hendrick M. Ruitenbeek, ed., *Psychoanalysis and Contemporary American Culture* (New York, 1964), pp. 91–106.

10. I am deeply indebted to Lloyd Goodrich for providing verbally the information in this paragraph and for allowing me to examine his personal notes on Hopper.

11. Lloyd Goodrich file, note dated April 20, 1946.

12. John Morse, "Edward Hopper, An Interview," *Art in America* 48, no. 1 (1960): 63.

13. Morse, "Hopper," 63.

FOUR. AMERICAN ART AND NATIONAL IDENTITY: THE 1920s

1. Giles Edgerton (Mary Fanton Roberts), "The Younger American Painters," *The Craftsman* 13 (February 1908): 521.

2. Robert Henri, "The New York Independent Artists," *The Craftsman* 18 (May 1910): 161. See also Gustave Stickley, "A Greater Sincerity Necessary for the True Development of American Art," *The Craftsman* 16 (April 1909): 55–59.

3. Hippolyte Taine, *Lectures on Art*, trans. John Durand (New York: Henry Holt, 1883), p. 30. See also Leo Tolstoy, *What Is Art?* trans. Charles Johnston (Philadelphia: Henry Abrams, 1898); John Albert Macy, "Tolstoy's Moral Theory of Art," *The Century* 52 (June 1901): 300; and Joseph Kwiat, "Robert Henri and the Emerson-Whitman Tradition," *PMLA* 71 (September 1956): 617–36.

4. Edgerton, "American Painters of Outdoors: Their Rank and Their Success," *The Craftsman* 16 (June 1909): 282.

5. "The National Note in Our Art: A Distinctive American Quality Dominant at the Pennsylvania Academy," *The Craftsman* 9 (March 1906): 753; "Irving R. Wiles: Distinctive American Portrait Painter," *The Craftsman* 18 (June 1910): 353. See also Bayard Boyeson, "The National Note in American Art," *Putnam's Monthly* 4 (May 1908): 133–35; and Kenyon Cox, "The American School of Painting," *Scribner's Magazine* 50 (December 1911): 765–68.

6. Randolph Bourne, "Our Cultural Humility," *The Atlantic Monthly* 114 (October 1914): 506.

7. "Picabia, Art Rebel, Here to Teach New Movement" *The New York Times*, February 16, 1913, sect. 5, p. 9.

8. "French Artists Spur On an American Art," *New York Tribune*, October 24, 1915, sect. 4, p. 2. See also "The European Art Invasion," *The Literary Digest* 51 (November 1915): 1224; "The Iconoclastic Opinions of M. Marcel Duchamp Concerning Art and America," *Current Opinion* 59 (November 1915): 346, cited in Dickran Tashjian, *Skyscraper Primitive* (Middletown, CT: Wesleyan University Press, 1975), p. 50.

9. Van Wyck Brooks, "The Culture of Industrialism," *The Seven Arts* 1 (April 1917): 655.

10. Harold Stearns, *America and the Young Intellectual* (New York: Doran, 1921), pp. 80–81.

11. Stearns, *America and the Young Intellectual*, p. 22.
12. From *291*, 5–6 (July-August 1915), reprinted in *Camera Work* 48 (October 1916): 69, cited in Tashjian, *Skyscraper Primitive*, p. 41.
13. Bourne, "Trans-National America," *The Atlantic Monthly* 118 (July 1916): 88–91; and Maxwell Bodenheim, "American Art?" *The Dial* (May 31, 1919): 544.
14. Paul Strand, "American Watercolors at the Brooklyn Museum," *The Arts* 2 (December 1921): 149, 150.
15. Bourne, "Trans-National America," 86.
16. "America As the Promised Land," *The New Republic* 32 (October 4, 1922): 135. See also Winifred Kirkland, "Americanization and Walt Whitman," *The Dial*, 66 (May 31, 1919): 537.
17. Editorials, *The Seven Arts* 1 (November 1916): 52, 53; and 1 (March 1917): 505.
18. *The Seven Arts* 1 (March 1917): 506.
19. On Hassam, see William Gerdts, *American Impressionism* (New York: Abbeville, 1984), p. 299. On Luks, see "Comment on the Arts," *The Arts* 1 (February-March 1921): 34.
20. Strand, "American Watercolors," 152.
21. See Gerdts, *American Impressionism*, pp. 199, 299; and Thomas Folk, *Edward Redfield* (New Brunswick: Rutgers University Art Gallery, 1981), p. 3.
22. Dorothy Norman, ed., *The Selected Writings of John Marin* (New York: Pellegrini and Cudahy, 1949), p. 50.
23. *Transition*, 16–17 (June 1929), in the Joseph Stella File, Whitney Museum of American Art.
24. Louis Lozowick, "The Americanization of Art," essay for the Machine Age Exposition, May 1927, reprinted in Janet Flint, *The Prints of Louis Lozowick* (New York: Hudson Hills, 1982), pp. 18–19.
25. William Carlos Williams, *In the American Grain* (New York: New Directions, 1956) (first published in 1925). This reference was kindly provided by Sarah Greenough, National Gallery of Art.
26. Robert Allerton Parker, "The Classical Vision of Charles Sheeler," *International Studio*, 84 (May 1926): 71.
27. Forbes Watson, "Charles Sheeler," *The Arts* 3 (May 1923): 335, 341.
28. Archives of American Art, Charles Sheeler Papers, Microfilm, Roll NSH 1, Frame 102.
29. This and the immediately following observations grew from conversations with Dr. Allen Kaufman, University of New Hampshire.
30. Leo Marx, *The Machine in the Garden: Technology and the Pastoral Ideal in America* (New York: Oxford University Press, 1964).
31. Thomas Hart Benton, *An Artist in America*, 4th rev. ed. (Columbia: University of Missouri Press, 1983), p. 41.
32. Benton, "American Regionalism: A Personal History," *An American in Art* (Lawrence: University Press of Kansas, 1969), p. 149, originally published in *University of Kansas City Review* 18 (Autumn 1951): 41–74.
33. Benton, *An American in Art*, p. 167.

34. Archives of American Art, Thomas Hart Benton Papers, Manuscript entitled "The 1930s," Microfilm Roll 2326, Frame 1478.

35. Stuart Davis, Journal 1920–1922, Collection of Wyatt H. Davis (microfilm copy courtesy of Robert Hunter), pp. 39–40. I want to thank Dr. John R. Lane for information on the journal.

36. Davis, Journal, p. 68.

37. Davis, Journal, pp. 39–40.

38. Quoted in John R. Lane, *Stuart Davis: Art and Art Theory* (New York: The Brooklyn Museum, 1978), p. 94.

39. *Soil* 1 (January 1917): 55, cited in Barbara Zabel, "The Machine as Metaphor, Model, and Microcosm: Technology in American Art, 1915–1930," *Arts Magazine* 57 (December 1982): 103.

40. "Made in America," *Broom* 2 (June 1922): 270.

41. "The Great American Billposter," *Broom* 3 (November 1922): 305.

42. From *Bulletin of America's Town Meeting of the Air* 5 (February 1940), in Diane Kelder, ed., *Stuart Davis* (New York: Praeger, 1971), p. 121; and Davis, "The Cube Root," *Art News* (February 1, 1943), in Kelder, ed., *Davis*, p. 130.

43. Davis, Journal, May 1921, p. 39.

44. Malcolm Cowley, "Pascin's America," *Broom* 4 (January 1923): 136.

45. Walt Whitman, *Complete Poetry and Selected Prose*, James E. Miller, Jr., ed. (Boston: Houghton Mifflin, 1959), pp. 460, 479.

46. Editorial in *The Seven Arts* 1 (April 1917): 630; Editorial in *The Arts* 2 (November 1921): 65; Paul Rosenfeld, "American Painting," *The Dial* 71 (December 1921): 656; and Marsden Hartley, "America as Landscape," *El Palacio* (December 1918): 340–41. The last reference was kindly provided by Elizabeth Broun, National Museum of American Art.

47. Statement by Benton in John I. H. Baur, ed., *New Art in America* (Greenwich, CT: New York Graphic Society, 1951), p. 131.

48. Letter to Alfred Stieglitz, October 10, 1921, cited in Tashjian, *William Carlos Williams and the American Scene, 1921–1940* (New York: Whitney Museum of American Art, 1978), p. 77.

49. Letter to Stieglitz, November 28, 1921, cited in Emily Farnham, *Charles Demuth: Behind a Laughing Mask* (Norman: University of Oklahoma Press, 1971), pp. 136, 137.

50. Henry McBride, "Modern Art," *The Dial* 70 (February 1921): 235.

51. "Comment on the Arts," *The Arts* 1 (January 1921): 31.

52. Charles Burchfield, "On the Middle Border," *Creative Arts* 3 (September 1928): xxv–xxxi.

53. [Henry McBride?], "The Winter of Our Discontent," *The Dial* 69 (August 1920): 159.

54. Edward Hopper, "Charles Burchfield: American," *The Arts* 14 (July 1928): 6, 10.

55. Brooks, "Enterprise," *The Seven Arts* 1 (November 1916): 60.

56. Hopper, "John Sloan and the Philadelphians," *The Arts* 11 (April 1927): 170.

57. Alexis de Tocqueville, *Democracy in America*, J. P. Mayer and Max Lerner, eds., George Lawrence, trans. (New York: Harper and Row, 1966), p. 477.

58. *The Art Digest* 1 (March 1927): 14.

59. Lloyd Goodrich, "The Paintings of Edward Hopper," *The Arts* 1 (March 1927):136.

60. For Ault and Bourgeois, see Typescript of Questions and Answers for an Exhibition [1920s?], Archives of American Art, George Ault Papers, Micro-film Roll D247, Frames 14–15.

61. Mary Austin, "New York: Dictator of American Criticism," *The Nation* 111 (July 31, 1920): 129–30.

62. Royal Cortissoz, *American Art* (New York: Charles Scribner's Sons, 1923), p. 18.

63. Thomas Craven, "Men of Art: American Style," *The American Mercury* 6 (December 1925): 426.

64. Forbes Watson, "The All-American Nineteen," *The Arts* 16 (January 1930): 303.

65. Benton, "America's Yesterday," *Travel* 63 (July 1934): 9.

66. Williams, *The Great American Novel* [1923], in Webster Scott, ed., *Imaginations* (New Nork: New Directions, 1970), p. 220.

67. "Quarterly Press Clips," People for the American Way (July-September 1986), p. 5.

68. Brooks, "Toward a National Culture," *The Seven Arts* 1 (March 1917): 538.

69. Brian O'Doherty, "Portrait: Edward Hopper," *Art in America* 52 (December 1964): 72.

70. Letter to Frank Rehn, October 11, 1938, Charles Birchfield File, Whitney Museum of American Art.

71. Charles Birchfield, "Henry J. Keller," *The American Magazine of Art* 29 (September 1936): 592. See also *Charles Birchfield* (New York: American Artists Group, 1945).

72. Frederick S. Wight, "Charles Sheeler," *Art in America* 42 (October 1954): 205; and Wight, *Charles Sheeler* (Los Angeles: Art Galleries of the University of California, 1954), p. 28.

73. Davis, "Rejoinder to [Thomas Hart] Benton," *The Art Digest* 9 (April 1, 1935): 12.

74. See, for example, Richard D. McKenzie, *The New Deal for Artists* (Princeton: Princeton University Press, 1973), p. 110; and Marlene Park and Gerald E. Markowitz, *Democratic Vistas: Post Offices and Public Art in the New Deal* (Philadelphia: Temple University Press, 1984), pp. 178–81.

FIVE. THE BEGINNINGS OF "THE AMERICAN WAVE" AND THE DEPRESSION

1. Samuel M. Green, *American Art* (New York: 1966).

2. *The American Annual, 1932* (New York: 1932), p. 72, article by Peyton Boswell, editor of *The Art Digest*. See also *The Art Digest* 5 (September 1, 1931): 17; and 6 (May 1, 1932): 1. Hereafter *The Art Digest* will be cited as *AD*.

3. *The American Art News* 22 (October 27, 1923): 1.

4. Daniel Aaron, *Writers on the Left* (New York: 1965), p. 119.

5. To be sure, George Luks could argue against sending painters abroad, but this was a minority view. See John Spargo, "George Luks," *The Craftsman* 20 (September 1907): 599–607. For a broader discussion of this problem, see Milton Brown, *American Paintings from the Armory Show to the Depression* (Princeton: 1955), pp. 173–74.

6. Thomas Craven, "Men of Art: American Style," *The American Mercury* 6 (December 1925): 425–432.

7. Craven, "The Curse of French Culture," *Forum* 82 (July 1929): 59.

8. Craven, *Modern Art* (New York: 1934).

9. Among the many studies that consider these social patterns, see John Higham, "Another Look at Nativism," and Henry F. May, "Shifting Perspectives on the 1920's," in Carl N. Degler, ed., *Pivotal Interpretations of American History*, II (New York: 1966); Hiram Wesley Evans, "The Klans Fight for Americanism," in George O. Mowry, ed., *The Twenties* (Englewood Cliffs: 1963); and William E. Leuchtenburg, *The Perils of Prosperity, 1914–1932* (Chicago: 1958), *passim*.

10. *The Perils of Prosperity*, p. 103.

11. Leuchtenburg, *Franklin D. Roosevelt and the New Deal* (New York: 1965), p. 157.

12. William Aylott Orton, *America in Search of Culture* (Boston: 1933), p. 14.

13. R. L. Duffus, *The American Renaissance* (New York: 1928), pp. 317–318.

14. Eugen Neuhaus, *The History and Ideals of American Art* (Stanford: 1931), p. vii.

15. Dana's remark is cited in Edwin Alden Jewell, *Americans* (New York: 1931), p. 32. See also AD 2 (December 15, 1927): 6; 2 (April 18, 1928): 3; 3 (January 15, 1929): 7; 5 (July 1, 1931): 20, and various editorials from 1930–32.

16. It became common at this time for artists and public alike to speak of New York as the center of world art.

17. AD 7 (September 1, 1933): 10.

18. Edmund Wilson, *The Shores of Light* (New York: 1952), p. 492.

19. AD 1 (May 1, 1927): 14.

20. AD 1 (August 1, 1927): 6.

21. AD 3 (March 15, 1929): 18.

22. George Biddle, "Tropics and Design," *The American Magazine of Art* 20 (August 1929): 438–39. This journal will hereinafter be cited as AMOA.

23. AD 4 (November 1, 1929): 27.

24. AD 4 (November 1, 1929): 27.

25. See especially AMOA 21 (June 1930): 368–381; and 21 (July 1930): 398–399.

26. AMOA 21 (December 1930): 679. See also AD 4 (January 1, 1930): 10; 4 (February 1, 1930), 11; 4 (February 15, 1930): 9; 5 (November 1, 1930): 5; and 5 (December 15, 1930): 17–18.

27. The question of the Midwest as the major art-producing region in the country in the 1930s, a particularly knotty one at best, will not be considered here.

28. AD 5 (November 1, 1930): 19.

270 NOTES TO PP. 88–99

29. *AD* 4 (April 1, 1930): 8.
30. Jewell, *Americans*, p. 9. See virtually any *Art Digest* for 1930.
31. Forbes Watson, "The Star-Spangled Banner," *The Arts* 18 (October 1931): 45.
32. *AD* 6 (March 1, 1932): 1.
33. *AD* 6 (November 1, 1931): 6.
34. *AD* 6 (November 1, 1931): 6; and *AMOA* 23 (December 1931): 470.
35. Matthew Josephson in *The New Republic* 70 (March 2, 1932): 73.
36. *AD* 6 (March 15, 1932): 15. The affirmative won.
37. *AD* 6 (July 1, 1932), cv.
38. *AD* 6 (November 1, 1931): 4; and *AMOA* 23 (December 1931): 487.
39. *The Nation* 136 (January 18, 1933): 72.
40. Holger Cahill, "American Art Today," in Fred J. Ringel, ed., *America as Americans See It* (New York: 1932), p. 256.
41. Jewell, *Americans*, p. 28.
42. *The Arts* 17 (October 1930): 21.
43. Personal letter ftom Benton, October 16, 1967.
44. *Edward Hopper* (New York: 1933), and John I. H. Baur, *Charles Burchfield* (New York: 1956).
45. *The Arts* 5 (April 1924): 219, and *AD* 2 (April 15, 1928): 19.
46. *AD* 4 (April 1,1930): 16.
47. Craven, "American Men of Art," *Scribner's* 92 (October 1932): 267.
48. *AD* 1 (March 1, 1927): 14; and Lloyd Goodrich, "The Paintings of Edward Hopper," *The Arts* 11 (March 1927): 136.
49. *AD* 3 (February 1, 1929): 16.
50. *Parnassus* 3 (October 1931): 6.
51. See especially, Charles Burchfield, "On the Middle Border," *Creative Art* 3 (September 1928): xxviii; Stuart Chase, *Men and Machines* (New York: 1929); and Lewis Mumford, "The Drama of the Machines," *Scribner's* 88 (August 1930): 151–161.
52. Articles on the German movement appeared as early as 1926. See *AD* 1 (December 1, 1926): 7. See also H. W. Janson, "The International Aspects of Regionalism," *College Art Journal* 2 (May 1943): 110–114. In a personal communication (14 March 1967) Daniel Catton Rich, Director, Worcester Art Museum, stated that Grant Wood told him that he had seen works by Otto Dix in Germany and felt that Dix's approach could be adapted for American use.

SIX. GRANT WOOD REVISITED

1. Biographical information is taken from Darrell Garwood, *Artist in Iowa: A Life of Grant Wood* (New York, 1944).
2. This statement first appeared, as far as can be determined, in *The Art Digest* (February 1, 1936): 18.
3. F. A. Whiting, Jr., "Stone, Steel, and Fire: Stone City Comes to Life," *The American Magazine of Art* (December 1932): 337.
4. "An Iowa Secret," *The Art Digest* (October 1, 1933): 6.

5. Garwood, *Artist in Iowa*, p. 119.

6. Garwood, *Artist in Iowa*, p. 120.

7. That it mocks the old notions of mid-western yeomen can be seen by comparing the painting to the following description cited by Henry Nash Smith in his *Virgin Land: The American West as Symbol and Myth* (Cambridge, 1950), Vintage Books, reprint, p. 752, from a speech read in the Virginia House of Delegates in 1832. "Sir, our native, substantial, independent yeomanry constitute our pride, efficiency and strength; they are our defence in war, our ornaments in peace; and no population, I will venture to affirm, upon the face of the globe, is more distinguished for an elevated love of freedom – for morality, virtue, frugality and independence, than the Virginia peasantry west of the Blue Ridge."

8. His first painting in his new style is usually thought to be *Woman and Plants*, 1929. It is a portrait of his mother.

9. American Guide Series, *Iowa* (New York, 1941), pp. 141–44.

10. Phil Stong, *Hawkeyes* (New York, 1940), p. 43.

11. See, for example, Gladys E. Hamlin, "Mural Painting in Iowa," *The Iowa Journal of History and Politics* (July 1939): 227–307; and Zenobia B. Ness and Louise Orwig, *Iowa Artists of the First Hundred Years* (1939).

12. Stong, *Hawkeyes*, pp. 48–49. See also, American Guide Series, *Iowa*, p. 132.

13. See Alfred Kazin, *On Native Grounds* (New York, 1942), especially chapters 1, 4, 7, and 8.

14. Sherwood Anderson, *Kit Brandon* (New York, 1936), p. 255. Cited in Kazin, *On Native Grounds*, p. 217.

15. Smith, *Virgin Land*, p. 286.

16. Max Lerner, *America as a Civilization* (New York, 1964), I, p. 152.

17. Edmund Wilson, *The Shores of Light* (New York, 1952), p. 499.

18. H. W. Janson, "The International Aspects of Regionalism," *College Art Journal* (May 1943): 110–14.

19. "The Tory Spirit," *The Art Digest* (October 15, 1934): 13.

20. Garwood, *Artist in Iowa*, p. 124.

21. *The Art Digest* 5(January 1931): 9.

22. Garwood, *Artist in Iowa*, p. 127.

23. These paintings, as well as others by Hawthorne, accompanied an article written about the artist just after his death. An academic figure, Hawthorne also painted workers and fishermen of Cape Cod. Leila Mechlin, "Charles W. Hawthorne," *The American Magazine of Art* (August 1931): 91–106. See also Elizabeth McCausland, *Charles W. Hawthorne* (New York, 1947). Born in 1872, Hawthorne died in 1930.

24. Marquis W. Childs, "The Artist in Iowa," *Creative Art* (June 1932): 462.

25. W. S. Hall, *Eyes on America* (London, n.d.), p. 78.

26. Garwood, *Artist in Iowa*, p. 138.

27. Garwood, *Artist in Iowa*, pp. 162, 165.

28. Exhibited in 1932, they were illustrated in *Creative Art* (June 1932): 450–51.

29. Paul Engle, *American Song* (New York, 1934), p. xi, and, Archibald MacLeish, *America Was Promises* (New York, 1939).

SEVEN. THE RELEVANCY OF CURRY'S PAINTINGS OF BLACK FREEDOM

1. Laurence E. Schmeckebier, *John Steuart Curry's Pageant of America* (New York, 1943), p. 293.
2. The *Art Digest* 9 (February 15, 1935): 14; and other art journals.
3. Schmeckebier, *Pageant*, pp. 284–307, and mimeographed information sheet obtained from the Law School of the University of Wisconsin.
4. Schmeckebier, *Pageant*, p. 294.
5. Mimeographed information sheet mentioned in note 3 above.

EIGHT. THOMAS HART BENTON AND THE LEFT

1. Biographical data is taken from Thomas Hart Benton, *An Artist in America*, 4th ed. (Columbia: University of Missouri Press, 1983); and Thomas Hart Benton, *An American in Art* (Lawrence: University Press of Kansas, 1969), unless otherwise noted; Archives of American Art, Smithsonian Institution, Benton Papers, Microfilm Roll 2325, Frame 1061. Hereafter material from the Benton Papers in the Archives will be listed as in BP, Roll 2325, Frame 1061; Douglas Hyland, "Benton's Images of American Labor," in Elizabeth Brown, Douglas Hyland, and Marilyn Stokstad, eds., *Benton's Bentons* (Lawrence: Spencer Museum of Art, University of Kansas, 1980), p. 23. See also Archives of American Art, John Weichel Papers, Roll D 60–62, Frames 42–44.
2. Interview statement in *Art Digest* 9 (15 April 1935): 12; BP, Roll 2326, Frame 1478, written manuscript entitled "Thirties"; Benton, "American Regionalism: A Personal History of the Movement," in *An American in Art*, 167. Essay first published in *The University of Kansas City Review* 18 (Autumn 1951): 41–75.
3. Emily Braun and Thomas Branchick, *Thomas Hart Benton: The America Today Murals* (New York: The Equitable Life Assurance Society of the United States, 1985), pp. 39–65; Benton, *An Artist in America*, pp. 30, 202.
4. Braun and Branchick, *Thomas Hart Benton*, p. 64.
5. Leo Huberman, *We the People* (New York: Harper & Brothers Publishers, 1932).
6. A second strike scene is in the Thomas Hart Benton and Rita Benton Testamentary Trusts. The third is in an unknown collection. For the exhibitions, see Joseph Kwiat, "John Reed Club at Exhibition," *New Masses* (February 1933): 23–24; and *An Art Commentary on Lynching* (New York: Arthur U. Newton Galleries, 1935).
7. Stephen Alexander, "Art," *New Masses* 15 (23 April 1935): 29.
8. "Benton Taps Heart of America in Monumental 'Indiana Mural'," *Art Digest* 7 (1 July 1933): 10.
9. For a fuller account, see Matthew Baigell and Allen Kaufman, "The Missouri Murals: Another Look at Benton," *Art Journal* 36 (Summer 1977): 314–321.
10. Benton, *An Artist in America*, p. 29.
11. For his early socio-political position, see Benton, "Form and Subject," *Arts* 5

(June 1924): 303–308, reprinted in Matthew Baigell, ed., *A Thomas Hart Benton Miscellany* (Lawrence: University Press of Kansas, 1971), pp. 8–16.

12. *Art Digest* 7 (July 1, 1933): 6.

13. Thomas Hart Benton, "America's Yesterday," *Travel* 63 (July 1934): 45.

14. Matthew Baigell, *The American Scene: American Painting of the 1930s* (New York: Praeger Publishers, 1974), pp. 61, 210.

15. *Art Digest* 7 (1 July 1933): 6.

16. Thomas Hart Benton, "Art and Nationalism," *Modern Monthly* 8 (May 1934): 232–236, reprinted in Baigell, *Miscellany*, p. 56.

17. These citations are taken from Benton, "Art and Social Struggle: Reply to Rivera," *The University Review* (University of Kansas City) 2 (Winter 1935): 71–78, reprinted in Baigell, *Miscellany*, pp. 39–49. See also written draft in BP, Roll 2327, Frames 243–263.

18. For Benton's later reaction, see BP, Roll 2327, Frames 9–10, handwritten manuscript entitled "Thirties." For Benton-Davis interchange, see *Art Digest* 9 (March 15, 1935): 20–21; *Art Front* 1 (April 1935): 2, and 1 (May 1935): n.p.; BP, roll 2327, Frame 993, written manuscript page; Baigell, *Miscellany*, pp. 58–65; and David Shapiro, ed., *Social Realism: Art as a Weapon* (New York: Frederick Ungar, 1973), pp. 95–107; BP, Roll 2327, Frame 4, written manuscript entitled "Thirties." Benton's position on Soviet dictatorship clearly is implied in Thomas Hart Benton, "Art and Social Struggle," reprinted in Baigell, *Miscellany*, p. 43; and "Benton Goes Home," *Art Digest* 9 (15 April 1935): 13.

19. BP, Roll 2327, Frame 10, written manuscript entitled "Thirties"; from an interview in *The New York Times*, February 8, 1935, reprinted in *Art Digest* 9 (15 February 1935): 21, and in Baigell, *Miscellany*, p. 74; *Art Digest* 9 (April 1935): 13; Ruth Pickering, "Thomas Hart Benton on His Way Back to Missouri," *Arts and Decoration* 42 (February 1935): 19–20; interview in *Demcourier* 13 (February 1943): 3–5. The latter two references are in Baigell, *Miscellany*, pp. 75–77, 94–102.

20. Thomas Hart Benton, "Confessions of an American," *Common Sense* 6 (August 1937): 11; see also 6 (July 1937): 7–8; and 6 (September 1937): 19–21.

21. *Common Sense* 6 (August 1937): 12; and 6 (September 1937): 20–21. For preliminary drafts, see BP, Roll 2327, Frames 881–886.

22. BP, Roll 2327, Frames 2–10, written manuscript entitled "Thirties."

23. BP, Roll 2326, Frame 591, written manuscript entitled "After"; BP, Roll 2327, Frame 701, untitled manuscript.

24. BP, Roll 2327, Frame 159, typed manuscript entitled "Dilemma."

25. For a contemporary response to this image, see Stuart Davis, "Rejoinder to Benton," *Art Digest* 9 (1 April 1935): 12, reprinted in Shapiro, *Social Realism*, pp. 102–107; Thomas Craven, *Modern Art* (New York: Simon and Schuster, 1934), p. 312.

26. See my essay, "American Art and National Identity: The 1920s," included in this book.

27. BP, Roll 2325, Frame 1082, typed manuscript entitled "The Intimate Story – Boyhood."

28. BP, Roll 2325, Frames 51–550, 1046, typed manuscript entitled "The Intimate Story – Boyhood."

29. BP, Roll 2325, Frames 533, 542–545, 548–550; Benton, *An Artist in America*, p. 45.

30. Benton. *An American in Art*, pp. 167–168; BP, Roll 2325, Frames 66–67, undated letters; Benton, *An Artist in America*, pp. 76–77; Thomas Hart Benton, "My American Epic in Paint," *Creative Arts* 3 (December 1928): xxxv.

31. "Mourning and Melancholy," in James Strachey, ed. and trans., *The Standard Edition of the Complete Psychological Works of Sigmund Freud* (London: The Hogarth Press, 1957), 14, p. 249.

32. Anna Freud, *The Ego and Mechanisms of Defense* (New York: International University Press, 1946), p. 128.

33. Sigmund Freud, *The Ego and the Id* (London: The Hogarth Press, 1927), p. 44.

34. For additional information, see Lawrence Goodwyn, *Democratic Promise: The Populist Mind in America* (New York: Oxford University Press, 1976); and Norman Pollack, ed., *The Populist Mind* (Indianapolis: Bobbs-Merrill, 1967). The major figure was Governor Lorenzo D. Lewelling of Kansas in 1893, in *The Populist Mind*, p. 52.

35. Benton, "My American Epic in Paint," xxxvi; Benton, *An Artist in America*, pp. 3–16.

36. James A. Henretta, "Social History as Lived and Written," *American Historical Review* 84 (December 1979): 1308. This article was kindly brought to my attention by Professor John Gillis of Rutgers University.

NINE. THE EMERSONIAN PRESENCE IN ABSTRACT EXPRESSIONISM

1. Francis V. O'Connor, *Jackson Pollock* (New York: Museum of Modern Art, 1967), p. 32.

2. John Wilmerding, "Introduction," in Wilmerding, ed., *American Light. The Luminist Movement, 1850–1875* (Washington, D.C.: National Gallery of Art, 1980), p. 17. See also Barbara Novak, *American Painting of the Nineteenth Century* (1969; rept. New York: Harper and Row, 1979), chs. 5–7.

3. My reading of Emerson is based on Richard Poirier's *The Renewal of Literature: Emersonian Reflections* (New York: Random House, 1987) and Harold Bloom's *Poetry and Repression* (New Haven: Yale University Press, 1976) and *Agon* (New York: Oxford University Press, 1982). Some of my citations from Emerson's writings came from these books.

4. Edward Waldo Emerson and Waldo Emerson Forbes, eds., *Journals of Ralph Waldo Emerson* (Boston: Houghton Mifflin, 1911), vol. 5, pp. 398, 399.

5. *Ralph Waldo Emerson* (New York: Library of America, 1983), p. 412. Unless otherwise noted, all references to this volume will be carried in the text with the name of the essay and page number from which the reference was taken.

6. Jackson Pollock, "Statement," *Possibilities* 1 (Winter 1947–48), cited in B. H. Friedman, *Jackson Pollock: Energy Made Visible* (New York: McGraw-Hill, 1972), p. 100.

7. Pollock, in Friedman, *Jackson Pollock*, p. 229.
8. Arthur E. McGiffert, Jr., ed., *Young Emerson Speaks* (Boston: Houghton Mifflin, 1938), cited in Jerome Loving, *Emerson, Whitman and the American Muse* (Chapel Hill: University of North Carolina Press, 1982), p. 35.
9. Stephen E. Whicher et al., eds., *The Early Lectures of Ralph Waldo Emerson*, 3 vols. (New York: Cambridge University Press, 1959–72), cited in Loving, *Emerson*, p. 15.
10. *Clyfford Still* (San Francisco: San Francisco Museum of Modern Art, 1976), p. 110.
11. Dorothy Miller, ed., *15 Americans* (New York: Museum of Modern Art, 1952), p. 22.
12. J. Benjamin Townsend, "An Interview with Clyfford Still," *Gallery Notes* (Albright-Knox Art Gallery, Buffalo) 21 (Summer 1961): 9, 14.
13. From the manuscript "Lectures on Human Culture," 1837–38, cited in Stephen Whicher, *Freedom and Fate: An Inner Life of Ralph Waldo Emerson* (Philadelphia: University of Pennsylvania Press), p. 84.
14. From an unpublished letter written by Newman in 1947, reproduced in Ellen H. Johnson, ed., *American Artists on Art: From 1940 to 1980* (New York: Harper and Row, 1982), pp. 17, 19.
15. From "The Plasmic Image," manuscript cited in Thomas B. Hess, *Barnett Newman* (New York: Museum of Modern Art, 1971), pp. 37–38.
16. Sherrye Cohn, *Arthur Dove: Nature as Symbol* (Ann Arbor: UMI Research Press, 1985), p. 37.
17. From "The Ideographic Picture," Betty Parsons Gallery, 1947, cited in Johnson, *American Artists*, p. 15.
18. Newman, "The Sublime Is Now," *The Tiger's Eye* 6 (December 1948): 53.
19. Newman, "The First Man Was an Artist," *The Tiger's Eye* 1 (October 1947): 60.
20. Emerson and Forbes, *Journals*, vol. 5, p. 288.
21. Bloom, *Poetry and Repression*, p. 254.
22. Robert Motherwell, statement in "What Abstract Art Means to Me," *Bulletin* (The Museum of Modern Art) 18 (Spring 1951): 13.
23. Newman, "The Sublime Is Now," p. 51.
24. Bloom, *Poetry and Repression*, pp. 244, 254.
25. Bloom, *Poetry and Repression*, p. 248.
26. Hess, *Barnett Newman*, p. 26.
27. Bloom, *Agon*, p. 154.
28. Harold Rosenberg, "The American Action Painters," in *The Tradition of the New* (New York: Grove Press, 1961), pp. 25, 26–27.
29. For a reading of this passage in a different context, see my "American Landscape Painting and National Identity: The Stieglitz Circle and Emerson," in this book.
30. From an exhibition statement, The Little Galleries of the Photo-Secession, 1914.
31. "John Marin By Himself," *Creative Arts* 3 (October 1928): xxxix; and Emerson, "Self-Reliance," p. 269.

32. Emerson and Forbes, *Journals*, vol. 8, p. 90.
33. Herbert J. Seligmann, ed., *Letters of John Marin*, 1931 (Westport, Conn.: Greenwood Press, 1970), n.p.
34. Emerson and Forbes, *Jounrals*, vol. 8, p. 122.
35. Calvin Tompkins, "Georgia O'Keeffe – The Rose in the Eye Looked Pretty Fine," *The New Yorker* (March 4, 1974): 55, cited in Katherine Hoffman, *An Enduring Spirit. The Art of Georgia O'Keeffe* (Metuchen, N.J.: Scarecrow Press, 1984), p. 89.
36. *Georgia O'Keeffe* (New York: Viking Press, 1976), opposite plate 100.

TEN. AMERICAN ART AROUND 1960 AND THE LOSS OF SELF

1. The first two citations are from "The Poet," *Essays: The Second Series* (1844), and the third is from *Nature* (1836), reprinted in Joel Porte, ed., *Ralph Waldo Emerson: Essays and Lectures* (New York: Library of America, 1983), pp. 448, 456, and 44.
2. For Newman, see "The Sublime Is Now," reprinted in John P. O'Neill, *Barnett Newman: Selected Writings and Interviews* (Berkeley: University of California Press, 1990), p. 173; for Russell, the gloss is from his essay, "A Free Man's Worship," and is cited in Wylie Sypher, *Loss of Self in Modern Literature and Art* (New York: Vintage, 1962), p. 160. See my "The Emersonian Presence in Abstract Expressionism," in this book.
3. Douglas Davis, *Art and the Future* (New York: Praeger, 1973), p. 37.
4. Maurice Berger, *Labyrinths: Robert Morris, Minimalism, and the 1960s* (New York: Harper and Row, 1989), p. 12; and Robert Morris, "American Quartet," *Art in America* 69 (December 1981): 104.
5. For Cage's chronology, see Richard Kostelanetz, ed., *John Cage* (New York: Praeger, 1970), pp. 37–39. For the Judson Dance Theater, see Sally Banes, *Democracy's Body: Judson Dance Theater* (Ann Arbor: UMI Research Press, 1983), *passim*.
6. See for example, Daisetz Teitaro Suzuki, *Studies in Zen*, ed. by Christmas Humphreys (New York: Dell Publishing Co., 1955), and Alan Watts, *The Way of Zen* (New York: Pantheon Books, 1957).
7. John Cage, "Experimental Music" in *Silence: Lectures and Writings* (Middletown, CT: Wesleyan University Press, 1961), p. 10.
8. Suzuki, *Zen*, p. 28.
9. Suzuki, *Zen*, p. 24.
10. Kostelanetz, *Cage*, pp. 33, 118.
11. Robert Rauschenberg, "Oyvind Fahlstrom," *Art and Literature* 3 (Autumn-Winter, 1964): 219.
12. Barbara Rose, ed., *Art as Art: The Selected Writings of Ad Reinhardt* (New York: The Viking Press, 1975), pp. 205–206, 142.
13. Morris, "Three Folds in the Fabric and Four Autobiographical Asides as Allegories (or Interruptions)," *Art in America* 77 (November 1989): 144.
14. Bruce Glaser, "Questions to Stella and Judd (1964)," in Gregory Battcock, ed., *Minimal Art: A Critical Anthology* (New York: E. P. Dutton, 1968), pp. 157, 158.

15. "Circles," from *First Series* (1841), in Porte, *Emerson*, p, 403.
16. Nancy Holt, ed., *The Writings of Robert Smithson: Essays with Illustrations* (New York: New York University Press, 1979), p. 78.
17. From "Discussions with Heizer, Oppenheim, Smithson (1970)," in Holt, *Smithson*, p. 177.
18. Lucy R. Lippard, "Breaking Circles: The Politics of Prehistory," in Robert Hobbs, ed., *Robert Smithson: Sculpture* (Ithaca: Cornell University Press, 1981), p. 32.
19. "Entropy and the New Monuments," in Holt, *Smithson*, p. 13.
20. Sypher, *Loss of Self*, pp. 73, 74.
21. "Four Conversations," in Eugenie Tsai, *Robert Smithson Unearthed: Drawings, Collages, Writings* (New York: Columbia University Press, 1991), p. 105.
22. Gary Shapiro, *Earthwords: Robert Smithson and Art After Babel* (Berkeley: University of California Press, 1995), pp. 17, 19–20, 15.
23. Berger, *Labyrinths*, p. 129–133.
24. Sypher, *Loss of Self*, p. 35.
25. Morris, "Robert Morris Replies to Roger Denson (Or Is that a Mouse in My Paragone?)," in *Continuous Project Altered Daily: The Writings of Robert Morris* (Cambridge: MIT Press, 1994), p. 313.
26. Emerson, "Circles" (1841), in Porte, *Emerson*, p. 412.
27. *Georgia O'Keeffe*, (New York: Viking, 1976), opposite plate 100; and, Katherine Hoffman, *An Enduring Spirit: The Art of Georgia O'Keeffe* (Metuchen, NJ: Scarecrow Press, 1984), p. 13.
28. Yvonne Rainer, "A Quasi Survey of Some 'Minimalist' Tendencies in the Quantitatively Minimal Dance Activity Midst the Plethora, or an Analysis of Trio A," in Battcock, *Minimal Art*, p. 267.
29. Kimberly Paice, "Portals," in *Robert Morris: The Mind/Body Problem* (New York: The Guggenheim Museum, 1994), p. 100.
30. "Semiology and Grammatology," interview with Julia Kristeva, in Jacques Derrida, *Positions*, trans. Alan Bass (Chicago: University of Chicago Press, 1972), p. 26.
31. Berger, "Wayward Landscapes," in *Robert Morris: The Mind/Body Problem*, p. 30.
32. Andy Warhol and Pat Hackett, *POPism: The Warhol '6os* (New York: Harcourt Brace Jovanovich, 1980), p. 16.
33. David Reisman et al., *The Lonely Crowd: A Study of the Changing American Character* (Garden City, NY: Doubleday Anchor Books, 1953), pp. 37, 41.
34. Kenneth J. Gergen, *The Saturated Self: Dilemmas of Identity in Contemporary Life* (New York: Basic Books, 1991), pp. 17, 133–134.
35. Warhol, *The Philosophy of Andy Warhol (From A to B and Back Again)* (New York: Harcourt Brace Jovanovich, 1975), p. 7; and Watts, *Zen*, pp. 19–20.
36. Jean Baudrillard, "The Ecstasy of Communication," in Hal Foster, ed., *The Anti-Aesthetic: Essays on Postmodern Culture* (Port Townsend, WA: Bay Press, 1983), pp. 132–133.
37. Warhol, *The Philosophy*, pp. 80, 82, 199; and "Warhol in His Own Words,"

in Kynaston McShine, ed., *Warhol: A Retrospective* (New York: The Museum of Modern Art, 1989), pp. 457, 463.

ELEVEN. PEARLSTEIN'S PEOPLE

1. Harry Levin, *The Power of Blackness: Hawthorne, Poe, Melville* (New York: Knopf, 1958), p. 7.
2. Henry Steele Commager, *The American* Mind (New Haven: Yale University Press, 1950), and Lloyd Morris, *Postscript to Yesterday: American Life and Thought, 1896–1946* (New York: Harper and Row, 1947).
3. See my "The Silent Witness of Edward Hopper," in this book.
4. See my *The American Scene: American Painting of the 1930s* (New York: Praeger, 1974), p. 110.
5. Hayden Herrera, "Pearlstein: Portraits at Face Value," *Art in America* 63 (January/February 1975): 47.
6. Discussed in Bernie Zilbergeld with John Ullman, *Male Sexuality: A Guide to Sexual Fulfillment* (Boston: Little, Brown, 1977), *passim*.
7. Herrera, "Pearlstein," 47.
8. Georg Lukacs, *Realism in Our Time*, trans. by John and Necke Mander (New York: Harper and Row, 1971), pp. 47–92.
9. Viktor Frankl, *Psychotherapy and Existentialism: Selected Papers on Logotherapy* (New York: Simon and Schuster, 1967), p. 19.
10. Philip Pearlstein, "Figure Paintings Today Are Not Made in Heaven," *Art News* 61 (Summer 1962): 52.
11. Cited in *St. Louis Post Dispatch*, February 27, 1977, in file at Alan Frumkin Gallery, New York City.

TWELVE. ROBERT MORRIS'S LATEST WORKS: SLOUCHING TOWARD ARMAGEDDON

1. Immanuel Kant, *Critique of Judgement*, trans. by J. H. Bernard (New York: Macmillan, 1951), p. 82.
2. Kant, *Critique*, pp. 83–84.
3. Samuel Monk, *The Sublime* (Ann Arbor: University of Michigan Press, 1960), p. 7.
4. Edmund Burke, *A Philosophical Enquiry into the Origin of Our Idea of the Sublime and Beautiful.* First published in 1757.
5. William Gilpin, *Remarks on Forest Scenery*, 1 (1791), p. 252, cited in Andrew Wilton, *Turner and the Sublime* (London: British Museums Publications, 1980), p. 72.
6. Grace Glueck in *The New York Times*, January 18, 1985, Section C, p. 22.
7. "The Ides of Art: 6 Opinions on What Is Sublime in Art," *Tiger's Eye* 6 (1948): 52.
8. Robert Morris, "The Art of Existence," *Artforum* 9 (January 1971): 28.
9. Robert Morris, "Notes on Sculpture: Part 4," *Artforum* 7 (April 1969): 51.
10. The following information is based on these sources: Howard N. Fox, *Metaphor: New Projects by Contemporary Sculptors* (Washington, D.C.: Smith-

sonian Institution Press for the Hirshhorn Museum and Sculpture Garden, 1982); Marti Mayo, *Robert Morris* (Houston: Contemporary Arts Museum), 1982; Thomas Krens, *The Drawings of Robert Morris* (Williamstown, Mass.: Williams College Museum of Art, 1982); Nancy Marmer, "Death in Black and White," *Art in America* 71 (March 1983): 129–133; and Sally Yard, "The Shadow of the Bomb," *Artsmagazine* 58 (April 1984): 73–82.

11. Fox, *Metaphor*, p. 62.
12. Yard, "The Shadow of the Bomb," 76.
13. This and the following texts were supplied by the very helpful staff of the Sonnabend Gallery.
14. Robert Morris, "American Quartet," *Art in America* 69 (December 1981): 92–106.
15. Morris, "American Quartet," 104.
16. Matthew Baigell and Allen Kaufman, "Thomas Cole's *The Oxbow*: A Critique of American Civilization," *Artsmagazine* 55 (May 1981): 167–169.
17. Morris, "American Quartet," 96.
18. James Merrill, *Mirabell: Books of Number* (New York: Atheneum, 1978), p. 25. This poem was brought to my attention by Cleo McNelly and George Kearns of the Rutgers University English Department.

THIRTEEN. A RAMBLE AROUND EARLY EARTH WORKS

1. Robert Smithson, "A Sedimentation of the Mind: Earth Projects," *Artforum* (September. 1968), in Nancy Holt, ed., *The Writings of Robert Smithson* (New York: New York University Press, 1979), p. 83.
2. Michael Heizer, "The Art of Michael Heizer," *Artforum* 8 (December 1969): 34.
3. Edward Fry, *Projects in Nature* (Far Hills, N.J.: Merriewold West, 1975), not. pag.
4. Nicholas Capasso, "Environmental Art: Strategies for Reorientation in Nature," *Arts Magazine* 59 (January 1985): 73–74.
5. "Interview," *Avalanche* I (Fall 1970): 25.
6. "Discussions with Heizer, Oppenheim, Smithson," *Avalanche* (Fall 1970), in Holt, *The Writings*, p. 174.
7. "Earth (Symposium at Cornell University, 1970)," in Holt, *The Writings*, p. 160.
8. Jack Burnham, "Dennis Oppenheim: Catalyst 1967–1970" *Artscanada* (August 1970), in Alan Sonfist, ed., *Art in the Land* (New York: Dutton, 1983), p. 46.
9. "Discussions with Heizer, Oppenheim, Smithson," in Holt, *The Writings*, p. 171.
10. John Beardsley, *Earthworks and Beyond* (New York: Abbeville, 1984), p. 19.
11. Heizer, "The Art of Michael Heizer," p. 32.
12. "Discussions with Heizer, Oppenheim, Smithson," in Holt, *The Writings*, p. 173.
13. John Gruen, "Michael Heizer: You Might Say I'm in the Construction Business," *Art News* 76 (December 1977): 48.

14. "Artist Known for Works Created in Nevada Desert," *The New York Times*, June 3, 1985, Section C, p. 17.

15. Paul Shephard, *Man in the Landscape* (New York: Ballantine, 1967), p. 61.

16. Craig Adcock, "The Big Bad: A Critical Comparison of Mount Rushmore and Modern Earthworks," *Arts Magazine* 57 (April 1983): 104.

17. Mark Rosenthal, "Some Attitudes of Earth Art: From Competition to Adoration," in Sonfist, ed., *Art in the Land.*, p. 64.

18. Matthew Baigell, *Thomas Cole* (New York: Watson-Guptill, 1981), p. 13.

19. Holt, "Sun Tunnels," *Artforum* 15 (April 1977): 34, 35. See also Beardsley, *Earthworks*, p. 50.

20. Shelley Rice, "Fields of Vision," *Land Marks* (Annandale-on-Hudson, N.Y.: Bard College, 1984), p. 74.

21. Diana Shaffer, "Nancy Holt: Spaces for Reflections and Projections," in Sonfist, ed., *Art in the Land*, pp. 174, 175.

22. Howard Junker, "The New Sculpture: Getting Down to the Nitty Gritty," *The Saturday Evening Post* (November 2, 1968): 42. For this often cited passage, see, for instance, Beardsley, *Earthworks*, p. 19.

23. Peter Hutchinson, "Earth in Upheaval," *Arts Magazine* 43 (November 1968): 18.

24. Rainer Crone, "Prime Objects of Art: Scale, Shape, Time," *Perspecta* 19 (1982): 22–23.

25. *Ralph Waldo Emerson: Essays and Lectures* (New York: The Library of America, 1983), p. 10.

26. Melinda Wortz, "Walter de Maria's The Lightning Field," *Arts Magazine* 54 (May 1980): 173.

27. Klaus Kertess, "Earth Angles," *Artforum* 24 (February 1986): 78.

28. Robert Morris, "Some Notes on the Phenomenology of Making: The Search for the Motivated," *Artforum* 8 (April 1970): 62, 66.

29. Holt, "Hydro's Head," *Arts Magazine* 49 (January 1975): 59.

30. *Henry David Thoreau* (New York: The Library of America, 1985), pp. 391, 37, 38.

31. Holt, "Hydra's Head," 59.

32. *Emerson*, p. 403.

33. Richard Poirier, *The Renewal of Literature: Emersonian Reflections* (New York: Random House, 1987), p. 30.

34. Lucy R. Lippard, "Breaking Circles: The Politics of Prehistory," in Robert Hobbs, ed., *Robert Smithson: Sculpture* (Ithaca: Cornell University Press, 1981), p. 32.

35. Smithson, "A Sedimentation of the Mind," in Holt, *The Writings*, p. 89.

36. "Interview with Robert Smithson for the Archives of American Art, Smithsonian Institution (1972)," in Holt, *The Writings*, p. 154.

37. Smithson, "A Sedimentation of the Mind," in Holt, *The Writings*, p. 86.

38. "Discussions with Heizer, Oppenheim, Smithson," in Holt, *The Writings*, p. 172; and Smithson, "Frederick Law Olmsted and the Dialectical Landscape," *Artforum* (February 1973), in Holt, *The Writings*, p. 124.

39. Smithson, "A Sedimentation of the Mind," in Holt, *The Writings*, p. 91.

40. Holt, *The Writings*, p. 89.

41. Holt, *The Writings*, p. 85.

42. Max Weber, *Essays on Art* (Privately printed, 1916), pp. 14–15.

43. Weber, *Essays*, p. 49.

44. Smithson and Gregoire Muller, ". . . The Earth, Subject to Cataclysms, is a Cruel Master," *Arts Magazine* 46 (November 1971): 41.

45. Arthur Dove, "An Idea," catalogue statement, The Intimate Gallery, 1927, in Barbara Haskell, *Arthur Dove* (San Francisco: San Francisco Museum of Art, 1975), p. 135.

46. Sherrye Cohn, *Arthur Dove: Nature as Symbol* (Ann Arbor: UMI Research Press, 1985), p. 31.

47. Mark Rothko, "The Romantics Were Prompted," *Possibilities* I (Winter 1947–48): 84.

48. Statement in Jeffrey Wechsler, "Response to the Environment," in Sonfist, ed., *Art in the Land*, p. 263.

49. Robert Joseph Horvitz, "Nature's Artifact: Alan Sonfist," *Artforum* 12 (November 1973): 32.

50. Jonathan Carpenter, "Alan Sonfist's Public Sculpture," in Sonfist, ed., *Art in the Land*, p. 144.

FOURTEEN. REFLECTIONS ON/OF RICHARD ESTES

I want to thank Renee Baigell, George Kearns, Cleo McNelly, and Cynthia Prebus for their bibliographical suggestions, and Renee Baigell for clarifying some thoughts in this essay.

1. Illustrated in Louis K. Meisel, *Richard Estes: The Complete Paintings, 1966–1985* (New York: Harry N. Abrams, 1986).

2. *Richard Estes: The Urban Landscape*, interview with John Arthur (Boston: Museum of Fine Arts, 1978), 19, 26, 17.

3. Lloyd Goodrich Folder, The 1940s, item dated April 20, 1946, Whitney Museum of American Art.

4. John Perrault, "Richard Estes," in Meisel, *Richard Estes: The Complete Paintings*, p. 12.

5. Edward Hopper, "Charles Burchfield: American," *The Arts* 14 (July 1928): 7.

6. Perreault, "Richard Estes," p. 17.

7. Perreault, "Richard Estes," pp. 25–26.

8. *Richard Estes: The Urban Landscape*, 23.

9. Perreault, "Richard Estes," p. 11. See also Linda Chase, Nancy Foot, Ted Burnett, "The Photo-Realists: 12 Interviews," *Art in America* 60 (November–December 1972): 79.

10. John Arthur, "Artist's Dialogue: A Conversation with Richard Estes," *Architectural Digest* 39 (October 1982): 208.

11. Newsletter, Allen Frumkin Gallery 7 (Winter 1979): 3.

12. *Richard Estes: The Urban Landscape*, 27.

13. Perreault, "Richard Estes," p. 36.

14. Brian McHale, *Postmodernist Fiction* (New York: Methuen, 1987), pp. 9–10.

15. McHale, *Postmodernist Fiction*, p. 14.

16. Arthur, "Artist's Dialogue: A Conversation with Richard Estes," 208.

17. McHale, *Postmodernist Fiction*, p. 47.

18. For Velazquez's painting, see especially Michel Foucault, *The Order of Things* (New York: Random House, 1970), pp. 3–16. First published in 1966.

19. Letters to Gustave Geoffroy in 1908 and 1912, in Richard Kendall, *Monet By Himself* (Boston: Little, Brown, 1990), pp. 240, 245. See also Charles F. Stucky, *Waterlilies* (New York: Macmillan, 1988), p. 18.

20. Michel Hoog, *The Nymphias of Claude Monet at the Musee de l'Orangerie*, English edition (Paris: Editions de la Réunion des Musees Nationaux, 1989), p. 75.

21. Bob Rogers, "Realism and the Photographic Image," *Gazette des Beaux-Arts*, series 6, vol. 98 (September 1981): 94.

22. Foucault, "What Is an Author?" in *Language, Counter-memory, Practice: Selected Essays and Interviews by Michel Foucault*, trans. by Donald F. Bouchard and Sherry Simon (Ithaca: Cornell University Press, 1977), p. 117.

23. Jean Baudrillard, "The Ecstasy of Communication," in Hal Foster, ed., *The Anti-Aesthetic: Essays in Postmodern Culture* (Port Townsend, WA: Bay Press, 1983), p. 133; and "Simulacra and Simulations," in Mark Poster, ed., *Jean Baudrillard: Selected Writings* (Stanford, CA: Stanford University Press, 1988), p. 167.

24. Frederic Jameson, "On Diva," *Social Text* (Fall 1982): 118.

25. Jameson, "On Diva," 118.

26. Jameson, "Postmodernism and Consumer Society," in Foster, ed., *The Anti-Aesthetic*, p. 119.

27. Perreault, "Richard Estes," p. 11.

28. Arthur Burton, "Schizophrenia and Existence," in Hendrik M. Rutenbeek, ed., *Psychoanalysis and Contemporary American Culture* (New York: Dell Publishing Co., 1964), pp. 91–106. See also "The Silent Witness of Edward Hopper," in this book.

29. Charles Baudelaire, *The Painter of Modern Life and Other Essays*, trans. by Jonathan Mayne (New York: Phaidon, 1964), p. 9.

FIFTEEN. BEN SHAHN'S POSTWAR JEWISH PAINTINGS

1. None of these issues was addressed in Howard Greenfeld's recent biography, *Ben Shahn, an Artist's Life* (New York: Random House, 1998).

2. Ziva Amishai-Maisels, "Ben Shahn and the Problem of Jewish Identity," *Jewish Art* 12–13 (1987): 314.

3. David G. Roskies, *Against the Apocalypse: Responses to Catastrophe in Modern Jewish Culture* (Cambridge: Harvard University Press, 1984), pp. 13, 19. The phrase "eternal contemporaneity" appears in Yosef Hayim Yerushalmi, *Zakhor: Jewish History and Jewish Memory* (Seattle: University of Washington Press, 1996 [1982]), p. 96.

4. Ben Shahn, *Love and Joy About Letters* (New York: Grossman Publishers, 1963), p. 5.

5. Seldon Rodman in *Ben Shahn: Portrait of an Artist as an American* (New York: Harper and Brothers, 1951), p. 171, mentions that Shahn ate unleavened bread (matzoh) on Passover and fasted on Yom Kippur.

6. Ben Shahn, *The Shape of Content* (New York: Vintage Books, 1960 [1957]), pp. 32–40; and Ziva Amishai-Maisels, *Depiction and Interpretation: The Influence of the Holocaust on the Visual Arts* (New York: Pergamon Press, 1993), p. 78.
7. This reading was suggested by Rabbi Ephraim Edelstein. For a different reading of this work as well as others, see Frances Pohl, "Allegory in the Work of Shahn," in Susan Chevlowe, ed., *Common Man, Mythic Vision: The Paintings of Ben Shahn* (Princeton: Princeton University Press, 1998), pp. 111–144.
8. Avram Kampf, *Contemporary Synagogue Architecture* (New York: The Union of American Hebrew Congregations, 1966), pp. 134–136. The blowing of the shofar is mentioned several times in Scripture. See, for instance, Exodus 19:16, and Psalms 47:6, 81:4–5, and 98:6.
9. From Mishna 3:3 and 3:4, in Philip Blackman, ed., *Mishnayoth*, Vol. II, *Order Moed* (2nd ed.) (New York: The Judaic Press, 1963), pp. 395–396.
10. Rev. Dr. A. Cohen, ed., *The Twelve Prophets* (Bournemouth, Hants.: The Soncino Press, 1948), pp. 335–336, 345.
11. Rev. Dr. A. Cohen, ed., *The Psalms* (London: The Soncino Press, 1945), pp. 133, 439; Cohen, ed., *The Twelve Prophets*, p. 221; and Dr. Judah J. Slotki, intro., *Daniel, Ezra, and Nehemiah* (London: The Soncino Press, 1951), p. 179.
12. Roskies, *Against the Apocalypse*, p. 28.
13. Amishai-Maisels, "Ben Shahn and the Problem of Jewish Identity," 316.
14. Rev. Dr. A. Cohen, ed., *Jeremiah* (London: The Soncino Press, 1949), pp. ix–x.
15. Ben Shahn, *Ecclesiastes: Or the Preacher* (New York: Grossman Publishers, 1971 [1967]), n.p.
16. Rev. Dr. A. Cohen, ed., "Ecclesiastes," in *Midrash Rabbah* (London: The Soncino Press, 1938), p. 298.
17. Bernarda Bryson Shahn, "Ben and the Psalms," in John D. Morse, ed., *Ben Shahn* (New York: Praeger Publishers, 1972), p. 217.
18. Ben Shahn, *The Alphabet of Creation: An Ancient Legend from the Zohar* (New York: Schocken Books, 1954); and Shahn, *Love and Joy About Letters*, published in 1963.
19. The passage from the *Zohar* appears in Edmond Fleg, *The Jewish Anthology*, trans. Maurice Samuel (New York: Harcourt, Brace and Company, 1935), pp. 196–198. Fleg, in turn, took his material from Louis Ginzburg's *Legends of the Jews* (Philadelphia: The Jewish Publication Society of America, 1911), vol. 1; and from the *Zohar*, vol. 1, 2b-3b. For Gershom Scholem, see *Major Trends in Jewish Mysticism* (New York: Schocken Books, 1946), pp. 134, 136.
20. Fleg, *The Jewish Anthology*, pp. 196–198. Shahn repeats this story in *Love and Joy About Letters*, pp. 18–19. The ultimate source for this story is in one of the first surviving mystical books, the *Sefer Yetzirah*, or *Book of Creation*. See Aryeh Kaplan, *Sefer Yetzirah: The Book of Creation*, rev. ed. (York Beach, ME: Samuel Weiser, 1970), pp. 26, 100; see also Yehuda Libes, *Studies in the Zohar*, trans. Arnold S. Schwartz (Albany: State University Press of New York, 1993).

21. Scholem, *Major Trends*, pp. 132, 133, 134.
22. Scholem, *Major Trends*, p. 136.
23. Shahn, *Love and Joy About Letters*, pp. 5, 17. For more on Abulafia, see Moshe Idel, *The Mystical Experience in Abraham Abulafia*, trans. Jonathan Chipman (Albany: State University of New York Press, 1988).

SIXTEEN. BARNETT NEWMAN'S STRIPE PAINTINGS AND KABBALAH: A JEWISH TAKE

1. Thomas Hess, *Barnett Newman* (New York: Museum of Modern Art, 1971). See also Robert Rosenblum, *Modern Painting and the Northern Romantic Tradition* (New York: Harper and Row, 1975), p. 209; Annette Cox, *Art-as-Politics: The Abstract Expressionist Avant Garde and Society* (Ann Arbor, Mich.: UMI Research Press, 1977), p. 69; and Avram Kampf, *Jewish Experience in the Art of the Twentieth Century* (South Hadley, Mass.: Bergin and Garvey, 1984), p. 197
2. Gershom G. Scholem, *Major Trends in Jewish Mysticism* (New York: Schocken,1946), pp. 263, 265; see especially pp. 260–76.
3. Hess, *Newman*, pp. 56, 71; see also pp. 52–61, 83.
4. Barnett Newman, "Memorial Letter for Howard Putzel" (1945), in John O'Neill, ed., *Barnett Newman: Selected Writings and Interviews* (Berkeley: University of California Press, 1990), pp. 97–98.
5. Barnett Newman, "Stamos" (1947), in O'Neill, ed., *Newman*, p. 109.
6. Barnett Newman, "Ferber" (1947), in O'Neill, ed., *Newman*, p. 111.
7. Barnett Newman, "The Sublime Is Now" (1948), in O'Neill, ed., *Newman*, p. 170; Thomas Cole, "Thoughts and Occurrences" (ca. 1842), quoted in Barbara Novak, *Nature and Culture in American Landscape and Painting, 1825–1875* (New York: Oxford University Press, 1980), p. 10.
8. Ralph Waldo Emerson, "Circles" (1841), in *Ralph Waldo Emerson* (New York: Library of America, 1983), p. 412; and Walt Whitman, preface to the 1855 edition of *Leaves of Grass*, in *Walt Whitman* (New York: Library of America, 1982), pp. 24–25. See also my "Watt Whitman and Early Twentieth-Century American Art" and "The Emersonian Presence in Abstract Expressionism," in this book.
9. John Paul Sartre, *Existentialism*, trans. Bernard Frechtman (New York: Philosophical Library, 1947); Martin Buber, *Tales of the Hasidism: The Early Masters*, trans. Olga Marx (New York: Schocken, 1947); and Scholem, cited in n. 2.
10. Sartre, *Existentialism*, pp. 37–38. See also the following articles published in *The New York Times Magazine* (section 6): John L. Brown, "Chief Prophet of the Existentialists," February 2, 1947, pp. 20–21, 50–52; Simone de Beauvoir, "An Existentialist Looks at Americans," May 25, 1947, pp. 19, 51–53; and Paul F. Jennings, "Thingness of Things," June 13, 1948, pp. 18–19.
11. Harold Rosenberg, "Mystics of the World" (1947), reprinted in Rosenberg, *Discovering the Present* (Chicago: University of Chicago Press, 1973), pp. 239, 240, quoting Buber, *Tales*, p. 251.

12. Rosenberg, *Discovering the Present*, p. 240, quoting Buber, *Tales*, pp. 107, 2, 4.
13. Rosenberg, "Is There a Jewish Art?" (1966), reprinted in Rosenberg, *Discovering the Present*, p. 230.
14. For this reading of Buber, see Scholem, "Martin Buber's Interpretation of Hasidism," in Scholem, *The Messianic Idea of Judaism and Other Essays on Jewish Spirituality* (New York: Schocken, 1971), pp. 240–45.
15. Scholem, *Major Trends*, pp. 274, 276.
16. Barnett Newman, "Recent American Synagogue Architecture" (1963), in O'Neill, ed., *Newman*, pp. 181–82. Newman quotes Isaiah 6:1.
17. Hess, *Newman*, p. 52, quoting Scholem, *Major Trends*, p. 59.
18. Hess, *Newman*, p. 61, quoting Scholem, *On the Kabbalah and Its Symbolism* (New York: Schocken, 1965), pp. 159–204. See also Scholem, *Major Trends*, pp. 69, 75, 99, 127, 138, 145.
19. Scholem, *On the Kabbalah*, p. 173.
20. Donald Kuspit, "The Abandoned Nude: Natan Nuchi's Paintings," in Kuspit, *Natan Nuchi* (New York: Marfield Perry Gallery, 1992), unpaginated.

SEVENTEEN. POSTSCRIPT: ANOTHER KIND OF CANON

1. From *The New York Times*, June 4, 1935. See also Grant Woods's essay, "Revolt Against the City," in James Dennis, *Grant Wood: A Study* (New York: Viking, 1975), p. 234; and "Stone City's Second Season," *The American Magazine of Art* 26 (August 1933): 391.
2. Charles Burchfield, "Henry G. Keller," *The American Magazine of Art* 29 (September 1936): 592–593; and Edward Hopper, "John Sloan and the Philadelphians," *The Arts* 11 (April 1927): 170, 177.
3. Jackson Pollock, "Jackson Pollock," *Arts and Architecture* 61 (February 1944): 14.
4. Greg Tate, "Nobody Loves a Genius Child: Jean-Michel Basquiat, Flyboy in the Buttermilk," in *Flyboy in the Buttermilk: Essays in Contemporary Culture* (New York: Simon and Schuster), p. 241, quoted in Lisa Bloom, "Ghosts of Ethnicity: Rethinking Art Discourses of the 1940s and 1980s," *Socialist Review* 24, nos. 1 and 2 (1994): 156.
5. John Kuo Wei Tchen, "Believing Is Seeing: Transforming Orientalism and the Occidental Gaze," in *Asia/America: Identification in Contemporary Asian American Art* (New York: The Asia Society Galleries, 1994), p. 22; Tere Romo, "Forward," in *Xicano Progeny: Investigative Agents, Executive Council, and Other Representatives from the Sovereign State of Azatlan* (San Francisco: The Mexican Museum, 1995), p. 7; Lucy Lippard, *The Pink Glass Swan: Select Essays on Feminist Art* (New York: The New Press, 1995), p. 17; Norman Kleeblatt, "Passing into Multiculturalism," in Kleeblatt, ed., *Too Jewish? Challenging Traditional Identities* (New York: The Jewish Museum, 1996), pp. 6, 7; and Richard J. Powell, *Black Art and Culture in the Twentieth Century* (New York: Thames and Hudson, 1997), pp. 166–167.
6. Michael Walzer, "Multiculturalism and the Politics of Interest," in David

Biale et al., eds., *Insider/Outsider: American Jews and Multiculturalism* (Berkeley: University of California Press, 1998), p. 93.

7. David Harvey, *The Condition of Postmodernity: An Enquiry into the Origins of Cultural Change* (Malden, MA: Blackwell, 1990), p. 44.

8. Harvey, *The Condition of Postmodernity*, p. 54.

9. Jean Baudrillard, "The Ecstasy of Communication," in Hal Foster, ed., *The Anti-Aesthetic: Essays on Postmodern Culture* (Port Townsend, WA: Bay Press, 1983), pp. 126–127.

10. Michael Sgan-Cohen, "Touching the Essence: The Work of Natan Nuchi," in *Natan Nuchi: Paintings* (Haifa: The Museum of Modern Art, 1992), pp. 63–64.

11. Henry L. Feingold, *Lest Memory Cease: Finding Meaning in the American Jewish Past* (Syracuse: Syracuse University Press, 1996), p. 7.

12. Jean-Paul Sartre, *Anti-Semite and Jew*, trans. George J. Becker (New York: Schocken, 1948), p. 66.

13. Eric Hobsbawm, "Introduction: Inventing Traditions," in Hobsbawm and Terence Langer, eds., *The Invention of Tradition* (London: Cambridge University Press, 1983), pp. 1–13. For a specific application of these ideas, see Yael Zerubavel, *Recovered Roots: Collective Memory and the Making of Israeli National Tradition* (Chicago: University of Chicago Press, 1995).

14. See my "Kabbalah and Jewish American Artists," *Tikkun* 14 (July/August 1999): 59–61; and "Jewish American Artists: Identity and Messianism," Baigell and Milly Heyd, *Complex Identities: Jewish Consciousness and Modern Art* (New Brunswick: Rutgers University Press, 2000).

15. *Beth Ames Swartz: Israel Revisited* (Privately printed, 1981); Lippard, *The Pink Glass Swan*, pp. 112–113; and Powell, *Black Art and Culture in Twentieth Century America*, p. 180.

16. Ziva Amishai-Maisels, *Depiction and Interpretation: The Influence of the Holocaust on the Visual Arts* (New York: Pergamon Press, 1993).

17. Albert Elsen, *Seymour Lipton* (New York: Abrams, 1974), pp. 20–29; and Harris Rosenstein, "Lipton's Code," *Art News* 70 (March 1971): 47.

18. Adolph Gottlieb and Mark Rothko, "Letter to *The New York Times*, 1943," in John W. McCoubrey, *American Art, 1700–1960* (Englewood Cliffs, NJ: Prentice-Hall, 1965), p. 211; and "The Ideographic Picture (1947)," in John P. O'Neill, ed., *Barnett Newman: Selected Writings and Interviews* (Berkeley: University of California Press, 1990), p. 108.

19. Yosef Hayim Yerushalmi, *Zakhor: Jewish History and Jewish Memory* (Seattle: University of Washington Press, 1982), p. 36. See also David G. Roskies, *Against the Apocalypse: Responses to Catastrophe in Modern Jewish Culture* (Cambridge: Harvard University Press, 1984), pp. 13, 17, 159.

20. James E. Breslin, *Mark Rothko: A Biography* (Chicago: University of Chicago Press, 1993), pp. 26, 407.

21. Breslin, *Mark Rothko*, p. 325.

22. Sander L. Gilman, "The Jew's Body: Thoughts on Jewish Physical Difference," in Kleeblatt, ed., *Too Jewish?* p. 71.

23. See, for instance, Michael D. Harris, "Memories and Memorabilia, Art and Identity: Is Aunt Jemima Really a Black Woman?" *Third Text* 44 (Autumn

1998): 25–42; and Pamela Newkirk, "Pride or Prejudice," *Art News* 98 (March 1999): 114–117.

24. The phrase, in a different context, is taken from Robin Chandler, "Xenophobes, Visual Terrorism and the African Subject," *Third Text* 35 (Summer 1996): 17.

Publication Sources

1. Geoffrey M. Sill and Roberta Tarbell, eds., *Walt Whitman and the Visual Arts.* New Brunswick: Rutgers University Press, 1992, pp. 121–141
2. *Art Criticism* 4, no. 1 (1987): 27–47
3. *Arts Magazine* 49 (September 1974): 29–33
4. *Arts Magazine* 61 (February 1987): 48–57
5. *Art Journal* 27 (Summer 1968): 387–396
6. *Art Journal* 26 (Winter 1966–1967): 116–122
7. *Kansas Quarterly* 2 (Fall 1970): 19–29
8. R. Douglas Hurt and Mary K. Dains, eds., *Thomas Hart Benton: Artist, Writer, and Intellectual.* Columbus: The State Historical Society of Missouri, 1989, pp. 1–34
9. *Prospects* 15 (1990): 91–108
10. *Art Criticism* 13, no. 2 (1998): 42–53
11. *Art Criticism* 1 (Spring 1979): 1–11
12. *Art Criticism* 2, no. 1 1985): 1–9
13. *Art Criticism* 5, no. 3 (1989): 1–15
14. *Art Criticism* 8, no. 2 (1993): 16–25
15. Never published
16. *American Art* 8 (Spring 1994): 33–44
17. Never published

Index